UNCOMMON
CLAY

Other books by Burke Wilkinson

NOVELS

Night of the Short Knives
The Adventures of Geoffrey Mildmay
Proceed at Will
Run, Mongoose
Last Clear Chance

NAVY TRUE STORIES

By Sea and By Stealth

BIOGRAPHIES

The Zeal of the Convert
Francis in All His Glory
Young Louis XIV
Cardinal in Armor
The Helmet of Navarre

ANTHOLOGIES

Cry Sabotage!
Cry Spy!

Burke Wilkinson

Photographs by David Finn

A Helen and Kurt Wolff Book
Harcourt Brace Jovanovich, Publishers
San Diego New York London

UNCOMMON
CLAY

THE LIFE AND WORKS OF
AUGUSTUS SAINT GAUDENS

Copyright © 1985 by Burke Wilkinson

Requests for permission to make copies of any part of the work should be mailed to: Permissions,
Harcourt Brace Jovanovich, Publishers, Orlando, Florida 32887.

Library of Congress Cataloging in Publication Data
Wilkinson, Burke, 1913–
 Uncommon clay.
 "A Helen and Kurt Wolff book."
 Includes index.
 1. Saint-Gaudens, Augustus, 1848–1907. 2. Sculptors—
United States—Biography. 3. Saint-Gaudens, Augustus,
1848–1907—Criticism and interpretation. I. Title.
NB237.S2W55 1985 730'.92'4 [B] 85-8480
ISBN 0-15-192749-9

Printed in the United States of America

First edition

A B C D E

For Franny
as always

CONTENTS

Illustrations follow page 238.

PREFACE

Piecing together the life story of a man like Augustus Saint Gaudens, famous sculptor in his own time, half forgotten today—is like gathering flotsam from the drowned hull of a ship. The hull—the life itself—lies some fathoms down. Every now and then a fragment comes twisting to the surface—a deed, a memory, an insight. It has been my task as biographer to collect the fragments, coordinate them with what is known, and come up with some kind of coherent reconstruction.

In the case of Saint Gaudens, one might have thought that his autobiography, written a year before his death, would serve as a kind of ship's log, salvaged before the ship was lost. It would be reasonable to expect that the main events of his life, both public and private, would have been set down there in some sequential way. But self-told lives can conceal as well as clarify. *The Reminiscences of Augustus Saint Gaudens*[1] belongs in the category of those that conceal. Despite the many entertaining details in its pages, the celebrated American sculptor does not emerge very clearly. The reason is simple. During the spring and summer of 1906, when he was composing the memoirs, his wife, Augusta; his son Homer; and his niece-in-law, Rose Nichols, were all on hand and deeply involved. They made it their task to see that the final product was completely sanitized and quite bloodless.

The captive author, ill from the cancer that would kill him the following year, managed to sound a note of warning and apology which breaks through the protective family cordon: "I could a tale unfold that would make what appears like candlelight in sunshine; but various considerations, conventional and otherwise, bar the way vexatiously."[2]

Certainly, the Saint Gaudens who emerges from the auto-
biography is a plastic figure, not modeled very closely from life.
In reality he was a vivid and compelling man with born gifts of
leadership. He had a molten temper, which ran mostly under-
ground. His humor was simple and warm, and there was a healthy
ambition under the Gallic charm.

Not much of this comes through in the book. Nor was his
private life as unruffled as the *Reminiscences* would have us be-
lieve. After a few happy years there was a widening gap between
him and Augusta. Homer, their only child, at times drove him
to near despair. "I wish that we may be comrades and not fighting
father and son of which there are so many and which is so intensely
foolish," he once wrote.[3]

The two handsome volumes of autobiography, which The
Century Company published in 1913, still show up occasionally
at book fairs and rummage sales. Homer "edited and amplified"
the draft his father managed to put together in that last, dying
year. The son's interpolations are bland and affectionate, and the
narrative moves competently until the whitewashed, almost wart-
less figure is done.

The most vivid parts of the autobiography concern Saint Gau-
dens' childhood and early manhood, for there was as yet little to
conceal, and little that would embarrass his family. But more and
more as it goes along the book becomes a cover-up, a cautionary
tale in the cautious sense of the word.

The American reviews of the *Reminiscences* were polite, but
the point about their blandness recurred often. Writing in the
Yale Review, Lorado Taft put it like this: "The story of the great
achievements . . . is at first disappointing. The author does not
wear his heart upon his sleeve. . . . We have to take the emotion
for granted." Again and again, said Taft, we have to go back to
the great works themselves, "charged with some strange potency
that never diminishes. . . . We must therefore content ourselves
with the sketches and the completed works, admirably repro-
duced, and such incidents of their growth and dedication as the
whim of the author has preserved."[4]

A British edition, appearing later the same year, received much the same treatment. The *Times Literary Supplement* was rueful: "Unfortunately, though it may seem ungracious to say so, we cannot regard the book as altogether successful. . . . It fails to give that general picture of Saint Gaudens, his theories, his methods, and his work which one has the right to look for in the biography of an artist." Moreover, the reviewer went on, "a family member, who assembles such a book, is apt to pass over some things about which the reader would like to be informed, and to dwell upon others which are quite unimportant."[5]

In order to see Saint Gaudens whole as artist and as man, one must give heed to all the surfacing fragments. Only by probing his inner life, so sedulously guarded and screened, can we understand the creative process which drove him so strongly.

His other life—with Davida Clark, his favorite model and mistress—has hardly ever been touched on. She bore him a son, Louis, and for over twenty years was a dominant influence in his life. Saint Gaudens' relationship with Mary Lawrence, later Tonetti, the daughter of a Hudson River family, who was considered one of his most talented pupils, has not been examined in any depth.

In his day Augustus Saint Gaudens was a towering figure, both in the world of art and on the national scene. He was a member of an inner group of men who in the 1880s and 1890s were "like a yeast in the intellectual life and growth of the nation" in a burgeoning time.[6] Senior statesmen were Henry Hobson Richardson and John La Farge. Other members were John Hay, Stanford White, Charles Follen McKim, Richard Watson Gilder, Henry James, and Henry Adams.

His bold, tawny look of a Renaissance soldier of fortune, his quick sympathy for those who wished to learn from his talent and experience, and more than anything else the great creative talent itself made him a legendary figure.

But sometimes the brighter the flame, the quicker the quenching. Soon after his death, oblivion began to settle over and around his memory. There was of course a retrospective show at

the Metropolitan Museum of Art, which later, in somewhat re-
duced form, moved around the country. Richard Watson Gilder
penned a fervent ode in farewell. Kenyon Cox, Royal Cortissoz,
and others wrote winged words to send him on his way. "His
greatest works loom large with supernal conception," Talcott Wil-
liams contributed. "In them is a sudden sense of the invisible
spirit of the age made visible by the artist who represents not
himself but his time."[7]

Nevertheless, the mantle of sculptor-statesman quickly set-
tled on the decent shoulders of Daniel Chester French. Even the
statues that were Saint Gaudens' enduring legacy somehow began
to lose their luster. Such American icons as the windblown Ad-
miral Farragut in Madison Square, the great somber standing
Lincoln in Chicago, the Sherman, the Shaw, the *Diana* swift as
her own arrow seemed to fade a little into the landscape. Half
forgotten, the shrouded figure in memory of Mrs. Henry Adams
brooded away year after year over her grave and his in Rock Creek
Cemetery.

They all appeared to be out of the mainstream of American
art. As recently as 1965, the *Encyclopedia of World Art* patronized
Saint Gaudens, saying that he was "as over-praised as Hiram
Powers" and calling his sculpture "picturesque rather than sculp-
tural."

This business of waiting for Valhalla can be long. There seems
to be no rule of thumb for artists and writers and the time they
take to achieve it. For years it was fashionable to consider John
Singer Sargent merely stylish and stylistic. Even in his own life-
time, Thomas Eakins was condemned to an oblivion of sorts. The
portly shade of Henry James stood in the shadows for a quarter
of a century before full recognition came. Scott Fitzgerald saw
the quenching of his own bright star, and his limbo lasted a decade
before the star began to go up the sky once more.

Now the fame of Augustus Saint Gaudens is flowing again.
The resurgence began modestly enough back in 1969, when the
National Portrait Gallery staged a show of his bas-reliefs. Greeting
this very full selection of the more intimate works of the sculptor,

John Canaday offered this accolade: "These portraits of turn-of-the-century Americans are as vivid as they are evocative. . . . The Saint Gaudens show is in a word beautiful."[8]

Prices for Saint Gaudens works have multiplied by ten, by twenty in the last two or three years, and continue to climb. Scholarly theses blossom and proliferate. New York's Metropolitan Museum of Art held a major retrospective of the sculptor's official and intimate works in late 1985.

As for Augustus Saint Gaudens himself, John Wilmerding, deputy director of the National Gallery, made it quasi-official when he ranked him among three towering figures of the late nineteenth century: "In its subjective power and expressive feeling, the art of Saint-Gaudens can stand worthy comparison to two of the artistic giants of his time: the American painter Thomas Eakins and the French sculptor, Auguste Rodin."[9]

Part of this renewed fame is of course the pride America is taking in its own art of the last century. We are discovering that there really was an American flowering (if not exactly a Renaissance), that we were not as dependent on Europe as we had imagined. The Luminists, the landscapists like Frederick Edwin Church and Thomas Cole and Albert Bierstadt, the great individualists like Homer and Eakins and many others, are now being seen for what they are. The architects too, although mostly inspired by the Old World, did bring an American flavor and sturdiness to their sumptuous creations. H. H. Richardson, Richard Morris Hunt, Charles Follen McKim, and Stanford White are among the names being refurbished today.

It is the world's loss that Augustus Saint Gaudens did not see fit to tell his full story. The process of seeking the truth has not been an easy one. Over and above the family secrecy and caution, there were two devastating fires at the sculptor's Cornish, New Hampshire, studio, which destroyed many of the letters and prized possessions. One of Louis Clark's sons kept a packet of Saint Gaudens' letters to Davida for many years. But, in some bitterness, he and another son finally destroyed the packet unread, and—they thought—unwanted.

Only a handful of people are alive today who remember Saint Gaudens first-hand. It has been my good fortune to interview them all.

My five-year quest—and that of my resourceful assistant, Elizabeth Ajemian—has gone from California to Ireland to the foothills of the Pyrenees, and into many archives. Some of the voyaging has led to shoal water and marshland, some has proved most rewarding.

Augustus Saint Gaudens himself was not much given to philosophy. But in his last days he managed to write a line that sums up his vigorous outlook on life: "You can do anything you please," he wrote in a still-firm hand; "it's the way it's done that makes the difference."[10]

How he did it, how he achieved a life rich in creation, a life lived with great gusto and no little grace, is what this biography is about.

— A NOTE ON THE NAME —

On both the spelling and pronunciation of his name, Augustus Saint Gaudens' own wishes are known. In answer to an inquiry, he wrote on May 8, 1888: "Dear Sir: My name should be spelt without a hyphen IE. Saint Gaudens" (Saint Gaudens Collection, New York Public Library).

In filling out his form for *Appleton's Cyclopedia of American Biography* (vol. IV) he indicated the true pronunciation: "Saint Gaudens pronounced as it would be read in *English* IE. 'gau' as in 'gaudy,' 'ens' as in 'enslave' " (form is dated April 27, 1888, also in the SG Coll, NYPL).

Throughout the present book I follow the sculptor's wishes about the spelling except when quoting from others who use the hyphen or the shortened form of "St." Brother Louis preferred the latter, so I use "Louis St. Gaudens" for him. Son Homer favored the hyphen, so I employ "Homer Saint-Gaudens" throughout.

Book I

THE LEARNING YEARS

1

PYRENEAN PATRIMONY

"Bernard Paul Honeste if you please."

—Bernard Saint Gaudens[1]

"I ALWAYS THOUGHT I was a kind of cosmopolitan, gelatinous fish; *pas du tout;* I belong in America."[2]

For many years the Gallic and Gaelic strains in Augustus Saint Gaudens were in some conflict. The twin strands of his French patrimony and his Irish matrimony caused a kind of fighting in his heart. When he was fifty, his discovery of his basic Americanness resolved the conflict and with this came a great sense of homecoming. He wrote the lines quoted above from Paris in September 1898. Then he went on: "That [America] is where I want to be and remain; elevated railway dropping oil and ashes on the idiots below, cable cars, telegraph poles, sky-line and all have become dear to me, to say nothing of things many, many more times more attractive; friends, the scenery, the smell of the earth. . . ."

Augustus Saint Gaudens was born in Dublin, Ireland, on March 1, 1848. His birthplace was a typical Dublin house of the simplest kind—three-story red brick with a pleasant Georgian door and fanlight and almost no cornice. It was on Charlemont Street, about two miles due south of the spot at the end of O'Connell Street where the Saint Gaudens statue of Charles Stewart Parnell would be unveiled sixty-three years later.

3

Augustus' father, Bernard Paul Ernest Saint Gaudens, came from the little town of Aspet in the foothills of the Pyrenees.[3] A cobbler by trade and a wanderer by inclination, he had by the early 1840s strayed as far afield as Ireland, and was working for an Irish shoemaker. It was there that he met Mary McGuiness, who bound slippers in the same shop. They fell in love, married, and lost two boys—one at the age of six, one in infancy—before the arrival of Augustus, who in his own words turned out to be "red-headed, whopper-jawed and hopeful" from the start.[4]

Although the sculptor did not visit the village of his ancestors until he was nearly fifty, Aspet and the area known as the Haute-Garonne bulked very large in his father's life. The elder Saint Gaudens told so many tales of his boyhood there that the Pyrenean town and countryside helped to shape the son as well. Historically, the Haute-Garonne, now a *département*, was a part of Gascony. From time immemorial the Gascons, as we know, have been great talkers and great fighters, and have done both with considerable dash. No fewer than seven of Napoleon's marshals, "members and companions of his glory,"[5] came from the mid-Pyrenees. So did Foch, Joffre, and Gallieni of World War I fame. As for the talk, the word "gasconade" has gone into several languages to describe a boastful way of speaking.

Cyrano de Bergerac and D'Artagnan are of course half-legendary Gascon prototypes. In his love of tall talk and in a certain exuberant charm, Bernard Saint Gaudens was also very Gascon. He was stocky, deep-chested, rich-voiced, with dark-red hair and a light-red mustache. All his life Augustus would remember and use certain of the father's expressions. "What you are saying and nothing at all is the same thing" was one such phrase. "As much use as mustard plaster on a wooden leg" was another.[6]

Concerning the origins of the family name, Bernard had many fantastic stories. The version to which local historians give some credence tells of a fifth-century shepherd boy called Gaudens, an early Christian. Found at his devotions by a band of Saracen marauders from across the mountains in Spain and mocked by them, he continued to pray. One of the band, a certain Maleck, drew his

4

scimitar and beheaded the youth. To the astonishment of the raiders, Gaudens picked up his severed head and escaped into a small nearby church, managing to bar the door before he died.

Another version of the martyrdom says that the raiders were Visigoths. Since the whole region was in turmoil, and remained so until long after Charles Martel's victory over the Arabs in 732, either version is possible. In any event, many miracles took place at the tomb of the young shepherd. Pilgrims came in multitudes, and the area began to prosper. Gaudens was canonized; the town that grew on the ridge not far from the tomb was called Saint-Gaudens in his memory. Today it is a city and a *sous-préfecture* of the *département*. There is a splendid view of the barrier wall of the Pyrenees across rich fields and forested slopes. At the foot of the ridge, the snow-fed Garonne runs in green turbulence.

Aspet is a small ancillary town some five miles south of Saint-Gaudens. It has a main square, the Place de la République, with two cafés and a graceful fountain of the time of Henry IV. Down the Grande Rue, which goes from the square to the Place Saint-Michel, where the parish church is, there are several medieval houses with overhanging upper stories. The second house up from the lower square is a pleasant, not-so-ancient structure whose ground floor was once a store. It was the Saint Gaudens family home in Bernard's time and before. Madame Jacques Georgelin, born a Saint Gaudens, now lives there in summer.

The country around Aspet tilts upward toward dark foothills, and it is not much changed since Bernard Saint Gaudens' day. There is still a lot of good hunting, for wild boar, bear, and Pyrenean chamois are plentiful in the mountain country. Lower down, grouse, partridge, and gray mountain pheasant abound.

According to local lore, three kinds of people live hereabouts. In the mountains and high valleys, the natives are said to be hardworking, frugal, superstitious, and ignorant. On the slopes, in the pleasant towns like Aspet, the men and women are good workers but also good livers, and much merrier. The people of the plain are lazy and indolent. Like his ancestors, Bernard was obviously a man of the second category.

With the exception of the boy saint back in the dim early

days, the first mention of the name Saint Gaudens appears in a fifteenth-century entry in the archives of the town of Aspet. A certain Jean Saint Gaudens is inscribed as being a shoemaker by trade who died in 1491. Another Saint Gaudens forebear, according to family tradition, served in the elite bodyguard of Henry III of France, whose members assassinated the power-mad Duc de Guise in 1588.

There also exists, in the records of the annual assembly of the south of France (the États de Languedoc) for the year 1620, a reference to a Sieur de Saint Gaudens. He raised the question of his salary as deputy and tax collector for the town of Carbonne, northwest of Saint-Gaudens. If he had to share it, the Sieur said loftily, "people of quality would not wish to accept the deputation."[7]

By the eighteenth century, the Saint Gaudens family seems to have fallen on more modest times. Bernard's father, André, born in 1787, served in the ranks in the Napoleonic Wars. His wife, whose maiden name was Boy, sold butter and eggs in the market place at Aspet, and left the proverbial box full of gold pieces under her bed when she died. André died young, but not before siring four sons and a daughter. Bernard was the fourth son.

Even though the Saint Gaudens thread runs a little thin down the ages, it is there, and documented. So this is as good a place as any to dispose of a persistent myth that the sculptor's real name was Labat.

This canard about the Labat name crops up in the *Histoire Universelle des Arts* by Louis Réau, which came out in Paris in 1936. Réau's entry on Augustus Saint Gaudens includes the statement that his father "came originally from a village in the Pyrenees of the arrondissement of Saint-Gaudens, of which he borrowed the name."

José Dhers, the historian and folklorist of the Haute-Garonne, who died in 1983, has recorded a similar story. When, some years after Saint Gaudens' death, the sculptor's fame began to filter back to southern France, local interest and pride were aroused. "It was discovered," Dhers writes, "that toward 1835 a

6

shoemaker of Aspet, Bernard Labat, had emigrated to Ireland. After marrying there, he left for the United States, and there took the name of Saint-Gaudens."[8]

Helping to perpetuate the myth was an American sculptor called Truman Bartlett, whose malevolent path we will cross again. Jealous of Augustus' rise to fame, Bartlett gleefully harped on Saint Gaudens' humble origins, and his father's supposed adoption of the more stylish-sounding name.

The fact that André Saint Gaudens' daughter married the village apothecary at Aspet, whose name was Labarthe, may have contributed to the Labat legend. When I questioned Monsieur Dhers closely about where he himself had picked it up, he shrugged his shoulders and readily admitted that it had come his way by "*esprit d'oreille*" only—that is, by word of mouth and ear. He could cite no written evidence.

So let's lay the ghost of Labat, and accept the splendid name the sculptor bore for what it surely was.

Less is known about Mary McGuiness Saint Gaudens than about her ubiquitous husband. We learn in the *Reminiscences* that she came from County Longford and that her father was a plasterer. She had, Augustus tells us, "wavy black hair and the typical long, generous, loving Irish face." That she had a good deal of common sense to balance Bernard's strut and bravado emerges quite clearly from her few letters that have come down. At a key moment in his life Augustus accepted her wise judgment, as we shall see.

The sculptor's French orientation is confirmed by his comment on seeing Aspet for the first time in 1897: "It is impossible for me to describe my emotions upon arriving at the village I had heard my father speak of so frequently and at seeing my name over a door at the head of a little narrow street where a cousin of mine conducted a shoe-trade and also dealt in wines. It is that singular sense of being at home where one has never been before which I am sure is the result of inherited memory."[9]

Aspet and the Pyrenean foothills were in his blood and bone, and had been from the start.

7

2

THE THRUST OF A CITY

"My Theme is memory that winged host. . . ."

—Evelyn Waugh,
Brideshead Revisited

IN THE YEARS of the great famines in Ireland, starting in 1846, one-third of the nation of ten million people perished. Of the survivors, over a million came to the United States, though many died on the way across from ship fever—a form of typhus—and from other ailments stemming from conditions on the hellish ships.

The year 1848 had started out well enough, and there were high hopes of a good potato crop. But in June the weather turned wet, and by mid-July another blight had set in. As the Irish summer lengthened, even potatoes that had seemed sound when picked were blackening with a terrible fungus. Now, in the third year of the terror, many landowning farmers and shopkeepers joined the mass exodus, which included the little Saint Gaudens family. Emigration was not quite so disorganized as it had been, and Bernard, Mary, and Augustus seem to have had a fairly tranquil passage.

They sailed from Liverpool on the *Star of the West* and landed in Boston in September.

Like thousands of others who came pouring in, the Saint Gaudenses found Boston most unwelcoming. The emigrants had come to be regarded as the dregs of Europe and an intolerable

burden to the taxpayer. They were able to do only the simplest kind of day labor, everyone said, and signs reading *No Irish Need Apply* proliferated in store windows and factory offices.

Leaving Mary and Augustus in Boston temporarily, Bernard Saint Gaudens went on to New York. By the late 1840s it had a population of half a million—three times that of the New England city—and was better able to cope with the influx from Europe. Houses at the lower end of Manhattan were being vacated as the gentry moved uptown. Four percent of the population lived in cellars.

Bernard found a house on Duane Street near City Hall. He set up his cobbler's shop there. Being French rather than Irish helped, and so did the Gallic charm. His sign proclaiming *French Ladies Boots and Shoes* proved a magnet to customers. Soon enough he was able to send for his wife and child.

Within months they moved to a better house, on Forsyth Street. "It was there," Augustus writes in the *Reminiscences*, "that I made the beginnings of my conscious life."[1]

In the summer of 1906, when he was setting down his life story, he was already mortally ill with cancer, if in brief remission. As he lay on a sofa in his Cornish studio, the memories would come flooding back. If the account of his grown-up years grows increasingly reticent, the glimpses of his New York childhood are quite delightful, with a touch of the poet in the telling; they reveal a youthful feeling for form and texture that foreshadowed the sculptor. "Ecstatic, dreamlike playing," he writes, "and the picking of flowers in the twilight among the graves of an old burying-ground . . . blended with similar ecstatic enjoyment of the red wheels of the locomotive in some journey out of New York, are my first impressions, vaguely discerned in the gray, filmy cobwebs of the past."

Either in 1850 or 1851 Mary Saint Gaudens had another son, Andrew. In 1854 Louis St. Gaudens was born, the gifted, erratic brother whom Augustus would love and shepherd all his life. By that time Bernard had rented a whole building on Lispenard Street for home, shop, and a tenant or two.

As Augustus grew, he took part in countless street fights, for

he was, he tells us, "unusually combative and morose." He and his gang "ran with Fire Engine Number Forty" of the Elm Street Station. Those who ran with other engines of other companies were natural enemies. "Heroic charges and counter-charges down Lispenard Street, bold forays into the enemy's ground to defend the honor of Engine Number Forty . . . dominated life then as much as anything has since."

There were "lickings galore" in the local school and outside. A "solitary and tremendous caning" by one of his teachers for clowning in class produced a "hatred and feeling of injustice as profound as anything that has occurred in later years." On summer nights Augustus and other boys on the block would stretch strings from the high stoops to wagons standing in the street, the object being to knock off the hats of passers-by. If a policeman in all his dignity was the victim, and terrible reprisal threatened, the boys would scatter like startled birds.

Here is a good example of the straightforward style of this part of the *Reminiscences*, on the recurrent theme of the activities centering around the local firehouse: "At this time came the wonderful trials of skill between the volunteer fire-engines at the liberty pole on the corner of West Broadway and Varick Street, the contest being over which engine would throw a stream of water the highest, and, if possible, above the pole. The screaming delight of the boys, as they ran out of the adjoining school at three o'clock and witnessed this contest, may be judged."

Sunday outings to the Jersey shore opened up fresh vistas. "The roaming about under the trees, and the going to and fro on the river, seated with a line of other boys on the front of the boat, our legs dangling on edge, was untold enjoyment. These were great days, for on Sundays father gave us each five cents, two to pay the ferry over, two back, and one to spend."

Once, after an attack of typhoid, he slept in a country home on Staten Island. "In front of the house was a bare hill. The going to that hill was a thing looked forward to for days, and its climbing one afternoon, to find that there were hills still farther away, was my first feeling of the ever-mysterious beyond."

The discovery of the hills-beyond-the-hill, this sense of wonder of what lay farther away, would last him all his life.

From the age of nine or even earlier, Augustus's *fureur esthétique* began. It took the form of a rage to draw, first with chalk on his slate at school, then with charcoal on the walls of a white-painted house in the country, to the anger of his hostess. "And at last I created a much more ambitious painting, on the fence in the backyard, of a Negro boy with a hole in his trousers, through which the bare knee was seen. The joy derived from that knee!"

To a boy whose artistic pores were opening, New York was a stimulating place to grow up. There was a sense of excitement, of a new city on the move, bursting with energy, boisterous, riotous. It was still something of a frontier town. Pigs and oxen ran loose in the streets; new people came pouring in by the shipload.

Not many years later, Henry James, enumerating the excellences of New York, wrote that one great asset was "the resource of its easy reference to its almost incomparable river."[2] In the 1850s the Hudson had not yet quite come into its true glory. The "easy reference" was the daily dumping by hand of the night's sewage. Only very slowly were the shanty towns along its banks giving way to long piers to serve the great ships.

But there were symptoms of better things to come. Since Manhattan was a north-south island without recourse to west or east, expansion had no way to go but up the island. In 1850 the potter's field, usual line of demarcation for a city, moved from Fiftieth Street to Eighty-sixth Street. In 1857 a commission hired Frederick Law Olmsted to create Central Park, which would become the first urban space of its kind in the world. The same year the celebrated architect James Renwick began to supervise the construction of the graceful Gothic filigree that would become Saint Patrick's Cathedral, far up Fifth Avenue between Fiftieth Street and Fifty-first.

There were February mornings when the Adirondack wind down the Hudson blew so hard—and the colors were so intense—that they seemed to the young Augustus like the first mornings

of the world. There were also times of fear when the Irish would stage anti-British riots and the streets would empty, then erupt into sudden violence.

One of the wonders of the day were the clipper ships that came surging up the bay or took off like gulls for far places, topsails quivering a hundred feet above their slender hulls. They bore names like *Sovereign of the Seas, Flying Cloud*, and *Witch of the Waves*, and they were the fastest things yet fashioned by the hand of man for his voyaging. Their record for the Liverpool–New York run was thirteen days, and for the voyage around the Horn to San Francisco just under ninety.

Bernard Saint Gaudens prospered in a modest way. He had some strange ideas about footwear, including the advantages of squeezing the foot about two inches behind the toes. "Naturally if you compress the foot in this manner," he would say, "the toes will open out like a fan."[3] This was supposed to be comfortable, and also to add to the beauty of the foot "by giving a long, narrow appearance." In good part because of Bernard's picturesque personality and his colorful blend of fierce French accent and Irish brogue, the ladies kept coming. His clientele included the wives of Governor Edwin Morgan and Governor John Dix and assorted Astors and Belmonts. The beautiful Mrs. Dan Sickles, wife of the general who had lost a leg at Gettysburg, came often. Men customers were rarer, but Horace Greeley dropped by, partly because he enjoyed arguing with Bernard about his odd philosophy of footwear. More important to this story was another regular, Dr. Cornelius Rea Agnew, who noticed Augustus' deft sketches of shoemakers at work, and vigorously encouraged the boy's ambition to make a career in art.

Young Augustus felt the beauty stirring around him as well as the squalor. He observed, absorbed, dreamed—and drew.

3

THE GLYPTIC ART

"Perhaps what one wants to say is formed in child-
hood and the rest of one's life is spent trying to
say it."

—Barbara Hepworth[1]

"MY BOY, you must go to work. What would you like to do?"

"I don't care, but I should like it if I could do something
which would help me to be an artist."[2]

This exchange between Bernard Saint Gaudens and Augustus
took place when the boy had just turned thirteen. The father was
quite aware of his son's growing skill with pen and pencil. In
deciding to take him out of school, Bernard also knew that Au-
gustus was only a moderate scholar, and that the family income
could well be supplemented.

So it came about that Augustus was apprenticed to a cameo
cutter named Louis Avet. It was the "first fork in the road in his
life," and the fork that he was still traveling forty-five years later
when he came to write his memoirs.

Although cutters in shell already existed, Avet was the first
stone cameo cutter in America. "It was the fashion of the time,"
Augustus remembered, "for men to wear stone scarf-pins with
heads of dogs, horses and lions, cut in amethyst, malachite and
other stones." Tiffany's and Messrs. Ball, Black and Company

bought most of Avet's work, which his apprentice was allowed to deliver by hand.

Avet was a swarthy Savoyard and a harsh taskmaster. When he wasn't scolding he sang at his work, in much the same stentorian tones. "I can only describe my years with him as composing a miserable slavery," the sculptor wrote as memories of the narrow room, the foot-pedaled lathe, and the fine dust came flooding back.

What Augustus did acquire was the habit of hard work, which would last him all his life. At first Avet kept him doing rough designs, which he himself finished, but soon the apprentice was turning out the final products with more than acceptable skill.

Technically, cameo cutting as Saint Gaudens learned it is a form of the glyptic art, the art of carving with a chisel or another sharp instrument in hard material. It consists of a cutting away, a seeking and releasing of a shape or design embedded in stubborn matter.

By contrast, modeling in clay or other soft substances is the haptic art, the shaping and molding of a creation from a malleable mass.

Saint Gaudens had a born gift for both carving and modeling. His combination of manual dexterity and what would develop into a matchless eye would add up to the sculptor's equivalent of a musician's perfect pitch.

In later years, he infinitely preferred working in clay to carving in marble or stone. He often said that marble did not lend itself to the expression of emotion the way clay did (and did more permanently, when converted into bronze). But the resemblance of carving to the technique he used in his arduous, often dreary years as a cameo cutter—the long years when he labored as artisan rather than artist—cannot but have had some bearing on his preference for modeling in clay.

By 1861, the first year of Augustus' apprenticeship, the Saint Gaudens family had moved again. Bernard opened a shop at 268 Fourth Avenue, and rented a small apartment above a grocery store on nearby Twenty-first Street. To get to Avet's workshop,

which was far downtown, by seven o'clock in the morning presented a challenge. Augustus, like most boys, hated walking, but the ten-cent charge for the horse-drawn omnibus was beyond his means. He solved the problem by developing a technique of hopping on the back step of the omnibus without paying. His solution would "frequently be enlivened by a fight with some 'feller' who tried to crowd me off, or with one that I tried to crowd off, or by the switch of some cross driver's whip."

His life was not all drudgery. Even Avet had his lighter moments. Over weekends he would take Augustus fishing for eels off the sandy beach near Fort Hamilton or on hunting trips to the Weehawken Flats across the river in New Jersey. Avet shot the snipe and Augustus lugged the game bag and collected the downed birds. He was elated when he was allowed to have his own gun, but his moment of "devilish glee" came when the gun went off by accident within three feet of Avet's head "and sent him leaping into the air in a paroxysm of fright, curses and shouts."

It was during the second year of his apprenticeship that the fork in the road widened and became more clearly established. On a certain September day, Bernard took the fourteen-year-old Augustus to the Cooper Institute[3] on the Bowery, which had been established in 1859 "for the advancement of Science and Art." To be admitted to its free classes, one had to be sixteen or over. But Augustus brought along a roll of brown wrapping paper, and Bernard was prepared to do some fancy talking. By good luck, Abram Hewitt, son-in-law of Peter Cooper (founder of the Institute) and later a famous mayor of the city, was on hand that day. He was impressed when Augustus "caught up a pencil and made some additional sketches to prove his gift." The rule about age was waived, and he was allowed to enroll. For the next two years, Augustus went to school six nights a week, from the first of October through the end of March. The small class of fifteen to twenty drew from casts and from life. Though the sessions only lasted an hour—from 7:45 to 8:45—Augustus often stayed on until 11:00 working away. He became so exhausted from the cameo cutting by day and the drawing by night that his mother had to

drag him out of bed, administer a breakfast of tea and French bread, and tumble him down the stairs before he was fully awake.

Suddenly, one day, Avet, in a burst of temper worse than his normal state of rage, fired Augustus. The pretext was that the boy had not swept the crumbs from his luncheon off the floor near his lathe. Augustus quietly rolled up his overalls, went to his father's shop, and explained what had happened. Half an hour later Avet appeared, contritely offering five dollars more per week if Augustus would just come back. To his father's pride, his son refused to do so under any conditions. "This was no doubt the most heroic act of my existence," Saint Gaudens observes in the memoirs, "if not the only one having real style."

So the fork took another turn. His next employer, Jules Le Brethon, was also a cameo cutter, very skillful in shell but not versed in stone, although he owned a stone-cameo lathe. When Augustus applied for a job he was instantly put to work. Except that he was also dark and swarthy, and sang at his work, Le Brethon was as different from Avet as day from night. He shared his skills, allowed his new apprentice time to do modeling on his own, never yelled or scolded.

Shortly after starting work with Le Brethon, Saint Gaudens shifted his after-hours studies from the Cooper Institute to the National Academy of Design. Since the picturesque building that housed the Academy—a replica of the Doges' Palace—was next to his father's store at Fourth Avenue and Twenty-third Street, life became simpler as well as more agreeable.

Students in the Academy began studying in the Antique School, drawing from plaster casts of Greek and Roman statuary. On passing an examination by the faculty, they were promoted to the Life School, which included working from nude models. During Augustus' first year there the Civil War was still being fought, and there were only thirteen men in his class. But by the fall of 1865 there were over sixty. In the memoirs, Saint Gaudens mentions Emanuel Leutze as one of his instructors, although the evidence is that the German-born Leutze was not actually enrolled as a teacher until the academic year of 1867–68.

Leutze had already demonstrated his patriotic feeling for his

adopted land by such paintings as *Washington Crossing the Del-*
aware and *News from Lexington.* Whether by actual teaching or
by his works, he undoubtedly helped to instill an American pride
in Saint Gaudens. Another instructor was the genial Ohioan John
Quincy Adams Ward, who in 1874 would become the first sculptor
to be president of the Academy.

Other events contributed to Augustus' store of Americana,
as he realized when he looked back across some forty years:[4]

He remembered the tall, lanky figure of a "very dark man"
bowing to right and left from a carriage that seemed far too small
for his height—Lincoln on his way to Washington, D.C., to take
office.

He remembered the recruiting tent near the fine Henry
Kirke Brown statue of Washington in Union Square, and the
cavalry squadrons assembling in Madison Square, with the horses
"parked together and tied to trees."

He remembered the New England volunteers marching from
Grand Central Station (then just east of Madison Square) to take
the ferry south, thousands of them, singing "John Brown's Body"
as they tramped past.

He remembered the excitement of the war years, and the
extras proclaiming endless victories, victories, victories that never
seemed to be quite what they were touted to be.

He remembered the time of true victory at last, and General
Grant reviewing the troops. Under the slouch hat Grant's face
was kindly, and he liked it very well.

Most of all, saddest of all, he remembered the hushed, almost
interminable line of men and women down Chatham Street, wait-
ing to say their last farewell to their slain President. And Lincoln
lying in state in his bier at the head of the stair at City Hall. And
going back to the end of the long line to look again, so that he
would never forget his "vision of the big man" to whom he would
one day pay greater tribute.

Not all his impressions were of war and politics. A painting
and a work of sculpture seem to have had a direct bearing on
what he would later create.

The painting was displayed in the window of Goupil's Gallery

at Tenth Street and Broadway. It was Jean-Léon Gérôme's *The Death of Caesar*. The canvas, by an artist of enormous popularity in the France of the Second Empire, is one of Gérôme's most powerful historical interpretations. Totally abandoned, the corpse of the murdered Julius Caesar lies full-length below a statue of Pompey in the Roman Capitol.[5] Fleeing in the right background are the assassins. The crumpled toga containing all that is left of the great man is painted so meticulously that one contemporary French critic dubbed the work "the day of the laundress," but there was no denying the impact of the picture. Saint Gaudens never forgot it.

The sculpture was J. Q. A. Ward's *Indian Hunter*, which Augustus first saw in plaster in the back of a Broadway picture store. Later, in bronze, it would grace Central Park—an animated group of a hunter and his dog which was considered very modern indeed in the waning days of neoclassicism. Saint Gaudens' own contemplative *Hiawatha*, completed in Rome (1872–74), stems in good part from his admiration of the Ward work.

Except for the accident of his Dublin birth, Augustus Saint Gaudens was a born New Yorker. He loved the countryside in principle, and for brief outings, but he loved the city in fact and every day. At eighteen, he was a strongly built, high-spirited young man, quick-fisted and street-smart. He was no longer morose, as this glimpse by Thomas Moore, a friend of those student days, confirms: "I often think of those old times when we four, Gus, Herzog, Gortelmayer and myself, after class hours at the Cooper Institute on Saturday nights, took long walks arm in arm in Central Park shouting airs from *Martha*, the 'Marseillaise' and the like, in which Gus was always the leader with his voice and magnetic presence."[6]

The photograph at his lathe tells us a lot. The fine straight nose and the good jaw are already in evidence. The pride and ambition are there, in the alert, watchful pose. The eyes look out at the world with the hopefulness of youth, but already with a glint of the sustaining humor.

The next bend in the road was Bernard's idea. He was well

aware of Augustus' growing talent and saw that it was time for his son to go farther afield. He proposed to send him to Paris to see the 1867 Exposition there, and to stay on with relatives while the money held out. With the greatest enthusiasm, Augustus agreed. Passage was booked on the *City of Boston* for a February crossing.

Before sailing he had one or two matters to clear up. Late in the evenings and on Sundays, Augustus worked on a bust of his father and a drawing of his mother. Luckily the bust survived the 1904 fire at Cornish, and a copy of the drawing has come down to us.

Smoothly modeled in clay and later cast in bronze, the bust of Bernard is a work of some competence. The physical characteristics are well caught, although, as one critic said, "none of the shoemaker's colorful and emotional personality is present."[7] Despite the lack of inner qualities, it is Bernard to the life, just as Maitland Armstrong described him some years later, "a Frenchman with a fine leonine head, an aristocratic bearing and good blood in the veins I am sure."[8] The skin and bare chest of the statue are very smooth, the hair, mustaches and eyebrows are linear. Both the clay and the bronze treatments bear a remarkable resemblance in technique to J. Q. A. Ward's *Indian Hunter*, so much admired by the young sculptor.

The drawing of his mother has a freshness that is lacking in the bust—in part because it is a quick sketch, whereas the sculpture is a finished product. No longer beautiful in a youthful sense, Mary Saint Gaudens' face reveals great character, and it is rendered by the artist with considerable sensitivity.

The two works speak eloquently of Augustus' filial feelings at this time of parting. Writing of the loss of the original of the drawing of his mother in the 1904 fire, he referred to it as "perhaps the possession I treasured most in the world."[9]

Drawing and sculpture, sculpture and drawing. The final choice still lay somewhere ahead. But even at this early stage there are interesting clues. Though the individuality of Saint Gaudens' beautiful modeling—the slight roughness, the use of shadow

and ridge—was still to emerge, the ability to catch a working likeness was firmly established in the bust of Bernard. The drawing of Mary shows little predilection for color, and a good deal for the sculpturesque, in the sharp contrasts of light and dark.

There is evidence, however, that his inclinations lay very close to a painter's. The bas-reliefs he created with such pleasure are the nearest form to painting that a sculptor can employ. In designing them the sculptor sets up a vertical easel and then makes what is, in Brenda Putnam's succinct definition, simply a "raised drawing."[10] Bas-reliefs resemble paintings in two of the three dimensions: their length and breadth are the same. It is only in the projection which brings the third dimension into play that the bas-relief differs. And this, Miss Putnam points out, can be as little as an eighth of an inch, "as in some of Saint Gaudens' exquisite portraits."

In those final days he also cut a cameo for a girl named Mary who worked in a button factory upstairs from Le Brethon's studio. She frightened him, he tells us, almost as much as she attracted. The night before he sailed for France, Augustus called at her house, suddenly presented her with the box containing the carved brooch, "told her he was going away the next day, said goodbye, shook hands and there was an end to that."[11]

So, we see Augustus Saint Gaudens on the eve of his departure as a young man both boisterous and shy, after the manner of the very young. He already possesses, at eighteen, a genuine skill in cameo cutting—a skill honed by six years of hard apprenticeship. More recent are his developing talents in the closely related media of drawing and of modeling in clay.

On that same last night, his master, Jules Le Brethon, gave a dinner in his honor. As Augustus picked up his napkin, a hundred francs in gold cascaded out. Besides his passage money, this and a hundred dollars his father had contributed were all there was to underwrite the adventure.

The trip to the Paris Exposition would last five years.

4

CITY OF LEARNING,
CITY OF LIGHT

"Do not be taken in by the facility of beginners,
it is often an obstacle later on. . . . They make less
progress because they do well right away, with
ease and without reflection; they are like students
with good memories."

—Camille Pissarro,
Letters to His Son Lucien

SAINT GAUDENS crossed the Atlantic in steerage, and was "sicker
than a regiment of dogs." But his first impression of Paris by night
was joyous. Heavy carpetbag in hand, he walked from the Gare
du Havre to the Avenue de la Grande Armée, where his uncle,
François Saint Gaudens, lived. The glittering, gaslit Place de la
Concorde and the Avenue des Champs-Elysées, rising nobly to
the grandest arch in the world, dazzled him.

His uncle, a remover of buildings by trade, was in financial
straits. Most of the demolition work that stemmed from the bold
city planning of Baron Haussmann was finished by now. He wel-
comed his American cousin for as long as the hundred dollars
held out; then the welcome rapidly cooled. By good luck, Au-
gustus found work under an Italian cameo-cutter named Lupi on

the Rue des Trois Frères. He also secured lodgings for himself on the same picturesque street near the top of Montmartre.

His master plan for the Paris visit had focused on gaining admission to the École des Beaux-Arts as soon as possible, and studying there for as long as he could afford it. To his dismay, he found that his application had to be screened by Mr. Washburne, the American Minister, and that the usual waiting period was many months long. As it turned out, interviews, formalities, and red tape took a full year.

He went once or twice to the great Exposition of 1867, original objective of his trip. But it seems not to have made any profound impression. Seeing Gérôme's *The Death of Caesar* prominently displayed brought pleasure, and a pang of homesickness. He shared the indignation of many of his contemporaries that Courbet and Manet, those two great individualists, were once again, as in 1855, compelled to exhibit near, but not in, the vast complex of the world's fair itself.

Mary, the girl to whom he had given the cameo just before his departure, wrote asking if he still meant to keep company with her. Busy with his new life, busy with survival, he never quite got around to answering her letter.

He moved to cheaper and cheaper rooms, ending in the attic of an apartment house opposite the Collège de France, near the Sorbonne. One reason for his straitened circumstances was that cameo cutting was a highly competitive business in Paris and one that attracted many highly competent craftsmen. Work for a newcomer came only in spurts.

There was a more compelling reason, however. In applying for admission to the Beaux-Arts, Saint Gaudens had made a lifetime decision: he asked to be assigned to a sculptor's atelier, not a painter's. In order to be as ready as possible when his acceptance did come through, he took courses in modeling at one of the *"petites écoles"* that were ancillary to the Beaux-Arts. His school was the École de Médecine on the street of that name near the Beaux-Arts compound itself. He studied there in the mornings and evenings, and cut cameos

sporadically in the afternoons. But he "worked so much at the school, and so little at the cameos," that he became miserably poor.

At last the important-looking envelope with the seal of the United States on it arrived, carrying the news of his formal acceptance at the École des Beaux-Arts. The date of his actual *enregistrement* was March 30, 1868.[1] His sponsoring sculptor, in whose atelier he would study, was the distinguished, very stylish François Jouffroy.

Sixty-two years old, "tall, thin, dark, wiry, with little, intelligent black eyes,"[2] Jouffroy had won the Grand Prix de Rome, ultimate award for Beaux-Arts students, in 1832. He had been elevated to officer rank in the Legion of Honor in 1861. At the time of Augustus' enrollment, his atelier was the triumphant studio of the day. From it, Alexandre Falguière had achieved the Prix de Rome two years before. Antonin Mercié would do so the following year.

Everyone knew that Jouffroy had good links to the Tuileries palace, and that the Emperor himself was partial to his work. Most of the work was official and religious, including a fine Saint John in the Église Saint-Gervais and a Napoleon I at Auxonne, much admired for the episodes in bold relief around its base. To Augustus, Jouffroy's *Secret of Venus* was a singularly beautiful nude. The statue shows a young girl on tiptoe whispering in the ear of a Hermes. In the *Reminiscences*, Saint Gaudens demonstrates how early his own preferences were forming. The statue, he tells us, was "modeled in the classical tradition then prevailing, but with such distinction that the affectation added to its charm instead of detracting from it."[3]

The Académie des Beaux-Arts was founded in 1648 by a small group of artists led by Charles Le Brun. Of the twenty-two founders, twelve were *"anciens"* who had studied in Rome. Inevitably, the study of classic and Renaissance art was the heart of the instruction. As the school grew and flourished, the top prize naturally became the Grand Prix de Rome. Winners went to Rome for two years, on a sort of pilgrimage. Later the prize carried four

years of study there, with studio, models, and other expenses covered by the state.

It was Jean-Baptiste Colbert, Louis XIV's great Minister, who made the Beaux-Arts official. *"Il fallait confier aux artistes la gloire du roi"* was his way of stating his intention. Colbert's original idea of the way to enhance the monarch's glory was to buy masterpieces from the Pope. But the Pope of the day did not wish to sell any of his treasure, so the Colbertian alternative was to have the instructors and students at the Académie copy them.

The school survived the Revolution by keeping a low profile and by changing its name from the rather fancy "Académie" to "École." The old convent on the Rue des Petits Augustins became its permanent home. Splendid Renaissance elevations from the châteaux of Gallion and Anet, fine courtyards and gardens, murals, bas-reliefs, and bits of Gothic cloister helped create an atmosphere well suited to the *"existence méditatif et actif"* of the students.

The teaching was visual and practical rather than abstract. It was also interdisciplinary, before that forbidding phrase was born. Architects learned to draw, sculptors to design. Everyone was grounded in the fundamentals of the classic orders: the Doric, the Ionic, the Corinthian, and the Composite. Out of this intimate knowledge of the orders came a love of order which some have called obsession.

But the story of the Beaux-Arts is also a story of revolt and resistance. In its credo, from very near its beginning, nothing could be gained by slavish imitation. Copying the classics was only a steppingstone to originality. Among its legendary stars, there was a romantic Géricault for every classic David, a Delacroix for every Ingres. Even Jacques-Louis David, whose own discovery of the antique world opened such vistas that he called his Roman years "an operation for cataract," put his individual stamp on everything he did.

The great early- and mid-nineteenth-century French sculptors—David d'Angers, Rude, and Carpeaux—were classicists by training. All three—as Grand Prix winners—had the Roman experience. Yet they modeled with a naturalism and a fresh vigor that are among the glories of French sculpture.

The ancient tenet that art must originate in suffering and sorrow was also refuted in the Beaux-Arts credo. "The students knew how to create in joy," one of its last directors, Georges Huisman, said. "They gave themselves up in spite of great hardship to the pure joy of painting, of drawing, sculpting, engraving. . . ."

The student's capacity for joy as well as hard work was encouraged. Fetes, balls, tombolas gave them a chance to exercise their wit and imagination, and to make the tranquil old Quartier Latin come alive with their revels. Climax and focus of all the fun was the Bal des Quat'z'Arts. Starting under the statue of Melpomene in the great Salle named for the Tragic Muse, the revelry overflowed into every corner of the Beaux-Arts demesne and spilled out into the streets of the Quartier. Fabulous costume (and the absence of costume) astonished and delighted. (Both creation and joy are largely gone now. In the 1970s the architectural ateliers were broken up. Other studios are being phased out, and the demesne itself is mostly a museum.)

The first American to go to the Beaux-Arts was Richard Morris Hunt in 1848. The famous architect-to-be was followed soon after by his artist brother William Morris. To his vast later prestige John La Farge served an apprenticeship in the mid-1850s in the studio of Thomas Couture. Another familiar Left Bank figure was James McNeill Whistler, although he seems never to have been formally inscribed as a Beaux-Arts student.

The flow accelerated in the 1860s, with H. H. Richardson and Charles Follen McKim joining architectural ateliers, and Thomas Eakins studying sculpture under Dumont and painting under Gérôme. Winslow Homer was in Paris for ten months in 1867, drifting around the edges of the Beaux-Arts and showing some of his work as a military artist in the Civil War with considerable success. Six months after Saint Gaudens was admitted to the Jouffroy atelier, the promising young American sculptor Olin Warner reported there.

At the time, nearly a thousand students were enrolled in the studios of the École, with another three hundred *aspirants* hovering in the wings hoping to qualify. The three architectural ate-

liers drew just over half the undergraduates, with 260 in the three studios for painters and 171 in the three for sculptors.[4] Women were admitted to some of the *petites écoles* but not to the Beaux-Arts itself. Age limits for French students were from fifteen to thirty, but there were no limits for foreigners.

Augustus had been warned that hazing often made the life of a *nouveau* miserable. He managed to avoid most of it. His good nature and strong physique helped, as did a willingness to roar the "Marseillaise" in English on request. "I was not made to undress or to be painted nude or to undergo any of the ignominies that the poor beginner endures. I was finally admitted to full membership, becoming in my turn one of the most boisterous of the students."[5]

From the start, there were prizes and awards for which competition was fierce. First came the *concours de place*. Everyone submitted life studies, and the winners were given the best places in the studio for the month to come.

Augustus was aware from his first days of the weeding process that led to the selection of the Prix de Rome. In the spring, the top ten qualifiers were given studios of their own, where, for the rest of the term, they could work in splendid seclusion to finish the treatments they had proposed. To his acute disappointment, however, Saint Gaudens discovered that no foreigners were eligible for the prize of prizes and the Roman years.

Nor did Saint Gaudens win any of the lesser prizes and awards.[6] But there were consolations, chief among them the backing and encouragement of his master. Jouffroy would come and stand beside his pupil, making shrewd criticism in an offhand way and looking anywhere but at the sketch or model in hand. Sometimes, if it was a clay model, he would actually mold the clay as he talked, at the same time rolling a little wad of bread in his left hand.

There is a revealing entry in the *Reminiscences* on Augustus' sense of his own future: "The steadiness of Jouffroy's compliments consoled me for my inevitable failures in direct competition. These failures did not for a moment discourage me, however, or create any doubts in my mind as to my assured superiority. Doubts have

come later in life, and in such full measure that I have abundantly atoned for my youthful presumption and vanity."[7]

Although Saint Gaudens never had any inordinate love of nature, there were expeditions outside Paris that gave him great pleasure. One was a walk to Saint-Valéry in Normandy, then up along the coast to Dieppe. Once again he experienced that sense of delight at seeing "hill beyond hill" which he had originally felt as a boy on Staten Island.

Two fellow students became lifelong friends, Alfred Garnier and Paul Bion. Garnier and he wrestled at the local gymnasium, swam in the *piscine* near the Louvre. Long after, in a letter to Louis St. Gaudens, Garnier described Augustus' love of swimming: "You should have seen him throw himself from the top of the stairs, diving, disappearing, and reappearing. I tell you again it was an intoxication for him."[8]

Bion was not so robust, "a long, thin, intellectual young fellow who had been most shamefully hazed on entering the school."[9]

Along with Alfred Garnier and another friend named Dammouse Augustus took a Swiss walking trip for his summer vacation in 1869. Once during their weeks in the Alpine countryside they came to a small castle beyond a stream. Here is how Garnier described what ensued: "We stopped to admire the castle, whereupon, at a large window near the top, appeared a woman. Was it a woman or a young girl? . . . She appeared to be young and beautiful, seen in a castle from afar by youths of twenty. . . . After a moment, our delightful young girl, whom we made out so indistinctly, waved a white scarf. Immediately, the imagination of Augustus and myself took fire and flame."[10] Augustus and Garnier were all for delivering the damsel, but the less romantic Dammouse convinced them that it was already late and that they had far to go before night.

Although the government-run École des Beaux-Arts charged neither admission fee nor tuition, Saint Gaudens continued to have a hard time financially. His vast energies, most of which he poured into his studies rather than his cameo cutting, began to flag.

Enter Truman Bartlett, the thirty-five-year-old Yankee sculp-

tor who would become Augustus' harshest critic and *esprit malin*. Bartlett had studied under Emmanuel Frémiet, nephew of the great François Rude. Frémiet was a vigorous, sometimes even elegant Second Empire sculptor, but not much of the vigor or the elegance rubbed off on his pupil. At the time when Bartlett first crossed Saint Gaudens' path, in the fall of 1869, he was in the process of creating an *Angel of Life*, a peculiarly lifeless draped figure that became one of his few known works.

Bartlett and a friend were dining one night at an art-student restaurant just back of the Beaux-Arts. As he recalls it in his unpublished autobiography,[11] a "woe-begone fellow" came in. The friend told Bartlett that the new arrival was named Saint Gaudens and that he was having a very hard time of it.

"Can't something be done for him?" Bartlett asked.

"No, not that I know of."

"I would like to meet him."

So the friend beckoned to Saint Gaudens, who joined them. They asked how he was.

"I'm feeling pretty well this morning because my master has told me that a little sketch that I have made is worth putting in plaster, and I would like to put it in terra-cotta."

"Perhaps I can help you out," Bartlett said. "I am having a figure put into terra-cotta myself now."

"I should be very glad to have you give me some assistance."

The next morning Augustus arrived at the agreed time at Bartlett's studio on the Avenue d'Eylau. He brought along a small figure of an Indian crouched on a rock trying to spear a fish—an early version of his *Hiawatha*.

"After telling him how to put the figure in terra-cotta, I asked him some questions about himself. His clothes were wretched and he had only one shirt to his back. . . . I had two good living studios in the Avenue and I told him to move over and live in one of them with his bed and lathe and take his meals with Mrs. Bartlett. I also gave him some shirts."

In addition, Bartlett drafted a letter to Americans living in Paris announcing the availability of Saint Gaudens as a cameo

cutter of high repute. Shortly afterward, Bartlett left for America, and so the Bartlett memoirs do not record how long Saint Gaudens stayed on at the studio, or what results if any the letter brought.

Augustus' own mention of this encounter with the older man is sparse enough, one of only two mentions of Bartlett in the entire *Reminiscences*: "I moved to Truman Bartlett's studio near the Arc de Triomphe, sleeping on a mattress on the floor."[12]

Truman Bartlett would never forget the kindness he himself had done, and the claims for gratitude he had staked out. With his own career never quite flourishing, he watched sourly from the sidelines as the younger man rose to fame. No fewer than forty-seven pages of his autobiography consist of rasping observations on Saint Gaudens—his morals, his low friends, his use of others to reinforce his dubious talent. They serve a certain usefulness as antidote to the adulation in which Augustus moved in later years. But they will be mentioned here only when they cast some light, even if garish and slanted, on the career of the man.

Three months into Augustus Saint Gaudens' third year at the Beaux-Arts—in June 1870—a series of events began in France that would cut short his stay there and change his whole life.

5

THE TEARING
OF THE FABRIC

PARIS IN THE YEARS when Augustus Saint Gaudens first studied
there had a late-summer glow about it, like sunlight on September
lawns. Everything seemed in its proper place. The beautiful new
capital city that the energetic Baron Haussmann was creating,
with its boulevards slashing through the old *quartiers*, its fine
parks and grandiose public buildings, was almost complete. The
opera was brilliant, the cafés overflowing. Yet there was a growing
feeling that the springtime of empire lay well behind. A general
loosening of the fabric of France seemed to be setting in.

If we are to understand Saint Gaudens' actions in the summer
of 1870—actions he himself admitted were "very odd"—some
background concerning the eighteen-year span of the Second Em-
pire is in order. If we wish to clarify his ambivalent attitude toward
his own French inheritance, such a backward glance is indis-
pensable.

It was during the three-year period 1867–70, which marked Augustus' first direct exposure to French painting and sculpture, that many of his lifelong preferences and prejudices were formed. So the artistic climate of the Empire must also be sketched in.

Central to the gaudy story of the Empire's rise, heyday, and fall was the personality of Louis Napoleon himself. Except in his opportunism and his modest height, he bore little resemblance to his mighty uncle. The first Napoleon was a man made for war and swift action. Despite the ramrod mustache and the daggerlike tuft of beard, the nephew was a leader only by fits and starts. During the 1860s his health began to fail, and he seemed to be sinking into a kind of lethargy.

"Napoleon the Little" had been declared emperor in 1852 after a manipulated plebiscite. The magic of the Napoleonic legend, the witchery of the name, had worked powerfully in his favor. Eighteen years later, in June of 1870, he held another carefully organized public vote to convince himself that all was still well. The results were soothing. Seven million Frenchmen said they approved of the Empire, and only a million and a half dissented. It looked as if the disastrous Italian experiment, the long-drawn-out folly of the attempt to establish Maximilian of Austria on the Mexican throne, the increasing diplomatic isolation of the Empire itself were all either forgotten or forgiven.

The plebiscite was illusion only. In July, Bismarck and the Duc de Gramont, Louis Napoleon's own foolish Foreign Minister, maneuvered France into a war with Prussia that neither the Emperor nor most of the nation wanted. By early August, Louis Napoleon was a prisoner at Sedan, along with eighty-three thousand of his men who had capitulated there. Abdication followed swiftly. On September 4, the Third Republic was proclaimed. Paris braced itself for the famous siege as the Prussian armies rolled across the land.

It had all begun with such promise. For the first seven years Napoleon III scarcely put a foot wrong. In 1853 he married Eugénie de Montijo, the Spanish noblewoman whose beauty helped make the court of the Tuileries the most brilliant of the century. In the words of a historian of the period, "joy was unconfined."[1]

Although the Emperor quickly turned the Corps Législatif into a rubber-stamp assembly, the Senate into a sideshow, he liked to think of himself as a man with his people's welfare at heart. First of all he would of course restore the glories of the First Empire. But this time, he said, the Empire meant Peace, not War. His despotism, he almost believed, was simply a means to an end. Freedom was the dream and the goal.

In that same year of 1856 the Prince Imperial was born, and the succession was secure. Joy continued unconfined.

The cradle that the city of Paris presented to Napoleon III and Eugénie became a symbol of the baroque Empire. Made of rosewood, silver, and gilded silver, it was shaped like a boat. A silver eaglet with outspread wings covered the bow. At the stern, a silver statue of Paris held a crown over the cot itself. It was prominently displayed at the 1867 World Exposition.

From the first the Emperor had been an enlightened patron of science and the arts. With its yearly salons, its great world exhibitions, and its thronging École des Beaux-Arts,[2] Paris began to replace Rome as the city where everything was happening. The 1856 Exhibition was a triumph that also served as a benchmark for renewed relations with England. Queen Victoria and the Prince Consort received a thundering welcome, and they in their turn were dazzled by the City of Light.

Despite the fine talk of peace, there were many wars, but they were generally remote—and successful. At the conclusion of the Crimean War the peace conference was even held in Paris, another triumph for the *arriviste* Emperor.

The year 1859 saw a darkening of the political scene. In the deepest secrecy Louis Napoleon met with Cavour, the great Piedmontese statesman, at Plombières. The Emperor promised to support Piedmont should a pretext be found for Austria to be termed the aggressor against her own Italian provinces. The pretext was found, the battle joined. But after the bloody victories of Magenta and Solferino, Louis Napoleon discovered that he had little taste for carnage. Without informing his new Italian friends, he pulled out of the Alliance, helping himself to Nice and a rich slice of Savoy as his payment.

As all Italy flamed into revolt, the Pope's temporal holdings collapsed. French Catholics began to veer sharply away from their Emperor. Hoping to appease the liberals, so long suppressed, Louis Napoleon loosened the restrictions against free speech a notch or two, and was paid back by ever-sharpening attacks in the press.

As his power base continued to crumble, he looked around a little wildly for support. In a gesture of considerable grace, he allowed the pictures rejected by the Salon of 1863 to be hung in the same exhibition building as those that had passed muster. So the Salle des Refusés came into being, with 604 paintings on display. One contemporary observer compared it to the way editions of the classics put all the unsuitable, pornographic passages at the back of the book for easy access. Manet's *Déjeuner sur l'herbe* and Whistler's *Girl in White* each scored a *succès de scandale*—and the Emperor garnered no special thanks for his broad-mindedness.

The Emperor and his Empress themselves had very conventional tastes. Right up to the collapse, the names that mattered to them were those of narrative artists deriving rather faintly from David and Ingres. These included Gérôme, the icy teller of tales; Meissonier, painter of battles and Bonapartes, "playing prettily on his little flageolet" (as Zola said); Alfred Stevens, the Belgian colorist; and Winterhalter, who painted royalty by the hectare. Thomas Couture, whose *Romans of the Decadence* first won him fame as far back as 1847, was popular at the palace until he quarreled with the Empress over the correct costume for the Prince Imperial in his never-finished mural of the baptism.

These artists shared a *souci de l'anecdote*, perhaps best translated as "narrative concern." It runs through most of the painting of the Second Empire, whether pseudo-classical, pseudo-eighteenth-century, or pseudo-Oriental. The pseudo-classical in particular had a style of its own, called the Pompeian. To understand it, one French critic said, one needed only a schoolboy memory of a few snatches of the Odes of Horace.

Gérôme and Meissonier and the rest would have been amazed that it is some of their obscure contemporaries who have come

down to us as the great masters. Those who have passed the test of time include Manet, the *boulevardier* who sold a handful of pictures in his own lifetime; Courbet, the earthy loudmouth known for his violent political views and a style considered primitive and naïve; Daumier, the "vulgar caricaturist"; and *"le rustique"* Millet.

From the sidelines, some of the true artists uncapped their barbs at those who catered to the public taste. Of Meissonier, Manet cruelly said, "It is only his breastplates that are not made of iron." Manet's colleague Fantin-Latour remarked of Couture's early triumph that "it was not the decadence of Rome that we beheld but the decadence of art."

Despite his early admiration for the anecdotal talent of Gérôme, and a later awareness of Meissonier, Saint Gaudens was more interested in the sculpture of the Second Empire than the painting. Along with his growing skill in modeling, his eye and taste were steadily developing. Fortunately, the sculpture of the era was of a considerably higher standard than the painting. From what he saw around him he learned a good deal about style and technique, which he would later quote in his own mature works.

Statues go on for a long time. As John Russell has pointed out, "A painting sits on a wall and can be ignored. Traditional sculpture occupies the same space as ourselves, mimics our way of standing, and forces us to get out of the way."[3] The "thereness" of marble and stone and bronze is such that works in these media are ever present and very present.

Back at the turn of the eighteenth century, Napoleon I had stripped Rome of many of her great antiquities and displayed them in Paris, among them the *Apollo Belvedere* and the *Laocoön*. He also tried, without success, to lure Canova and Thorvaldsen, the two great neoclassic sculptors, to his court on permanent assignment.

Instead of copying the classics, or modeling themselves on the neoclassicists, the two best early-nineteenth-century French sculptors were extremely independent-minded men: Jean-

Antoine Houdon and David d'Angers. With their vigor and naturalism, they would have been fine in any age. In the sterile Napoleonic era, they glow.

It was not until the Revolution and the First Empire became history, became legend, that voices began to emerge to celebrate past glories.

The word "romantic," all-embracing for conflicting strains, was often used to describe these mid-century sculptors. "These romantic sculptors made themselves the choristers of the national virtues," French critic Maurice Rheims wrote.[4] They were indeed. Not only were the heroes and heroines of the Revolution and the Napoleonic paladins immortalized, but Charlemagne's Roland, François Villon, Joan of Arc, and Jacques Coeur were included in the pantheon.

Twenty years after his student days in Paris, Saint Gaudens listed the French sculptors who had influenced him most. Four of them were very much in evidence in the late 1860s: François Rude (1784–1855), Jean-Baptiste Carpeaux (1827–75), Emmanuel Frémiet (1824–1910), and Jean-Alexandre-Joseph Falguière (1831–1900).

As early as 1837, Rude's high relief of *Departure of the Volunteers in 1792* was unveiled on the right flank of the Arc de Triomphe. The female figure shrieking her message of defiance and victory to the surge of men below is known as La Marseillaise, but she is France herself as well. Some of her high intensity is also contained in Rude's statue of Marshal Ney near the spot where the *brave des braves* was shot. The sculptor's device of placing memorabilia like Ney's baton and the royal order for his execution at the feet of the embattled figure would have a strong effect on Saint Gaudens.

We will hear more later about Falguière and Frémiet, for their full fame came at the time of Saint Gaudens's own. Suffice it to say that they were sharers in the new naturalism, and in the energy that was so much a part of the romantic themes.

35

Another prominent Second Empire sculptor was Antoine-Louis Barye (1795–1875), whose strenuous groups of animals-and-humans and animals-and-animals were the creations of a superb craftsman. Théophile Gautier called him "the Michelangelo of the menagerie," but he enjoyed a vast popularity.

And so we come to the splendid Carpeaux, counterpart in sculpture to Delacroix himself—for each in his way was the leading romantic of his time. Carpeaux's *Count Ugolino and His Sons* is a seminal work. Shunted aside in the 1855 Exposition, this group, by now in marble, was prominently displayed at the international show twelve years later. The Dantesque theme of the father forced by hunger to devour his own dead sons was treated in such a way as to play down the morbidity, and the modeling was rightly compared to Michelangelo's.

Equally naturalistic but wonderfully lighthearted was Carpeaux's *La Danse*, which was unveiled in 1869 on the façade of the almost completed Opéra. Charles Garnier, the architect, had given the sculptor free rein. As a result, the sinuous nudes swirling around the cymbal-striking Genius of the Dance created an effect of merriment and abandon that delighted many and disturbed some. Conservative critics used a lot of ink attacking it, and one outraged citizen actually poured ink over its rough-stone surface. The government, by now preoccupied with graver matters, announced its intention of having the group removed, but never quite got around to doing so before the collapse of the regime. A few short months later, the sumptuous Opéra would be converted into a storehouse for some forty-five hundred tons of food during the great siege.

La Danse has since been recognized for what it truly is, *"le dernier feu d'artifice de la fête impériale."*[5] It was indeed a set piece, a fireworks glimmering in the gathering dusk of empire.

For time was running out.

6

WHEN THE WIND
IS SOUTHERLY

ON THE NIGHT of July 19, 1870, Augustus Saint Gaudens and his friend Alfred Garnier were at the Opéra. The performance was of Daniel-François Auber's *La Muette de Portici*, a story of Naples in revolt. Most unusually for the time, the libretto treated the aspirations of the simple people of the city in heroic fashion. When at the climax the revolt fails, Fanella, the mute heroine, plunges into the crater of Vesuvius.

Near the end of an already highly charged evening, one of the leading performers came on stage with a French flag in his hand and announced to the hushed audience that France had declared war on Prussia. The cast joined hands, the audience sprang to its feet, and together they all roared out the "Marseillaise."

After the final curtain, everyone surged out onto the Boulevard des Italiens, where a huge crowd had already gathered. Thousands were screaming *"À Berlin!"* . . . *"À bas Bismarck!"* . . . *"Vive la guerre!"* There were a few scattered shouts of *"Vive l'empereur!"*

Augustus was not carried away, for he believed that it was Louis Napoleon and a small but vocal war party in Paris who had pitchforked France into declaring war. He and Alfred Garnier and some friends tried to restrain the mob with fists and canes, but they could make no dent in the swelling frenzy.

A day or so later, watching troops marching off "half-intox-icated, bawling or rather profaning the 'Marseillaise,' " Saint Gau-dens observed that the soldiers seemed to him "like so many innocent men condemned to death marching to their doom." His observations are in a remarkable letter to an American lady, Mrs. Elisha W. Whittlesey, who had been his patron in Paris before she returned home.[1]

Despite hopeful bulletins from the front, rumors of disaster after disaster kept seeping through. The Beaux-Arts was in sum-mer recess. Wanting for once to be solvent when (and if) school reopened in the fall, Augustus slaved away at his cameos. His younger brother, Andrew, had turned up from New York and was working in a porcelain factory in Limoges, two hundred miles south of Paris. Deciding to pay him a visit, Saint Gaudens started out for Limoges on September 4, a fateful day in the history of France.

It was not until the next morning that the full impact of what had happened rolled over him: the Emperor had abdicated at Sedan and the Third Republic had been declared. A few days later, in the same letter to Mrs. Whittlesey, he described his feelings: "On a fine Sunday morning they threw off all this non-sense . . . the Republic instituted . . . and shortly after, Jules Favre's Grand Address, the declaration of this party which now became and is the entire French nation who now see the rotten-ness of the famous Empire."[2]

The letter is a little wobbly on syntax and grammar. But, considering that it was written by a man whose formal schooling had stopped at thirteen, it expresses his feelings with considerable force: "The French are now defending *their* Soil, Homes, Rights, and What's More Liberty. It is now a war of Liberty against Tyranny since King William still continues the war after his formal declaration that he only made war to the Emperor. . . . I am now heart and Soul in the French cause."

The letter becomes a chronicle of anxious days, and an at-tempt to explain his own actions: "I immediately decided to go back and enlist when I saw the Proclamations posted on the walls

of Limoges with 'République Française.' . . . I started the follow-
ing morning and arrived the next day in Paris. Ah but 'there's
the rub.' On coming out of the Depot I saw a regiment leaving
for the war. I saw mothers, wives, sisters embracing their hus-
bands, brothers in a most heart-rending manner. . . . I then
commenced to think myself of my own home far away, of my own
loving parents, of the fearful sorrow it would bring over learning
my decision. . . ."

Augustus went to see various relatives and friends, all of
whom tried to dissuade him from enlisting. At exactly this moment
he received a letter from his mother, "imploring him in the most
earnest manner not to meddle in politics and to come back to
America."[3]

He decided not to enlist after all.

He stayed long enough in Paris to see the defeated army of
Marshal MacMahon come reeling back. Arms stacked, the troops
bivouacked on the Avenue de la Grande Armée. Some were in
the shadow of the Arc de Triomphe itself, an irony not lost on
the disconsolate and somewhat rudderless Augustus.

His low spirits in the wake of the decision stemmed partly
from the fact that his friend Alfred Garnier had joined the colors,
and that Olin Warner, his American colleague in the Atelier Jouf-
froy, had enrolled in the Foreign Legion.

Aimless now, but determined not to go home with his tail
between his legs, he returned to Limoges and his brother Andrew.
The same September 17 letter to Mrs. Whittlesey makes his
feelings very clear: "I would be happy if my family were here
now so there would be no excuse for not fighting. It is a continual
torment for me I assure you to think there is such a glorious cause
to fight and die for. . . ."

He lingered in Limoges for several months. The weather
worsened, although there were occasional days when the wind
from the south bore a message of warmer climes. He began to
feel a strong pull toward Rome, where he knew there was em-
ployment to be had, and where some Beaux-Arts friends had
already fled.

A letter Augustus wrote to Alfred Garnier on September 21 is very much along the same lines as his letter to Mrs. Whittlesey: "I am persuaded, and I don't blame you for it, that you must call me: there's a coward!"[4] He goes on to tell Garnier how the sight of the battalions tearing themselves away from their families, and his own homesickness, had made him a little crazy: "All that shakes my good resolution when (suddenly!) I receive a letter of eight pages from my mother . . . in terrible grief." He explains how her pleas prevailed, asks Garnier to put himself in Augustus' place, and knows his friend will understand.

Augustus, with his conflicting French, Irish, and American loyalties, was actually far from alone in his dilemma about offering his services to France. James McNeill Whistler, the ex–West Pointer, who considered himself very French at the time, was the most candid about the role he chose. With a kind of inverted gallantry, he told a questioner, "I hid in a cellar; I am a coward, I am."[5]

Many of the French artists took French leave. Carpeaux, Monet, and Sisley practiced their profession in London. Rodin slipped away to Brussels for a five-year sojourn.[6] Manet and his friend Degas did enlist, but Manet for one found his duties as a combat artillery officer too strenuous, and soon settled for a less demanding staff job. Courbet, of the outspoken left-wing opinions, was jailed after the fall of the Commune, which had governed Paris during the Prussian siege, and was lucky to survive.

Often the artist is more observer than active participant. Despite his leaden mood, Augustus kept his eyes open, and even found some diversion. He enjoyed an excursion to some fine ruins in the countryside near Limoges, and admired three churches, including the great cathedral, and several Norman bridges in the city itself. With his poet's touch he described to Mrs. Whittlesey the Rue de la Boucherie, a one-family street of butchers: "You recognize Rembrandt's colors immediately in the aspect of those little dark shops in the narrow street with the wrinkled faces of the owners peeping out."[7]

The message of Roman warmth and promise carried on the

occasional Mediterranean wind reached Augustus. He started south in miserable November weather. The "wholehearted wife" of the owner of the pension where Andrew lodged gave him figs and chocolate and an "extraordinary pâté" to sustain him on the voyage. His only other possession was the box with his cutter's lathe in it. Andrew loaned him a hundred francs.

He worked his way across the spiny *massif central* and down the Rhone Valley. At Marseilles he boarded a small steamer bound for Civitavecchia, the port of Rome. The two-and-a-half-day trip through mountainous seas was sheer torture. He clung to the bow rail a good deal of the time, and watched some sailors less ill than he dispose of his prized pâté.

By contrast, the train trip from Civitavecchia to Rome across the Campagna was a blessed relief. There was a silvery haze over the land. Tan-colored marshes and fertile fields slipped past. From time to time, in the distance, broken lines of Roman aqueduct marched across the fields. Shepherds waved their crooks as the train roared past. Once he saw a cluster of farm buildings huddled under a stub of medieval tower, and once he spotted a wine shop with a bush over the door.

The air was so soft and the unfolding countryside so pleasing that it all seemed like heaven, or at least the promise of heaven to come.

7

A MANTLING
OF MARBLE (I)

> "Rome is the great compost heap of civilization,
> one layer lying beside the other so that at every
> step one is reminded of some great human achieve-
> ment."
>
> —Kenneth Clark,
> *The Other Half*

EVERYONE SHOULD HAVE a dream country that is more home than home, and many people do. If one is lucky enough ever to discover the country in actuality, it is likely to become a case of love at first sight. For Augustus Saint Gaudens, France had not quite turned out to be that other country. Perhaps his father's homeland had been in his conscious, everyday life for too long. On his first trip there the sense of wonder and of homecoming was considerable but not overwhelming. Rome was quite a different matter: from the start Augustus was enchanted, and the enchantment, the sense of *déjà vu*, would last him all his life.

It had begun during that train ride across the Campagna. The indelible moment came the next morning as he was walking up the Via Porte Pinciana. At the top of the street he saw a stone pine against the blue Roman sky, and it seemed to embody all

the other welcoming impressions. "It was as if a door had been thrown open to the eternal beauty of the classical."[1] Looking back years later, he told Margaret Chanler "how he owed everything to classic art: how Rome had opened his eyes to beauty and how hard it had been for him to leave it."[2]

Augustus had come to Rome with a growing sense of purpose. It was time, he believed, to create a piece of sculpture that would "astonish the world."[3] He no longer thought of himself as a student: he was fully fledged and ready to stake out a future. Rome, with its ever-present sense of past glory, was surely the perfect place to do so.

By the time the train from Civitavecchia pulled into the Roman station it was quite late in the evening. Nevertheless he went straight to the house of a Beaux-Arts colleague named Publio de Felici. He was told that his friend had gone next door, and there he found Publio making love to "the most beautiful girl he had ever seen."[4] To the romantic Saint Gaudens it was a fitting augury for his own time in Rome.

De Felici loaned him a room and allowed him to set up shop there until he could find a studio. On that same first day, thanks to de Felici, he met a red-bearded dealer named Rossi who lived on the Via Margutta, where many of the foreign artists had their studios. Rossi paid well for good cameos, and was able to absorb a great deal of Augustus' somewhat intermittent output.

A few days later, Saint Gaudens ran into another Beaux-Arts friend, the gentle, melancholy Soarés dos Reis. A Portuguese sculptor of great promise, Soarés had come to Rome to escape the war, and like Augustus was in the mood to make his bid for fame. They found a studio together on the Palazzo Barberini, on the side that gave onto the charming Via San Nicolo da Tolentino. The studio was on the same floor as a much fancier range of rooms occupied by William Wetmore Story. As Augustus and Soarés soon discovered, Story was, by virtue of almost twenty years' residence, the dean of the artists' colony in Rome. His beard and mustache were quite perfect, and he wore a large beret that looked as if it was pressed every morning.

Story, a Bostonian, was the son of Joseph Story, Associate Justice of the Supreme Court, who died in 1845. A talented amateur in water color and clay, the younger Story sought and obtained the commission to do a monument to his father. This led to Rome and more study. His *Cleopatra*, much admired at the London Exposition of 1862, gained further fame by being fully described in Nathaniel Hawthorne's *The Marble Faun*.

Suetonius, the second-century (A.D.) Roman historian, tells us that Caesar Augustus found Rome a city of brick and left it a city of marble. Imperial Rome, as the first Emperor created it, did indeed gleam and glitter with marble of many hues. There was the snowy Carrara marble, the golden travertine (still quarried along the Tivoli road), "creamy Numidian marble scarcely less shimmering than the Carrara, black agate from Laconia, alabaster, porphyry and red granite from Egypt."[5]

Many of these were later used for purposes the first Emperor could hardly have foreseen. In order to embellish Christian basilicas, early popes stripped much of the marble from the Forum. They did this so thoroughly that it has been said that those early popes found antique Rome—the Forum, anyway—a city of marble and left it of brick.

In Augustus Saint Gaudens' day, some nineteen centuries after the time of Caesar Augustus, there was still a lot of marble about. Classical sculpture seemed to be everywhere, to instruct and inspire. The *Laocoön* and the *Apollo Belvedere*, back from their travels, were in one of the Vatican museums. The Sculpture Gallery at the Capitol displayed the *Dying Gaul*, the Lycian *Apollo*, the *Satyr* of Praxiteles in replica (inspiration of Hawthorne's *Marble Faun*)—as well as portrait busts by the score of Roman men of state and war, and Roman matriarchs.

Donatello, Michelangelo, and Bernini evoked the Renaissance and the Baroque Age. Although Canova and his great disciple, Thorvaldsen, had died earlier in the century, their works lay like a mantle of snow in the Roman galleries and museums.

The studios of the two sculptors, crammed with gods and goddesses, nymphs and heroes (almost worthy of their classical ancestors), were prime attractions for the tourists who flocked to Rome.

Of particular immediacy to the foreign artists in Rome was the plentiful supply of Italian marble, and the availability of the splendid corps of artisans, many of them true artists, to translate clay into plaster cast and so into enduring marble.

The Canovan tradition of open house in the studio on set days of the week had expanded by 1870 to include soirées as well. William Wetmore Story's studio, crammed with tapestries, armor, weapons, and bric-a-brac, teemed with activity by day and night, and much business was done there.

Another very active studio was that of Randolph Rogers, a great shaggy man whose sentimental neoclassical creations were enjoying quite a vogue. A description by Maitland Armstrong, who was American Consul to the Papal States at the time, brings strikingly home the mass-production methods employed to satisfy the market: "He [Rogers] had lately made a statue of Nydia, the blind girl of Pompeii, which had great popular success, particularly among Americans, who ordered many replicas for their houses. She was depicted as listening intently, groping her way with a staff. I once went to his studio and saw seven *Nydias*, all in a row, all listening, all groping, and seven Italian marble cutters at work cutting them out. It was a gruesome sight."[6]

Augustus and Soarés suspended a wire down the middle of their small studio and slung a sheet over the wire. Then each set to work modeling his masterpiece-to-be. Soarés chose as his subject *The Exile*, hero of a poem by his fellow countryman Luiz de Camoëns. He envisaged a figure that perfectly complemented his own mood of habitual melancholy. Augustus reverted to his Paris theme of a contemplative *Hiawatha*. On the pedestal of the finished statue he planned to carve lines from the Longfellow poem about the Onondaga chieftain that would match the mood of the nude figure: HIAWATHA / PONDERING MUSING / IN THE

45

FOREST / ON THE WELFARE OF HIS PEOPLE / ON THE SMOOTH BARK OF A BIRCH TREE / PAINTED MANY SHAPES AND FIGURES /. This use of lettering to enhance a mood and further a narrative would become one of Saint Gaudens' most characteristic and effective devices.

Looking back thirty-five years later, he was able to mock the solemnity of his approach to this first major production, and found himself "pondering musing on my own ponderous thoughts and ponderous efforts."[7] In the same self-deprecatory tone he told his friend Will Low that he considered the figure of an Indian "the necessary mistake of every American sculptor."[8]

Saint Gaudens worked on his clay figure in the mornings, and on the bread-winning cameos in the afternoons. The evenings, spent mostly in the cafés with French, British, and American artists, were congenial, and there were wonderful, eye-opening expeditions over the weekends to Tivoli, Frascati, Albano, and the Sabine Mountains. Except for bouts of Roman fever (the local form of malaria), it was a joyous time for Augustus, a time of friendships that would prove lasting and, in due course, of commissions that made the future seem full of promise.

His observation of political activity, sharpened in Paris by the tribulations of the Second Empire, slackened in the relative stability of Rome. Shortly after his arrival he did witness a formal entrance of Victor Emmanuel I to the newly created Kingdom of Italy. Although the King was not yet resident in Rome, the event evoked "a bewildering instant of wild enthusiasm from the people as he was driven past at a very high speed, preceded and followed by a crowd of dragoons."[9]

Saint Gaudens' own interests veered sharply to nature and antiquity. He and a hilarious band of comrades took a train to Naples one fine morning to witness Vesuvius in its violent eruption of late April 1872. Halfway out of Rome the trees began to turn grayish with volcanic ash, and "Naples itself seemed in the midst of a driving storm, the mountain itself being visible only in rifts of smoke and cinders."[10]

Saint Gaudens' outgoing personality and his Beaux-Arts credentials earned him quick acceptance in the artists' colony. The

Roman Times, the weekly newspaper of the Anglo-American colony, in its edition of October 28, 1871, lists him among the twenty-five English and American sculptors working in Rome. Others included Story, of course; Harriet Hosmer; the much-loved William Henry ("Riney") Rinehart, who died there three years later; Randolph Rogers; and the ineffable Truman Bartlett.

Several of the thirty-five painters mentioned were already famous. George Inness was back in Rome for a second stay, his Hudson River fame secure. Elihu Vedder, vigorous of line and mysterious of subject matter, had not yet produced his famous illustrations for the *Rubaiyat*, but his talent and high spirits made him a local favorite. The opalescent effects and flickering yellows of William Gedney Bunce's canvases, mostly Venetian in inspiration, were catching on.

Although fewer in numbers than the painters, the sculptors carried more weight with the public. Nathaniel Hawthorne, who had saturated himself in the life of the artists' colony some years before while gathering material for *The Marble Faun*, thought that this was perhaps so "on account of the greater density and solid substance in which they work, and the sort of physical advantage which their labors thus acquire over the illusive unreality of color. To be a sculptor," Hawthorne concluded, "seems a distinction in itself; whereas a painter is nothing unless individually eminent."[11]

Maitland Armstrong, even if not included in the *Roman Times* list, was very much a part of the artists' colony. A nephew by marriage of the then Secretary of State, Hamilton Fish, he had received his appointment as Consul to the Papal States in 1869. In the following year Italy was united at last, and the Papal States were absorbed into the new nation. Two years later, in 1872, Armstrong was promoted to be Consul General to the Kingdom of Italy. Besides his consular duties, Armstrong painted, did mosaics, designed stained glass, and in due course wrote *Day Before Yesterday*, an agreeable chronicle of his varied life. His path and Saint Gaudens' crossed often in later years, and they became fast friends.

Another new Roman friend was Dr. Henry Shiff. Born in

New Orleans of a Jewish father and a French mother, he had served as a surgeon in the Confederate Army. After practicing medicine for a time in New York, he went abroad, and spent the rest of his life in Italy, Spain, and France. A dabbler in philosophy and in the arts, and a "lover of the toads and smells of Rome,"[12] he came to have a great influence on Saint Gaudens. When Augustus' son was born, in 1880, the sculptor named him Homer Schiff in honor of this boon companion, though he slightly misspelled the name.

Truman Bartlett's feelings about Saint Gaudens had not yet ripened into virulent dislike. In those first days in Rome, when Augustus was looking for a studio, Bartlett assumed the role of wise old hand and tried to help. He told Saint Gaudens of a dying American artist whose quarters would soon be available. Augustus went around to see the stricken man, whom he found to be in paralysis, somewhat incoherent but remarkably cheerful. The artist was William Gedney Bunce. Buoyed by his courage and good cheer, Saint Gaudens often went back to see him. Bunce made a good recovery, later returned to America, and was still alive in 1907, "sound as a drum and lively as a cricket."[13]

So Saint Gaudens found his Palazzo Barberini studio without Bartlett's help. Some months later, a New York girl who had bought some fine onyx stones asked Bartlett if he knew anyone who could cut them into cameos. Bartlett recommended Saint Gaudens, but told the girl she would have to go to his studio alone for he did not want the sculptor to know who had sent her. She went, and gave Augustus a commission for eighteen hundred francs. Bartlett does not fail to point out in his autobiography what a princely sum this was at the time.[14]

That same winter of 1870–71, a certain Montgomery Gibbs was living, with his wife and two pretty daughters, at the Hotel Costanzi on the Via San Nicolo. Mr. Gibbs, a New York lawyer and a writer of guidebooks, wanted someone to carve him a cameo of Mary Queen of Scots. Two American ladies referred Mr. Gibbs to Saint Gaudens and gave him the address of the studio, which was near the hotel.

A letter written years later by Belle Gibbs tells what happened next: "Upon going there, Mr. Gibbs found only a little boy, who told him his master was very ill but that he had taken care of 'the model' and had kept it wet. He then undid the wrapping from the clay figure of Hiawatha, which so impressed Mr. Gibbs that he hastened to discover the sculptor. He found him dangerously ill in a low attic, and immediately had him removed to better quarters and nursed."[15]

The happy ending was that Mr. Gibbs offered to advance the money for the plaster cast, which would in principle lead to the carving of the marble statue itself. In return, Saint Gaudens was to agree to do marble busts of Belle and Florence Gibbs, which he was more than pleased to do.

What motivated Mr. Gibbs, and where he thought his beneficence might lead, is explained in a letter to his young protégé: "I am sure that the last thing of which I stand in need is a marble statue, particularly on the dimensions of your 'Hiawatha.' But for the fact that I sympathize very strongly with you in your struggles to maintain yourself here until your genius and labors shall have met the reward to which I feel they are entitled, I would not have thought of attempting any arrangement by which you might be enabled to complete your large work and make yourself known."[16]

Augustus was on his way at last.

8

A MANTLING
OF MARBLE (II)

"That passion for the classical which so stirred him
on his first sojourn in Rome and which never really
left him . . ."

—Royal Cortissoz
in the *Dictionary of National Biography*

A REVEALING PHOTOGRAPH of Saint Gaudens was taken early in
his Roman years. The watchful, defensive quality, so noticeable
in the photograph at his lathe a few years before, is gone now.
The eye is candid and trusting, the down-tilted mustache trimly
becoming. He wears a little poniard of beard between lower lip
and chin, like a vestige of the late, unlamented Second Empire.
The black string tie, the coat with rolled lapels and double-breasted
waistcoat are all quite stylish. He looks exactly like what he was—
a handsome, sanguine young man with a promising career opening
up before him.

Augustus had actually received a first commission for a work
of sculpture just before Mr. Gibbs made his magnanimous offer.
This was for a marble bust of Eva Rohr, twelfth and youngest
child of John Rohr, publisher of a New York German-language
newspaper. The sculptor created a Victorian period piece of con-

siderable charm. It shows Eva, who was studying opera in Rome, in the pose of Marguerite in Gounod's *Faust*. There is a natural grace in the slight inclination of her head. One braid of her long, fair hair trails fetchingly over her left shoulder. On the Gothic base there is a quotation from *Faust* which may have had personal overtones: "I'M NEITHER LADY, NEITHER FAIR, AND HOME I GO WITHOUT YOUR CARE." One wonders if Augustus had offered to see Eva home and been refused, and if in the modeling he had therefore stressed the primness of her lovely head. Whether Augustus carved the marble himself and what payment he received for the diminutive (eighteen-inch) bust are matters unknown, as is the present whereabouts of the work.[1]

Augustus' relationship with the Gibbs family bulked much larger than the Rohr connection. The cameo of Mary Queen of Scots was cut at speed and with Augustus' vast facility. The busts of Belle and Florence, the two plump, pretty Gibbs girls, came next and in due course were converted into marble. This time there is evidence that the sculptor did have help in carving at least one of the finished products. When the bust of Florence was being roughed out in marble, an imperfection was uncovered over the left eye. So Augustus was forced to buy another marble block, and he tells us that the work on the hair and accessories had to go on after he left for America in the fall of 1872.[2]

Mr. Gibbs' generosity made the trip home possible. He recognized that Augustus had been away a long time, and that he had not thrown off the after-effects of Roman fever. Besides, he had introduced his protégé to several distinguished Americans who wanted to pose for their busts after they returned to New York.

One of them was William Maxwell Evarts, general counsel for the United States in the case against Great Britain for abetting the forays of the Confederate raider *Alabama*. Mr. Evarts, who later became Secretary of State and Senator, was working in Geneva, but he and his family were in Rome quite often. His daughter, Hattie, made the first visit to the Saint Gaudens studio. It seemed that her father had a fine, bony, patrician head very much

like the head of Cicero. Would Mr. Saint Gaudens do a copy of one of the classic busts of the Roman orator, and one of Demosthenes for good measure? Augustus was delighted to do so. He did them so well (with some help from various Italian craftsmen) that the next step was a commission to do Mr. Evarts' own high, bony, patrician head.

Montgomery Gibbs, who seemed to know all the Americans abroad that year of 1872, also introduced Augustus to Edwin Stoughton, prominent New York patent lawyer and later Minister to Russia, and to Edwards Pierrepont, soon to be Attorney General in the Grant administration and then Minister to the Court of Saint James'. Commitments to model their heads in New York were forthcoming.

Before starting for home, Augustus managed to finish his clay model of the long-suffering *Hiawatha*. Even in its earliest Paris versions, the Indian chieftain had been envisaged as contemplative. In final form he now seemed weighed down by the cares of his people. Naked except for a loincloth, he is sitting with legs gracefully crossed, looking pensively at a quiver of arrows by his side. The quiver, and two stiff little feathers thrust into his top knot, are the only clues to his race. The strongly aquiline nose is as Roman as it is Indian. The pose is attractive, with the crossed legs creating a *contrapposto* effect of two masses in tension.

Competent as it is, the *Hiawatha*, which was going to astonish the world, is a work of no great distinction. Its unmistakable antecedents are J. Q. A. Ward's *Indian Hunter*, so much admired by Augustus in its New York gallery, and, quite startlingly, Thomas Crawford's *The Dying Chief*, carved in Rome in 1856.[3]

What was important at the time was that Mr. Gibbs liked it, and the relevant question was whether to have it cast in bronze or carved in marble. Gibbs seemed to favor the former. In answer to his letter on the subject, Augustus came out strongly for marble: "My figure, if reproduced, will not improve so much in bronze as it will in marble for the reason that to have it finished in bronze the clay has to be excessively finished, which would take a great deal more time. . . . There is the other reason, that the marble

will no doubt be much cheaper. . . . I am certain that if you see it reproduced in that substance you will not regret it."[4]

Unquestionably, Augustus was making a virtue out of marmoreal necessity. The healthy profits of the American sculptors working in Rome were firmly rooted in the easy availability of marble and the ability of the Italian craftsmen to carve it for modest fees. The assembly line that Maitland Armstrong found so gruesome—those seven blind Pompeian girls all in a row—was simply one manifestation of the mid-nineteenth-century urge to broaden the base of culture. All told, *Nydia* went into a hundred editions. Harriet Hosmer's *Puck*, much admired at the London Exposition of 1862, was copied fifty times at a thousand dollars each.

The copying of many things was integral to the broadening process. Photography and lithography, both very new, were very much part of it. Music was increasingly "reproduced" in music halls, not just confined to palaces and stately homes. Copies of works of art, both in sculpture and painting, were in great demand in this Age of Replication.

One curious spin-off was the tendency to downgrade the creator of the original clay model and to elevate the role of the carver of the copy. During his close study of the American sculptors in Rome, Nathaniel Hawthorne came to feel that they were somewhat untrue to their noble profession. First of all, with the slight hyperbole permitted to genius, he defined the profession: "A sculptor should be even more indispensably a poet than those who deal in measured verse and rhyme. His material . . . is a pure, white, undecaying substance. It insures immortality to whatever is wrought in it, and therefore makes it a religious obligation to commit no idea to its mighty guardianship save such as may repay the marble for its care, its incorruptible fidelity. . . ."[5] It seemed to the novelist that the Americans in Rome who practiced the high calling were clever and complacent. To some at least, "marble had no such sanctity as we impute to it. . . . It was merely a sort of white limestone from Carrara, cut into convenient blocks, and worth in that state about two or three

dollars a pound; and it was susceptible to being wrought into certain shapes . . . which would enable them to sell it again at a much higher figure." To Hawthorne, "some small knack in handling clay, which might have been fitly employed in making wax-work,"[6] plus in many instances the skill of the Italian artisans, was about all that was needed.

From such nineteenth-century beginnings may be traced the feeling that persists to this day in some quarters that modeling in clay is not so noble a profession as carving in stone. The true sculptor, by this way of thinking, must chisel and hammer and drill in his quest to liberate his creation from the bondage of stone. The glyptic art is somehow more admirable, more exalted, than the haptic.

Twentieth-century sculptor John Bernard Flannagan describes the carver in this way: "Often there is an occult attraction in the very shape of a rock or sheer abstract form. To that instrument of the subconscious, the hand of a sculptor, there exists an image in every rock. The creative act of realization merely frees it."[7]

Though Henry Moore has turned to bronze castings for most of his later work, he is on record as saying, "The act of carving fulfills the deepest and most fundamental levels of my being as a sculptor."[8]

Augustus Saint Gaudens possessed born skills in both modeling and carving. His true glory in the years of his fame would be achieved in clay and plaster, made permanent by casting in bronze. But during his Roman years he was of necessity a man who converted to marble like all the rest.

Some description of the delicate art of pointing is necessary here for the part it played during Augustus' time in Rome, and later. The technique was known to the Greeks and Romans but became something of a lost art in the Middle Ages and the Renaissance. The Renaissance in particular was not a time for copies and copyists: each creation was unique, and no one had the temerity to serve as "point man" to Donatello or Michelangelo.

It was Canova, on the verge of the Age of Replication, who

revived the art and perfected the technique, using it extensively to meet the demands for his masterpieces. In essence, pointing involves the transferring of thousands of points or dots, first marked on the plaster cast, to the rough-hewn marble, by means of a vertical rod equipped with an adjustable arm. This "pointing machine," which rests on three raised metal supports fastened to the plaster model, can be moved to rest on three points similarly located on the marble. A retractable needle on the end of the arm is fixed on a point on the model, and the machine is then set in place on the marble, where the needle indicates the position and depth of the small hole that must be drilled to reach the equivalent point. It is moved back and forth between the model and the marble, thus establishing an infinite number of points. When the carver chisels away the material between these, a close approximation of the model results.

How can one be sure that the copy is a true one? This is the question that laymen ask. The answer lies in the eye and hand of the carver. If he is experienced in his craft, the reproduction will faithfully match the original. Robert Baillie, one of the most gifted copyists of his time, places the role of the point man very high indeed: "a carver who is also an artist interprets the plaster model much as a musician interprets a printed score."[9]

It is interesting and revealing that the Saint Gaudens memoirs mention only one of his fellow American sculptors in Rome: he mourns the death of the esteemed William Henry Rinehart but makes no comment on his creations or his talent.[10] As a Beaux-Arts man, imbued with the new naturalism and the new romanticism, he kept his distance professionally from his compatriots in their late afternoon of sentimental neoclassicism. Yet, as we have seen, a certain amount of their approach did rub off on him, especially in the case of the *Hiawatha* and the bust of Eva Rohr.

Socially, the American sculptors and painters, whatever their artistic inclinations, got along very well together. Maitland Armstrong has left us a lively account of a typical gathering at the

Falcone, an ancient Roman *trattoria* in the maze of streets near the Pantheon. Not all the artists who gathered there were famous, but the great bond was the feeling that they were the best. "The billowy primitive stone floor and the tables furrowed and black with age could not detract a whit from the fragrance of the macaroni sizzling in the next room, while the heads of the old wine casks that studded the walls reminded us that there still remained much chianti to be met and conquered."[11]

One sultry July night in 1872, Riney Rinehart gave a dinner there, and it is this occasion that Armstrong describes in detail. "Dawn had drawn disgracefully near before all the tales were told and all the songs sung by the convivial crowd. . . . The name of my next neighbor was Augustus Saint Gaudens."

This was their first meeting, and Armstrong was strongly impressed. "When my new found friend and I sallied out after dinner we came upon [Elihu] Vedder sitting on one of the large stones at the corner of the Via Frattina and the Piazza di Spagna gazing with solemn attention at the moon as it hung in quiet glory over the Pincian Hill. Dawn was just touching the skies and the chill of early morning was in the air. But from that position not all the expostulations of Saint Gaudens and myself could budge Vedder, and after a time we forebore and left him still sitting on his stone in silent contemplation."[12]

Armstrong left for Venice the next day on his consular duties, and did not pick up again with his new friend for a year. It was high time for Augustus to take advantage of Mr. Gibbs' generous offer of passage money home. He wrote Belle Gibbs that he had booked steerage but that some day he would be a famous artist and would travel first-class.

There was one final short delay on his day of departure, and this shows that the state of his finances was not yet much more than precarious. It seemed that he had piled up a thousand-lire debt at a restaurant run by a man known, because of his immense girth, as "the Hippopotamus." The proprietor got wind of Augustus' departure and lay in wait at the station to prevent his leaving. Fortunately, a "voluble mutual friend" was along to as-

sure the creditor that the best way to be repaid was to let the sculptor go.[13]

He spent a day or two in Paris, seeing it dented and scarred by the bitter fighting of siege and Commune, and sailed from Liverpool for home. The captain of the ship and several of the ranking officers seemed particularly fond of the bottle, he noted— a fact that did not induce unalloyed confidence when "the ship sailed by the coast of Ireland in very rough weather, so near that we could see the breakers."[14]

During his years abroad, Augustus had been a bad correspondent at best. With no advance warning at all, he barged into his father's shop—to the family's surprised delight.

9

A PLUMING
OF WINGS

THE MONTHS AUGUSTUS SPENT in New York form one of the least documented periods in his life. He left Rome some time after the marathon dinner party described by Maitland Armstrong, and was back in Rome by July of the following year.[1] While still in New York (May 1873), he wrote to Mr. A. B. Mullett, supervising architect of the Treasury, to ask about a national competition for a statue of David Glasgow Farragut. In the letter, he mentioned that he was about to return to Rome. If the competition did in fact exist and was still open, he planned to begin work on his own entry there.[2] So the New York interval can be bracketed as occurring between July 1872 and May 1873.

Homer Saint-Gaudens' annotation in the *Reminiscences* merely states, "Saint-Gaudens had little to say of his stay in New York. . . . It was successful and short though full of intense nervous stress."[3] The stress came from his quest for new commissions, and from some problems with the patrons he did acquire. There was also worry over his mother's health, for she had aged a great deal during the five years he had been away.

Augustus manages to compress a good deal of information into the two paragraphs of the memoirs he devotes to the trip home: "I was not long idle in New York, as, shortly after my arrival, I began the bust of Senator Evarts in the dressing room

of his house on the southwest corner of Second Avenue and Fifteenth Street. Thereafter one thing led rapidly to another. . . ."[4]

He goes on to mention working on the busts of Edwin Stoughton and Edwards Pierrepont. He also received a double commission from Mr. Levi Willard, an admirer of his old mentor, Le Brethon: a sarcophagus and a figure of *Silence*. Concerning the latter, which was destined for the Masonic Building in New York, Saint Gaudens wrote cryptically, "The less said the better."

Along with the first drafts of the busts of the three prominent New Yorkers, the figure of *Silence* was either shipped or carried by Augustus to Rome for conversion into marble; we will pick up its trail later. It marked the sculptor's first real bickering with a client, at a time when he was not yet ready to assert himself.

In Paris and especially in Rome, Saint Gaudens had discovered that he could make himself agreeable to the very rich. His good looks and vitality obviously worked well with Americans traveling abroad. Even in his own time of ascendancy, this affinity for the climate of wealth remained. Louis St. Gaudens, who loved his brother but enjoyed inserting the occasional barb, commented on it years later: "There is one thing about him that I am sure of, and that is that he is happy among rich people. I have never seen him in a bad temper when he was in their company. I don't mean this in any unkindness. He has a right to be happy, and if he does like to curry favor with the rich like a flunkey, it is a very unimportant sin. . . ."[5]

The rich were also Augustus' natural habitat. He homed in on them like a pigeon. They possessed the old, entrenched money in New York and elsewhere that was able to weather the financial disasters just before and during the Grant administration, such as Black Friday (1869)—when Jay Gould tried to corner the gold supply and created a crisis in the securities market—and the Great Panic of 1873.

Looking around New York after five years abroad, Saint Gaudens realized that American taste in sculpture was undergoing some

stirrings of change. The neoclassical was no longer the only acceptable style. Evidence could be seen of a new naturalism, of a sturdy American realism thrusting up through the frozen layers of the pseudo-Greek-and-Roman.

An example of the growing taste for realism was the fact that J. Q. A. Ward's *Indian Hunter*, so long admired by Augustus, had been enlarged, cast in bronze, and given a permanent Happy Hunting Ground in Central Park. Another example was Henry Kirke Brown's rugged Lincoln, which was unveiled in Union Square in 1868, the year after Saint Gaudens left for France. Lincoln's clothes were everyday, with only a mantle to add the kind of idealism still flourishing in Rome.

Back in the 1840s, when Hiram Powers' *Greek Slave* first toured the country, there were separate showings for men and women. Made to seem respectable by the chain that bound her and her faint air of contempt for her Turkish captors, the marble nude statue was a vast success. Critics still disagree about the impact of the *Greek Slave*. Some, like Peter Gay, think the proper Victorians contrived to get a good deal of pleasure and enlightenment from the smooth breasts and flanks and other anatomical details of the Powers statue. Kenneth Clark, however, took the opposite view. With specific reference to the *Greek Slave* he wrote: "Easier to get with child a mandrake root than consider the marble Venuses of the Victorians as objects of desire."[6] As early as 1859, Erastus Dow Palmer's *White Captive* provided a less hypocritical, and a very American, answer to Powers' most celebrated creation. She too has been stripped and bound, but she is much more at home in her own pelt. Powers' storytelling in stone was still popular in the 1870s. By engraving, photograph, and reproduction in marble and ceramic, by pulpit and parody, the fame of the *Greek Slave* continued to spread.

At a more homespun level were the popular genre groupings of John Rogers (1829–1904). Subject matter ranged from his early, serious *The Slave Auction* to the gently humorous *Checkers up at the Farm*. (Defining what constitutes genre in sculpture and painting is not easy. Museum director Peter Marzio has stated

the problem in a sentence and a question: "The boundaries of genre have always been vague. At what point does a family picnic become a 'landscape with figures'?"[7] There is no question but that the Rogers works are of the family-picnic variety.) In his lifetime Rogers sold over seventy thousand of these front-parlor pieces. The average price was fifteen dollars, complete with instructions for repainting in case of chipping or other wear and tear. The Age of Replication was still at its crest.

Civil War monuments were of course proliferating, and Saint Gaudens studied the field. His Roman friend Randolph Rogers was well out in front. Rogers' formula of a central shaft with four military figures at the corners was being bought all over the country. In the far-flung cities no one seemed to mind very much that there were only slight variations in the treatment of the corner figures.

Saint Gaudens found that William Wetmore Story and William Henry Rinehart both enjoyed considerable prestige in America. But a crop of sculptors of much more native talent was beginning to press them. One was Erastus Dow Palmer, now at the height of his career (his bronze of Chancellor Robert Livingston would shortly take First Class Honors at the Philadelphia Centennial). Another sculptor working the American vein of naturalism was Thomas Ball, made famous by a vigorous equestrian Washington in the Boston Public Garden. Ball's *Emancipation* group, begun in Florence in 1863–64 and finally unveiled in a bronze version in Washington, D.C., in 1875, is bolder in conception. It shows a frock-coated Lincoln freeing a kneeling slave. The raised hand is godlike, the gesture a benediction.

The more eccentric William Rimmer, as sturdy and stubborn as the New England granite he carved with such great power, was also stirring up comment.

In *Day Before Yesterday*, Maitland Armstrong remembers Saint Gaudens' account of a session with one of his eminent sitters, known only as the Distinguished Diplomat, or "D.D." The story

tells us a good deal about Augustus' attitude toward the rich at the time:

> When the bust was well underway, Saint Gaudens noticed that the Distinguished Diplomat kept bringing the conversation around to Socrates and Seneca, Marcus Aurelius and Plato. The reason for this was not long obscure. "I find," said the D.D., "after a careful examination, that all these distinguished men had very broad foreheads—just broaden mine a bit." Saint Gaudens, afraid to object, meekly complied. Repeated urgings and the resultant broadenings brought the forehead finally to the point where it seemed affected with some dreadful swelling disease. But this did not bring complete satisfaction to the heart of the sitter. He suggested that these same great forerunners of his were also notable for having very deep-set eyes. So poor Saint Gaudens was forced to bore and bore, deeper and deeper, until he almost pierced through to the back. He told me this story with great excitement . . . illustrating it all by puffing out his cheeks and making violent boring gestures with his forefinger. He said he'd give anything to get hold of that bust and smash it to atoms.[8]

The D.D. was almost certainly Edwards Pierrepont, who became Minister to Great Britain in 1876.[9] Far from being destroyed, the marble bust is on view in the National Museum of American Art in Washington, D.C. It has a pomposity of broad brow and deep-set eye, of divided beard and flaring mustache, that is almost parodic.

The few remaining ascertainable facts of the New York visit can be quickly told.

Saint Gaudens gave lessons in cameo cutting to a group of four that included his brother Louis, now eighteen, and his own friend Louis Herzog from Cooper Institute days. Augustus discovered

to his pleasure that he enjoyed this first venture into pedagogy, and that the needed words came easily.

He sent his brother and Herzog to Rome a month or so before his own return. They were to set up shop to ply their new trade there, and also to make arrangements for the carving of the clay models of the three busts and the *Silence*.

Augustus met several new clients who gave him commissions for copies of antique statues, which he could either carve himself or delegate to Roman artisans.

He also made a new friend who would have a considerable influence on his career. This was the gusty thirty-four-year-old architect, Henry Hobson Richardson, already large of girth and gargantuan of talent.

Some time in late May or early June of 1873 Augustus sailed for Liverpool on the steamer *Egypt*. His mother stood weeping on the dock at the moment of departure, and he had his own premonition that he would not see her again.

His career had not yet quite taken off. After the manner of many an artist before his time and since, he was "pluming his wings for a flight."[10] The competence was there, the spur of fame was roweling away at his flanks. All that was missing was the shaping spirit of love.

She had been copying masterpieces in the Palazzo Barberini, within a few yards of his studio. Then for a while she was away, in Switzerland and Austria. She came back in late November 1873 and they met for the first time shortly thereafter.

Her name was Augusta.

10

AUGUSTUS AND AUGUSTA

"Amo, amas,
I love a lass,
 As a cedar tall and slender.
Sweet cowslip's grace
Is her nominative case
 And she's of the feminine gender."

—John O'Keeffe[1]

THEY MET AT one of those parties Americans were forever giving one another in Rome. During the holiday season they saw a good deal of each other, and by January they were contriving to be together for some part of almost every day.

Augusta Homer looked like a girl in a Louisa May Alcott novel. She was slim and quite tall, and held herself beautifully. Her hair was piled high in a pompadourlike effect. The eyes were extraordinary, a blue that seemed sometimes to go almost black. As the days passed, Augustus came to realize that her flattering air of "anxious attention" was partly caused by her deafness.[2] She had a most attractive smile.

The Homers were old New England stock to the sturdy bone. The first of the name to come to America was Captain John Homer, who sailed his own ship from England and settled in Boston

in 1650. Augusta's grandfather "Mutton" Homer had a fine brick house on Beacon Hill, but liked to go down to Faneuil Market, sling a fresh killed sheep over his shoulder, and carry it home.

The family lived in a comfortable house in Roxbury, with servants, horses, and croquet lawns. Her father, Thomas Johnston Homer, had prospered for a time in the textile business. Through the dereliction of a partner, the business failed. By the 1870s most of the servants were gone, the stables were half empty, the croquet lawns unmown.

Augusta's mother worried a good deal about her second daughter's health. Some people said she was overprotective, but by the time Augusta was twenty-four there were genuine reasons for concern: growing deafness and symptoms of neurasthenia. It was decided to send her abroad with whatever money could be collected for the purpose. Her brother, Joe, just out of college, would go along as escort. The plan was for them to winter in Rome and travel to Vienna in the spring if more professional help was necessary. Joe, who was medically inclined, hoped to pursue medical studies while they were abroad.

They reached Rome in December 1872 by way of London and Paris. Augusta, who drew quite skillfully, wanted to study in an art school but could find none that took women students. Even a private instructor seemed to be unavailable. She decided to copy some of the great masters in the Palazzo Barberini collection, which numbered among its treasures a Fra Angelico triptych, Raphael's enchanting *Baker's Daughter*, and El Greco's *Birth and Baptism of Jesus*. To sharpen her skills, she first chose Guido Reni's *Beatrice Cenci*, so much admired by the poet Shelley and others.[3] Her workmanlike copy still hangs in the Saint Gaudens house in Cornish.

Her hearing grew no better. Writing to her mother on February 12, 1873, she confessed that she had been feeling "sick, blue and homesick . . . with that threatened abscess in my head hanging over me like a black pall."[4] But by the next week she reported good progress with the painting and struck a more cheerful note: "This Rome agrees with me so splendidly."

In May she and Joe went to Vienna to consult a Dr. Gruber.

There is a revealing letter from Joe to his sister Eugenie, which shows that looking after Augusta was a full-time assignment:

> Dear Sister Genie,
>
> I'm beginning to long to see you. . . . My plans have again been upset and for another month I must play "bodyguard." Of course I am willing to do all I can to help poor Gussie's infirmity and as she can't stay here alone and feels that she must stay here of course there's only one thing for me to do and that without complaint. . . .
>
> I am soon 22 years old . . . have still my profession entirely to learn. The care and living with Gussie has taken so much of my time and thought (to say nothing of spare "change") that I've not been able really to study since I've been with her. . . .[5]

In letters to her mother and father of May 15 and 16, Augusta reports Dr. Gruber's diagnosis. The trouble had originally begun in the throat and proceeded to the nerves of the ear. If it was not arrested she would be totally deaf in a few years' time. The doctor feels that he can at least prevent the deafness from growing worse. He recommends baths at a Swiss spa for the summer, consultation in the fall back in Vienna and Rome for the winter. Catching cold, he warns, is the greatest hazard, a warning that will influence her for years to come.

Augusta's stay at the Swiss spa of Ragaz did not prove to be particularly helpful, as her return visit to Vienna showed. Writing her mother on September 15, she comments, "I think the baths have done me no good at all. . . . As for Dr. Gruber, sometimes I think he has and then again I think he hasn't. My hearing is as variable as ever. Well, I mustn't think of it for if I do it makes me blue."

Back in Rome on schedule, on November 28, 1873, Gussie— no one who knew her at all well ever called her anything else— picked up her copying of old masters again. She also found some art classes that would take women, and a private teacher. In the

classes the students studied anatomy and drew the human body, but Gussie developed one reservation: "I haven't the spunk to draw skeletons." In these letters home the words "spunk" and "spunky" recur often. When she is well she feels "spunky," and when she is sick or dejected she is "not so spunky." It is clear that spunk was what she very much admired—and herself possessed in good measure.

To his vast relief, Joe Homer went home at last. Gussie found rooms at 56 Via Babuino, about halfway between the Piazza del Popolo and the Spanish Steps, and two women friends to share them with her. Just below lived an American sculptor, Thomas Ridgeway Gould, and his young wife. They both liked Gussie and kept an eye on her.

It was probably at the Goulds' apartment that Augustus first met Augusta. He had come to know the Goulds through Mr. Evarts and was in demand for many of the festivities of the closely knit American colony.

Gussie's first report home mentioning her new friend is a letter written on Sunday, December 18, 1873: "Mr. St. Gaudens of New York, until recently known . . . as Mr. What's his name, a promising young sculptor, is my particular admirer and escorts me home regularly. It's a pity the walk isn't a little longer."

On that same Sunday she went to church, sat up front, and actually heard the sermon. She adds that she plans to go to Mr. Saint Gaudens' studio to see how he sculpts. "They say very finely but I shall see for myself."

A letter the day after Christmas tells of Saint Gaudens' taking her to an artist's studio in the Villa Medici with "the loveliest garden in all Rome." They wandered through a little wood "where it was so easy to imagine some of the Medici plotting some foul deed." Coming to an observatory with a view over Rome and the whole countryside, she wanted to stay all afternoon.

The next letter, undated, goes to the heart of the matter. She tells her mother that she doesn't know whether Mr. Saint Gaudens is serious or not, but that she likes him very much, "how much I don't know." That the so-prominent Mr. Evarts is his

patron, and that he is on intimate terms with the George Innesses, impresses her. Although she still knows very little about him, "he appears very much the gentleman."

She goes on to describe her beau to her mother coolly enough. "Neither short nor tall, blue eyes, straight nose and thick brown hair and whiskers, neither handsome nor homely and when you first meet him does not impress you as being particularly talented but the more you know him the better you like him. . . ." She doubts that Augustus is in a position to marry, despite the impressive number of commissions he has undertaken, and estimates that "there are ten chances to one that he will never ask me and about the same that I shall say no if he does. Oh dear," she concludes, "these young men are kind of bothers after all."[6]

By January 25, she has seen his studio and been impressed by his talent. He in turn has been to the Barberini to watch her at her work: "His criticisms are splendid for me," she writes her mother, "and he seems more interested in my progress than I am myself."

In another undated letter, Gussie touches on Augustus' French-Irish parentage but thinks that he himself is "American to the backbone." He has told her that he does feel his parents' lack of social position. On this subject Gussie asks her mother a key question. Since all else is in his favor—high principles, talent, pluck, perseverance—"ought that to stand in the way of his happiness and mine?" Augustus has had a touch of Roman fever, and this has helped to clarify her own feelings: "I didn't realize or know how much I did care about him until now that he is not well."

By February 8, again to her mother but also for her father, Gussie fills in details of Augustus' family problems. Neither of his brothers wish to share the responsibility for supporting the aging parents. "He has made up his mind to do it alone."

Nevertheless, the sculptor has declared himself. "Mr. Saint Gaudens is very much in love with me but as he is situated now he can think of nothing further." Because of his family obligations he does not wish her to make any promises for at least two years.

The same February 8 letter mentions the fact that there are two other young men in Rome "who think entirely too much of me." Yet some sort of long-term understanding has been reached; the mutual, somewhat rueful commitment is there. "I think I am sorry for Mr. St. Gaudens and myself but maybe it will all come out right in the end." She notes that the American colony thinks that they are as good as engaged, but, then, "people must have somebody to talk about." This letter closes on a revealing note: "I am not dead in love but perhaps I would be if I thought I ought. This is a queer letter I know but I can't write what I feel and want for I hardly know myself."

On February 22, Augustus writes to Mr. Homer to ask his consent to an engagement. The request was granted, with the proviso that he and Gussie not marry until he had secured a major commission which would make his finances and his future more substantial.

There is an undated fragment of a letter from Gussie to her mother that puts this not exactly rapturous engagement into a more cheerful context: "You'll have to get used to a Gus Gussie in the family. . . . Someday when you see some splendid statue you will be proud to say my son-in-law did that—now there's a little romancing for you. . . ."

Saint Gaudens' own entry in his memoirs is laconic enough. He and two friends had taken a walking trip to Naples in the late summer: "We returned to Rome again at the end of the vacation, and there, shortly after, I met Miss Augusta F. Homer, who later became Mrs. Saint Gaudens."[7]

Not much remembered joy seems to have filtered down the intervening years. But there was at least one moment when Augustus's natural exuberance did break through the formalities of Victorian courtship. Soon after meeting Augusta, he bought himself "an inexplicably high silk hat, his first."[8] Umbrella-less, in a driving rain, he walked across the Piazza di Spagna to see her and show off his purchase. The hat was not quite the same after the downpour, but Augustus' high spirits were in no way dampened. It is pleasant to think of him at that moment—newly in

love with Gussie, and excited by the heightened sense of promise that life seemed to hold.

Still, one senses something a little out of focus about Augustus during those early months of his relationship with Gussie. Her bulletins to her mother are full of praise for his "noble" character and of samplings like the following: "A more upright man I never met. . . ." "There is an innate refinement about him. . . ." "He is courted in every way [by Americans in Rome] but is unaffected as a man can be. . . ." "He neither smokes nor drinks." There is even an unlikely glimpse of the sculptor at the Goulds' helping Gussie dress a doll for a Christmas-tree decoration.

What were his motives? Certainly he was in love. But, like Gussie, he was perhaps not dead in love. He surely saw marriage to Miss Homer of Roxbury and Boston as a step up socially. Add the enchantment of Rome and, by March, the coming of the soft Roman spring with all the fun of picnics and parties and open-air concerts, and the mixture would become heady enough, the motivation unsurprising.

They agreed that she would go home in June and that he would follow when his various Roman commitments were fulfilled. His specific objective in America would be to obtain a major commission so that they could marry, and this he would pursue with all the energy of his ardent spirit.

For now the hitherto missing element—the sweet compulsion—had taken its place beside the talent and the ambition.

The previous fall, of 1873, when he was back in Rome but had not yet met Augusta, Saint Gaudens had picked up his life pretty much where it had left off the year before. Financially, he was now more solvent. He quickly paid off the Hippopotamus for his grubstake, and was riotously welcomed at the restaurant in the process.

Soarés dos Reis had gone back to his native Portugal, so now Saint Gaudens had their old studio to himself. With his many commissions and projects, he found that he could use all the

available space. He did, however, greatly miss his gentle friend, who had even tolerated his raucous singing while at work. (On his return home, Soarés scored a hit with his melancholy *The Exile*, and rapidly went on to become his country's ranking sculptor. Today a museum in Oporto bears his name and honors his memory. Unfortunately, he committed suicide at forty-two.)

The *Hiawatha* project, so enthusiastically embarked on by Montgomery Gibbs, languished for a time. Mr. Gibbs' plans for showing the plaster cast in America, and for an ultimate sale there, never quite materialized. Then, one day, Augustus found another sponsor: his father's old friend Governor Edwin Morgan turned up at the Hotel Costanzi, and was delighted to discover that Augustus was working nearby. Morgan offered to pay the eight hundred dollars to have the figure of the Indian carved in marble, and agreed to buy the finished product himself.

Badgered from America by Levi Willard, Augustus slaved away at the figure that was to exemplify the Masonic virtue of *Silence*. As former Junior Grand Warden of the Grand Lodge of the Masons in New York, Mr. Willard was full of ideas and felt he was entitled to express them all.

He wrote, for example, that he thought the shrouded figure should be modeled in Egyptian dress. Saint Gaudens' polite but firm answer shows that he was gaining some steerageway in the gritty business of artist-patron relations: "I have got . . . all the necessary information for the Egyptian figure in case you wish it. But I very strongly prefer what I have done, as do all who have seen it. Besides, the subject being abstract, I think it better after all not to follow any exact style, for the reason that Silence is no more Egyptian than it is Greek or Roman or anything else."[9]

What he created was a standing figure of a mysterious veiled woman with an admonitory forefinger pressed against her lips in the gesture of silence and secrecy. In treatment it is not very different from a long line of draped ladies with which Saint Gaudens was undoubtedly familiar. He was still in lock step with Henry Kirke Brown and his *Ruth* and with Harriet Hosmer's *Zenobia*, which had been prominently displayed at the New York

Exhibition of 1864. Nearer to home, the *Silence* was certainly close cousin to his new friend Elihu Vedder's many paintings of sibylline women.

There is one surprising entry in the *Reminiscences* concerning this pre-Augusta time in Rome: "I began at once on the figure of Silence; and in addition inaugurated a fifth love affair, a very brief one, however, with a beautiful model, Angelina by name, with whom I wanted to elope to Paris. She was wise enough to refuse, and that passed away like those which preceded it."[10]

What and where the four previous love affairs were can only be matters of conjecture. Whether they included, by his definition, Mary, the girl in New York who worked in the button factory upstairs from Le Brethon's shop (and who struck such terror in his heart), we can only guess. It is the last mention of any romance at all, for from here on in the memoirs Saint Gaudens was content to fashion a public image, not a private or an intimate one.

In all likelihood, Angelina was the model for the *Silence*. As such, she may have influenced the series of idealized women that Saint Gaudens never wearied of creating. The long, narrow face, more a rectangle than an oval, and the straight, high-bridged, very classical nose do recur often in later creations, as do the full lips. In the case of the *Silence*, the slight sag at the corners of the mouth may have been improvised by the sculptor for narrative purposes, to complement the admonitory forefinger.

The polite transatlantic bickering went on for a long time, and some points went to Mr. Willard. The finished product undoubtedly was diminished by the fussy drapery he insisted upon, for instance. The overall effect is of a statue neither better nor worse than many of its contemporaries.

The *Silence* was cut in marble by Italian artisans after Saint Gaudens' return to New York, and shipped to America. Willard was not satisfied by their rather free-wheeling Italian interpretations. After Saint Gaudens himself had chiseled some last changes, the Masons grudgingly accepted it. The sculptor's own final comment on the matter came in 1876 in a letter to J. Q. A. Ward: "Had I my own way completely, I would have created an entirely different thing."[11]

An ultimate irony was that, in the years of Saint Gaudens' fame, the Masons took great credit for their foresight in commissioning the symbolic figure. Its interest today lies chiefly in its being a remote forerunner of the *Adams Monument*, the beautiful cadenza and climax of Augustus' long series of statues of otherworldly but not disembodied women.

Louis St. Gaudens and Louis Herzog made good progress that autumn with the cameo-cutting project they had come to Rome to set up. Thanks in good part to Augustus' reputation in the delicate art, there were plenty of commissions. In directing his two pupils, and in pitching in himself when the demand was great—or when he needed the ready money—Saint Gaudens demonstrated for the first time the ability to lead and to delegate that would stand him in good stead as his career expanded.

Even though he himself was bone sick of the work, he once cut a brooch and a pair of cuff links in a single twelve-hour stint at the wheel. When, in mid-November 1873, his brother fell desperately ill of pneumonia, he took over a fair share of the workload. His superb cameo of a *Youthful Mars* dates from the winter of 1873–74. Carved in white stone against a black onyx background, it shows the god beardless and in profile, wearing a crested, dragon-ornamented helmet.[12] Equally fine is the last cameo Augustus ever carved, a *Mary Queen of Scots* which he converted into an engagement ring for Augusta.

Falling in love and getting engaged did not completely change Saint Gaudens' Roman routine. When he was not playing *cavaliere servente* to Miss Homer, there were still jolly evenings at the Caffè Greco and the restaurant of the Hippopotamus. One of his boon companions was Dr. Shiff, whose unusual philosophy of mild political anarchy fascinated him. Saint Gaudens later wrote of Shiff that "on the whole he exerted a more powerful influence in forming what little character I have than any other man I ever met."[13] Although Shiff's business experience seems to have been confined to collecting Oriental bronzes to supplement his love of real-life Roman toads, he also helped Augustus with his rather complicated finances.

Others at the all-male evenings were the durable Elihu Ved-

der; Maitland Armstrong, now in his glory as Consul General to a whole nation; William Gedney Bunce; and two Frenchmen. One was the dashing Carolus-Duran, once just plain Charles Durand; he was nicknamed "caracolus" for the way he caracoled his horse in the Bois de Boulogne, and this in due course was shortened to Carolus. His Paris atelier would become the training ground for John Singer Sargent, Kenyon Cox, Will Low, and other Americans. The second Frenchman was Marius-Jean-Antonin Mercié, just finishing his years as a Prix de Rome scholar. Mercié's nonchalant *David* had earned him top honors at the Paris Salon of 1872 and the Legion of Honor as well. He was the first man ever to win the Legion while still a student, a fact not unnoticed by the slower-moving Saint Gaudens.

Augustus did embark on several other projects that, like the *Hiawatha,* were to astonish the world and earn him the fame he felt his due. He made a clay sketch of the baby Emperor Augustus being crowned with a laurel wreath and placed on a pedestal by a woman slave. Writing boastfully to Florence Gibbs, he reported that a visitor had told him he would make his fame and fortune with it, "and that it was the best work that had been done in Rome for a long while."[14] A sarcastic Swiss friend's remark that it looked like a locomotive somewhat dampened his enthusiasm, however.

He tried his hand at a nude Mozart with a violin in his hand. Later he commented wryly on this forgettable masterpiece: "Why I made him a nude is a mystery."[15]

News filtered in from America that a committee was forming to select a sculptor for a New York statue of Admiral Farragut, so Augustus also made some preliminary clay sketches of the naval hero. (The open competition on a Farragut for Washington, D.C., that Saint Gaudens had inquired about earlier had never taken place: at Mrs. Farragut's request the commission was assigned directly to Vinnie Ream Hoxie.)

Saint Gaudens lingered on in Rome until the early spring of 1875. Although the soft Roman air and the congenial life of the artists' colony still held their own delights, it was high time for

him to make the break. Winning the new Farragut competition would be a reasonable focus for his dreams and ambitions. Of more immediacy, it would make his marriage possible. Now, at last, he was prepared to put all the ardor of his buoyant spirit into this quest.

11

THE LUCK OF AUGUSTUS SAINT GAUDENS

"The luck to possess talent is not enough; you must also possess the talent to have luck."

—Hector Berlioz[1]

SAINT GAUDENS was so homesick for Rome that he left the faucet running in his studio washbasin to remind him of the tinkling fountain in the Barberini Gardens. The janitor of the building, who had worried where the leak was, was not amused when Augustus explained the reason for his act of nostalgia, and made the sculptor turn the water off. Augustus fell back on his other means of expressing how much he missed Europe: as he worked away, he bawled the serenade from *Don Giovanni* and the Andante from Beethoven's Seventh Symphony at the top of his powerful voice.

Financially he was near the edge again. Paying his Roman debts and passage home had drained him, and he could barely afford the shabby studio he took in the old German Savings Bank Building on the corner of Fourth Avenue and Fourteenth Street. For a while he was the only tenant on the second floor. He hated climbing the iron staircase and walking the empty corridors to his "sad studio."

Bad news on the way home had started his depression. First there was a telegram, forwarded from Rome by Dr. Shiff, which reached him in Paris; it reported that his mother was very ill. A second message came soon after with the news he had feared for so long: his mother was dead.

Some years later, when his friend Richard Watson Gilder lost his own mother, Saint Gaudens wrote a letter that tells us, touchingly, how he himself felt when the blow fell: "I have gone through the same grief you are having; and although at times it seems as if I could not bear it, again I felt that I could have no heart when it seemed as if nothing had occurred. . . . Now I know that I had a heart as regards my mother, and the trial has been like a great fire that has passed, and it seems, after all these years, as the one holy spot in my life, my sweet mother."[2]

He slept at his studio as well as worked there, for his father's house was full. Andrew Saint Gaudens had come home, and there were other relatives and tenants. By a stroke of good fortune at this melancholy time, his good friend Maitland Armstrong turned up in New York and took a studio in the same building. Free of consular duties at last, Armstrong was embarking on a full-time artistic career. Besides providing congenial company, he made a most practical contribution to Saint Gaudens' comfort: his furniture had been shipped from Rome in large packing cases, one of which he gave to Augustus to convert into a bed.

Shortly after Saint Gaudens' return, Gussie Homer took off for Charleston, South Carolina, to escape the long-drawn-out New England winter. This was the first of many such hibernations, and it left Augustus free to pursue the Farragut award with all the energy and verve he could muster.

He had ascertained from his friend Governor Morgan, also back in New York, that the competition was very much alive. Morgan coached him on the best ways to approach each of the eleven commissioners—generals, prominent businessmen, other ex–office holders with names like Appleton, Grinnell, and Montgomery.

Later that same spring, while Gussie was still in South Car-

olina, Augustus went to Boston to look into another competition. This was for a seated statue of Senator Charles Sumner. Augustus stayed long enough to work out and submit a sketch. On his return to New York, no one bothered to inform him that it had been decided (a) to make the statue a standing figure and (b) to select another sculptor without any formal contest. Then and there Saint Gaudens vowed never to enter a competition again. He did, however, redouble his efforts to win the Farragut. He particularly cultivated the Admiral's widow and son, and he sought out all the commissioners.

In December 1875 Gussie was off again on another of her health-seeking hegiras, this time to Fayal in the Azores with her sister Genie. They would be away until the following June. By now Augustus was on friendly terms with her parents and kept them informed of developments in the crucial contest. "I have never moved around about anything as I have about this," he wrote Mrs. Homer. "I have made two models, a large drawing and a bust, and I have not allowed the slightest or most remote chance for my bringing influence to bear to escape me. . . . As far as I can see I am in a very fair way to have the commission."[3]

Two weeks before Gussie's return from Fayal, he was plunged in gloom about his prospects: "I am afraid that I shall have no good news in regard to the Farragut for her when she comes. In fact I am afraid that that affair is done for."[4] There were indications that the necessary money had not been raised. There was also a rumor that the choice, if it ever was made, would fall on one of the bigger-name sculptors. Another rumor was that the decision might not be made until the spring of 1877.

Augustus continued his no-stone-unturned attack. In June 1876 he wrote J. Q. A. Ward asking to use his name as a reference. By now Ward was himself a big name, and one of the most successful civic sculptors of his day; he was very much under consideration for the Farragut. In his mid-forties, Ward looked rather like a "less-gnarled, less saddened Michelangelo."[5] He was a generous if sometimes cantankerous man who kept his own studio staff small and encouraged new talent outside it. His answer to

Saint Gaudens was characteristic of his more generous side: "I sincerely hope that the gentlemen of the Committee will commission you to do the work. If you think that any reference to me in the matter would assist them in coming to such a conclusion I would most cheerfully express my faith in your ability to give them an earnest and most interesting statue."[6]

So there the matter stood as the year 1876 wore on. Knowing that he could not stake all his future on one throw of the dice, Augustus scrambled after any new work to meet current needs, picked up old friends, and made many new.

One of the latter was John La Farge, whom he met through Maitland Armstrong. In the fifteen years since his Beaux-Arts days, La Farge had acquired considerable prestige in the art world. He was a muralist at a time when murals were coming into great demand, and a practitioner of the age-old craft of stained glass, into which he breathed new and vivid life. His biographer, Royal Cortissoz, has called him "our sole Old Master" but he really was a kind of World Citizen of the Arts.[7] Henry James referred to the "variety of his initiations," which simply meant that he borrowed freely from past masters. His exemplars included Giotto, Raphael and Titian, Delacroix, and even Thomas Couture, in whose atelier he learned a good deal about color. Putting the best construction on La Farge's catholicity of mentors, Frank Jewett Mather once wrote, "it is much to have had an American painter on easy borrowing terms from Giotto."[8]

As he grew older, there was something disappointing about La Farge, except in his genius for creating stained glass. "He promised much, he suggested much, but fulfilment eluded him," is the way one recent critic put it.[9] When Saint Gaudens first met him, he was still in his forties, with jet-black hair and a dark-brown complexion. He wore very thick glasses but seemed to miss nothing. He was, as his Jesuit son and namesake once said, "acutely susceptible to the white magic of women."[10]

One day La Farge and Maitland Armstrong dropped by Saint Gaudens' studio to find the sculptor in deep depression. Augustus was contemplating some casts he had brought with him from

Rome. They were the work of Antonio Pisano, known as Pisanello, early-Renaissance master of the high and low relief, and of the precise art of the medallion. Augustus said to his friends that he despaired of ever doing comparable work.

La Farge spoke "quietly and incisively" in answer: "Why not? I don't see why you should not do as well."[11]

This was just the boost that the mercurial Saint Gaudens needed. His Gascon buoyancy of spirit began to return. "There is no doubt," he recalled, "that my intimacy with La Farge has been a spur to higher endeavor, equal to if not greater than any other I have received. . . ."[12]

It was thanks to La Farge that Saint Gaudens made his one professional venture into painting. When Henry Hobson Richardson won a much-coveted competition to build a new Trinity Church in Boston, he turned over the decoration of the interior to La Farge. La Farge in turn recruited a group of younger artists to help him with the elaborate plans for frescoes and decorative lettering. Among the artists chosen were Francis D. Millet, George Maynard, Francis Lathrop, and Augustus Saint Gaudens.

Saint Gaudens worked on location in Boston from November 1876 to February 1877. Gussie was back from Fayal, and it suited him very well to be near her. He painted a perfectly adequate green-robed Saint Paul for the chancel arch, and a seated Saint James in a lunette high above the transept floor. What mattered far more to his career was the association with Richardson, Frank Millet, and others who would touch his life again and often. (One observant spectator was a small, bearded Harvard professor who occasionally turned up to watch the rearing of the great church. His name was Henry Adams.)

Saint Gaudens had solidified his friendship with H. H. Richardson on his return from Rome in 1875. The architect was just coming into his professional pre-eminence, and his girth seemed to have grown with his fame. Although his health was already causing concern, he made no attempt to control his love of Southern cooking and champagne. Yellow waistcoats defiantly emphasized the vast expanse beneath. He often wore a monk's robe and

cowl, suggestive of Byronic revels and attesting to his love of the Middle Ages.

Richardson's taste ran to the Romanesque, but he actually used ten centuries of architecture as his textbook. Somehow he managed to put his own mark on all he designed. Bainbridge Bunting has written that Richardson's work was "characterized by a mood of gloomy robustness."[13] Certainly his churches, railroad stations, and libraries, his courthouses and country houses— round of arch and rough of masonry—imposed on much of America a rather heavy European look. Still, the vitality was very great. His departure from a purely American idiom was such that for a while at least "he gave American architecture a new musculature and a new skin."[14]

Together, Richardson and Saint Gaudens created a memorial in New York's Church of the Incarnation that is vintage Richardson and very moderate Saint Gaudens. It celebrates the virtues of the Reverend Henry Eglington Montgomery, a much-loved rector of the church, who died in 1874. The Richardson contribution is an elaborate six-foot wall piece in tan and red sandstone. Four squat marble columns give it the look of a tabernacle-in-little. The tabernacle frames and almost overpowers Saint Gaudens' medallion of the head and shoulders of the clergyman. Modeled in high relief—which by definition refers to any work in relief whose circumference is more than 50-percent detached from the supporting plaque—this was Augustus' first venture into bronze. It lacks the decorative quality and the sense of intimacy that would later stamp his reliefs. The memorial does, however, possess one pleasing innovation: his lettering is an integral part of both medallion and frame, not just words on a pedestal below.

As they worked together on the *Montgomery Memorial* and at Trinity Church, Richardson had noticed a talent in Saint Gaudens that served broader purposes than just sculpture. This was his already matchless, his infallible eye. It was the innate quality that told him when his own work was right at last, and which explains his seemingly endless revisions in search of that end. But

he could also pinpoint what was right and wrong in painting and architecture.

Some years later, when Richardson was designing his cele- brated complex of the Allegheny County (Pennsylvania) Court House and Jail, he made a profusion of drawings for the great 250-foot central tower. Unable to decide which was right, he wired Saint Gaudens to come solve the dilemma. Augustus did so unerringly, as the superb building testifies to this day. In recon- structing the episode, architect Daniel Burnham remembered Richardson's saying that he "had more confidence in Saint Gau- dens' opinion regarding mass and outline than of any other man" and that he "seemed to be able to pick out the best instinctively."[15]

In this same mid-1870s period, two men who would pro- foundly affect Saint Gaudens' life and career became his friends: Stanford White and Charles Follen McKim, both then young architects working in Richardson's office at 57 Broadway.

One day, when White happened to be in the German Savings Bank Building, he heard someone bellowing snatches of classical song. He poked his head into the second-floor studio to see if the singer was in extreme agony, or just in agony. Whatever his opinion of the quality of the song, White took an instant liking to the man. "Every time I see Saint Gaudens I hug him like a bear," he wrote his mother some time after that first encounter.[16] The friendship would last a full thirty years, until the murder of White by the insanely jealous Harry Thaw.

Stanford White drew like a god, had a joyous appreciation of all things beautiful, and was himself the designer of everything from magazine covers to picture frames to buildings of a disarming grace. He had a blazing halo of red hair, a mustache the shape and color of a frankfurter, and a flair for self-publicity. He did everything at flank speed.

McKim's first meeting with Saint Gaudens took place in an ice-cream parlor. The discovery of their mutual fondness for choc- olate and vanilla and strawberry was just the first of many bonds. They found that they had both been at the Beaux-Arts the exact same three years, and France would exercise her lifelong pull on

each. The Renaissance, both Italian and French, drew them like a magnet.

McKim had played baseball at Harvard and skated marvelously well. On outings in the Luxembourg Gardens during his Paris years he threw a ball so high that the French stopped to watch in wonder. During the winter, when the ponds in the Bois de Boulogne were frozen, spectators stood three-deep to admire the long swerve and sweep of his outer edges. Born of Quaker parents, McKim was a less exuberant man than White, but he had a way about him and could find the right words when he needed them. Saint Gaudens nicknamed him "Charles the Charmer" and "Blarney Charles." In the years when McKim, Mead and White was the most famous architectural firm in the land, McKim designed buildings of great and restrained elegance. He made the creation of each a ritual and a labor of love.

The big event of 1876 was the Centennial Exposition in Philadelphia. It opened on May 10 and closed in the rain on November 10, the day the nation was riven by the contested election of Rutherford B. Hayes over Samuel J. Tilden. The fair was twice the size of the Paris Exposition nine years before. It occupied 285 acres and there were 249 buildings, large and small, to celebrate American and foreign art and industry. The granite-and-brick Memorial Hall, on a bluff overlooking the city and the Schuylkill river, housed the art, with an Annex behind for the spillovers. All told, the two buildings contained seventy-one galleries and 3,646 works of art.

A New York screening committee that included J. Q. A. Ward and Henry Kirke Brown accepted Saint Gaudens' marble bust of William Maxwell Evarts. It was quite an honor for a sculptor known only to a few rich patrons. Selection may have been influenced by the prominence of the sitter, who became Secretary of State a few months later.

The bust is more than a work of promise; it is a considerable achievement. While the bare chest and aquiline features of Mr.

Evarts, as well as the cold white marble itself, give a superficial neoclassical impression, there is a vibrancy in the slight angle of the head, a tension in the neck muscles, that imparts reality. This is one of the first times that Saint Gaudens demonstrated what his friend Theodore Roosevelt later attributed to him: "that lofty quality of insight which enables a man to see to the root of things."[17] In simpler terms, the Evarts showed how well he could catch a likeness.

Augustus went to Philadelphia himself to make sure the bust was given good display in the Hall, not the Annex. Looking around at the art that had been assembled, he realized that both painting and sculpture were more retrospective than forward-looking. Narrative and genre dominated. Randolph Rogers' blind *Nydia* and William Wetmore Story's majestic *Medea* brought memories of Rome but also evidence that the marble suavities of the neoclassical were still very much in vogue.

In the Massachusetts Pavilion, Daniel Chester French's *Minute Man* with his flintlock rifle and plow—narrative surely, almost genre—was much admired, a spirited reminder of the first American '76. No fewer than twenty-nine of John Rogers' groupings—pure folk art—gave pure pleasure to many.

On display near the entrance to Memorial Hall were 325 Italian statues, mostly marble "boudoir" sculpture concerning lovers and the ways of love. The cunning craftsmanship made this exhibit one of the top hits of the Exposition.

Tucked away almost unnoticed in the back of the Belgian section of the Hall were eight disturbing works by an expatriate Frenchman named Auguste Rodin.

The paintings on display were by both early-American masters and contemporaries. Stuart, Sully, Peale, Copley, and West were among the former. In the midst of the placid landscapes, the old oaken buckets, and Adirondack twilights of the latter, William Merritt Chase's *Court Jester* and a glowing, painterly still life by John La Farge proclaimed better things to come. Condemned like the Rodin works to comparative oblivion was Thomas Eakins' sempiternal *The Gross Clinic*. Considered too

explicit in its depiction of surgery-in-process, it was relegated to an outlying medical exhibit of the U.S. Army Post Hospital. . . .

Even if the paintings and sculpture in the Exposition stressed the tried and true over the bold and innovative, more Americans saw more art than ever before. There were as yet few museums and galleries in the nation. The response was trend-setting: soon there would be many.

Saint Gaudens' good luck in winning a place at the Centennial was balanced by a rejection the following May that lit an angry fuse in him. Since his days in Rome he had been experimenting with a clay sketch of a little Greek girl lying on a low Pompeian bed, kissing an infant. He had brought the sketch—by then in plaster—to America, and later, at the request of a member of the Hanging Committee of the National Academy, submitted it to their 1877 Exhibit. It was refused, on the rather insulting grounds that space was not available. Saint Gaudens was furious, perhaps in some degree because he knew that the group was unfinished and not very serious.

The repercussions have their place in art history. Augustus' friend Richard Watson Gilder put it like this: "I have often said that the Society of American Artists was founded on the wrath of Saint Gaudens."[18]

For some years, younger American artists had felt that they were receiving second-class treatment in the various shows and exhibits of the National Academy. The older, established artists were being prominently hung, and newcomers like George de Forest Brush, Frank Millet, Francis Lathrop, George Maynard, and Walter Shirlaw were shown high up or in dark corners. Even Whistler was "skied." Some attempt had been made by the Hanging Committee to ameliorate the situation by featuring the newcomers in one show, but this only infuriated the old guard and made matters worse. On the same day that Saint Gaudens complained to Gilder about his rejection, the dissidents were foregathering for a meeting. One of them was the talented Helena De Kay, Gilder's wife, and the meeting was to take place at the Gilders' East Fifteenth Street house.

Gilder, poet and critic, was acting as secretary to the disaffected group. He suggested that Saint Gaudens join them, which the sculptor did. That night the Society of American Artists was founded to challenge and defy the well-established Academy. Walter Shirlaw was elected president, but it was Saint Gaudens' indignation, burning like a gas, that fueled the flame.

Rejection is always harder to take if some measure of success has preceded it. Saint Gaudens' overreaction to the turndown of the plaster cast of the Greek girl stemmed from his triumph in December 1876: during that month the Farragut Commission finally came to a decision. The vote was six to five in favor of J. Q. A. Ward. Ward then showed his colors, and they were true blue. "Give the younger man a chance," he said, and withdrew his own name. So the verdict was reversed, and Augustus, as runner-up, won the prize he had coveted for so long. Now he was free—free to create a major work at some leisure, free to marry his Gussie at last.

They were married in a Unitarian ceremony at the Homer house in Roxbury on June 4, 1877. Sixty-three relatives and friends were present. Two days later the couple sailed for Europe. In July they took up their new life in a pleasant Paris apartment on the Rue du Faubourg Saint-Honoré.

12

A TIME FOR PARIS

"It sounds like a paradox, but it is a very simple
truth that when today we look for 'American' art
we find it mainly in Paris. When we find it out of
Paris, we at least find a great deal of Paris in it."

—Henry James[1]

THEY WERE HAPPY in the Faubourg Saint-Honoré apartment.
Then, when their short lease there ran out, they were happy in
a *pied-à-terre* on the Boulevard Pasteur. On New Year's Day 1878
they left for Rome. For nearly three months they were happy
there, reliving their courtship and renewing their love of the
classics ("I appreciate all the grand works more than ever," Au-
gustus wrote Maitland Armstrong[2]). Back in Paris that March,
they were happy in a comfortable fourth-floor apartment at 3 Rue
Herschel, which was theirs for over a year. From the narrow iron
balcony they had a fine view of the seventeenth-century elegances
of the Palais Luxembourg and, farther away to the north, the
gaunt, disparate towers of Saint-Sulpice.

They had left New York to seek some peace and quiet for
Augustus to work in. In Paris, they reasoned, he would be able
to complete the Farragut and also to fill the various commissions
that were to sustain them during its creation. Besides, they had
found the New York atmosphere somewhat stultifying, particu-

larly after the bitter quarrel that had brought the Society of American Artists into being. Paris, they hoped, would prove to be a more congenial artistic climate. Even with the passage money over and back, they figured that living there would be less expensive.

They were still quite dependent on Gussie's parents for financial help. Between August of their first year in Paris and the following May they asked for and received over two thousand dollars. Gussie's letters to her father went straight to the point. On February 12, 1879, for example, she writes asking for another installment "as soon as possible." She slightly dilutes the peremptory tone by adding, "I hope we are not giving you too much trouble but we find that it takes a good deal of the 'filthy lucre' to keep the ball rolling."[3]

Another worry was Louis St. Gaudens. He had disappeared from Paris in 1876. One day, after over two years, he turned up in Paris to Augustus' and Gussie's joy and relief. "Gus, I'm married," were his first words to his brother. Saint Gaudens looked at him in astonishment, but before he could speak Louis added, "She's dead."[4] That was all the family ever learned except that the girl was French and had died in childbirth. Augustus was able to arrange for his brother to study at the Beaux-Arts, where he was soon making excellent progress. He also pitched in, helping with much of the modeling in his old role of skillful assistant.

After several false starts, Augustus found an enormous studio at 49 Rue Notre Dame des Champs. It had once been a dance hall. There was so much space that he allowed several of his painter friends to set up their easels high in the gallery where the orchestra had performed.

One day Maitland Armstrong turned up in Paris and quickly became one of the regulars at the studio. He was much amused by the "alternate waves of exultation and despair that swept over Saint Gaudens as he worked."[5]

Everybody sang. One favorite was "Once Aboard the Lugger." From the gallery a voice would ring out: "You secure the old man, I'll bind the gur-r-l!" From the floor would come the

sculptor's bellow: "Once aboard the lubber she is mine." No one could persuade Saint Gaudens to change his (land-)lubberly variation.

Before leaving New York, the sculptor had agreed to undertake a commission to help John La Farge with a reredos for Saint Thomas Church. The reredos, or altar screen, was to consist of a central panel of angels in high relief worshipping a plain Latin Cross. Flanking the ten-foot-high panel would be murals by La Farge of scenes from the Resurrection. The deadline for delivery of this ambitious project was so close that it was given priority even over the Farragut.

As La Farge and Saint Gaudens envisioned it, this fusion of sculpture and painting in an interlocking theme and composition would mark a first in American art. In bringing it to life, La Farge slightly overdid his intellectual dominance of the sculptor from three thousand miles away. His copious correspondence is full of instructions like "Make the projections sufficient to cast a strong shadow and keep the darks as I have them."[6] Augustus stood his ground admirably: "I understood from our conversation about the work that the drawing you made was simply your idea of what would be a good division and disposition of the reliefs and that I was at liberty to change it in the execution of the work if it seemed necessary."[7]

The work went on at great speed. With no fewer than five helpers, Augustus managed to complete an angel every two and a half days. Their dawn-to-dusk schedule seven days a week began on August 29, and the finished product, cast in cement on location, was shipped to America on September 20!

Some time during this period of forced labor, his bitter enemy-to-be Truman Bartlett dropped by. According to Bartlett, he ran into "Saint-Guadens" (whose name he almost never spelled right) on the street and the younger sculptor asked him to come see him.

Here is Bartlett's account of what happened: "I went, saw his wife and a lot of men working on this plaster decoration (for a church in New York). . . . He saw that I was looking at it with

some care. He apologized and said, 'This is a job that does not interest me and I am glad to get it off my hands by letting someone else make it for me.' "

Having set the scene with this unlikely bit of dialogue, Bartlett drove home the knife: "The photographs of that piece of plaster and any of the work that he has done with his own hands will show that that piece of work was done better than anything he has ever done himself."[8]

What the jaundiced vision of Bartlett prevented his seeing was that Augustus Saint Gaudens of the near-infallible eye and proven gifts of leadership was directing a team that was producing very good work indeed.

One day during this same short interval of the modeling of the reredos, Augustus allowed himself an hour or two off to make a new friend. This was the well-liked painter Will Low, who had studied under Gérôme and Carolus-Duran.

Knocking at Low's door, the sculptor addressed him in his straightforward way: "Your name is Will Low, is it not? You had a bully picture in the Academy of Design last spring, and I wanted to come and tell you so. My name is Saint Gaudens."

"Come in," Low replied, "I know you very well." It developed that they had actually met once in New York through Olin Warner. More important, Low was aware that Augustus was already becoming a semilegendary Beaux-Arts figure. Despite Saint Gaudens' failure to win top honors there, an awareness of his talent and gusty personality had grown during the eight years in which he had been away.[9]

Soon Low returned the visit. Pointing to the fast-multiplying flock of angels, Saint Gaudens explained that he was planning to gild them after they were cast in cement, to take away the dead-white look they would acquire. Low, an excellent colorist, suggested that the surface be treated in polychrome instead to give a somber richness of hue rather than a sham bronze look. Saint Gaudens jumped at the suggestion and asked Low to help with the painting, which he did. So began one of Augustus' many friendships, half personal, half professional, which were to prove so rewarding to all concerned.

Working together and seeing him after hours, Low spotted a talent in Saint Gaudens: his way with words. When he talked (or wrote) about something that concerned him, usually some phase of the creative process, Augustus projected his feelings with force, even with eloquence. Low later described this characteristic:

> . . . Saint-Gaudens had a gift of making one "see things." He, in all simplicity, believed himself to be virtually inarticulate; and for any personal exercise of the spoken or written word, he quite honestly professed much the same aversion as he, the skilled artist, would feel for the bungling attempt of the ignorant amateur. But it was precisely because he was so intensely an artist that his mental vision was clear, and that which he saw he in turn made visible—there is no other word—to others. . . . I have heard many who by common consent would be accounted better talkers than he endeavor to repeat some story or incident originally told by Saint-Gaudens and the contrast was painful between the vivid, full-coloured image of the one and the pallid copy of the other![10]

Just as H. H. Richardson had become aware of Saint Gaudens' eye for perfection and also for its lack, Low was the first to comment on the sculptor's articulateness. It is clear now, by the light of hindsight, that his eye, with its equivalent of perfect pitch; his hands, with their haptic gift for shaping and molding clay into beauty; and his voice, which could move others when he himself was moved, all stemmed from the same ardent spirit. In one of his best-known, oft-repeated remarks, Augustus himself described the essence of the matter well: "No one ever succeeded in art unless born with an uncontrollable instinct toward it." It was this instinct, in its many manifestations, that Saint Gaudens possessed in such large measure.

Having worked double-time to finish the reredos, Saint Gaudens was distressed to learn that La Farge had lagged behind on his share of the work. "I regret very much he did not tell me he would not be ready," he wrote to Maitland Armstrong, "for then

I would have passed a great deal more time, studied up on the Renaissance and produced a better thing."[11]

When the altar piece was finally unveiled, in late 1877, its welcome was warm. Richard Watson Gilder sent the press clippings along. To Augustus' surprise and Gussie's sharp annoyance, La Farge received the lion's share of the praise. All that Saint Gaudens was given were a few scattered pats on the back for faithfully carrying out the La Farge master plan. The *World* noted that "the poetical feeling . . . was of course La Farge's."[12] Will Low's polychrome glaze over angels and cross garnered as much attention as the statuary itself.

The truth is that Saint Gaudens and his helpers had modeled better than they knew. Under the pressure of a harsh deadline, they achieved considerable grace. The early-Renaissance angels are enchanting, all kneeling yet no two alike in their orisons. Margaret Bouton noted that the figures "commenced that combination of sweetness and gravity which culminated in the *Amor Caritas*."[13] Lorado Taft also saw the work as breaking new ground, calling it "the sweet forerunner of the sustained achievement of Saint Gaudens' poet-life."[14]

Today we can only judge the merit of these angels adoring the cross from an archival photograph or two, and from a contemporary drawing in *Scribner's*,[15] for the story of the altar screen has a sad ending. On August 8, 1905, Saint Thomas Church burned to a gaunt shell. Saint Gaudens' charming angels crumbled in the fierce heat of the fire, and La Farge's subdued glowing murals were incinerated. The loss of this benchmark in the art of collaboration was and is a calamity.

The fact that most of the praise for their joint project went to La Farge caused Augustus' admiration for the painter to molt no feather. The older man continued to exercise the kind of intellectual ascendancy over him that Edmund Wilson wielded more arrogantly over Scott Fitzgerald and other authors of the 1920s and '30s. While still collaborating across the Atlantic, the two produced the LeRoy King Tomb, which can be seen today in the Island Cemetery at Newport, Rhode Island. With reference

to his own role in carving cross, Corinthian column, and oak-leaf ornamentation, Saint Gaudens poured words into a crucible of praise. The tomb "was absolutely his [La Farge's] design, and possessed that singular grace, elevation, nobility and distinction which is characteristic of whatever he has touched. I was the tool who modeled for him then."[16]

The trip to Rome in January of 1878 awoke in Saint Gaudens all his past love. "Italy has a greater charm for me than ever," he wrote La Farge, "and I should not be at all surprised if I remained here all the time I am doing my work. I wish I had the angels to do over again and could do them here."[17] Then Augustus had another severe attack of Roman fever. He and Gussie decided to return to Paris before the hot weather. "You don't know how I hate the idea of going back to dark, sloppy Paris after this glorious place," he wrote to Stanford White.[18]

There was, however, another compelling reason to go. Maitland Armstrong had been appointed head of the committee arranging the exhibit of American art for the Paris International Exposition of 1878. He asked Saint Gaudens to help him select the art, which was quite a tribute to the relatively unknown young sculptor's taste. Armstrong explained that eighty-four pictures were being sent over from America, of which some forty would be accepted. There would also be pressure from American artists in Paris to slip in their work. Armstrong was to have complete freedom in both selection and hanging. Saint Gaudens accepted the position with alacrity.

So back to Paris they went, with only a few clay sketches of the Farragut to show for nearly three months in Italy. Despite his misgivings, the return marked the start of a most constructive two years, in an atmosphere of growing creativity.

French sculpture was on a rising curve. After the deep humiliation of the Franco-Prussian War and the trauma of the Commune, sculpture filled a very real need. More than any other art form, it helped to staunch the wounds that French pride and

spirit had suffered. Somehow the national article of faith that there had been gallantry—even honor—in defeat lent itself perfectly to marble and to bronze. France drew solace from a proliferating number of statues of heroic young men with broken swords, of lions at bay, of splendidly defiant Mariannes shielding their wounded.

Exemplars of civic virtues and the arts were also given their share of the reflected glory. At the time of the collapse of France in 1870, there were exactly nine statues of illustrious French men and women in Paris. Thirty years later there were 110.

Joan of Arc came closer than any other historical figure to being the personification of the mood of the Third Republic. Emmanuel Frémiet's Joan, locked high in her stirrups, banner streaming, graced the Place des Pyramides. Joan communing with her voices at Domrémy, Joan holding her sword aloft in the sign of the cross, Joan in chains—such themes reminded France of some of her richest hours.

Of the many Joans, the one Saint Gaudens liked best was Paul Dubois' little-girl Joan, which now stands before Rheims Cathedral. She wears her heavy armor lightly. Her legs are akimbo and in her right hand she wields a sword far too massive for her slight strength. The overall effect is nothing short of bewitchment.

Most admired of all the compensatory statuary of the 1870s and '80s was Marius-Jean-Antonin Mercié's *Gloria Victis*. No one captured the mood of France *redivivus* as did Augustus' old comrade of Beaux-Arts and Roman days. This *Glory to the Vanquished* is a group consisting of a dying youth, with sword shattered nearly to the hilt, and a young woman with wings who represents Fame. As his life ebbs away, she carries him resolutely into glory, into Valhalla.

Each morning Saint Gaudens walked the pleasant mile from 3 Rue Herschel to his studio at 49 Rue Notre Dame des Champs. First he turned left on the Avenue de l'Observatoire, with its sculpture-strewn greensward and five alleys lined with flowering

chestnut trees. At the place where the Avenue joins the Boulevard Saint-Michel, he would often pause to admire the Observatory Fountain, considered by many the finest fountain in Paris.

He particularly liked the four sinuous nudes by Jean-Baptiste Carpeaux that form the centerpiece and crown of the fountain. In their assigned roles of the Four Quarters of the World, they supported (and still support) an armillary globe. Below the group, many samples of the virtuosity of Emmanuel Frémiet also delighted Saint Gaudens' eye: eight seaborne horses rearing in tandem, eight turtles spitting, four dolphins balancing on their snouts in the shallow lagoon.

Saint Gaudens would then walk past the spot where Marshal Ney was shot after the restoration of the Bourbons in 1815. Nearby, where the Rue Notre Dame des Champs abuts the Place de l'Observatoire, he often paused to admire François Rude's galvanic statue of Ney, forever freeing his saber from its strongly grasped scabbard.

He knew that back in the 1840s, when Rude had been roughing out his figure of the Marshal, he had wanted to perpetuate the legend that Ney, in his ultimate moment, had bared his chest and cried, "Shoot straight for the heart." He knew that Louis Napoleon, then President, had requested a less spectacular moment.

He knew too that an immense crowd had turned out to watch the execution of the *brave des braves*, including, so the story went, a Russian general in full uniform. During the fifteen minutes when the body lay sprawled on the ground, a horseman, rumored to have been a *milord anglais*, had jumped his horse over the fallen hero in a gesture somewhat less than gallant.

Living in an atmosphere of domestic happiness, passing works by kindred spirits like Carpeaux and Frémiet and Rude each morning and again on his way home, breathing the atmosphere of a France that was finding herself anew, Augustus moved confidently to bring his Farragut to fruition.

13

HERO IN THE MAKING

"I have such respect and admiration for the heroes of the Civil War that I consider it my duty to help in any way to commemorate them in a noble and dignified fashion worthy of their great service."

—Augustus Saint Gaudens[1]

IN HIS MATURE YEARS Augustus Saint Gaudens gave the impression of being a man of considerable culture, and he was. Making up for his lack of formal education, his quick mind absorbed information on a wide range of subjects. But at the time of his campaign for the Farragut, there were still enormous lacunae.

Maitland Armstrong recalls an episode that showed how large these gaps were. One day, back in the period when the two friends had adjacent studios in the old German Savings Bank Building, the sculptor was as usual turning over ideas for one of those masterpieces that would make his name and fame. It had occurred to him that Moses might be a possible subject. He asked Armstrong where he could find some information on the prophet and lawgiver. Somewhat surprised, Armstrong answered that the Old Testament wasn't a bad place to start. He loaned the sculptor his copy of the Bible forthwith. Late that same night, Saint Gaudens came to his friend's studio in a state of high excitement, Bible in

hand. "I've never read this before," he exclaimed. "It's the most remarkable thing I have ever seen!"[2]

He was learning fast. While still retaining that vivid sense of discovery, he was also becoming quite capable of research in some depth. In New York, before leaving for Paris in 1877, he read everything he could get his hands on concerning the Admiral's life and exploits, absorbed all that Mrs. Farragut and son Loyall Farragut could tell him, and studied all available photographs.

He learned that David Glasgow Farragut (1801–70) had become a midshipman in the U.S. Navy at the age of nine, and had seen combat in the War of 1812. At just over twelve, he had acted as master of a prize taken on the high seas.

Farragut, as Saint Gaudens soon discovered, was no climber or courtier. By 1861 his competent but quite average career was drawing to a close. With the outbreak of the Civil War it went up the sky like a star shell. On January 9, 1862, Captain Farragut was placed in command of the West Gulf Blockading Squadron with instructions to "proceed up the Mississippi River and reduce the defenses which guard the approaches to New Orleans, and so take the city."

He did exactly that, with the loss of 184 men. Lincoln, who was still having trouble finding a fighting general, had gotten himself a sailor after his own heart.

Mobile Bay was Farragut's finest hour. At its head lay the city of Mobile, last Gulf Coast port still held by the Confederacy. The seaward defenses included the powerful Fort Morgan, Fort Gaines, and a double line of mines, known at the time as "torpedoes."

The Union ships in two columns entered the channel below the city on August 5, 1864. U.S.S. *Tecumseh*, in the lead, struck one of the mines and sank. The next ship, U.S.S. *Brooklyn*, confused and losing steerageway, signaled "torpedoes ahead."

Lashed to the rigging just below the main top of the U.S.S.

97

Hartford, Farragut called out in his strong voice, "Damn the torpedoes. Full speed ahead." There is some evidence that his actual words were "Watch out for the torpedoes, proceed with caution." The North, hungry for a hero, delightedly accepted the more pungent version, as has history.

Battered and bypassed, the two forts held out for some days. But the crucial moment had passed; the battle was won, and very shortly the city fell.

A grateful Union made Farragut its first vice admiral in December 1864, and two years later he became the reunited nation's first full admiral. Lincoln said that Farragut's sea command was the best appointment he had made in the war, for no one was as willing to take great risks when the stakes were high.

Saint Gaudens also learned that the Admiral stood five feet six and a half inches, and was strong and swarthy, and a fine fencer. And he had given tongue to at least one other sinewy phrase: "The best protection against the enemy's fire is a well-directed fire from our own guns."

Liking the man for what he was as well as for what he had achieved, Saint Gaudens continued his quest in clay for the magnificent sailor.

While still in Rome in early 1878, Saint Gaudens had written Stanford White about the possibility of their working together on the project: "I have been pegging away at my Farragut. When you come over I want to talk to you about the pedestal."[3]

White answered with his usual exuberance: "I hope you will let me help you on the Farragut pedestal. . . . Then I should go down to Fame, even if it is bad, reviled for making a poor base for a good statue."[4]

White turned up in Paris in July 1878, and the close collaboration that ensued marked another first of its kind. Up to that time, architects had been called in routinely to supply a base for a finished statue. Collaboration every step of the way produced spectacular results.

White had taken final leave from the office of H. H. Richardson, with the blessings of the great architect. Before starting out on his own, he wanted to see the wonders of the Old World first-hand. Along with him came Charles Follen McKim, who was betwixt and between for other reasons: his wife had left him, taking with her their three-year-old daughter.

The arrival of the two architects enlivened the daily routine at the Rue Herschel, which the contented but not totally domesticated Saint Gaudens admitted "had little of the adventurous swing that pervaded my previous struggles."[5]

Between his vigorous forays around Europe, White actually lived with the Saint Gaudenses. On the subject of Gussie, his letters home are blunt and explicit: "She is very kind . . . mends my clothes and does all manner of things. She is an animated clothes rack, slightly deaf and mean to that extent that no comparison will suffice. Why fate should have ordained that such a man should be harnessed to such a woman, heaven only knows."[6] Poor Gussie! "Mean" in those days meant mean about money, and it is quite possible that White did not fully realize that the Saint Gaudenses were not yet entirely in the clear financially. As for Gussie, she took quite a liking to Augustus' whirlwind friend, and heartily approved the way he refused seconds when the dessert was in short supply.

On Gussie's younger sister Eugenia (Genie), who had come to Paris to help out and share the fun, White is more expansive. In the same letter to his mother quoted above, he reports that "her pretty sister and utter antipodes is staying with her now, and perhaps fate is also wise allowing me *only* to stop a day while I am in Paris."

One perfect July day shortly after their arrival, White and McKim burst in on Saint Gaudens at his studio. The sculptor was working away, slightly overdressed by his standards in a white linen blouse that was Gussie's idea, making him in her opinion look "quite respectable."

The two redheads wanted him to drop everything and join them on a walking tour in southern France. Saint Gaudens protested that he was about to be visited by some of the wives of the Farragut committee, who were anxious to see what progress he was making.

A day or two later, White and McKim came back, to find Augustus whistling cheerfully at his work. "Evidently," McKim said, "the ladies were pleased."

"No, they weren't," Augustus answered. "If they had been I should have known that it was bad!" The subject of the walking tour came up again, and again he shook his head. It seemed that some of his comrades of Beaux-Arts days were coming to have a look.

The opinion of the old boys, when they did come, was crisp enough: "Saint Gaudens, you have given Farragut your legs." Saint Gaudens was sensitive about his legs, which were slightly bowed. Relaying the comment of his colleagues to White and McKim on their next visit, he got angry all over again. Suddenly he lifted the finished head of Farragut off the body, then tipped the body over. As the clay crumbled into a hundred fragments on the floor of the studio, he roared his final answer to the trip: "Come on, I'll go to hell with you fellows now!"[7]

The eleven-day vacation was a rollicking success. To get south, they surged down the Rhone in a canal-barge type of boat, saturated from stem to stern with the smell of garlic. Once in Languedoc they admired Roman remains, pretty girls, and medieval fortresses with almost equal enthusiasm. Stanford White's account of the trip is the fullest, and includes a glimpse of the trio at the huge amphitheater at Nîmes: "We sat down on the top row of seats and imagined ourselves ancient Romans, and then I went down and rushed madly into the Arena, struck an attitude and commenced declaiming. McKim and Saint Gaudens heard me perfectly. I stabbed five or six gladiators and rushed out with the guardian in hot pursuit."[8]

At Arles they marveled at the portal of Saint-Trophime, the church that had inspired Richardson in his great design for Trinity. At the little out-of-the-way town of Saint-Gilles, White in particular was dazzled by the marble three-arched porch of the church. "The Huguenots knocked the noses off the saints and I hope they have been well boiled for it," he wrote in summation.

From Arles, the foothills of the Pyrenees and the village of Aspet were no great distance. But the question of going there seems not to have arisen. Saint Gaudens' deep nostalgia for the country of his forebears would come later.

Once back in Paris, he quickly modeled a medallion to celebrate the outing. This was the first of his affectionate cartoons in clay. Without cluttering the design, he managed to include quite a lot in its six-inch diameter. At the top is Stanford White, simplified to a moonrise of bushy hair, wide-set eyes, and a flaring mustache. To the right of a central T-square are the elements of McKim, a vast dome dominating tiny features. To the left is the sculptor himself in jutting, one-stroke profile. Various inscriptions in jocular near-Latin carry out the mood. Augustus gave bronze reproductions to his two friends, and treasured a third copy all his life.

Then, with new zest, he started to put Admiral Farragut back together again. One underlying problem all along had been the artistic handling of modern dress. His props for the Farragut—all he had to work with—were "cap, sword, belt, buttons, and the resource of trying to strike away from the stuff we have in America."[9]

By September 1879, his concern over the work in progress had reached a high pitch. He wrote Maitland Armstrong, "I'm completely and thoroughly befuddled and disgusted with Farragut; therefore it must be very good—eh?"[10]

By late December his state of confusion was rarer still, as he professes in a letter to Richard Watson Gilder, who was living in London that winter: "All my brain can conceive of now is arms

with braid, legs, coats, eagles, caps, legs, arms, hands, caps, eagles, eagles, caps and so on; nothing, nothing, but that statue."[11]

On the same day (December 29) on which he wrote Gilder, he came to realize that the search for the true Farragut was about over. He reported to his mentor La Farge that the statue was nearly done and that he would return to New York as soon as it was cast in bronze. "I am completely *abruti*," he added, meaning that he was reduced to stupidity. "I haven't the faintest idea of the merit of what I've produced. At times I think it's good, then indifferent, then bad. I am certainly anxious to get your opinion on the whole work . . . for I feel the necessity of your influence more than anyone I know."[12]

Even before it was cast in bronze, a pattern of praise for the Farragut began to form, a pattern that helped to resolve Saint Gaudens' doubts and fears. The first encouraging sign came when he submitted a plaster cast of the full figure to the 1880 Paris Salon, along with five bas-reliefs. (Their subjects were three American artist friends in Paris—Frank Millet, William Gedney Bunce, and George W. Maynard—as well as Dr. Shiff and the celebrated French artist Jules Bastien-Lepage.)

He was more than delighted when his submissions brought him his first Honorable Mention at the Salon. Several of the French critics caught something unusual and singularly American in the figure of the naval officer. Writing in the *Revue des Deux Mondes*, Émile Michel in particular felt that Saint Gaudens had captured "the especial quality of a race . . . that initiative and boldness which Americans possess and which Farragut exemplified to the life."[13]

Having Stanford White even as intermittent lodger ensured good coordination of statue and pedestal. The design the two friends worked out was soon a far cry from the simple exedra envisaged in the early sketches. It was to be made of stone, and carved in New York. The final version had still been undecided when White went home in September 1879. On December 17 he wrote Saint Gaudens that "the plan for the pedestal has a flatter curve and the whole pedestal is broader and lower. . . . I

have kept the rise in the back of the seat in a modified and more subtle form so you'd be satisfied. . . . All I've got to say is if any Greek temple had any more parabolic, bucolic, or any other olic kind of curves about it than this has . . . a lunatic asylum or hospital must have been added to an architect's office."[14]

White's letters to Saint Gaudens during this period tend to open with extravagant salutations. "Beloved Snoops" and "Doubly Beloved" are fair samples. "You clay-daubing wretch" is another term of endearment, used in the text of one of the letters. Saint Gaudens' replies usually open "Dear Old Hoss" or "Dear Bianco" or something equally jaunty. In this bantering, affectionate jargon we can see what V. S. Pritchett calls "a well-known mode of Victorian emotionalism."[15]

Even when the boisterous White was on his architectural pilgrimages he bombarded Saint Gaudens with letters. Once White wrote Augustus from Rheims in a particularly high state of excitement: the sculptor was to drop everything and join him to study the Gothic figures on the cathedral façade. And bring Genie! Gussie decreed that her younger sister could indeed go along if she wore a bonnet and a gold wedding ring for respectability.

The trio stayed at a commercial hotel. In their tiny parlor, Genie darned White's socks while the men roasted apples on strings before an open fire. The next day, after seeing the marvels of the cathedral, they took off for Laon in a third-class coach. There they saw another wondrous cathedral, which crowned a hill in the middle of a wide, misty plain. During the day at Laon they counted their money and found that White had just enough to get back to Rheims and his research there. As for Augustus and Genie, they arrived back in Paris with a bare three or four sous between them.

There were jinks and high jinks to relieve the unremitting work of the studio. One evening Saint Gaudens' brother Louis and Stanford White turned up at the Rue Herschel excruciatingly late for dinner. All three were covered with yellow paint.

"What has happened?" Gussie and Genie screamed at them in unison, angry but at the same time relieved that they had shown up at last.

"Bunce had a yellow day," was the cryptic answer.

"A yellow day?"

"A yellow day."

Augustus was the enlightener. He explained that William Gedney Bunce, who was sharing the studio, had been as usual dabbling with his favorite color. "He started to smear it over one of his Venetian sketches, so we got rid of him while we smeared it off—over everything."

The three were in high glee over their attempt to cure the much-loved Bunce of his predilection.[16]

Other diversions included picnics at Fontainebleau, Sunday concerts at the Cirque d'Hiver, midnight mass at Saint-Sulpice on Christmas Eve. There were old friends like Frank Millet and George Maynard of the Trinity Church apprenticeship days, and new friends like the cigar-chomping Samuel Langhorne Clemens and handsome young John Singer Sargent. The latter, fresh out of the atelier of Carolus-Duran, had a studio on the Rue Notre Dame des Champs and was already rivaling his master with his dazzling virtuosity. Dr. Shiff blew in from Rome with time to spare for endless philosophical conversations in the cafés. There were French friends like the enamelist Alfred Garnier and Paul Bion, still sculpting but beginning to withdraw a little into his role of observer of life and art. Augustus was on good but more formal terms with Paul Dubois, whose work he admired so greatly.

Among the Americans, Frank Millet was everyone's favorite. He had the knack of bringing people together and the gift of inspiring them to join in any artistic undertaking that had caught his fancy. Millet at fifteen had served as a drummer boy in the Civil War, and was later a war correspondent in several Balkan disturbances. He had traveled everywhere in the Near and Far East, and his handsome face was stained by many strange suns. From Turkey he brought a real-life bashi-bazouk. Fierce of weaponry and mustache, the Turkish irregular guarded his studio,

where more exotic weapons and exotic musical instruments abounded.

During the winter of 1878–79 the London-based Richard Watson Gilder came often to Paris. Appropriately enough, Gilder posed for the legs of Farragut, for he too had been a drummer boy in the Civil War. Like Farragut he was quite small, and his legs were a shade straighter than Saint Gaudens'. Gilder's most marked characteristic was his long, straight black hair, which inspired several observers to describe him as "the man who had been rained on."[17]

Gilder had already written some exquisite poetry celebrating his love of his Helena. He had also worked on the staff of *Scribner's*. The couple and their son Rodman had come abroad for rest and recreation before Gilder took over the editorship of *The Century Magazine*, the post that was to earn him his lasting fame.

Knowing that Gilder was not too busy between jobs, Saint Gaudens wrote from Paris asking his help on a commission that the sculptor had undertaken with grave misgivings. This was for a statue of a man called Robert R. Randall, an eighteenth-century American merchant and privateer. On his death in 1801, Randall had left money to provide for Sailor's Snug Harbor, an asylum and hospital for aged seamen on Staten Island. There was no record of what Randall actually looked like. Not very interested in conjuring up a shadowy figure, Saint Gaudens kept putting off work on the project.

With his growing concern for authentic dress, he asked Gilder to do some research for him: "I want to know whether sea captains in the merchant service of about 1770–1790—English or American—wore tri-cornered hats, if not, what kind of hat was worn? Also if they wore boots; and if so, what kind and if they did not wear boots whether they wore leggings, or big coarse stockings, coming up over their knees. . . . Also, was the pea jacket similar to present ones?" Realizing that he was demanding a good deal, Saint Gaudens fell back on the jocular tone he and White used so often: "I don't mean that you should look through

50000000000000000 engravings. . . . If at all troublesome or out
of your way 'nuff said.' "[18]

After this burst of energy, Saint Gaudens seems to have
allowed the Randall assignment to languish again. In early 1879
the Gilders came to Paris, partly on Saint Gaudens' urging. Au-
gustus and Gussie helped them find an apartment, and they quickly
became a welcome addition to the American fraternity.

Gussie grew happier all the time. "It is strange how fasci-
nating life here becomes after living a couple of years," she wrote
her father on June 13, 1879.[19] In September, she and Genie
took a trip to Switzerland. Augustus was able to join them for
three days at the spa of Château d'Oex, so it was not one of
those long separations that would soon become the recurring
pattern.

One of Gussie's main pleasures was furnishing their apart-
ment. She bought shrewdly and well, with a view to future use.
For 115 francs at the Bon Marché she bought a "veritable old
Persian rug with some outlandish name and pretty dusty."[20] Else-
where she found a fine old carved chest from the time of Charles
IX and a copy of a Donatello bust on a handsome stand. When
he had time, Augustus came along on her shopping expeditions:
"We bought a queer old-fashioned bureau this morning for $4. It
is pretty worm-eaten and one of the brass handles is gone, still,
Augustus likes it."[21] She bought old prints, odd lanterns, a hand-
some tapestry.

She was very happy painting old chairs and tables, using her
copyist's skill for these more domestic labors. In part because
of her deafness, she didn't mind the long hours alone while
Augustus was at the studio. She was especially pleased
when he allowed her to help with the clay modeling of the
braid on Farragut's tunic, for this made her feel part of the
team.

Gussie was happier still when, early in 1880, she found that
she was pregnant. Augustus was delighted. On May 17 she wrote
her father for extra money, for doctor's bills and for the purchase
of small mountain strawberries by the bucketful at twenty-eight

cents a pound. "Although rather an extravagance, I feel that I must have them as I want fruit more than anything."[22]

Some problems developed over the casting of the Farragut. The well-known Gruet foundry did the pouring of the bronze, but the first draft was a near disaster. Saint Gaudens postponed their departure for home until he was satisfied at last.

They sailed on July 3. Their cabin was a commodious one on the main deck, as befitted a sculptor whose present was assured and whose future was assuming great promise. Louis St. Gaudens had a more modest cabin below decks.

The plan on landing was for Gussie to go directly to her parents in Roxbury to await the arrival of the child.

Her happiness was now complete.

14

THE CRESTING
OF THE WAVE

New-rich hostess: "And this is our Louis Quinze room."
Cultured guest: "What makes you think so?"[1]

THE NATION WAS in remission, that summer of 1880. The scandals and financial panics of the Grant years were past history now, and the one-term presidency of Rutherford B. Hayes was drawing to a close. Hayes' administration had been a sensible, a solstice time. With his one-vote majority in the Electoral College—and its confirmation by a Republican-tilted commission—the start had not been too promising. When, in mid-term, the easy-going chief executive lost control of both the Senate and the House, he had of necessity to sail wing-and-wing with the Democratic legislators in order to keep the ship of state on course. This situation, not foreseen by the Founding Fathers, did not lend itself to much forward motion. The able Hayes stood up to the Congress courageously. He managed to curb the notorious spoils system, purge the cloacal Indian Bureau, and heal many of the scars which the South still bore from the Civil War.

When the question of running for a second term came up, Hayes chose not to put his hazardous victory to another test. James A. Garfield, fellow Republican and fellow Ohioan, was elected president in November 1880, with a small but workable

(and simon-pure) majority in both popular vote and Electoral College. Hayes disappeared into private life and good works. After a while, most Americans remembered only that he had possessed the largest beard of any president ever, and the narrowest majority.

Now, following the bitter years of Reconstruction and the loggerhead time of Hayes, America was in expansive mood. Symptoms were the inventions of the telephone and electric light, which made Alexander Graham Bell and Thomas Alva Edison twin gods of the new technology. The railroads, key indicators on the chart of economic health, had been running a high fever. Many lines had been built that, so far as profits were concerned, turned out to be roads to nowhere. Now the companies began putting out reasonable tendrils again, opening up areas where there was a genuine need for transport.

In the 1870s, immigration from Europe had totaled some two and a quarter million people. For the ten years beginning in 1880, the figure doubled. Even though many of the immigrants were cruelly exploited, most did find jobs. In a sense, the door really was golden.

During the Civil War years, tentative income taxes had been imposed. But by 1880 this tax had long been repealed, and corporations were still tax-free. This taxless state at a time of rapid growth, and the availability of so much cheap labor flooding in from abroad, were root reasons for the Age of Elegance now setting in. A great wave of new money was cresting. America was in the mood for grandeur, and the new aristocracy was in a position to command it. After all the anxious, divisive years, it was almost as if a kind of *droit de splendeur* was coming into being—which the piratical lords of industry were ready to exercise as their very own.

Hard-bitten old Commodore Vanderbilt caught the spirit of these booming times well when he said, "The law, as I see it, goes too slow for me when I have the remedy in my own hands."[2] At his death in 1877, the Commodore left William H. Vanderbilt, his son and principal heir, ninety million dollars. Eight years later,

at William's death, the sum had doubled. Such spurting fortunes were typical of the day.

Out of a large desire to celebrate their own success, and sometimes from a small, faint sense of guilt, the new American tycoons showed considerable civic responsibility. They founded museums, art galleries, symphony orchestras. Public parks and playgrounds were named for them, and churches reared or greatly enlarged at their expense. For more personal reasons, country clubs and city clubs proliferated.

Some of the key years for such philanthropy were 1879, 1880, 1881, and 1882. You can still see these dates on many cornerstones and wall plaques, celebrating largesse.

The very rich poured a great deal of their substance into their own dwelling places. These symbols of the new imperial America included town houses of Renaissance grandeur and eighteenth-century elegance, ninety-room "cottages" by the sea, and pleasure domes with somewhat hazy Gothic and Tudor credentials in the mountains.

The architects, artists, and artisans who catered to the needs of the gaudy barons of business were a closed circle, for the most part Beaux-Arts–trained. It was there that many of the friendships had been forged. Drifting back from Paris in the late 1870s and early 1880s, this interlocking group was quick to learn about the care and feeding of the rich, and in particular about the housing of same. "The millionaires in search of a place had been taught to trust the arbiters of taste," Wayne Andrews noted, "and the designers themselves had learned something about scale and proportion."[3]

Inevitably, the architects were the prime movers in seeking out the big commissions. Until his death in 1886 at the early age of forty-seven, H. H. Richardson had been the high priest of his profession. In his last years he was more of a romantic than a revivalist, but he still drew splendidly on many centuries for inspiration. In 1879, Stanford White, Charles Follen McKim, and their steady, hardheaded friend William Rutherford Mead joined forces to found the firm that would dominate American taste for

the next three decades. Richard Morris Hunt, master builder of châteaux where the only wars were social ones, was another architect in great demand. Since he had come home from Paris in 1870, he had a headstart in ending the era of the brownstone and the mansard roof.

Members of the inner circle looked out for one another. If the architect needed a mural for a mansion or a church, he usually thought first of John La Farge; but boon companions like Maitland Armstrong, Will Low, Kenyon Cox, and Edwin Blashfield were also available. For monuments, overmantels, chancels, and bas-reliefs, Augustus Saint Gaudens' name would soon lead all the rest. If he was busy, there were, on the recommended list, such sculptors as his brother Louis, Olin Warner, Daniel Chester French, and others in the old-boy net. When it came to portraits, no one could hold up a mirror to opulence the way John Singer Sargent could, working out of Paris and London for most of the 1880s. Thomas Eakins could shine his light into darker corners, and Cecilia Beaux was showing that she could attain, in her likenesses, a restrained elegance and beauty.

Standing by to give the finished product the right reception and the proper gloss were a group of critics who were themselves members of the closed circle. In his new responsibilities as editor of *The Century Magazine*, Richard Watson Gilder was soon on his way to becoming supreme arbiter of the arts. Kenyon Cox, Maitland Armstrong, and Will Low were all competent artists, but, as is surprisingly often the case with good middling men, all three wrote better than they drew. Mariana Griswold Van Rensselaer, whose taste was excellent, commented on architecture and sculpture with a fine authority. She also seems to have developed a discreet but possessive affection for Augustus Saint Gaudens.

Augustus came home at exactly the right time. Beaux-Arts training was still the badge of distinction; an Honorable Mention at the Paris Salon was the rosette on the badge. (Between 1860 and

1910, 160 American artists competed in the annual salons. The only American ever to turn down an award was James McNeill Whistler. Even though he was fully aware that the French reserved the larger honors for themselves, he indignantly rejected the Second Prize for which he was nominated.)

The ten-month period between Augustus' return in July 1880 and the unveiling of the Farragut the following May was an odd-even time for the sculptor. It saw the beginning of many projects, and the completion of a few. The readying of the statue of the Admiral took up more and more time, until toward the end it obliterated everything else.

Here are some of the events and nonevents of these interim months:

After camping out for a while in the studio of William Gedney Bunce, who had also come home, Augustus and Louis lodged and worked for a few months in the old Sherwood Building at Sixth Avenue and Fifty-seventh Street. Then they rented a more ample studio at 148 West Thirty-sixth Street, where they stayed for the next fifteen years.

Augustus manfully tackled the Randall statue again, hoping to rid himself at last of that anomalous personage. At the same time, he put Louis to work on the two bas-reliefs, *Courage* and *Loyalty*, for the pedestal of the Farragut, with astonishing results.

With more joy than he was able to muster for the Randall, Augustus modeled three angels for the tomb of his patron, Governor Morgan. Now in his seventies, Morgan had outlived all his five children and was sharply aware of his own mortality. Saint Gaudens had received the commission while still in Paris and made preliminary sketches there, using his recurrent theme of celestial but very womanly figures.

As often as possible, he traveled to Roxbury to see Gussie. Her loving letters to her "dear old hubby" helped to bridge the gap. A typical sample, dated August 4, told of daily chores, of old friends dropping by, of the clothes she was making for the imminent baby. She ended, "You have no idea how I love the little thing, and my husband."[4]

Gussie produced a son on September 29, who was christened Homer in honor of his maternal grandfather. He was given the middle name of Schiff for the expatriate doctor-philosopher, with the rather stylish extra "c" already mentioned.

Augustus picked up his own connection with the superrich by undertaking to model some fireplace caryatids and other decorations for the town house of William H. Vanderbilt. Designed in the style of Henry IV, the house would soon fill a good part of the Fifth Avenue block between Fifty-seventh and Fifty-eighth Streets.

He expanded his staff to help meet the commissions that were piling up. One new assistant was Frederick MacMonnies, who came to work as a studio boy at sixteen, and quickly demonstrated a precocious, sometimes disturbing, talent. Another was Philip Martiny, destined for fame at the Chicago World's Fair in 1893.

At H. H. Richardson's urging, Augustus undertook two ten-foot plaques for the *Oliver and Oakes Ames Monument* to be erected in Wyoming. The chosen location was the high point crossed by the Union Pacific Railroad, which the two brothers had done a great deal to bring into being. Richardson's design called for a pyramid of local granite, sixty feet square by sixty feet high. Construction began in 1880, with granite dragged to the lonely promontory by oxen. The two bronze plaques, high up on the beautiful stark pyramid, one facing north and one south, show both brothers in profile, both bearded. The Union Pacific railroad has since been relaid elsewhere, so that few people today ever see the monument. The only attention it receives is the scarring of the plaques and granite by the random gunfire of passing cowboys.

As a change from more encompassing subjects, Saint Gaudens in this interval created some of his finest bas-reliefs. His own favorite was the nineteen-inch bronze of Samuel G. Ward, financier and art patron. It is modeled in relief one-eighth of an inch high, the lowest Saint Gaudens ever attempted and the one that comes nearest to an injunction of his friend Bastien-Lepage

that he paint in clay. It is unquestionably a triumph in the medium. Another of his own favorites was the tall, narrow bronze of the youthful Sarah Redwood Lee, pre-Raphaelite in spirit and, as such, tangible evidence of his admiration for the paintings of Sir Edward Burne-Jones.

A nonevent was the rejection of Saint Gaudens' candidacy to the prestigious Century Association. Several members had nursed a grudge since the 1878 Paris Exposition. They resented the way Maitland Armstrong and Augustus had gone about the selection of American entries—turning down or "skying" the work of old hands like themselves, choosing and giving prominent display to new talent. Since Armstrong was already a Century member, they took their resentment out on the still-obscure Saint Gaudens. After the Farragut catapulted him to fame, he was put up again, and sailed in.

Sometimes Saint Gaudens' taste and dedication in matters of art warred with his very Irish desire to please. An episode at a vernissage, remembered by Maitland Armstrong, illustrates this conflict in his character. The scene was a Paris art gallery in that same year of the Exposition. At the opening, Armstrong and Augustus took a violent dislike to one of the pictures, agreeing that it was hopelessly bad. Then some people who knew Saint Gaudens buttonholed him and asked if he didn't immensely admire this same picture. Augustus admitted that he did indeed, and quickly extricated himself.

"Saint Gaudens," Armstrong said reproachfully, "you're not living up to your principles. That's a bad picture and you know it."

Augustus sprinted after the people who had questioned him, singled out one of them, and called out: "I beg your pardon, sir, I shouldn't have said that was a good picture: I know for a fact that it's dreadful!"[5]

With his intimates, this trait of wishing to please was little in evidence. Augustus sparred with Stanford White over many of

the details of the Farragut, always with deep respect for the architect's love of beauty. For his part, White, despite the flaring red hair and mustache, never lost his temper. "Although he looked like Vercingetorix" and "was as strong as a prizefighter," he was the gentlest of men.[6]

Even before Saint Gaudens came back from Paris, there was discussion over the site of the statue of the Admiral. White wrote describing various locations in Madison Square. His own choice was one "in a sweller part of the Park, just where the aristocratic part of the Avenue begins and right opposite Delmonico's and the Hotel Brunswick. . . . The stream of people walking down Fifth Avenue would see it at once."[7] After a great deal of discussion with everyone from La Farge to Frederick Law Olmsted, this site was finally agreed on.

Saint Gaudens was a casual and not very satisfactory correspondent. In one of his infrequent letters from Paris he told White that Genie Homer would be arriving home on a certain ship— but he gave the wrong date, and it was only by sheer chance that White happened to be on the dock when she arrived, looking, as he wrote Saint Gaudens, "the perfect picture of loveliness and health."[8] In this same letter, after upbraiding Augustus for providing false information, White mentions that he hopes to find some way of going to Boston to see Genie and to "ask the five hundred and fifty questions I wish to." Somehow the New York life and the pressure of new work engulfed him, however, and he never managed to do so.

There were other Farragut problems. Of great concern to both Saint Gaudens and White was the wording of the long inscription on the pedestal and the treatment of the lettering. The conformation of the stylized sea that held together the various elements of the bluestone base was another matter of endless experimentation. Arguments with the authorities over the location of the pebble path leading up to the monument turned into a long-drawn-out headache. The question of the correct patina for the

dark bronze of the statue itself absorbed Augustus the perfectionist to the end.

As the day fixed for the ceremony—Memorial Day 1881—drew near, all other projects receded. Saint Gaudens' own description of the climate of the time makes a lively paragraph in his pointillist style. First noting "the toughness that pervades a sculptor's life," he breaks down the elements of that life: "For we constantly deal . . . with molders, contractors, derricks, stonemen, ropes, builders, scaffolding, marble-assistants, bronze-men, trucks, rubbish men, plasterers and what-not else, all the while trying to soar into the blue."[9]

At last the day arrived. With the nation's high tide of new achievement beginning to run, the timing was perfect. Augustus would play his part, and ride the cresting wave.

15

A MAN OF NO OTHER
TIME OR PLACE

"Great Art . . . is not the filling of a desire but the
creating of a new desire."

—Louis Kahn

THE LATE-SPRING DAY is blue and gold. The scene is the north-
west corner of Madison Square, just across Fifth Avenue from
Delmonico's. The occasion: the unveiling of Saint Gaudens' statue
of David Glasgow Farragut. The date is May 26, 1881.

A wind down the Hudson has blown the sky clear of cloud.
By midmorning the wind has slackened and the flags of nation,
state, and city scarcely stir on their standards. Prominent on the
dais is former Governor Edwin Morgan, prime mover as we know
in obtaining the commission for the thirty-three-year-old Augus-
tus. Most of the Farragut committee are on hand, including dap-
per little Marshall Owen Roberts, a friend of Abraham Lincoln
and the stubborn opponent of the selection of the unknown sculp-
tor. Sadly missing was another one-time governor of the state,
General John Adams Dix, chairman of the committee until his
death two years before.

Poet and editor Richard Watson Gilder is there, looking as
usual as if he had been left out in the rain. Comely Mariana

Griswold Van Rensselaer is there—lively critic of art and architecture and an early champion of Saint Gaudens. Bluff, burly J. Q. A. Ward is there, dean of American sculptors, whose withdrawal triggered the commissioning of Saint Gaudens. Also there, in unmistakable black, is Mrs. Farragut, widow of greatness; with her is her son Loyall Farragut, popular young man about Manhattan. Bernard Saint Gaudens is there, broad of chest and almost as broad of smile. Nearby is Augustus, terrified that he may have to make a speech—a fear that proves groundless. By his side is Augusta, mightily proud of her Gus on this day of days.

Holding the lines that will part the canopy draped over the monument is Quartermaster John Knowles. Seventeen years before, on a certain thunderous morning in Mobile Bay, he had lashed Farragut to the rigging of his flagship so that the Admiral could command the battle from above.

Between the dais and the dense crowd, a company of sailors in dress whites stands at attention, and behind the shrouded statue a battery of artillery has been drawn up, ready to fire the salute when the moment comes.

There are quite a few speeches. The main address is delivered, with his usual verve, by the prominent Mr. Joseph H. Choate. As expected, it is long and witty. There is a lot about the Admiral and the Union he did so much to save, and almost nothing about the sculptor.

Then, in solemn cadence, the battery fires the nineteen-gun salute, the honors due the first four-star flag officer in our history. The veil is firmly drawn aside, and there is the Admiral with the wind in his face.

The leading citizens on the dais and the crowd below like what they see, and the more they look the more they like. The applause, polite at first, swells to a steady drumfire of approval and is long sustained.

What pleases the crowd is the sturdy figure of the naval officer standing foursquare on his quarterdeck. His left hand grasps his binoculars, his right hangs in perfect repose. The wind that stirs the skirts of his uniform is not the gentle breeze of the day of

unveiling but the high, harsh wind whistling down Mobile Bay as flagship and fleet churn into action. The strong, very American face is composed as Farragut faces his moment of destiny. There is a calmness, a nobility, in the way he stands. He is so still he seems almost to move.

On closer observation, the spectators discover that the blue-stone base is as thrilling as the statue above it. The naked sword, vertical in a slatting sea, links the eye most satisfactorily to what is going on below. Crouched to the left and right are female figures of a great simplicity carved in low relief. The left-hand figure represents *Courage*, the right *Loyalty*. Inscriptions on the wings of the pedestal in Roman capitals honor THE MEMORY OF A DARING AND SAGACIOUS COMMANDER AND A GENTLE AND GREAT SOULED MAN. The words flanking *Courage* proclaim the proud intent THAT THOSE WHO COME AFTER HIM AND WHO WILL OWE HIM SO MUCH MAY SEE HIM AS HE WAS SEEN BY FRIEND AND FOE. . . .

At the ends of the curving exedra or bench below the two female figures there are two beautiful dolphins with water flowing over them, forming the arms of the bench. The sword, the symbolic figures, the slatting sea, and the dolphins are all forerunners of the style called Art Nouveau that will come into being in the next decade. Even the term itself has not yet been born.[1] To some, the new and very decorative treatment is puzzling, but to most of the people there the details of the base are, like the whole day and the stalwart hero above, exciting and triumphant.

The fact that the public had been fed for so long on a stale diet of marble slavegirls, men in togas, and sentimental genre groupings helps us to understand the impact that the Farragut made. The critics quickly took up the cry. Soon the whole country was welcoming with a fresh delight Saint Gaudens' realism which was yet romantic, his striking juxtaposition of bronze and stone, of lettering and low relief.

Commenting on the statue itself, art critic Kenyon Cox wrote, "There is no cold conventionalism . . . but a penetrating imagi-

nation which has got at the heart of the man and given him to us 'in his habit as he lived,' cool, ready, determined . . . a sailor, a gentleman and a hero."[2]

In the June issue of *Scribner's*, Richard Watson Gilder also went overboard: "In modeling severe, broad yet minute in finish . . . full of dignity and reserved force—Saint Gaudens' bronze Farragut might also be called the work of some new Donatello." Mariana Van Rensselaer contributed a long piece in *The American Architect and Building News*. At the outset she simply states that the Farragut "is the best monument of its kind that the city has to show." She refers to "its strong national accent," and enlarges on this American quality by saying that "the subtle qualities of race and national character are strongly prominent . . . while the general canons which bind in all ages the sculptor's art have not been in the least transgressed."[3]

A clue that Mrs. Van Rensselaer's praise was not totally disinterested lies in her notation that there was "small reference made by any of the speakers of the day to the artist himself or to the artistic qualities of his work."

The base was upsetting to some. An editorial, in the same issue of *The American Architect* as Mariana Van Rensselaer's panegyric, observed that it made the hero himself into "an incident of the back of a sofa." The base itself is "primitive . . . a series of stone slabs on end, after the manner of a Druidical cromlech rather than of a classic exedra."

But the torrent of praise continued to pour in. Maitland Armstrong, by now an arbiter of taste, wrote to his friend Augustus that he had built better than he knew: "You have gone beyond art, and reached out and touched the universal heart of man."[4]

Long afterward, Lorado Taft, sculptor and historian, struck the nationalistic note again, calling the Farragut "a man of no other time or place." Then he went on to put the day and the statue in context: "When in 1881 the 'Admiral Farragut' was unveiled in Madison Square, the work of a new leader was discovered; the foreign and unfamiliar name was henceforth to head the list. . . . Many of our best critics rate him not only our greatest sculptor but the greatest of American artists. . . ."[5]

In this perpetuation of the memory of an authentic American hero, the nation had also acquired a new star. Suddenly everyone wanted to know more about Augustus Saint Gaudens. Who was he? Where did he get that splendid name? Where would his talent take him next?

Book II

THE YEARS OF GROWING FAME

16

WHAT WENT RIGHT AND
WHAT WENT WRONG

THE TIMING WAS PERFECT. America, in those piping days of the early 1880s, was looking for the fabulous, and the Farragut was one answer. It was a masterpiece in the old, medieval sense of the word: the creation by which an apprentice in a field qualified for the title of master. In the broader meaning that came to be accepted later, the statue also merited the label of masterpiece— a work of art "judged against a recognized system of acquired values" and not found wanting.[1]

Those values went back to the sculpture of Greece and Rome. Many critics saw in the Farragut some of the high clarity and detachment that the Greeks attained (as Maurice Bowra puts it) "by their avoidance of excessive realism or melodramatic display."[2] The man seemed to possess the Roman virtues of stoicism and virility so often celebrated in their bronze and marble. The calmness and total individuality of the Saint Gaudens figure reminded many commentators of early-Renaissance sculpture in general and Donatello's tranquil yet alert Saint George in particular. And, in the elegance of the modeling, they saw echoes of the Beaux-Arts style in which the sculptor had been so immersed.

What Americans liked most of all about the Farragut was that it was American. Certainly the statue had grandeur. But here also was a New World directness. Somehow the elegance was achieved without ostentation.

In the years leading up to the Admiral's statue, Augustus had been like a writer before his first novel. Just as a new writer serves notice by short story and article that he has the gift of words, there had been advance clues that a major talent was forming. His bas-reliefs were in effect his short stories. Now he had written an epic.

The repercussions in his public life were far-reaching. If failure and thwarted ambition manifest themselves in myriad ways, there is a pattern to success, and to the lives of the people who attain it, that has a remarkable sameness.

Like most avid seekers after fame, Saint Gaudens enjoyed it very much when it came, reacting to his sudden glory like a bird dog on a crisp October morning.

Commissions poured in. William H. Vanderbilt wanted a bas-relief of the old Commodore for his new house. Cornelius Vanderbilt, a favorite grandson of the late Commodore, ordered a bronze of his own two sons, and another of his seven-year-old daughter Gertrude, who later became a famous sculptor herself. German emigrant Ferdinand Heinrich Gustav Hilgard—now a railroad magnate and plain Henry Villard—had employed McKim, Mead and White to build him the finest palazzo in New York in the lot behind Saint Patrick's Cathedral. The architects, true to form, enlisted John La Farge to decorate the interior. And La Farge, also in character, came up with specific assignments for Saint Gaudens: a carved zodiac clock for the grand stair, an overmantel with crouching figures representing Joy, Hospitality, and Moderation for the dining room, and two indoor wall fountains with vertical fish for fonts.

Like the guildmaster he now was, Augustus farmed out much of the Villard work to brother Louis, to MacMonnies, Martiny, and other apprentices. Meanwhile, he himself worked along on the Morgan tomb and also modeled caryatids of Love and Peace to be sisters-in-spirit to the three Morgan angels. The marble caryatids were designed to support a mantel in the Cornelius Vanderbilt house. Today, after a wandering career during which they were separated from the mantel, and some years when they were missing completely, they are in the American Wing of the

Metropolitan Museum in New York, supportive again and as beautiful as ever.

He finished a small clay model of the Randall at long last and sent it along to a specialist to be enlarged to something over life size before casting. When this was done, Saint Gaudens asked Stanford White, La Farge, and Will Low, each on his own, to go and see how well the mostly mechanical process had been carried out. All three reported that the manliness and grace of the smaller model had been lost, and that they were convinced that even Augustus' skill in reworking surface could not restore them. Perforce the process was repeated, and this time the enlargement was more skillful. Three years later, finally, in 1884, the figure was cast and the project tottered to a solution. The privateer-philanthropist—freestanding and quite bold, but still without much fire in his belly—took his place on a lofty pedestal among the old sailors of Snug Harbor.

In the year of his new fame, Saint Gaudens embarked on what would turn out to be his longest assignment. This was the statue of Colonel Robert Gould Shaw, the young Massachusetts aristocrat who had been killed leading his regiment of black soldiers in a frontal attack on a Charleston fort eighteen years before. After the Civil War, a commission had been formed in Boston to honor his memory in some way, and fifteen thousand dollars was raised. But the project languished until H. H. Richardson persuaded the members to revive it, and to request Saint Gaudens to work out a proposal for a monument.

Richardson himself made a rough sketch of an equestrian figure under a curved canopy. Augustus, more than ready to try the horse-and-rider theme, which he felt was a challenge every sculptor should face, liked the idea. The family—especially Shaw's indomitable mother, who had inspired him to command black troops in the first place—objected. Brave as Shaw had been, noble as he undoubtedly was, they thought that the man-on-horseback motif should be reserved for chiefs of staff and army commanders. They found the treatment pretentious, and, on reconsidering, Richardson and Saint Gaudens agreed.

Deeply concerned now, Saint Gaudens cast about "for some

manner of reconciling my desire with their ideas."[3] He came up with the solution of associating Shaw directly with his troops in a bas-relief, and thereby reducing his importance. In the ensuing months and years, the rider became almost a statue in the round, and the marching men assumed an ever-greater importance.

The full story of the Shaw takes up a later chapter, for the ending came only in 1897. But a glimpse of Saint Gaudens and Richardson before the architect's early disappearance from the scene belongs here, in a discussion of this preliminary stage. Augustus had traveled to Boston to confer with his friend about the Shaw and other matters. As he had several times before, he dined with the Richardsons in their Brookline house. Gathered in the dining room with its blood-red walls were the architect, his charming wife, and several lively children. Richardson as usual wore his flamboyant yellow waistcoat and spoke with his spurting stammer. His greeting was familiar. "S-S-Saint Gaudens," he said, "ordinarily I lead a life of a-a-abstinence, but tonight I am going to b-b-break my rule to celebrate your visit, you come so rarely."

Although alcohol was forbidden, the same ritual was repeated on each Saint Gaudens visit: "He would thereupon order a magnum of champagne, which, as none of the family drank it, had to be finished by him and me. Unfortunately I am very moderate in such matters, and the result was the consumption of virtually the whole magnum by my good friend. . . . The proceeding doubtless occurred every night, as he always arranged to bring home a guest."[4]

After the Farragut unveiling, Gussie went back to her family in Roxbury. In July, she and Homer spent several weeks at a summer hotel in Cohasset. During August and September they were at Cornwall-on-Hudson, along with Gussie's mother. That December Augustus found a fine house for rent at 22 Washington Place, and early the next year the little family was reunited at last.

Meanwhile, like his career, Augustus' social life flourished.

Since 1877 he had been a member of the Tile Club, which met once a week in a basement room adjacent to a back courtyard on Tenth Street. Now he went there often. The thirty other members were mostly artists, and all men of talent. One of them liked to bake tiles and to try to copy on canvas the delicate colors that resulted—hence the club name. Members paid no dues, elected no officers, were guided by no bylaws. Each had a nickname: Elihu Vedder was "The Pagan," Francis Millet "The Bulgar," muralist Edwin A. Abbey "The Chestnut" (for his ability to tell stale tales with a straight face), and Augustus inevitably "The Saint." Tile members criticized one another's work with great candor, loved to dress up for Greco-Roman dinners, often took sketching trips. One of these, by barge up the Hudson and along the Erie Canal, was famous for its duration and high spirits. By 1887, after the manner of many similar clubs, the spontaneity had lessened, and the Tile Club began to peter out.

Augustus was elected to the Century Association in 1885. As a Centurian, he was one of some five hundred of the city's eminent men in art, architecture, literature, and science. "Everybody knew everyone else or, if they didn't, scraped acquaintance," editor Henry Holt remembered fifty-five years later, "and everybody was worth knowing."[5]

The clubhouse was a comfortable old building on Fifteenth Street, very like a Saint James Street club in London. In 1891 the move was made to elegant new quarters on Forty-third Street designed by McKim, Mead and White, all of whom were Century members.

The monthly buffet suppers were much relished. Between times only oysters, bread, and cheese were served, but an adventurous member could cook himself a rarebit. There was always some show in the club gallery, usually parodies of pictures and statues. Stunts abounded, from burlesque ballets to lampoons and satires. "The fun was simply colossal," Holt recalled wistfully. On a visit earlier in the club's history, William Makepeace Thackeray, a clubman of no little gregariousness, pronounced it the most enjoyable club in the world.

Another symptom of success both professional and social was Saint Gaudens' election in 1881 to the presidency of the Society of American Artists, which his own ire had fanned into life four years before. By the end of its first year, the Society had twenty-two members; by 1888 there were over a hundred. As early as its first exhibition, the splinter group established a jury system that ruled that the names of the competing artists were to be concealed during the judging. Old artists and new gained honest exposure. Some of the more familiar names selected for display were Winslow Homer, George Inness, Albert Pinkham Ryder, and John La Farge. New talent given prominence included Sargent, William Merritt Chase, Whistler, Eakins, and J. Alden Weir. Exhibits in 1879 and 1880 honored expatriates Mary Cassatt and Whistler, to make the point that Americans were not without honor abroad. (During the 1880s the Society began to close ranks again with the National Academy of Design, from which it had once so drastically broken off. Hotheads like Saint Gaudens had mostly simmered down and become famous. Some of the early vitality drained away, but the mission had been accomplished in good measure.)

Another, if rather backhanded, gauge of Saint Gaudens' sudden fame was Truman Bartlett's stepped-up campaign to slur and slang him. The reception of the Farragut had been so warm that Truman Bartlett decided that he and his friend Olin Warner had to have a first-hand look themselves. After studying it, they agreed that it was "mighty well done" and "came to the conclusion that if St. Gaudens [the only time in his autobiography that Bartlett spells the name right] had really executed the statue, he had done a piece of work better than anyone who knew him had ever expected."[6] The more Bartlett thought about the monument and its excellence, the more suspicious he became, especially when "Saint Guadens' limited time of study had been considered." Finally he wrote to his son Paul, who was serving an apprentice-ship as a sculptor in Paris, and asked him to make a few inquiries. "Young Bartlett wrote back that he knew the French sculptors, and gave their names, who had actually made the statue for St.

Guadens, and that it was well known gossip among all the sculptors in Paris . . . that the work of the Farragut was far better than anything St. Guadens could do."

Bartlett, whose own sculpting career was in limbo now, but who was making something of a name for himself in Boston as teacher and critic, poured out his hatred to anyone who would listen. With his small, bright, wide-set eyes and sharp, grizzled beard, the two tusks of teeth that didn't quite meet, and the combination of profanity and poetry in his speech, he enlivened the Boston scene. He was known to be a friend of Walt Whitman. A profile of Bartlett by a contemporary, Daniel Gregory Mason, shows that people were on to "his skittish zest for profanity and in the wildest exaggerations." With specific reference to his stalking of Saint Gaudens, Mason writes, "He would ride a prejudice with the same crusading ardor that less daring souls reserve for their convictions. . . . When he was in search of such a 'pure hate,' piddling considerations of reason did not embarrass him."[7]

Bartlett had heard that the Randall had encountered some rough weather. He went to Staten Island and questioned the superintendent of Snug Harbor there, who told him exactly what he wanted to hear: "The whole transaction had been altogether the most disgusting one that we have ever had to do with. . . . The Trustees of the Harbor decided that it was a rotten object and so rotten that they were glad to get through with it."[8]

In connection with this sample of Bartlett's gift for hyperbole, there is an interesting footnote. In 1983, when the Snug Harbor home moved to Charleston, the old sailors begged to have the Randall moved too. To satisfy their wish, a second bronze cast was made at the Talix Foundry in Peekskill. The original can still be seen among the superb classical buildings of the Staten Island establishment, now a center for the arts.

A much more positive symptom of Saint Gaudens' rise to fame was the growing admiration of his French friend and Fidus Achates, Paul Bion. This old colleague from the days in Jouffroy's atelier had been born into the world of French art, for his father, Louis-Eugène Bion, was a well-known sculptor (whose stone stat-

ues *The Genius of Medicine* and *The Genius of Philanthropy* still grace the Louvre courtyard). Since the Beaux-Arts, Paul Bion's own career had slid gently downhill. From time to time he did compete for salon honors, his final submission being in 1882 with a plaster cast of *Le Petit Capet*, the sad little Dauphin who failed to survive the Revolution. It gained him no award. From then on, for the last fifteen years of his bachelor life, he put his sharp French wit and his shrewd French critical spirit into letters to his American friend. His comments on the Paris world of salons and exhibits, almost all of which have come down to us, are always original, often biting, and sometimes quite prophetic.

Augustus answered just frequently enough to keep Bion writing. One of the few Saint Gaudens letters that have survived shows how much he actually did look forward to the Frenchman's bulletins. "It is said," the letter opened, "that with perseverance a man can bore through a mountain with a boiled carrot. So with the perseverance of your correspondence you have accomplished a miracle in turning me into a correspondent. . . . Now do you think it at all necessary for me to reply to your letter in which you express some doubt as to the wisdom of your criticism of what I am trying to do? Once for all, I say to you that your criticism is the apple of my eye." After dilating on this theme, Saint Gaudens summed it all up in his direct way: "Say not another word on that subject. Scold me and criticize me when you will."[9]

A typical sample of Bion's reporting is this letter on the Rodins in the 1882 Salon: "This year we have little *pâtés* of Rodin. Two busts. One represents the painter Paul Laurens. But it looks exactly like Joan of Arc, two peas in a pod. . . . I no longer see an artist who faces his subject and sincerely tells himself he will render it better than before. Instead I see a comedian who, having had success with certain gestures, renovates them and hopes for more of the same bravos."[10] For all his mockery Bion had a full awareness of Rodin's talent well before the career had really taken off: "Even in his aberrations it seems difficult for me not to declare Rodin a sculptor of character, and of exceptional quality."[11]

Bion had pungent views on painting as well as sculpture.

Here he is on a canvas of Gari Melchers, an American who spent some years in Holland: "The painting is solid enough, and that is also true of the fellows who are sailors in the North Sea. But it is very far from America, it is Flemish-German without the least relationship to the New World. This painting has drunk a lot of beer and smoked a lot of pipes."[12]

As the years passed, several new Bion themes emerged. One was a consistent urging that Augustus return to France to renew himself. The other was the Frenchman's increasingly perceptive commentary on Saint Gaudens' work, a healthy antidote to the adulation that lapped around his friend.

What went wrong? In sharp contrast to the growing public image and professional accomplishments came a sad falling-off in Augustus' life with Gussie. As early as 1880 there had been hints that all was not rose-colored. That summer before Homer was born, Gussie wrote teasingly from Roxbury of Augustus' future role of fatherhood and what changes there would be when she returned with babies and nurses in her entourage. Augustus, who had just hired a girl to pose for the bas-reliefs of *Courage* and *Loyalty*, answered good-naturedly enough with a seeming *non sequitur*: "Did I ever tell you what a lot of handsome female models there are here, far more than in Paris, and all of them have that rare thing—fine breasts."[13] The warning note is there.

Gussie was away for long periods, in part because of the death of her father. Mr. Homer died on Christmas Day 1880, and she spent a good deal of the time in the following year with her mother, both in Roxbury and on trips. At some point in early 1882 she finally did pick up her New York life again, and was able to share in Augustus' success, but the sculptor was beginning to chafe a little at domesticity. He and two friends fell into the habit of spending convivial evenings at a Broadway beer parlor not far from the Washington Square house. One friend was Francis Lathrop, the artist who had worked with him under Richardson. The other was Joseph Morrill Wells, a gifted young draftsman in the

McKim, Mead and White firm. Sharing a love of music, they enjoyed listening to the elderly, bald-headed violinist in the pub, whose talent was uneven but sometimes quite remarkable. His two accompanists gave less pleasure—a son who blew on a clarinet with no talent at all, and a pianist who was a "colorless banging performer."[14]

The upshot was that the three music lovers invited the violinist to come and play for them on Sundays in Saint Gaudens' studio, where the acoustics were excellent. By the fall of 1882 a club was formed and the well-known Standard Quartet engaged to replace the one violinist. Some forty friends, including artists and a scattering of millionaires, defrayed the expenses. Wells, who loved Beethoven, was the prime mover and picked the programs. Wells had a mordant wit. Three weeks before his death (of penumonia, in 1890) he turned down a McKim, Mead and White partnership, saying he had no wish to "sign his name to so much bad work."[15] His wit found expressions in the series of epigrams he jotted down. A fair sample: "To all great men who wish their littleness to remain hidden, my advice is: never sit for a bust or a portrait or build a house." Under Wells' sharpness lay a gentle nature, and he was much mourned. Attendance at the concerts, which continued more sporadically for some years, became an act of remembrance as well as comradeship.

In light of Gussie's deafness, the musical evenings at pub and studio seem unkind. But, along with the outings at the Tile Club and dining-in evenings at the Century, they became the order of the days off and the nights, with poor Gussie increasingly left on the sidelines. In June 1883 she went off to Nova Scotia with Homer and her mother. Her letters to Augustus show that she was low in health and spirits, but still very plucky: "Dr. Fitch comforts me by saying that I am making good progress and that I must expect to suffer until I am well. I shall try to say as little as I can about it as it is useless mouthing you."[16] Homer she found a "great comfort and pleasure" but "almost beyond managing."

In August, Augustus took a leisurely trip west with Stanford White, the main purpose being to visit White's brother, a mining

engineer in the New Mexico territory. Having observed the wreck of McKim's marriage and what he considered the near disaster of Saint Gaudens', White had remained a bachelor, often protesting, "You no catchee me marry." But now, on the train west, he told Saint Gaudens that he had been courting Miss Bessie Smith for three years and that he had just become engaged. She was, he went on, the thirteenth and youngest child of Judge Lawrence "Bull" Smith of Smithtown, Long Island. The nickname, White further explained, came from the fact that the original Smith grant was for land that could be circumnavigated by a man on a bull in a day.

Writing to Bessie Smith somewhere between St. Louis and Kansas City, White described how his friend Augustus took the news. "I have been telling St. Gaudens the reason for my idiotic smiles and that my troubles are all over; to which he answered after a preliminary dance around the car—that 'au contraire' they had just begun. He is a brute, is he not? But I consoled myself with the thought that thou, my sweetheart, were somewhat different from his cross-grained clothes rack of a frau." White showed Augustus a picture of Bessie, whom he had seen only once, and Augustus "pronounced you 'very very lovely' and then said he was glad I would be myself again: that I had been cross and moody and ill-mannered and unbearable for the last three years. . ."[17]

The high point of the Western adventure was a sixty-mile ride in a stagecoach with a drunken driver. Somewhere between Chloride and Engle, New Mexico, Saint Gaudens climbed to the top of the stage to see why they were careening along at so crazy a pace. In a letter to Bessie, White describes what happened next: "The driver falls into the boot after depositing the reins in St. Gaudens' hands, and St. Gaudens who had never driven in his life is master of the situation with four lively steeds on his hands and half the prairie to cover. But he did it noble and brought us in half an hour ahead of time."[18]

They also traveled to San Francisco and Tacoma, where White had business to do with Mr. Villard. Villard was touring his Northern Pacific Railroad with "a collection of English and Yarman

[German] Dukes and Contessas and High Cockalorums gener-ally," who bored Saint Gaudens to distraction.[19]

During the trip, Gussie wrote long, dutiful letters, sometimes as many as three a day, to different addresses, hoping to catch him on the wing. Toward the end they grew somewhat barbed. For instance: "Shall I direct letters to the *Palmer House* in Chicago or simply to Chicago?"[20] And, in the same August 23 letter, "Aren't you pretty tired with your journey about now?"

At their Chicago stop on the homeward lap, Augustus met by arrangement with some men who interested him more than Mr. Villard's High Cockalorums. These men were members of a committee that was deciding what to do with a bequest of forty thousand dollars in the will of a Chicago businessman named Eli Bates. He had stipulated that the money be used for a statue of Abraham Lincoln. To Augustus, this was the chance of chances, and the greatest challenge yet.

17

THE BEAUTIFUL
OBSESSION

The needle's eye
That doth supply
The thread that runs so true.

—American folk song

THE DECLINE IN CANDOR in the Saint Gaudens memoirs is not sudden but gradual. For a time after the Farragut unveiling, the tone stays the same, and the commissions that began to pour in, the friendships with Stanford White and others, and all the matters dealing with the building of a public image, are adequately covered. But slowly a cone of silence seems to lower itself over anything even remotely concerned with the sculptor's private life: *The Reminiscences of Augustus Saint Gaudens* become *The Reticences of*. There are amusing anecdotes, told with a flourish; hearty, old-boy letters to his many friends and good, solid accounts of how most of the major works came into being. But he seems more and more like someone talking about surface matters because silence would be embarrassing. . . .

Just before Gussie, Homer, and niece Rose Nichols closed ranks around Augustus, the sculptor wrote a fragment of his story in very rough draft. Here he was more explicit than in the pub-

lished version about *why* he did not choose to be more revealing: "All manner of considerations spicy as a rule bar the way vexatiously."[1] His watchful family trio changed "spicy as a rule" to "conventional and otherwise."[2]

In the fragment, Saint Gaudens also made it clear that he had no intention of communicating any real insights about his profession. This entry, which survived almost intact, helps to explain some of the blandness of the finished product: "If the reader hopes to find theories or dissertations on art and on the production of artists, it would be well to close the book at once, there is nothing of that in the pages."[3] This omission was rectified by Homer, who supplied skillful selections from his father's conversations about art, and from his letters.

Some time in the early 1880s, probably in 1881, Augustus Saint Gaudens fell in love with a beautiful model whose name was Albertina Hulgren or Hultgren. He called her Davida, presumably because of his admiration for Michelangelo's *David*. For a time she used the surname of Johnson, and then took to calling herself Davida Johnson Clark. On her recently discovered death certificate, dated September 15, 1910, she was identified as Davida J. Clark; her date of birth was given as December 30, 1861, and place of birth Sweden, which was also listed as the birthplace of both parents. Her occupation was "housewife" and marital status "widow," although she was in truth never either wife or widow. Louis P. Clark attested to the facts of the certificate but was not identified as her son.

The basic documentation about Davida's life can be found in an interview with Frances Grimes, Augustus' assistant and last confidante. The interview took place in June 1962, almost fifty-five years after the sculptor's death. Grimes was a talented young artist who first came to Cornish in 1894 to spend the summer with Herbert Adams and his wife, Adeline, of the Saint Gaudens entourage there. Grimes became an assistant to Augustus in 1901. Gentle and ladylike, she enjoyed the confidence of both Augustus and Gussie. She died the year after the interview.

Under skillful questioning and with great reluctance, she

lifted a corner of the curtain concealing Saint Gaudens' inner life. Her questioner was James Farley, a diligent Cornish-based news-paperman whose special subject at the time was the sculptor and his world. In the early part of the interview, they circle around the gaudy life of Stanford White. Grimes hints that there was some cooling of Augustus' friendship with the architect because of the way White flaunted his indiscretions. Farley then steers the line of questioning thus:

"But several people have spoken to me and intimated that Saint Gaudens [too] had interests outside his home."

GRIMES: "Oh, yes, he did. I'd rather not go into that. I don't think one needs to."

Farley tries to persuade Grimes to talk by pointing out to her that it is important for readers to get a picture of the complete man, that times have changed on such matters, and that, after all, it all happened a long time ago. Then he moves in again.

FARLEY: "I gather he had a separate ménage at one time?"

GRIMES: "Yes, he did." Further questions bring out a few more reluctant facts. She has no exact knowledge of when the affair began, but guesses it must have been in New York. She did know that the girl was very beautiful and that Saint Gaudens was "madly in love with her." It was generally believed that he had set her up in a house in Connecticut.

FARLEY: "Did Mrs. Saint Gaudens know about this?"

GRIMES: "Oh, she knew everything. Not because he told her, but she just found out."

FARLEY: "How did she react?"

GRIMES: "She said he was a Frenchman."

Grimes goes on to explain that Saint Gaudens would say he had to go to New York and that then, as often as possible, he would stay in Connecticut as much as a week at a time. This was still going on when Grimes first came to work for the sculptor. It ended when he became so ill he could no longer visit—"toward the last, for fully a year."

Finally, Grimes identifies the mistress as "Mrs. Clark" and recalls that they had a son, Louis. She says he came to Cornish

once after his father's death and, in some bitterness, quickly went away again. Now her views on the sculptor's way of life begin to come out:

GRIMES: "He was very amorous. He had a great many love affairs, not awfully serious for him. But he was partial to women. . . . For them they [the affairs] were serious."

FARLEY: "But he must have been serious in setting up a separate household?"

GRIMES: "I don't know of another case of anything like that. He had affairs all the time. Mrs. Saint G was well aware of this. They didn't live together. Mrs. Saint G confided in me a great deal and at one time she told me that they had not lived together since Homer was a little boy."

Grimes explains how pride and other things contributed to Gussie's decision to maintain the home. Of course, divorce wasn't so common then: "What would she have done, where would she have gone?" At that point Grimes relapses into her fears that she should not be talking as she is. Farley, very reassuring, reminds her of the importance of seeing the man warts and all.

GRIMES: "Oh, he had enough of those. He had frailties. He behaved badly as far as women are concerned, I think. In fact he said something like that to me—that he had behaved badly."

Farley wonders again whether Saint Gaudens and Stanford White were not really quite alike, and whether it would not have been difficult for Augustus to disapprove of White's flagrancies.

GRIMES (very quickly): "Oh, he disapproved very much of the kind of things White did. I think Saint Gaudens had deep feelings about his affairs."

FARLEY: "As long as they lasted."

Before they move on to other matters, Grimes makes the point again that Saint Gaudens' approach was *always* a romantic one.[4]

The love story of Augustus and Davida is the Pygmalion-Galatea myth in reverse. In the classical legend, the sculptor-king falls in

love with the ivory statue he has made. He prays to Venus that she be given life, and the prayer is granted. In one version of the myth, Galatea has a daughter who inherits one of the kingdoms of the earth.

In the real-life version, Davida, the flesh-and-blood girl, came *before* the statue. Augustus, the king of sculptors, fell in love with her and then in effect turned her into stone, capturing her beauty in his works. She produced a son, but he inherited no kingdom.

Long before Saint Gaudens actually met Davida, he had been searching for her. His dream of fair women never varied much. His own mother of the long, beautiful Irish face established the ideal. Angelina, the model in Rome with whom he had a brief affair, was an early answer to the quest. From the features of the figure of *Silence* for which she posed, we have a good idea of what Angelina looked like. The high forehead, the handsome Greek nose, the lids like veils, and the lithe, Amazonian body would all recur in the sculptor's works—and in his loves.

Gussie possessed some of the desired characteristics before illness, ever-increasing deafness, and hypochondria aged her. Then, in 1881, Davida started to model for the figure of the Morgan angels. The sculptor had found his beautiful obsession.

From that time on, certain traits appeared in all the idealized women in his sculpture. One such trait is a slight tilt of the head, sometimes to the left, but more often to the right. This lends enchantment, creating an effect of wonder and mystery. There are two other characteristics, first seen in the central Morgan angel, and to a lesser degree in her two sister-angels: the lips are merrier than in the *Silence*, and the nose is more delicate.

The central Morgan figure is the benchmark. She holds a long slender Scroll of Life in her extended hands. Her eyes are lowered as if she were reading the scroll. Her head is just slightly tilted, chin to the left, for that wondering effect.

Unfortunately, all that has survived of the Morgan group is a rough plaster sketch. The finished plaster cast was indeed made, and shipped to the Cedar Hill Cemetery in Hartford for conver-

sion into marble. But the shed protecting the work-in-progress burned; both casts and embryonic marble were damaged beyond repair.

Even in their rough state, the Morgan angels do suffice to establish the link to Davida. Another bit of evidence is the pair of caryatids for the Vanderbilt mantelpiece. Modeled at about the same time, they also have the charming turn and tilt of the head.

The most convincing link of all is the study in plaster that Saint Gaudens made for the head of his famous *Diana* in 1886. (When completed, the statue would ride the winds atop Stanford White's Madison Square Garden and become the best-known weathervane in the world.) Among the illustrations there is a photograph of this study placed beside one of the few known photographs of Davida Clark. Study it well. The conclusion seems inescapable. Here is Davida to the life, though the eye of the enraptured sculptor has added some loveliness. There is beauty in the eye of the beholden.

Finding explicit evidence of what Davida was like presents certain problems. There is not a single mention of her existence in the *Reminiscences*. Nor did Will Low, Maitland Armstrong, Richard Watson Gilder, or other boon companions of the sculptor mention her in their books or letters. As I explained in the Preface, two sons of Louis Clark destroyed Saint Gaudens' letters to their grandmother without even looking at them. The multitudinous correspondence of McKim and of Stanford White, the closest intimates, made no reference to her.

We have to go further afield and dig deeper, not just for the real Davida, but for Davida at all.

In sifting through the not very voluminous material, the researcher must play the role of the needle's eye in the old folk song—"the needle's eye that doth supply the thread that runs so true." He must control, and never lose sight of, an awareness of the sculptor's love for the Swedish model, the slender thread that runs through twenty-five crowded years.

One bit of evidence concerns the first mention of Davida in written form, which came in the shape of a copy of Keats' *Lamia*, illustrated by Will Low.[5] The book was inscribed: "To Davida Johnson with the best wishes of Will H. Low, Christmas, 1885." It has come down through the family to June Clark Moore and her daughter Valerie Saint Gaudens of San Diego. (Mrs. Moore's first husband was Louis Paul Clark, son of Louis. Valerie, who is a jewelry designer and sculptor, has taken her great-grandfather's name.)

On page 2 of the *Lamia* is a drawing of a woman's head in profile that is startlingly like Davida. None of the other illustrations in the book bears the slightest resemblance to her.

June Clark Moore and Valerie Saint Gaudens also have in their possession another family heirloom, an unsigned drawing of a seated woman in much the same pose as the head on page 2 of the *Lamia*. It is almost certainly Davida and probably the work of Will Low. Under the chair is a cryptic notation consisting of two letters in lower case and a numeral. Turned rightside up they read: "o p.2."

Conjecture: After using Davida to sit for the one chaste head, Low shifted to someone else for the many partially draped poses in the book. Knowing that his good friend Saint Gaudens was a jealous and hot-tempered man, he may well have decided that discretion was the better part of valor. The obscure entry under the chair is his way of acknowledging her brief contribution.

A further clue about Davida came in 1886, when Saint Gaudens was creating another of his angelic women. This figure was for the tomb of Anna Maria Smith in Newport. The delicate modeling is indelibly Augustus' own; the features and the tilt of the head are Davida's. Yet the signature on the tomb, still visible today, is "Louis St. Gaudens."

Conjecture: This was still fairly early in Saint Gaudens' affair with Davida, and Gussie was as yet ignorant of the liaison. Augustus may well have been simply covering his tracks.[6]

Augustus Saint Gaudens' French friend Paul Bion was aware that there was such a person as Davida. One Christmas he sent

her son an ivory carving with the injunction: "Monsieur petit Louis receive this plaything and continue to be a very good child obedient to your mother."[7]

One of the Bion letters made it clear that at a certain point Augustus was strongly attracted to the Mormon religion. The letter of July 20, 1886, assumed jokingly that he has converted: "What, you, Saint Gaudens, you have become a Mormon! You are sharing yourself with a lot of women! From now on when you are asked for news about Mrs. Saint Gaudens, you will have to ask which one. No. 3, No. 7, No. 12??? But you are not a Mormon. A real relief . . . Thank God!"[8]

Conjecture: In his French fashion, Bion was well aware that Saint Gaudens was something of a philanderer. But my guess is that at the time of this letter Augustus' desire was not for many women, but for one. He wanted to make an honest woman of Davida but did not quite know how to do so without irreparably hurting Gussie. Hence Augustus' Mormon fixation, which Bion commented on often.

Another fragment that has survived helps to establish where Davida lived in New York, and the date she moved to Connecticut. This is a note in Saint Gaudens' handwriting addressed to the Kate Field Company in Washington, D.C., which reads as follows: "Kindly send the 'Washington' to D. Clark, Noroton Heights, Conn. in the future instead of to 143 West 45th Street New York City as heretofore (signed) A. Saint Gaudens."[9] The *Washington* was a lively if short-lived publication dealing with politics and the arts.

One day a similar shard of evidence was discovered in a musty file in the Library of Congress. The file was an official one dealing with the World's Columbian Exposition, which took place in Chicago in 1893. Out of it fluttered a handwritten telegram in handwriting that is almost surely Augustus' own: "TO D. CLARK PERSONAL NOROTON CONNECTICUT I WILL GO TO NOROTON ON THE 6 PM TRAIN TUESDAY GUS."[10]

Conjecture: Although there is no date, the telegram was sent some time in 1892, when Saint Gaudens was acting as chief sculp-

tural adviser to the fair. The train referred to is the commuter he normally took from New York.

Several existing photographs show the house in Connecticut as a pleasant three-story clapboard affair with a front porch and some land. One of the two colored drawings made by Augustus that have survived is a crayon showing a boy of six or so playing with his rocking horse on the vine-framed porch.[11]

Conjecture: One has a glimpse of long summer days, and time perhaps hanging a little heavy, like the vines.

One other hard fact does emerge. In 1893 Saint Gaudens was negotiating a new contract for the *Garfield Monument* in Philadelphia. The original had called for a standing figure; now the agreement was for a heroic bust of the martyred President, guarded by a female figure of the Republic. The sculptor sent Davida, along with one of his assistants named Charles Keck, to sign the new document; her signature, a rather childishly scribbled "D. Clark," is a matter of record.[12]

Conjecture: Although Augustus' possessiveness cut Davida off from much of her old life, this was an attempt, like sending her the gossipy *Washington* magazine, to divert her.

The Garfield, unveiled in 1896, gives us some guidelines on Davida's appearance fifteen years or so after she and the sculptor first met. The idealized figure of the Republic is a noble one, a guardian angel without wings. The gaze is resolute. Some of the enchantment is gone, and the tilt of the head is barely apparent. But there is a grave beauty still.

Here she is, cloaked in the immortality that bronze imparts, looking the way she surely did more than halfway down the nights and days and long years of their love.

18

THE HARDENING
OF THE MOLD

"Develop technique . . . and then hide it."

—Augustus Saint Gaudens

THE ACCELERATED PACE of the 1880s was quite astonishing. Thomas Alva Edison demonstrated his incandescent lamp in public for the first time in 1879. That same year there were exactly 252 of Alexander Graham Bell's new-fangled telephones in all New York. By 1885 so many electric cables and telephone lines crisscrossed the streets that the city looked as if it were being held up by a wire mesh.

An ordinance was quickly put into effect ruling that all such surface wires were to run underground. Three years later—with some help from the devastating Blizzard of '88—no wire or cable could be seen.

In the mid-eighties the graceful spire of Trinity Church still dominated the cityscape. Then, in 1888, the first office building of steel-skeleton construction went up. Soon the Trinity spire had disappeared, dwarfed by the new "skyline."

Saint Gaudens' own rise was one more acceleration. In early 1881, before the Farragut, he was just another young sculptor struggling for recognition. By the mid-eighties he was a towering

figure in the world of art. "No art exhibition could be held in the United States unless he was a member," Truman Bartlett noted in bitter resignation, "and no monument could be erected unless he chose the author."[1]

Especially galling to Bartlett was Saint Gaudens' role in the competition for a statue of abolitionist William Lloyd Garrison. The time was January 1883. Augustus traveled to Boston at the request of the selection commission to view the various sketches that had been submitted. One of the competitors was Olin Warner, whom Bartlett considered a far more gifted sculptor than his enemy. "Think of St. Guadens judging Warner—ye Gods!" was his anguished comment.[2] Yet even though Warner won, Bartlett remained unappeased.

Back in 1873 we saw Augustus meekly writing to see if a Farragut competition was still open. Just over a decade later, when he was asked to submit an entry for a Lafayette statue for Washington, D.C., "he thanked the commission having in charge the proposed monument, for the honor conferred by the invitation to furnish a model . . . but stated that if the same proposal had been made to other sculptors he must decline the honor."[3] His position was quickly made known. For the next twenty years, many of the top projects were offered to him first, and his own terms and conditions were usually accepted.

The year 1884 was a time of more undertakings than completions but it did mark a certain hardening of the mold of Augustus' way of life. The pattern that began to emerge would remain in large degree the same until he pulled up his American stakes for Paris in 1897.

The first big happening was Stanford White's wedding to Bessie Smith. There were many festivities. Saint Gaudens threw himself into the arrangements for the bachelor dinner, which took place at Martinelli's five days before the wedding. The menu, which he designed, included a dozen cartoons of the bridegroom: White struggling through an after-dinner speech, White pulling

on his huge mustache, and, best of all, the mustache by itself yet unmistakably White. The dinner at the fashionable Fifth Avenue restaurant ended with a Spanish dance by Loyall Farragut and another of the guests, which only ended "when they had entangled themselves and everyone else in long wreaths of smilax."[4]

As his present to the couple, Saint Gaudens designed a bas-relief of the bride, and White himself contributed an elegant frame. Bessie holds some flowers in her left hand while her right hand parts the wedding veil, so that her fair, tranquil face is shown in full. Later, after tragedy came, some saw a portent in the slightly hesitant gesture of the right hand and its resemblance to the equivocal hand in the *Adams Monument*. Whether or not the sculptor was expressing any premonition, it is a beautiful work, showing Augustus' use of the bas-relief for purposes of love and friendship rather than as a commercial undertaking.

The pattern of the Saint Gaudenses' extended separations, which had started with Gussie's stay in Nova Scotia in 1883, began anew. The time apart was again more than four months—June through mid-October 1884—and once more Gussie, Homer, Gussie's mother, and Homer's nurse went to Halifax—with Gussie's everlasting ill-health as the familiar reason for the length of the holiday.

They still wrote frequently. Gussie often sent letters daily, and she became very upset if Augustus allowed too much time to pass before answering. His letters were replete with a sense of duty—he was overapologetic when he had been remiss about writing—but the only eloquence was the eloquence of omission concerning his secret life.

What does come through very clearly is his pleasure in their new home on Washington Place. Running east from Washington Square, the Place itself is a pleasant cobbled street, with broad sidewalks lined with shade trees at their outer edges. The row houses are red brick with high steps, cast-iron railings, and white Ionic doorways. Some are three-story, some four. Until his death in 1877 Commodore Vanderbilt lived at number 10. Henry James senior, father of the novelist, occupied number 27.

One wonders how Bernard Saint Gaudens, shoemaker and gusty extrovert, adjusted to his son's rise in the world. One glimpse in the memoirs is quite revealing. A few nights after the Farragut unveiling, Augustus and Gussie were wandering down Fifth Avenue after an evening at the Gilders'. They saw an old man standing bareheaded before the statue of the Admiral. "Why, that's Father," said Augustus, and then: "Father, what are you doing here at this hour?"

"Oh, you go about your business!" was the answer. "Haven't I a right to be here?" And they left him standing in the moonlight. . . .[5]

We know that Bernard was always welcome at the studio. René de Quélin, one of the assistants there in the early eighties, was very much aware of "the strong family ties of affection existing between himself [Saint Gaudens], his brothers and his father."[6] Louis, of course, was working at the studio. But "Père St. Gaudens made frequent visits, as did a brother—long since deceased— who was then engaged in a commercial pursuit." (That was Andrew, who designed in porcelain and died in 1891.) "Many little incidents brought out the beauty and sincerity of their devoted attachment for each other: the loving care and tender solicitude the brothers showed their venerable father and his great pride in each of his sons." De Quélin, a newcomer to the United States, had known Saint Gaudens slightly in France. He produced a good deal of the decorative work for the Cornelius Vanderbilt mansion. Writing forty years later, he particularly remembers Augustus' "generous, noble, and poetic spirit" and the "sudden bursts of brilliant sunshine and as sudden storms" which characterized his mercurial temperament.

It is not difficult to surmise that Gussie made Bernard uneasy, and that he avoided the house. The freer atmosphere of the studio was like old times. Bernard had married again, but there is no mention of this second wife in the *Reminiscences*.

As he grew old and infirm, Bernard's thoughts and conversation turned more and more to Aspet and the Pyrenees. His great wish was to see them once again. Some time in the late

1880s Augustus paid for the sentimental journey. He arranged for a cousin to meet Bernard in Bordeaux and escort him to his native village. "He will stay as long as he cares to," Augustus reported to Gussie, "and a desire of his life will be satisfied."[7]

The next recorded event in '84 was the whole sad business of the destruction of the Morgan angels. The fire took place on the night of August 26. "The shed around the Morgan group was burned down and my whole work is an utter and absolute ruin," he lamented in his letter to Gussie.[8] The wording in this letter shows that foul play was suspected. Some people thought that the incendiary might have been someone who bore Augustus a grudge. Frederick MacMonnies, who went to Paris shortly after the disaster, reported to Paul Bion that "the fire was set . . . by enemies of Morgan."[9] Knowing the endless work his friend had put into the three angels, Bion added his own commiserations: "What a terrible experience!"

Dilating on the episode to his friend William Dean Howells, Mark Twain, Hartford's world citizen, was sympathetic but caustic: "I suppose you heard how a marble monument in which Saint Gaudens was pecuniarily responsible burned down in Hartford the other day uninsured—for who in the world would ever think of insuring a marble shaft in a cemetery against a fire?—and left Saint Gaudens out of pocket $15,000."[10]

Relief came in the rhomboid shape of Charles Cotesworth Beaman, New York lawyer and bon vivant who had married Senator Evarts' daughter Harriet. Beaman, who liked artists and the atmosphere of Bohemia, had taken an interest in Saint Gaudens when the two had first met in Rome. Now he offered to negotiate with the executors of the Morgan estate, the Governor having died in 1883. Augustus accepted the offer with alacrity, and the executors rather grudgingly agreed to pay the sculptor thirty-five hundred dollars. This covered bare expenses but was small consolation for the pride and caring that had gone into the work.

The only good to come out of the whole episode was that the central angel of the Morgan group lived again in many idealized

figures, perennially modeled by Davida. The most celebrated achievement was the *Amor Caritas*, the angel named for the legend on the tablet she bears. Her raised arms support it high over her head, and stylized wings envelop it. She wears a long robe gathered at the waist by a garland of passion flowers. A crown of flowers complements the garland. There is a good deal of the Renaissance in the graceful figure, much that is Art Nouveau in the freedom of the composition—and a romantic lightness and elegance that are Saint Gaudens' very own.

The original eight-foot bronze was bought by the French government in 1898 and placed on display in the Luxembourg. It is now in the Louvre. A smaller (forty-inch) version has been reproduced many times.

The *Amor Caritas* in its various manifestations was a catalyst during a period when "a traditional aesthetic was giving way to a modern aestheticism."[11] The aesthetic headed for the dustbin was of an art based on Victorian morality in narrative form. All the old accepted virtues were coming into question. In painting this led to "Art for Art's Sake"—to viewing paint itself and the way it was put on as a virtue. American Impressionism, lasting long after the French precursor had splintered, and Art Nouveau were two manifestations.

In sculpture the new aestheticism induced a loosening of the guidelines, a broadening of inspiration. Special affinities began to develop—to the Quattrocento and the Renaissance, to ancient Greece and to Japan. "Americans explored the past and the distant with fresh relish and avidity."[12]

Saint Gaudens was developing a touch that was unmistakably his own. The French call it *la patte*—literally, "the paw." More to the point, it is the mark or brand that a man or woman puts on a work. Call it the bravura quality, the panache, if you will. Franz Hals had it in every stroke of the brush. John Singer Sargent was developing it at about the same time that Saint Gaudens was. In writing, it is what Hemingway possessed so indelibly and what made Scott Fitzgerald say that people would read his words like braille after he was gone, knowing they were his by the way they rose and fell. (We know now from the endless lists and notes that

he was forever compiling that Fitzgerald toiled ceaselessly at his silver sentences.)

As time went on Saint Gaudens, the perfectionist, took more and more time to reach the point where he was satisfied. Fitzgerald and Saint Gaudens exemplify the same axiom. The swift and the bold are not always achieved at speed. The born quality is the ability to know when the desired effect *has* been achieved.

A definite element of this panache is being sure enough of one's own gifts to borrow freely. It is almost like being in love, for it is a condition when everything seems *relevant*. In the crouch of a street cat one sees Blake's "tyger burning bright." A muddy brook in a rainstorm seethes with the foam of perilous seas.

In subject matter, Augustus was beginning to veer away from portrait statues and bas-reliefs, which were the novels and short stories of his works. His search was more and more for the meaning of life and the probings of the mysteries of the hereafter. Ultimately, this larger quest would absorb him completely; for a while, however, the twin strands would run side by side.

Two major projects, already much thought over and sketched in rough, would be formally undertaken in 1884. On February 23 he signed the contract for the *Shaw Memorial*. On November 14 agreement on the terms for the Lincoln was reached. Elapsed time for the completion of the Shaw would be fourteen years. On a rainy day in October 1887, in record time for a Saint Gaudens production of such magnitude, the Lincoln would be unveiled.

The year 1884 itself sped quickly. The Whites came back from their European honeymoon in September. The following month, Gussie and Homer were home at last, and Gussie took up her brisk, rather brusque running of Washington Place. White spent what leisure he had in the fall trying to make Augustus into a club man (he himself belonged to ten). Augustus, meanwhile, was discovering that he really preferred small, intimate dinners or a spot of music at the local.

He was content enough: with the challenging days at the studio, with the club life and the pub life, with the negotiations for the big commissions, and the time-consuming committees.

And Davida.

19

THE LAND OF LINCOLN-SHAPED MEN

The mountains are all hid in mist;
The valley is like amethyst;
The poplar leaves they turn and twist;
Oh, silver, silver green!

—Henry H. Knibbs,
"Out There Somewhere"

MOST OF THE OPEN PASTURES are gone now, for the forest is reclaiming the land. The wooded areas of oak and maple and birch—the old forest and the new—are very dense. In the protected gullies the white pines stand tall and straight.

The thickening process in the fields began toward the end of the last century, when many of the farmers moved away. Some went to the big cities, some to broader acres in the Midwest. Since few of the summer people who bought them out chose to farm the land, the process was quite rapid, for an unmown, ungrazed field can disappear in two or three years.

Along the Connecticut River there are still rich meadows, but the river itself, dammed upstream to prevent flooding, no longer runs as wild and free as it once did.

Mount Ascutney has changed least of anything since Augustus Saint Gaudens' day. It rises a moderate three thousand feet above

the river bed. But if you climb one of the satellite hills on the New Hampshire side and look back across, you will realize how splendidly its north-south ridge leads the eye upward to the summit, and how nobly the mountain commands its valley.

There is no comparable land nearby. North to Hanover, the terrain flattens out. West of Mount Ascutney, the pastures are open enough but rather barren, and the trees grow sparse. To the south, the river seems to lose its purpose a little, and the soil of the adjacent fields is sandy. To the east, there are miles of scrub pine and low bush.[1]

The Cornish colony is a town only in the regional sense of being a township. It is really a scattering of houses over many acres. Legally, the New Hampshire colony, like the state, is bounded to the west by the thread of the river. But in a more human way it is linked to the handsome Vermont town of Windsor by a covered bridge which may well be the longest in the land.

Ascutney is another link. For, like Etna and Fujiyama, it is a sacred mountain with a volcanic cone. The townfolk of Windsor and the one-time cityfolk of Cornish hold it in love, and some awe.

Augustus' rather formidable patron from Roman days, William Maxwell Evarts, was a native of Windsor. In true *grand seigneur* style he owned a good deal of land along the river north of the town. One of the fine houses in the Evarts enclave in Windsor itself was called The White House, just possibly reflecting Evarts' ambition. When his tour as Secretary of State ended in 1881, he took up his New York law practice again, and then, four years later, he began his term as Senator.

Charles Cotesworth Beaman matched his father-in-law's holdings with a steady acquisition of land on the Cornish side. He too owned a cluster of houses: he put three of them together to form a rambling mansion called "Blow-Me-Down," which sat very well on a plateau above the river and took its name from the

brook that flows into the Connecticut just north of the plateau.

The intriguing name needs some explanation, for it will crop up again in our story. Back in the 1770s, the white pine of the region was in demand for masts for the Royal Navy. Up the unnamed brook were good stands of pine. Someone in the party surveying the area noted the resemblance of the contours to Cape Blomidon in Nova Scotia, and approximated the name. An alternate version is that "Blow-Me-Down" was a chantey that the lumbermen sang as they sent the logs surging downstream, or wrestled with them in the turbulence.

Back in New York in 1875, Beaman and Saint Gaudens had picked up their Roman acquaintanceship, and Beaman became the lawyer for both Augustus and Stanford White. Now, ten years later, it suited him very well to urge the celebrated sculptor to become a charter member of the art colony he was organizing on his thousand acres. Having advised Augustus on the newly signed contract for the Lincoln, he was aware that he was looking for tall men to model for it. "Come on up to Cornish and have a look," Beaman urged. "I can promise you many Lincoln-shaped men."[2]

Saint Gaudens' love of nature was never excessive. True, the hill-beyond-the-hill had called to him since that day in Staten Island when he was very young. But he never felt any great inclination to trudge over every intervening hill. Maitland Armstrong confirmed this in his memory of a visit his friend had paid to the Armstrong family place up the Hudson from Newburg: "My father forced Saint Gaudens to climb to the top and admire the broad view down the river. . . . Saint Gaudens who didn't much care for exercise retaliated by telling of a Frenchman forced into a similar expedition who replied to the question whether he didn't love the beauties of nature, '*Moi, je les abhorre!*' "[3]

There were, however, several good reasons why Beaman's proposal was intriguing. Augustus liked Beaman, who was as merry and easy as his father-in-law, Senator Evarts, was imposing. Also, the sending of wives and children to seashore or mountains to escape the swelter of New York in summer was a recognized part of the pattern of the world in which he now moved. He had been

looking for a suitable place. Most of the resorts, like Newport and the Berkshires, seemed a little formal for his taste.

In all probability, he also wanted any time he could spare to pursue his still-secret affair with Davida. The distance from New York to Cornish was nine hours by train. You couldn't just pop up and back for weekends, the way the summer commuters to Long Island and the Jersey shore did. He would be able to live two lives without maintaining too frantic a pace.

In any event, Augustus and Gussie went up to Cornish in April 1885 to see what Beaman had in mind. This turned out to be a one-time tavern called Huggins' Folly on a highway that never quite got built. The tavern had deteriorated into a brothel and was now empty. On the dark, rainy day when they first saw it, Augustus thought it "so forbidding and relentless that one might have imagined a skeleton half-hanging out the window, shrieking and dangling in the gale."[4] He further recalls that he "was all for fleeing at once and returning to my beloved sidewalks of New York."

Gussie had other ideas. Glimpsing Ascutney through the driving rain, she visualized what a fine fair view it would make on a sunny day. She saw that the ramshackle house had possibilities. The brick was sound, and there were several good mantels. The big barn would convert into an excellent studio.

They negotiated. Beaman, who adjusted his prices to what he thought his artistic friends could afford, said they could have it for five hundred dollars. This still seemed like a lot, but finally an agreement was worked out: they would pay a nominal rent for as long as they wished, and have a free rein in making the house livable and workable.

They re-named it Aspet. Then, with the help of architect friends, including Stanford White, they lifted the face of the old tavern and manicured the grounds. A porch with white pillars was added to the west, where the view was. Classic pergolas like outdoor rooms reached out to the gardens and helped the house to hunker down in its own turf. Wide flower beds and an elaborate fence with Greek heads along it gave a Continental look. Someone

said that the house now looked like a New England old maid struggling in the arms of a satyr. The Saint Gaudenses' friend Edward Simmons thought it was more like "an upright New England farmer with a new set of false teeth."[5]

By early summer the hundred-year-old barn had been made ready to serve as a studio. Saint Gaudens brought three of his ablest assistants to Cornish to help him with the preliminary clay sketches for the Lincoln: his brother Louis, Swiss-born Philip Martiny, and Frederick MacMonnies, whom most people called Willie. Under the direction of the master they experimented with every possible pose. The main point at issue was whether to portray Lincoln as the Head of State (seated) or the Man (standing), and they all finally agreed on the latter.

As Charles Beaman had predicted, they quickly found the perfect model for the figure of Lincoln, a man named Langdon Morse, known as "Deacon," who lived in Windsor. Angular, with powerful shoulders, he stood six feet four, the President's exact height. One story in local Cornish lore shows that he and Augustus were soon on easy terms. Driving along in his two-seated phaeton, Augustus saw Morse on the main street of Windsor with his trousers rolled up an inch or two. "Roll those trousers down, Deacon," Saint Gaudens yelled. "I want them scuffed!"[6]

Although the sculptor was careless about what he wore himself, he was almost obsessed with the problem of how to deal artistically with modern dress. His concern had paid off brilliantly on the Farragut. Now he had more to draw on, for he had his own direct memory of the way Lincoln looked.

How Augustus left his lathe and ran down to lower Fifth Avenue to see the President-elect pass by is touched on in the *Reminiscences*. He recounted his impressions more vividly in a conversation with assistant James Earle Fraser in the late 1890s, which Fraser remembers like this: "Lincoln stood tall in the carriage; his dark uncovered head bent in contemplative acknowledgment of the waiting people; and the broadcloth of his black coat shone rich and silken in the sunlight."[7] As the summer wore

on and many poses were tried, Saint Gaudens unquestionably flashed back to that long-ago glimpse.

There were, of course, a certain number of earlier Lincolns to learn from and compare. The portrayal in Thomas Ball's *Emancipation Group*, first cast in bronze in 1875, is quite adequate work. While still in her teens, Vinnie Ream Hoxie had access to the White House, and Lincoln posed for her. She produced first a rather odd bust, and then a standing Lincoln that can be seen in the Capitol. Describing it after a tour of the Capitol Rotunda in the early 1870s, Mark Twain found no great cause for rapture: "You could not help seeing Mr. Lincoln, as petrified by a young lady artist for $10,000—and you might take his marble emancipation proclamation, which he holds out in his hand and contemplates, for a folded napkin; and you might conceive from his expression and his attitude that he is finding fault with the washing. . . . Nobody knows what is the matter with him; but everybody feels for him."[8]

To the public during his lifetime Lincoln was a homely, homespun figure. Even Nathaniel Hawthorne, who interviewed the President for a magazine in March 1862, reflected the conventional wisdom: "By and by there was a little stir on the staircase . . . and in lounged a tall, loose-jointed figure, of an exaggerated Yankee port and demeanor, whom (as being about the homeliest man I ever saw, yet by no means repulsive or disagreeable) it was impossible not to recognize as Uncle Abe."[9]

Although he did sense some grandeur, the sophisticated Hawthorne managed to be a shade patronizing: "But on the whole I like this sallow, queer, sagacious visage, with the homely human sympathies that warmed it; and . . . would as lief have Uncle Abe for a ruler as any man whom it would have been practicable to put in his place."

Walt Whitman, who was in Washington during the war years, occasionally saw Lincoln ride by in his carriage. Describing one such glimpse, he said he was especially struck by the inroads the

war had made: "The lines indeed of vast responsibilities . . . cut deeper than ever upon his dark brown face." Whitman still saw "all the old goodness, tenderness, sadness and canny shrewdness underneath the furrows." His poetic vision carried him a step further: "None of the artists or pictures has caught the deep, though subtle and indirect expression of this man's face. There is something else there."[10]

Those who saw the President from day to day were particularly aware of this elusive quality. John Nicolay, who with John Jay served as private secretary during Lincoln's White House years, states the problem and describes what could *not* be caught on canvas:

> Lincoln's features were the despair of every artist who undertook his portrait. . . . They put into their pictures the large, rugged features, and strong prominent lines; they made measurements to obtain exact proportions; they "petrified" some single look, but the picture remained hard and cold. . . . Graphic art was powerless before a face that moved through a thousand delicate gradations of line and contour, light and shade, sparkle of the eye and curve of the lip, in the long gamut of expression from grave to gay and back again . . . to that serious, far-away look that with prophetic intuitions beheld the awful panorama of war, and heard the cry of oppression and suffering. There are many pictures of Lincoln; there is no portrait of him.[11]

On the subject of his own face, Lincoln was deprecating and funny. At the time of the Lincoln-Douglas debates, when he was accused of being two-faced, he responded, "If I had another face, do you think I'd wear this one?" He liked to tell about a dream he once had in which he was at a party of a lot of plain people. Learning who he was, they began to comment on his appearance. One of them said, "He is a very common-looking man." The President replied, "Common-looking people are the best in the world: that is the reason the Lord makes so many of them."[12]

Lincoln had no objection to being photographed. Of the 136 poses that are believed to have been recorded, 120 survive either as originals or copies of lost originals. They range from the daguerreotypes and albumen prints of the pre-Washington days to the famous multiple-image stereographic plate that Matthew Brady made at his Washington studio in January 1864. Many of them are very fine indeed; all are deeply serious. Exposures in those days were so long that anything but a most artificial smile could not be held; a change of expression simply blurred the image. So the flickering humor, the sudden shifts in mood like a swallow's flight, were matters never recorded.

By the time Augustus Saint Gaudens undertook the Lincoln assignment, the hagiographers had been at work for twenty years, sanctifying and dehumanizing the martyred leader. It all began at the hushed moment in the house across from Ford's Theater when the President breathed his last. Edwin Stanton spoke the prophetic words that set the myths in motion: "Now he belongs to the ages."

Saint Gaudens' problem of finding the true Lincoln was compounded by the clamor for heroes in America. Most of the Founding Fathers had been honored by now. The completion of the Washington Monument was a kind of benchmark in this process. Twelve years before it was done at long last, Mark Twain noted that "the Monument is to be finished some day, and at that time our Washington will have risen still higher in the nation's veneration, and will be known as the Great-Great-Great Grandfather of his Country."[13]

Now that time had come, and the search for a new crop of heroes was under way. The nation was bursting with energy and pride. The Founding Fathers had entertained grave doubts about the survival of the Republic, but it had indeed survived its terrible ordeal, and something stronger had emerged. The Civil War was the "scarlet stitching" that made many into one. This had not happened all at once—first the bitterness and opportunism of the Reconstruction and the carpetbagging days had to be dealt with— but certainly by 1885 the land was a nation at last. . . .

It was natural and inevitable that Abraham Lincoln should be the Zeus of the new pantheon that was forming.

All that summer and fall Saint Gaudens sought for the true Lincoln behind the deity and the legends. Cornish turned out to be the ideal place to work, far from all the demands and interruptions of city life. When he could spare the time, he did go down to see Davida. But Cornish was the center of his activity—not New York, as he had planned.

They were all back in New York by November, and the search went on. One day something happened that made it easier. Richard Watson Gilder, a strong supporter of the project, happened to drop in on his artist-friend Wyatt Eaton, who lived in South Washington Square. On the table in the library Gilder saw a mask of Abraham Lincoln and a cast of his hands. Astonished—for he had not been aware of their existence—he asked Eaton where they came from.

It developed that they had been made by sculptor Leonard Volk in April and May 1860, to be used in modeling his statue of Lincoln in Springfield, Illinois—another of those rather moderate precursors of the Saint Gaudens Lincoln. Volk's son Stephen Douglas Volk—named for their relative, the "Little Giant" of the debates—had given them to Eaton in Paris.

The enterprising Gilder organized one of his typical committees. This one consisted of thirty-three members. With the money raised among them, the life mask and hands were purchased, and a cast in bronze or plaster made for each contributor. The casting was supervised by Saint Gaudens, the price of the contribution determining whether the recipient was given a bronze or a plaster cast.[14]

During that second year of work on the Lincoln, Augustus made extensive use of his bronze copy. The life mask and the hands served the same function that the measurements made by the artists had done in Lincoln's lifetime: they helped, but again they could not by themselves bring the man alive.

The missing element was supplied by Saint Gaudens. He sensed intuitively what the public wanted, and he knew in his heart how he wished to answer this need. He knew that the time had come to replace the image of the Immortal Rail Splitter that still figured in the mythology. Some rite of purification was in order, almost an apotheosis. Lincoln was to be ennobled but in a democratic way. The exaltation must give him back to the people whence he came.

He too had sensed the "something else," the yonderly quality, of which Whitman had been so aware, which Nicolay had felt even in the daily contacts, and which Hawthorne had by a narrow margin failed to grasp.

In putting his feelings about Lincoln into words, the sculptor was reticent and understated. Some time after Saint Gaudens gained possession of the Volk life mask, Gilder dropped by the studio to see how he was making out. The following conversation took place, as recalled by the editor:

Gilder: "What do you think of Lincoln?"

Saint Gaudens: "I take him to be a good man, a benevolent, kind man, called upon to take a great executive office."

Gilder: "But how about a prophet, a poet, a dreamer called upon to take a great executive office?"

Saint Gaudens (begging the question): "What else shall I read of his?"

Gilder promptly supplied him with many of Lincoln's speeches and other writings. With his discovery of research and scholarship still very fresh, Augustus devoured them. He asked Gilder to come around again to comment on the progress of the figure. After studying it, Gilder urged his friend to lower the head still further to give "that contemplative look which is so fine, and so characteristic of Lincoln."[15] Augustus complied, taking the criticism in good part, as he so often did.

Some years later, reminiscing with his favorite niece Rose Nichols, the sculptor made one of his simple but revealing comments that condensed a lot into a short space: "I never thought of Lincoln as ugly," he said.[16]

Augustus may not have been verbally articulate about Lincoln, but he put all his eloquence into the modeling itself. By the spring of 1887 he knew that the quest was over and that he had done his best. The larger-than-life clay figure was lovingly converted into plaster and then, by early summer, into bronze. Included in the final monument, integrally and most brilliantly, was the presidential chair designed by Stanford White, working in closest collaboration with his friend. From it the President is seen to have just risen, still lost in thought, as if to deliver a speech.

Some think to this day that he is about to launch into the Gettysburg Address. But the chair, with its stylized eagle, wings spread, carved into the curve of the back, is no camp stool. What White intended was something magic and legendary, not relating to any specific moment.

The unveiling takes place at Chicago's Lincoln Park on October 22, 1887. It is raining heavily, so the ceremony is short. Abraham Lincoln II, the fifteen-year-old son of Robert Todd Lincoln and grandson of the President, plucks the flag away from the twelve-foot figure.

What the crowd sees in wonder—and what we see today— is a Lincoln from whom the homely and homespun have been stripped away. The left hand grasping the lapel of the frock coat enhances the pensiveness of the bowed head. The right hand, behind the back, balances the slight droop of the head. The forward jut of the right leg adds a kind of majestic confidence.

The chair is seen to be a stroke of the imagination. From a distance, it imparts a monumental quality. Without it, the tall figure might seem sparse and skimped. Like a stage prop that has fulfilled its function, the chair disappears on nearer approach. Now the head commands us utterly.

The features are in effect an offprint of the fair land become nation. Here is a man to match our mountains and broad plains. The brow is a high ridge, the nose a promontory, the tumbled locks the primeval forest.

Saint Gaudens has done more than make Lincoln not ugly. There is strength and nobility here, and an austere beauty.

The press in succeeding weeks outdoes itself in its search for hyperboles. The consensus is instant: this is the finest portrait statue the country has ever seen.

As a sculptor and a man whose own roots were Midwestern, Lorado Taft perhaps reflected the feeling of the country better than anyone else. His comment in a magazine article some years later caught the immediacy of the moment of unveiling: "It does not seem like bronze: there is something human, or—shall I say?—superhuman about it. One stands before it and feels himself in the very presence of America's soul."[17]

It was as if the true Abraham Lincoln had never been seen before. From that time forward, he would be seen no other way.

20

HE WHO WOULD
VALIANT BE

Hobgoblin, nor foul Fiend
　　Can daunt his spirit;
He knows, he at the End
　　Shall life inherit.
Then fancies flee away,
　　He'll fear not what men say,
He'll labor Night and Day
　　　　To be a Pilgrim.

—John Bunyan,
The Pilgrim's Progress[1]

GUSSIE WAS PREGNANT again in the spring of 1885. The pregnancy did bring a truce in her clashes with Augustus and their by now constant bickering. Augustus became concerned when Gussie worked too hard, while packing up for that first summer in Cornish. "Now she is down with what Dr. Lee said was pretty near a miscarriage," he wrote a New York doctor, Emerson, before they left for the summer. At the same time he asked if Dr. Emerson could recommend a good doctor in the Windsor area. "The war horse is stabled [meaning Gussie was no longer on the rampage] and the Old 'Worry Bones' horse has been trotted out instead—only the mare 'worry bones' has a mate now and that's

me. I'm a little nervous about the trip and the possibility of a pull back such as this."[2]

She made it through the Cornish summer, but some time after their return to New York she miscarried. Augustus reported the loss in a sad little note to Gussie's sister Elizabeth Nichols: "It's all over. . . . She knew nothing whatever of the operation which lasted more than an hour."[3]

Gussie was ill all that winter. The ever-reliable, ever-cheerful sister Genie came down from Boston to help. Working overtime, more and more absorbed in his other life with Davida, Augustus slept in the Thirty-sixth Street studio a good deal of the time. Homer was some consolation to Gussie. Because of the many trips away from his father, he was very much of a mother's boy. Robust and headstrong, he was already becoming what he would be all his life, "difficult but never quite impossible."[4]

In that same year of 1885, Augustus modeled a bust of the five-year-old Homer with flowing Little Lord Fauntleroy tresses. Shortly afterward, the tresses were cut off. The father's terse comment is revealing: "Little infant Jesus had his hair cut. His mother wept."[5]

Another observation of the father's, made later in Homer's boyhood, is like a mournful cry, leavened by Saint Gaudens' gift for hyperbolic humor: "Everyone is having babies. . . . Homer is growing a mustache."[6]

The year 1886 marked a further settling-in at Cornish. To Mr. Beaman's pleasure, many artists followed in Saint Gaudens' wake. One of the first was Thomas Dewing, the painter whose portraits made all the ladies look willowy and mysterious. Another summer colonist was George de Forest Brush, the young Tennessee bachelor whose speciality was Western Indians. Brush built himself a tepee below "Aspet" on a bluff overlooking Blow-Me-Down Pond.

In 1890 came Charles A. Platt, the first of a dynasty of Platts. Landscape painter turned architect, Mr. Platt designed himself a Florentine villa with a strong American accent and a fine view of Ascutney. It was the prototype of many other Cornish villas to come. Three years later Stephen Parrish, Philadelphia painter

and father of the more famous Maxfield, built a house that un-conventionally faced north—but had a spectacular view of Ascutney from the back door.

If the first wave of summer people were painters and sculptors, the second, in the late 1890s, were writers. Leader among them was the American Winston Churchill. He was just six years out of the Naval Academy when his *Richard Carvel* became the best-selling novel of its day. The third wave, in the early 1900s, consisted of lawyers, doctors, politicians, and people attracted by the aura of celebrity—and by the reports that Cornish was less expensive than some of the fancier resorts.

Many of the newcomers became year-round residents. By the locals they were all lumped together as "New Yorkers." One laconic farmer defined the influx like this: "Anybody is a 'New Yorker' that comes from off."[7]

Most of the sculptors who came were of course in the orbit of the master sculptor. But one, the talented Herbert Adams, had his own studio nearby and was very much his own man. Daniel Chester French, already well along on his own journey into fame, spent two summers in Cornish but chafed a little under the aura of the master.

Several years later, Saint Gaudens was able to buy twenty-two acres of Beaman land, as he had long wanted to do. He paid twenty-five hundred dollars for the house and the trees and water that were "his great desire," and in addition agreed to do a bronze medallion of Squire Beaman. Augustus' letter to his jolly friend shows that the sculptor was well aware of his own worth: "My time is so occupied by my larger work that I am refusing to do medallions for a price that would more than pay for the entire property."[8]

The year 1886, in addition to being a key year for the *Standing Lincoln,* marked the completion of the bust of Davida. It also saw the commissioning of Saint Gaudens' most enigmatic work. This

was the *Adams Monument*, destined for Rock Creek Cemetery in Washington, D.C., and lasting fame. At Henry Adams' request, Augustus began a close collaboration with John La Farge in finding a theme that would honor the memory of his wife, Marian, called Clover, who had committed suicide the year before.

When, in early 1887, the Lincoln went on its way, it would have been logical for the Shaw to move up to the front platform for urgent completion. But the technical problems were still so many that it was fated to remain in lower priority for some years to come. Another, less exacting assignment, already well under way, held promise of quick solution.

This was for a statue of Deacon Samuel Chapin, one of the founders of Springfield, Massachusetts. Back in 1881, Saint Gaudens had modeled a bust of Chester W. Chapin, a sixth-generation descendant of the deacon. Mr. Chapin, Congressman and president of the Boston and Albany Railroad, had died in 1883. Before his death, he and his son, also Chester, who had become a friend of Augustus, asked the sculptor to model a monument to their ancestor, which they planned to give to the city of Springfield. He was more than pleased to undertake the commission.

Since no one had the vaguest idea what the old deacon looked like, and only very sketchy ideas about what kind of clothes he wore, a good deal of research was in order before the actual modeling could begin. Ladies of the Chapin family found and studied a collection of seventeenth-century woodblock prints, which were helpful in the matter of costume. Working from the images, they made small clothes and a long, many-buttoned doublet. They also knitted a pair of thick worsted stockings, which they had learned were of the period. There was plenty of evidence as to the characteristic Pilgrim-Puritan hat: high of crown, broad of brim, and with a buckle in front. The ladies improvised one.

In addition to honoring a slightly shadowy Pilgrim Father, Saint Gaudens wanted to make a statement about the Puritan or Separatist faith from which the Pilgrims sprang. The 102 Pilgrims who had come over on the Mayflower had chosen their name from the New Testament book of Hebrews, for they considered themselves "strangers and pilgrims on the earth." As such they

sought a new country, "a better country, that is, an heavenly."[9] But all Puritans were not Pilgrims; the Puritan sect, which was beginning to flourish in England, would rule the country in Cromwell's time.

In bringing to life an individual and doing honor to his faith, Augustus knew very well that he still had to work from some one person. Scott Fitzgerald's celebrated dictum had not yet been laid down, but its underlying principle was well understood by the sculptor: "Begin with an individual, and before you know it you find that you have created a type; begin with a type, and you find that you have created—nothing."[10]

The answer to the problem was ready to hand. Augustus had kept a plaster cast of the head he had made of Chester Chapin senior. The bust had pleased the family, and had been carved into marble. Now he reckoned it would serve very well as a model for the old deacon. Certainly, the broad forehead and rugged features of the railroad magnate were as near an approximation of his lineal forebear as the sculptor could ever hope to conjure up.

So, with a ready-made prototype for the head, and a male model named Van Ortzen to pose in costume for the stalwart body, Augustus, Louis St. Gaudens, and Philip Martiny went to work. (By this time, early in 1886, the precocious Willie MacMonnies was in France pursuing a career that was beginning to dazzle.)

The trio made clay sketches of many poses, some of which have come down to us in archival photographs. One shows the deacon with left arm akimbo and right hand pushing a cudgel before him like a compass needle to guide him in rectitude. Then Augustus had the happy inspiration of tucking a big Bible under the left arm, grasped by firmly flexed fingers. The result was rather like a seventeenth-century Moses clutching the tablet of the Ten Commandments.

The solution came quickly, along with the certainty that they had it right. This is exactly the same feeling *we* have when we see the figure today: he is so right that he is almost a cliché.

The splendid old deacon is shown striding along. The pine

branches at his feet are pushed aside by his progress. The tall hat sits four-square on the broad brow, but the brim has a lilt to it, adding to the sense of forward motion. The cudgel in the right hand is now gripped like a sword hilt rather than followed like a compass. Another inspired addition is the cloak which envelops the figure from shoulder almost to ground. More Cavalier than Pilgrim with its curling collar and swirling folds, it adds immeasurably to the thrust and surge of the sturdy figure.

The creation of the *Puritan* is an excellent example of the relationship between a master and his assistants at its most fruitful. Once the overall design had been agreed upon, Saint Gaudens allocated much of the detail. He knew from long experience that in Louis' case he had only to make a suggestion or two, for Louis's creative gifts with clay were almost as great as his own, and markedly similar. Like almost all his other assistants, Martiny needed closer supervision. But in special effects like the pine branches, in following carefully worked-out delineations like the folds of the deacon's cloak, he was very skillful indeed.

In this matter of skilled assistance the sculptor has a certain advantage over the painter. It is not too difficult to spot passages in a painting by another hand than the artist's. But a sculptor of the quality of Louis often approximates the master himself. And a man with a haptic gift of a Martiny "performs prodigies of execution when brought face to face with problems which, to the older man, seem tiresome repetitions but which with the infusion of young blood take on new life."[11] The master sculptor almost invariably takes the opportunity to make subtle changes before the clay is cast into plaster, and even in the bronze or marble itself. Canvas botches much more easily.

Stanford White's contribution to the *Puritan* was another example of good coordination. He was in on the planning from the start and designed a pedestal of granite from the state of Maine. The overall plan also called for a circular pool with four bronze turtles around it, representing the four seasons. The pool was at the far end of an enclosure, balancing the statue. Along the sides White and Saint Gaudens placed curtains of white birch.

Behind the statue, closing off the end, was an evergreen hedge. From the hedge, the all-embracing cloak was seen to serve another purpose: viewed from the back as well as front and sides, it created rich shadows, protecting the figure it enfolded against ugliness from any angle.

The statue was unveiled on Thanksgiving Day 1887. The location of the enclosure was Stearns Square in Springfield, near the railroad station.

Almost without breaking stride, the figure of the deacon took its place in the lore of the nation, and the folklore. History books and encyclopedias accepted him at once as the embodiment of the Puritan spirit, and so he has remained.

Kenyon Cox summed up this immediate recognition very well: "He is not merely a Puritan of the Puritans, he is a man also, a rough-hewn piece of humanity enough, with plenty of the old Adam about him; and one feels that so and not otherwise must some veritable old Puritan deacon have looked."[12]

The *Puritan* only stayed in Stearns Square until 1899. Plans for improving that part of Springfield never quite materialized, and the area deteriorated. A place was found in less striking surroundings near the public library. But Stearns Square is currently being refurbished, and the hope is that the deacon will be back in his enclosure some time in the late 1980s.

An almost identical twin to the figure of the deacon was commissioned by the New England Society of Philadelphia and unveiled on City Hall Plaza there in 1904. The face was made leaner and grimmer, so that it is no longer that of a Chapin. The spine of the book was labeled HOLY BIBLE (not that there had ever been much doubt of what the book was). To underline the fact that this was not a carbon copy of the earlier work, the not quite identical twin was called the *Pilgrim*. All that this really did was to remind people how interchangeable the two terms were.

In 1920, the *Pilgrim*, as peripatetic as his brother, was moved to its present location in Fairmount Park.

Quite a few reproductions were made of the *Puritan*. The rich, somber patina of burnished bronze lent itself ideally, and

the essence of the old deacon came through in almost any size.

Theodore Roosevelt's staff gave him one of the smaller bronze casts when he left the governorship of New York for the vice presidency in June 1900. T.R. was d-e-e-lighted: there was a curmudgeon quality about the deacon that appealed to him mightily. Even more in keeping with his strenuous view of life was the boldness, the valiant spirit, which this Father of all Pilgrim Fathers exuded.

21

TWO ROMANTICS

I loved a ship as a man loves burgundy or sunrise.

—Robert Louis Stevenson,
Edinburgh: Picturesque Notes

SOME TIME IN THE mid-1880s Saint Gaudens' friend Joseph Wells pressed on him a copy of Robert Louis Stevenson's *New Arabian Nights*. Since Augustus had great admiration for Wells' taste and judgment, he promptly read the book—and was bowled over by the fantastic tales. "These stories set me aflame as have few things in literature," he recalls in the memoirs.[1]

Stevenson had been in and out of Paris a good deal in the late 1870s. Will Low, who was a good friend of the Scottish writer, had wanted Saint Gaudens to meet him, sensing kinship. The busy sculptor had never quite managed to find the time. Now, in his belated discovery of Stevenson's talent, Augustus remembered that Low knew him well. He made Low promise to arrange a meeting if Stevenson ever came to America, and indicated that he would be more than honored to have him sit for a bas-relief.

Not long after, Stevenson turned up in New York. He was suffering from chronic tuberculosis and seeking a place to go for a cure. His mother and American wife were with him. They had heard that either Colorado or Dr. Trudeau's new Saranac Lake Colony in the Adirondacks might suit him very well.

The time was September 1887. They stayed at the Albert Hotel on Eleventh Street, a short walk from Washington Place. True to his word, Low introduced Saint Gaudens to Stevenson. Before this first meeting was over, the Scottish writer indicated that he would be more than willing to pose.

The mutual liking had been instantaneous.

"What did you think of him?" Low asked Saint Gaudens as they came away.

"Astonishingly young, not a bit of an invalid, and a bully fellow," Augustus answered.[2]

Shortly afterward, Stevenson told Low what he thought of Saint Gaudens.

"I like your sculptor," he said. "What a splendid straightforward and simple fellow he is, and handsome as well."[3] In a letter to his friend Sidney Colvin he slightly qualified this first impression: "I withdraw calling him handsome; he is not quite that, his eyes are too near together; he is only remarkable looking, and like an Italian cinquecento medallion."[4]

Low made a point of being at the modeling sessions whenever possible. Stevenson was confined to bed but worked along a good deal of the time, legs drawn up to support his manuscript. Sometimes Fanny read aloud. Sometimes there was conversation, ranging over a wide field.

One recurrent theme of Stevenson's was his love of ships and the sea, and the challenges of seafaring. "The man who has not taken his life in his hands at some time or other has not lived," he once remarked.[5] Stevenson, who had been intermittently bedridden for many years, had a special admiration for men of action, for soldiers and great administrators. He also confessed his secret fear that, should any man insult him, he would "present but a pitiable figure" in a fight.[6]

At one session, as he modeled away at the easel set up alongside the bed, Saint Gaudens mentioned that it was only by the purest chance that he had never done a nude statue of a woman.

"If I ever get a moment free, I intend to repair the omission," he added.

Low spoke up with a relevant quote from Emerson:

The sinful painter drapes his goddess warm,
 Because she still is naked, being dressed:
The god-like sculptor will not so deform
 Beauty, which limbs and flesh enough invest.[7]

Stevenson took a great liking to these lines. Out of his liking, and his admiration for the Renaissance look of his new friend, he dubbed Saint Gaudens "the god-like sculptor" and often addressed him as such.

There are conflicting views about what Stevenson looked like, and the impression he made. William Ernest Henley, the English poet who was a fellow battler against infirmity, observed him as "bold-lipped, rich-tinted, mutable as the sea, the brown eyes radiant with vivacity." Then his poetic vision soars: "A spirit intense and rare, with trace on trace of passion, impudence and energy." Seeking his peers, Henley puts him in high company: "A deal of Ariel, just a streak of Puck, much Antony, of Hamlet most of all . . ."[8]

Henry Adams' impression was less kind. He and John La Farge visited the Stevensons at Vailima, their Samoan home high above the Pacific. This was in 1890, two years after Stevenson left America in his search for health. Greeting his guests, the writer seemed to know a lot about La Farge the artist but nothing at all about Adams the historian. So Adams' description is dipped in malice: "A man so thin and emaciated that he looked like a bundle of sticks in a bag . . . eyes morbidly intelligent and restless." He did find Stevenson "extremely intelligent," but then his distemper returned in his comment that the author "looked like an insane stork."[9]

Henley's comment and Adams' were actually the obverse and reverse of the same coin. Stevenson's spell often wore a flushed and feverish guise, but it was unquestionably there.

His fame had preceded him to New York. *Treasure Island* (1883), *A Child's Garden of Verses* (1885) and *Kidnapped* (1886) were all well known in their British editions. *Dr. Jekyll and Mr. Hyde* was having a great success in England. Since international copyrights did not yet exist, recognition in America came in the

form of a pirated edition that was selling briskly. More of a windfall for Stevenson was the stage version of the novel, which opened in New York that September in an adaptation by Russell Sullivan.

Stevenson himself was not well enough to go to the opening, so he asked Will Low to escort his wife and mother. Swirling with high Victorian melodrama, scarfed in tendrils of London fog, *Dr. Jekyll and Mr. Hyde* captivated the first-night audience. The succulent double role of the doctor-killer proved to be the perfect showcase for the talents of thirty-year-old Richard Mansfield, and helped his swift rise to matinee idol and Shakespearean superstar.

The final curtain came down to thunderous applause, and Mansfield led the cast through many curtain calls. Then the cry of "Author! Author!" went up, and all eyes turned to the box where Low and the two ladies were sitting. With the applause drumming on and on, Low realized that he was being mistaken for the novelist. His reaction was to duck behind the ladies and literally go to cover on the floor of the box. The next morning, one of the New York newspapers reported that rarest of phenomena, a bashful celebrity: "The author, who was present, was acclaimed by the audience, but for some reason refused to respond."[10] Stevenson was much amused.

The success of the play increased the number of the autograph hunters and the curious who laid siege to the Albert Hotel. The faithful Low, watchdog of Stevenson's limited strength, screened all but a few. At the same time, Low was well aware that Saint Gaudens boosted the invalid's morale, and allowed him overtime for more conversation after the sittings were finished.

Stevenson and Saint Gaudens talked of many things, and found that they had many views in common. The writer discovered that the sculptor's feeling for the leaders of the Civil War was very like his own worship of England's great proconsuls and adventurers. Augustus' memories of the clipper ships winging their way up New York Bay, and the forests of masts and bowsprits along South Street, kindled a response in Stevenson, who craved to be well enough to charter a boat and sail the Atlantic Coast.

Saint Gaudens was quite able to talk vigorously and well

about his profession, and he did. This induced a Stevensonian confession about how he had learned the craft of the writer. In his youth he closely copied the famous essayists, Montaigne, Hazlitt, and Lamb among them. Stevenson called this "playing the sedulous ape," and it was not unlike Augustus' saturated awareness of classical and Renaissance sculpture when he was in Rome.

They were just two years apart, Stevenson at thirty-seven being the younger. By a matching combination of hard work and dedication, each had developed his own style, the kind of fluid simplicity that looks easy but almost never is. In the course of a dialogue on this subject of style, Stevenson grabbed his pen and dedicated one of his books to Saint Gaudens with a couplet:

> Each of us must have our way,
> Mine with ink and yours with clay.[11]

Even though Stevenson's usually impeccable grammar is missing here, the message and the pride are unmistakable. *We are brothers in our mastery.*

Both Stevenson and Saint Gaudens were romantics through and through. One was well and one was sick, but Stevenson inhaled Saint Gaudens' vitality like a vapor and drew strength from it. What Saint Gaudens did was to bring his own bolder, richer life into the sickroom, and make the writer yearn for a life of his own to match it.

For his part Augustus, with his bittersweet admiration for men of the kind of education he had been denied, found Stevenson's company riveting. He was dazzled by "the range of his frolic imagination" and his quicksilver sensitivity.[12] Like his books, Stevenson's conversation had what Vladimir Nabokov has called "a delightful winey taste," and Saint Gaudens drank it in.[13]

In that same fall of 1887, Augustus undertook another labor of love that in its own time would, like the Stevenson medallion, become a vast success. This was the modeling of the bust of

William Tecumseh Sherman, who was the only living four-star general of the U.S. Army. He had retired in 1883. The following year, in his usual salty style, he had turned down a chance to run for the presidency, both vocally and unequivocally: "If nominated, I shall not run. If elected, I shall not serve."

The General had recently moved to New York, where he was much sought after and lionized. He was vocal again on the subject of "being pestered with damned sculptors" about posing.[14] One of them, somewhat indirectly, was Saint Gaudens, urged on by Stanford White. It had been White's idea that his friend do a bust as a preliminary to a possible equestrian statue honoring the old warrior in the city of his choice. Running into a stone wall of refusal, White went to Whitelaw Reid, who was editor of the *Tribune* at the time, and asked him to persuade Sherman to pose. "I tackled the old gentleman the next time he came to my house," Reid recalled. "He swore a little and finally consented."[15]

Sherman gave Saint Gaudens some fifteen sittings, and Augustus found him fascinating. The General remembered his campaigns with verve and clarity. On other matters he was crotchety and kindly by turns. It was said of him that he never acknowledged an error and never repeated one. More pungently, one of his Civil War staff had mixed admiration and exasperation in a phrase: "For any purpose but commanding a quarter of a million men, the old man is a damned fool."[16] Augustus sensed a certain wariness, although for the most part Sherman was an excellent sitter. When the sculptor stepped to one side to study his profile, the General became a trifle uneasy. His eyes "followed me alertly," Augustus noted, reminding him of a military leader protecting his flanks and watchful of his lines of communication.[17]

Saint Gaudens often mentioned Sherman to Stevenson, who expressed a wish to meet the famous man of action. But that fall the writer's health was not up to it. A far more urgent matter was the finding of a more salutary place than New York for the winter.

The choice fell on Saranac, and a house was rented there.

The Stevenson family moved to the Adirondack clinic in late
September. The cold dry air was good for the writer. He was
outdoors a lot of the time, and even skated a little. But he hated
being surrounded by the invalids of the Trudeau colony, whom
he considered sicker than he. As for work, he managed to write
the bulk of *The Master of Ballantrae* during his seven-month
stay.

Augustus saw him go with deep regret. In five sittings of two
to three hours each he had finished the modeling of his friend's
head, but the hands and body remained to be done. What had
emerged, firm and lasting, was the bond of friendship. Writing
to Low just after the Stevensons left town, he makes this very
clear: "My episode with Stevenson has been one of the events of
my life. . . . It makes me very happy, and as the pursuit of
happiness is an inalienable right 'God-given,' 'one and indivisible'
. . . I'm damned if I don't think I have the right to be, provided
I don't injure anyone. . . ."[18] One senses here an oblique reference
to another intimacy. The surmise is that he was feeling slightly
guilty about Davida but that his relationship with the model was
injuring no one (meaning Gussie) for the simple reason that his
wife was still unaware of its existence.

In April 1888 the Stevensons came back to New York and
Eleventh Street. The writer was in considerably better health,
less bedridden and able to see more people. The sittings began
again. During one of them Saint Gaudens reported good progress
on the Sherman bust, and Stevenson again expressed the wish to
meet the great man.

In the course of the next Sherman sitting, Augustus asked
the General if he would be willing to give the writer an interview.

"Stevenson? Stevenson?" Sherman said. "Is he one of my
boys?"[19]

Augustus replied that he was Scottish, and an author.

"Not in the army, eh? What has he written?"

Augustus told him about the *New Arabian Nights* and Ste-
venson's other claims to fame. Sherman shook his head, uncom-
prehending. Then Augustus remembered that the old gentleman

loved the theater, and threw in the fact that Stevenson had written *Dr. Jekyll and Mr. Hyde*.

"He wrote that, did he? First-rate play, saw Mansfield in it. I'll be glad to meet your friend."

Some days later the meeting took place at the Fifth Avenue Hotel, where the Shermans were living. After Saint Gaudens introduced his friend, the General turned to Stevenson.

"Are you one of my boys?" he asked. "Corps? Regiment? Company?"

When the negative answer came, his mind seemed to wander and his interest to waver. "The conversation remained conventional and perfunctory," Saint Gaudens noted. Well briefed by Augustus, Stevenson remembered to mention his authorship of *Dr. Jekyll*, and the General brightened visibly. Stevenson then told Sherman how much he admired the latter's *Memoirs*, and the meeting took a new turn. As the writer asked knowledgeable questions about the campaigns, the General realized that this was no amateur. Soon paper and pencil were called for, maps broken out, and old battles fought once more.

Later the same day, Will Low asked Stevenson if he had been disappointed in the face-to-face encounter with his hero.

"Disappointed! It was magnificent to simply stand in the presence of one who had done what he has, and then to find him so genial and humane . . . and to think that he has led armies!"

Out of his admiration for the charm and intellect of Stevenson and the virility of Sherman came two of Saint Gaudens' most successful portraits.

The medallion of the writer, first in oblong form and then in circular, shows him in the pose Augustus had grown to know so well: propped up in bed by three pillows, legs drawn up to support the sheets of paper he was forever filling, right hand holding the cigarette he should not have been smoking at all. Behind the figure, in immaculate lettering, are characteristic lines from a collection of poems called *Underwoods* that Stevenson published in 1887. The first two are: YOUTH NOW FLEES ON FEATHERED

FOOT / FAINT AND FAINTER SOUNDS THE FLUTE; and the verse ends with a gallant flourish: LIFE IS OVER LIFE WAS GAY / WE HAVE COME THE PRIMROSE WAY.

The head is modeled with great delicacy and tenderness. Despite the trappings of illness around him, Stevenson's face bears no suggestion of infirmity. His expression is tranquil and somehow both alive and dreaming.

The circular medallion was especially popular, and many variations exist in both size and detail. After Stevenson's death in Samoa (1894), Saint Gaudens accepted the commission to do a revised seven-foot-seven-inch-by-nine-foot rectangular version for Saint Giles Cathedral in Edinburgh. The inscribed poem became a prayer written by Stevenson, beginning: GIVE US GRACE AND STRENGTH TO FORBEAR AND PERSEVERE. Instead of the cigarette, the author now grasps a quill pen, in a gesture more in keeping with the hush of a great church. There is additional lettering on the plinth, ending with Stevenson's oft-quoted requiem lines: HOME IS THE SAILOR HOME FROM THE SEA / AND THE HUNTER HOME FROM THE HILL. Stevenson actually wrote "home from sea," but the slightly altered line has been perpetuated.

There are a total of 1,052 letters in the various inscriptions on the plaque for Saint Giles. Each letter was modeled an average of twelve times before Saint Gaudens and his two helpers on the project, Frances Grimes and Henry Hering, were satisfied at last. In this ultimate version Stevenson seems less ill, for the bed is now a couch and the blanket a traveling rug.

After several false starts at casting, the plaque was finally unveiled in Scotland's own Westminster Abbey in June 1904. Although Robert Louis Stevenson's grave is "under the wide and starry sky" in far-off Samoa, the bas-relief, of a rich, almost chocolate-colored bronze, seems in its right and proper place among the statesmen and warriors of his native land.[20]

The Sherman bust turned out well also. All those sittings and gusty conversations paid off.

Augustus fussed from time to time over the fact that he could not persuade the General to button his coat collar.

Once he said, "Look here, General! When you see portraits of Bismarck, Von Moltke and other great generals, their coats are always buttoned up tight to the throat, and they look their rank. Do *just for a short time* button yours up and set your tie straight so I can get it as it should be."

Sherman fixed Saint Gaudens with a hard stare and said, "I don't give a tinker's damn how men chose to wear their coats, but I want you to know that the General of the Army of the United States will wear his coat any damn way he pleases."[21]

This turned out to be a piece of great good luck. The open collar and loosely knotted tie catch and enhance the spirit of the eagle-beaked head above. Sherman seems totally his own man, keen of eye and just short of being truculent. The ripple and flow of the bronze, in several surviving castings, perfectly reproduce the vigor of the old warlord. The bust became the principal source material for the equestrian statue, finally commissioned in 1891 and unveiled at the southeast entrance to Central Park in 1903.

The rest of the story of the Saint Gaudens–Stevenson friendship can be quickly filled in. In the summer of 1888 the writer took a house in Manasquan, on the New Jersey shore, where Will Low summered. Saint Gaudens went there twice as his modeling of the medallion neared completion. On the first visit, in late May, he brought eight-year-old Homer along. Although his father had told him on the trip down about Stevenson and his fame, Homer was restless in the bedroom and was soon sent out to play. Stevenson seemed stiff and uncommunicative, and the session went badly. Then Augustus suggested, as he had often before, that the author write something. Stevenson grabbed a piece of paper and soon was scribbling away, sometimes smiling to himself as he worked along.

Augustus accomplished his purpose for the day and told Stevenson he could stop writing. His friend continued for some time,

then folded the paper very carefully, placed it in an envelope, and handed it to Saint Gaudens.

It was addressed to "Master Homer Saint Gaudens." Stevenson said to give it to the boy "in five or ten years or when I am dead." Augustus put it in a safe and found it again at the time he was writing his memoirs. It tells us so much about Stevenson at thirty-eight and Homer at eight that its essence belongs here:

Manasquan, New Jersey, 27th May, 1888

Dear Homer St.-Gaudens:

Your father has brought you this day to see me, and he tells me it is his hope you may remember the occasion. . . . I must begin by testifying that you yourself took no interest whatever in the introduction and in the most proper spirit displayed a single-minded ambition to get back to play, and this I thought an excellent and admirable point in your character. You were also . . . a very pretty boy, and, to my European views, startlingly self possessed. My time of observation was so limited that you must pardon me if I can say no more: what else I marked, what restlessness of foot and hand, what graceful clumsiness . . . was but the common inheritance of human youth. But you may perhaps like to know that the lean, flushed man in bed, who interested you so little, was in a state of mind extremely mingled and unpleasant; harassed with work which he thought he was not doing well, troubled with difficulties to which you will in time succeed, and yet looking forward to no less a matter than a voyage to the South Seas and the visitation of savage and desert islands.

Your father's friend,

ROBERT LOUIS STEVENSON[22]

Shortly afterward, Stevenson left for the Pacific, and Augustus never saw him again. The writer found the sanctuary he was looking for in a Samoan plantation high on a hill and reached only by a most primitive track.

The friends did correspond. Stevenson's last letter, of July 8, 1894, reported the arrival of the bronze bas-relief after many almost insuperable difficulties: "This is to tell you that the medallion has been at last triumphantly transported up the hill and placed over my smoking-room mantelpiece. It is considered by everyone a first-rate but flattering portrait. We have it in a very good light, which brings out the artistic merits of the god-like sculptor to great advantage. As for my own opinion I believe it to be a speaking likeness and not flattering at all; possibly a little the reverse. The verses (curse the rhyme) look remarkably well."[23]

Robert Louis Stevenson died in December of that same year. He had gone down to his wine cellar for a bottle of his favorite burgundy. Uncorking it, he suddenly cried out, "What's the matter with me? What is this strangeness? Has my face changed?" What pulled him down at the last was not the tuberculosis which he had battled almost to a standstill, but a burst blood vessel in his brain. The end came two hours later.

Augustus remembered him all his days, quoted him often, and drew sustenance from his courage when he in turn endured long illness.

22

THE DELIGHTFUL ART

Quanto e difficile
Questo facile!

—Johann Adolph Hasse
(1699–1783)

"How difficult it is, this ease!" Johann Adolph Hasse was a German-Italian composer whose hundred-odd operas are long forgotten. But his remark, his slightly wistful paradox, has survived to this day. It has a special relevance to the works of Saint Gaudens. For, to a marked degree, Augustus possessed that mysterious quality that made it all look easy. The various means by which he achieved this ultimate facility lie at the heart of any understanding of his sculpture.

Until about the time that he turned forty (1889) Saint Gaudens was able to complete his major works at a fairly even pace. The beautiful simplicities of the *Standing Lincoln* and the *Puritan*, like the earlier *Farragut*, came into being without the endless changes and self-doubts that would bedevil his later works. For those clogging apprehensions of his led to a growing inability to know when a quest was over and a mission completed.

By contrast, his frequent forays into what Brenda Putnam called "the delightful art of medallic sculpture"[1]—his bas-reliefs—demonstrate a consistent singleness of purpose and a singularity in the final product which lasted all his life.

The years 1887–90 were especially productive of these clay portraits. During that four-year period, Saint Gaudens modeled ten of them, including the Stevenson medallion, and in doing so maintained and enhanced the high standard he had set from the start. This is as good a time as any to examine the syntax of these smaller works, so quickly wrought and now so greatly sought after.

The speed and dexterity with which they were done stem directly from his apprentice years as a carver of cameos. Sometimes these cameos were facsimiles of living people, and they were usually done in a hurry. When there was time, Augustus would make a charcoal or clay sketch beforehand, but usually there wasn't. Of necessity he learned how to hit off a likeness at speed. Since cameos are two-dimensional, the silhouetting of the head so that it stands out sharply from the background was the necessary skill he soon acquired.

The cameo cutting served him well in later years. For bas-reliefs are also two-dimensional in their horizontal and vertical lines; as for the third dimension—depth—the slightly raised surfaces seek to impart it, or at least the illusion of it. Saint Gaudens' own early *Samuel G. Ward*, modeled in relief of an eighth of an inch, is the supreme and astonishing example of his ability to create this illusion.

It is a curious fact that even in sculpture-in-the-round, the two-dimensional quality persists. This phenomenon, which lies at the root of all sculptural design, was well understood and described by German artist Adolf Hildebrand early in the present century:

Our vision is in its very nature two-dimensional; so that by a single intuition we perceive all the flat elements of the natural scene imagined. Though we may have to let our eyes wander over it, the whole is still unified by this continuity of vision from a single point of view. To perceive in visual images the third dimension, however, we must imagine ourselves as changing our point of view, and as getting *merely*

a succession of disconnected shifting views of the object more or less in profile.[2]

Hildebrand, whose small book is coming to be seen more and more in Europe as a seminal work, amplifies his theory like this:

> The point of view is determined by the arrangement of the figure. If the figure offers more than one plane picture, there will of course be more than one position from which to view it. The number of satisfactory aspects a work may have depends on the artist's conception; it may be two, front and rear, as in statues of a relief-like character; it may be three or four, etc. It is the energy with which the work emphasises these points of view, not their number which interests us here. But among all the possible aspects there will always be one that dominates. This one is representative of the total plastic nature of the object, and like a picture or relief, expresses it all in a single two-dimensional impression. . . .[3]

Stated more simply: it is the continuing outline or silhouette that holds a picture or statue together, and indeed that makes it beautiful. (When we close one eye the way artists and architects and indeed marksmen are forever doing, we do so to get a clearer picture. We see one picture instead of two, and the single picture is two-dimensional.)

In his multiple works, Saint Gaudens employed what John Wilmerding calls "the full vocabulary of his profession, from silhouette to low relief to high relief to figure-in-the-round."[4] But he never forgot the lesson learned early that the "silhouette remains in beauty still,"[5] providing continuity and coherence to the finished product.

It is interesting and relevant that about 90 percent of Augustus' bas-reliefs are in profile. From the beginning he realized that the head-on view is much more difficult. For example, the space between the corner of the eye and the ear, when modeled

in profile, can be transcribed quickly. If one attacks this area directly from the front, the space becomes elusive.

In the same way, a nose in profile is quite easy to model; a nose is a nose. In frontal attack it is far harder to capture.

This raises another question. Why do so many of Saint Gaudens' bas-reliefs of both men and women have large, handsome noses like his own? One simplistic answer is that he tended to admire people who had well-formed proboscises; since most of his earlier bas-reliefs were not done for financial gain, he was able to pick and choose his own subjects.

There is also a subliminal reason, however. If we remember that sculpture is often narrative in form, the fictional element enters here. Saint Gaudens had a healthy ego, which he labored to keep under good control. But one way in which it surfaced was in the transfer of his own splendid nose to many sitters. In much the same manner that novelists give their own looks and foibles to their characters, Augustus imparted his most prominent feature.

Saint Gaudens' bas-reliefs, then, are both biographical and autobiographical. They tell us a lot about the sitters—what they looked like to him, what kind of clothes they wore, what kind of humor or its lack was in them. They are rites of friendship. But they also reveal a good deal about the sculptor himself. Because so many of the sitters are fellow artists, they proclaim his pride in his profession. Because so many are women, they remind us of his pleasure in their company, and the volatility of his affections. Sometimes, when other evidence is sparse, these, his more intimate creations, light up dark corners of his life. . . .

The bas-reliefs are remarkably consistent in their beauty. They number about ninety in all. Two-thirds of this output was collected for the retrospective at the National Portrait Gallery in 1969. Oddly enough, seeing so many together produced a slightly numbing effect: they seemed almost monotonous in their perfection. They are better seen and studied a few at a time than gulped en masse.

Saint Gaudens turned out his clay portraits over a period of exactly thirty years. A handful were converted into marble, but

by far the greater number were cast only in bronze. The first was modeled in 1877, a likeness of his friend Maitland Armstrong. The last, unfinished at his death, was a most tender and loving plaque of Gussie, which may be construed as a celebration of their early, happy years together and an apologia for all his wandering ones.

Except for some of the lettering, he did all the modeling himself. He was utterly confident of his mastery. Frances Grimes remembered this well long after his death: "Saint Gaudens felt that relief was his milieu. In his studies-in-the-round he constantly asked his pupils and helpers, 'What do you think?' But in the bas-reliefs he employed others simply as tools."[6]

His preponderance was such that it would be easy to imagine that he had invented the medium himself. Actually the Egyptians did, with heads in profile and bodies, whenever possible, facing the spectator. The Assyrians, in a less static, pictorial way, were specialists in bas-relief, imparting vigor and drama. Greek friezes, with their flattened surfaces, seem marvelous to this day, and the Roman reliefs teem with men and brave deeds.

During the Renaissance in Italy, craftsmen like Antonio Pisano (1397–1455) brought the art of the medallion to new glory. "Pisanello" is well described by Vasari in his *Lives of the Artists*. Writing in the century after Pisano's death, Vasari quotes a contemporary collector: "This master was exceedingly clever in the execution of bas-relief, a work esteemed most difficult by artists, because it holds the mean between the level surface of pictures and the full roundness of statues. There are many highly esteemed medals of great princes by his hand. . . . I have a most beautiful medal of John Paleologus, Emperor of Constantinople, with that strange-looking hat that he used to wear."[7]

Saint Gaudens kept many casts and photographs of Pisanello's creations. His own penchant for modeling hats with sweeping brims derives directly from the wondrous domed and pointed headpiece of Paleologus. It was the magic of Pisanello in particular that caused Augustus to despair, that day in the studio of John La Farge, of doing as well as the men of the Renaissance.

Augustus was also fully aware of the revival of the art of the

bas-relief in nineteenth-century France. Specifically, he admired the work of David d'Angers, whose medallions, almost more pictorial than sculptural, were of a fine consistency.

Back in Paris in that same year, 1877, during which he did the Maitland Armstrong, he hit off a spate of bas-reliefs. One of them was of William Gedney Bunce in an upbrimmed hat in the manner of the headpiece of Paleologus. He also did a portrait in clay of fellow artist George Maynard, with a bend in his big nose that obviously gave the sculptor pleasure.

A near neighbor who often dropped in to see Saint Gaudens at his studio on the Rue Notre Dame des Champs was the twenty-three-year-old John Singer Sargent. He was completing his studies under Carolus-Duran and already demonstrating a flair and a facility that would soon eclipse his master's. Augustus was very much taken by the "tall, rather thin, handsome fellow," and the two became fast friends.[8] One bond was that they were both enormously hard workers. "Without a brush in his hand he [Sargent] never seemed wholly at his ease," Rose Nichols remembered.[9] Both Sargent and Saint Gaudens, as they grew famous, could put on shiny good manners, but both were acutely private people, and rather shy.

Sometimes Sargent would, with his vast facility, finish a portrait quickly but go on painting a sitter for a day or two because he could not bear to say he had done all he could. At the same time, there was something in him "which made it impossible to lessen the imperfections and give complete satisfaction."[10] He could paint only what he saw and felt, and this too made him a kindred spirit to the sculptor.

When the time came to paint Secretary of State John Hay (whom Augustus also did, in marble), Sargent saw that he looked like a shrimp and painted him as such—all the while wishing that he *could* make him less shrimplike. Like Saint Gaudens, he had a healthy awareness of his own mastery. Nevertheless, he much preferred to be complimented on his piano playing, which was somewhat less than masterful.

Augustus' small relief of the painter, dating from those early

days of friendship, gives every evidence of having been struck off quickly. There is no border ornamentation, and the lettering is almost a scribble. The hair is tousled, the short beard and mustache lightly modeled. The inscription is BRUTO/RETRATTO or "sorry portrait," seemingly in apology. Nevertheless, there is a jaunty charm here, and the medal perpetuates in bronze a friendship that was rock-solid.

Another frequent visitor at the studio was Jules Bastien-Lepage. He and Augustus were very much of an age and had been contemporaries at the Beaux-Arts. Lepage was of sturdy peasant stock. Augustus recalled that he was "short, bullet-headed, athletic and . . . dandified in dress" in those student days, and also remembered "disliking him for his general cockiness."[11] On renewed acquaintance he found him a curious mixture of this early bombast and a dazzling talent. He had become a plein-airist, one of the school of open-air painters who went in for naturalism and simple detail rather than impressions.

Lepage's *Annunciation to the Shepherds* just missed the Prix de Rome in 1878 but gained a certain fame by the fact that Sarah Bernhardt laid a wreath on it in tribute. The following year, with his *Jeanne d'Arc* as a peasant girl, he won all the glittering prizes. Saint Gaudens was so impressed by the magic of the painting that he persuaded a New York collector named Irwin Davis to buy it. In due course the canvas found its way to the Metropolitan Museum of Art, where it still haunts and fascinates.

Despite a slight residue of distaste for the man, Augustus agreed when Lepage proposed that they exchange likenesses of each other, a full-length sketch for a medallion. Lepage's sketch was lost in the Cornish fire of 1904, but the clay portrait of the painter that the sculptor created in 1880 is among his finest. He himself considered it one of his three best in the genre, along with the *Samuel G. Ward* and the *Sarah Redwood Lee*. He has pinned Lepage the way a collector pins a butterfly. Wearing a young man's neatly clipped beard and that bounce of self-satis-

faction, Lepage cradles his palette and his brushes with the confidence of a master. Royal Cortissoz rated the modeling very highly: "The touch is at once caressing and bold. . . . It is portraiture for the sake of truth and beauty, not for the sake of technique."[12]

Lepage died a short four years later of cancer of the stomach, within weeks of his most loving artist-friend, Marie Bashkirtseff. In her celebrated journal Marie describes him more gently than the bas-relief does. The bounce and bombast become "that air of unaffected and amiable serenity which is characteristic of great men" and she grants him "that infinite charm conferred by the consciousness of power."[13] Yet the net effect of the bas-relief, for all the shrewdness of the observation, is also tender. . . .

In the same year that it was completed and cast in bronze, the Lepage bas-relief was bought by the Boston Museum of Fine Arts, marking Augustus' first sale to a museum. He and Lepage drifted apart after their exchange of likenesses, but later Saint Gaudens contributed time and money toward the memorial statue of Lepage, which Rodin designed for the painter's native village of Damvilliers.

One of the few bas-reliefs of the 1880s that were not of friends or artists is the double portrait of the children of banker and railroad magnate Jacob Schiff. It was begun in 1884 and finished the following year. Mortimer Leo is seven and Frieda Fanny is eight, in the big sixty-seven-by-fifty-inch rectangle. Augustus made fourteen sketches in charcoal and clay without finding a theme; the children seemed to float rather aimlessly in space. Then he struck on a happy inspiration: he posed the Saint Gaudens family dog, a Scottish deerhound named Dunrobin, behind the children. The dog's forepaws and elegant head are to the right, with the little girl's hand lightly grasping his collar. Hindquarters and tail are to the left of the boy, breaking the line of the pilaster that forms the border of the plaque. There is no whimsy here. The

dog holds the medallion together in a delicate and satisfying continuum from edge to edge.

In June 1887 Frances Folsom Cleveland, the tall, dark-eyed bride of President Grover Cleveland, was visiting her friends the Gilders at Marion, Massachusetts. Amid much publicity she had married the forty-nine-year-old President the year before. She was just under half his age and, everyone said, the most beautiful and vivacious first lady since Dolley Madison. Now they were looking for a secluded place to summer in. It had been the Gilders' suggestion that she try the off-the-beaten-track Buzzards Bay village where they had a studio.

Gilder also thought it would be a fine idea if Saint Gaudens came to Marion while Mrs. Cleveland was there and did one of his clay portraits. Frances Cleveland liked the suggestion, and so did Augustus. There were several sittings. The circular medallion that resulted is a qualified success. The First Lady has her hair piled high in a chignon effect, and wears a dress with a romantic Elizabethan cowl. She appears a woman of great distinction. Her nose is prominent, almost beaked, after the manner of so many of Saint Gaudens' women sitters.

Grover Cleveland never cared for the finished work.[14] Twenty years after sitting for it, Frances Cleveland voiced certain reservations of her own: "I object to calling it a portrait. It is an exquisite piece of work. I think it does not suggest me in any way, but it does suggest *him* and I am very proud to have this bit of his work."[15]

After Grover Cleveland's death and her remarriage, Frances Folsom settled in Princeton, New Jersey. In answer to a query from Margaret Bouton in 1945, she reached back over fifty-eight years, and her memory served her well: "Yes, of course I have the portrait relief. . . . We spent four summers in Marion to be near our close friends the Richard Watson Gilders. The sittings were in Mrs. Gilder's delightful stone studio with the famous Stanford White chimney." Then she quotes some advice given

her at the time: "Get it done while his wife is away. He always does better work when Augusta is not there."[16]

There is a codicil to the episode at Marion, in the form of a photograph Gilder took of Mrs. Cleveland posing for Saint Gaudens. She is seated on a platform; he is modeling at an upright easel. She is plumper than the bas-relief seems to imply, and the nose is definitely of more modest proportions.

As for Augustus, he looks frail and ill. It is a matter of record that he fainted during one of these sittings.[17] We also know that during his working hours his usual luncheon was an apple, and that he was beginning to have bouts of nervous depression. Fatigue and undernourishment may well explain the blackout, and the somewhat subpar Cleveland medallion as well.

Kenyon Cox's well-known portrait of Saint Gaudens dates from this same year, and shows the sculptor looking much more robust.[18] The hair is dark brown rather than red, the beard is reddish. The straight promontory of nose is the outstanding feature, as always. What is newer is a slight incipient melancholy in and about the eyes.

Cox's likeness shows Augustus in the process of modeling a bas-relief of William Merritt Chase, his friend of the Tile Club and the American Academy of Design. He is portrayed in an artist's smock and a perfect tam o'shanter, painting away. Although Chase was as plump as a pouter pigeon, there is an illusion of slenderness about the head and shoulders that is more like Saint Gaudens than his subject. And the profiled face itself, with sharp nose and beard, has strong overtones of the sculptor's own face.

Long after, Chase's sister-in-law remembered his pleasure in the elegant rendering: "Mr. Chase and Saint Gaudens made a bargain to make portraits of each other. Will painted a head of Saint Gaudens, and then he made a really beautiful relief of Mr. Chase. . . . Chase *loved* the portrait and had it built in over the big stone fireplace in the entrance hall in their Shinnecock Hills house."[19]

Two other bas-reliefs of the prolific 1887–90 period bring out

highlights of Saint Gaudens' increasingly complicated private life, and cast some shadows. That of Mariana Griswold Van Rensselaer is delineated so primly that it almost seems a cover-up. The other, bearing marks of open admiration, is of Violet Sargent, sister of John Singer.

Mariana was three years younger than Augustus. In the late 1870s, when he first met her, she and her husband and young son were living in New Jersey. She was just beginning to write the articles on art and architecture that would make her famous. Later, after the death of both husband and son, she contributed many articles to the magazines that affirmed her admiration for the sculptor and also showed a certain possessiveness. The fervent tribute to the Farragut was one of the first.

Saint Gaudens modeled the long, narrow plaque of Mariana during the period when he was reworking the bas-relief of Mrs. Cleveland, and making heavy weather of it. Mariana later recalled that he "sought solace" in having her pose, and also that he was especially intrigued by the challenge of the high lace collar she habitually wore.[20]

The finished portrait is the profile of a slender, handsome, almost formidable grande dame. The hair is upswept and braided in the back, with frontal curls. The mouth is pursed and anything but inviting. Yet we know from the bits of correspondence that have survived that a relationship which was certainly affectionate and at least mildly flirtatious had sprung up between them.

For example, there is a letter from Robert Louis Stevenson to Saint Gaudens from Saranac remembering a visit by Augustus, Mariana, and Will Low to his New York hotel room. Stevenson evoked the threesome like this: "Now in step, you and LeBas [his French nickname for Low] and Mrs. Van Rensselaer like three radiant angels, all arm in arm . . ."[21] The imagination of the invalid had obviously been fired by the visitors. The author's description seems a far cry from the tight-lipped, almost spinsterish lady of the bas-relief.

The tone of the exchanges between Mariana and Augustus is light. On September 30 (1888), just before Gussie's departure

for Switzerland and another cure, Mariana wrote to wish her well: "My dear Saint Gaudens . . . Please give my love to Mrs. Saint Gaudens and the same to yourself if you will have it, oh, maker of masterpieces!"[22]

On October 15 Saint Gaudens replied, possibly to the same letter: "Dear Mrs. Van Rensselaer: I have your note. Mr. Gilder told me Saturday that you had returned and I propose peeking in on you some evening this week. If I should not, however, you peek in on me some day when the sun makes you feel like taking a walk. At the end of the week the bronze lady [meaning his bas-relief] will be fastened to her setting."[23]

Another, undated note from Saint Gaudens that fits into this time frame explains why he has not been to see her: "I've done nothing but model, model, model furiously for the last month. I've been putting negroes of all types in the Shaw, and it's been great fun. I'm as happy as a clam over it, and consequently beautifully negligent of every friend no matter how much they may have passed before my vision as I was driving away at my dark-eys."[24]

This may be all we will ever know about the sculptor and the society lady whom he held in affection and some awe. Lois Dinnerstein, who has studied Mrs. Van Rensselaer closely, sums the relationship up like this: "I suspect that the playful tone probably represents gallantry on the part of the artist." She feels that Mariana's fragmentary notes "illuminate a relationship, not of lovers, but of a camaraderie of troopers in a holy crusade—that is, for the improvement of the arts in America."[25]

The Violet Sargent interlude, if interlude it was, is almost undocumented and is soon told. She was eighteen years old when she arrived in New York from England with her famous thirty-four-year-old brother in January 1890. For perhaps the only time in his almost passionless life, Sargent now fell extravagantly in love. His inamorata was Carmencita, the fiery Spanish dancer whose talent and temperament were the talk of New York. It was at one of her private performances at a late soirée, probably at William Merritt Chase's big studio, that Augustus first saw Violet.

Saint Gaudens, far more intrigued by Violet's profile than by the dancer, asked to do her portrait.[26]

The clay portrait which resulted was converted into marble. Violet is rather dashingly perched on a bench, tuning a guitar. Her legs are crossed informally, right leg over left. Even in an ankle-length dress, her right haunch has a swing and lilt to it. The usually hyperbolic Royal Cortissoz disliked the plaque intensely, calling its effect "awkward, even ugly," but he is dead wrong.[27] The bas-relief has the very spirit of youth in it. Violet is a pretty girl lovingly touched into life.

In return for modeling his sister, John Singer Sargent did a portrait of Homer at the age of ten, with his mother hovering protectively behind him. According to one of Sargent's biographers, the boy in the portrait is "naive, ingenuous and charming . . . without a trace of self-consciousness," so that must have been the way the artist saw him.[28]

After the completion of the plaque, Violet receded a little, merging with many others on the crowded Saint Gaudens scene. She spent two summers at Cornish, helping around the two studios at Aspet. She studied art in Rome and later married Francis Ormond, who was head of a Swiss watch consortium.

In the 1890s the Saint Gaudens bas-reliefs began to lose their intimacy and sense of immediacy. More and more, they were of public figures, modeled to help meet growing financial needs. A good example is the double portrait of Attorney General Wayne MacVeagh and his wife looking at each other with cool affection across their many years together. Still, the artistry remains very high, the draftsmanship impeccable.

Seen overall for the thirty-year period, the record is most impressive. The sculptor re-created a genre in his own images. Often imitated, they have not been matched. To paraphrase a line from the changing of the guard in *Hamlet*: For these reliefs, much thanks.

23

INTERLUDE WITH
DATES AND STORIES

THE YEARS 1888–91 marked the completion of two major projects that played large roles in the crescendo of Saint Gaudens' fame. One was the *Diana* for the Madison Square Garden tower, the other the monument in memory of Mrs. Henry Adams. These four years were also characterized by considerable activity and change, both in his public life and in his private.

In 1888 Augustus undertook what turned into a ten-year stint of teaching at the Art Students League. The school, which was the first independent art school in the country, had started back in 1875 with seventy pupils enrolled. By 1882, when it moved from West Twenty-third Street to West Fifty-seventh Street, there were nine hundred, in nineteen separate classes. Its distinguished faculty included Kenyon Cox, J. Alden Weir, and William Merritt Chase. From 1885 to 1891 Thomas Eakins instructed in anatomy, "molding the muscles in clay directly on the bones of human skeletons," a new method that enjoyed a considerable vogue.[1]

Augustus taught modeling, but insisted that his students be well grounded in charcoal drawing and anatomy before they came to him. He was patient with them and tried hard never to ridicule their work. But once, when a pupil showed "no gleam of intel-

ligence," he picked up a tool and slashed his work to pieces. At the same time, he softened what he felt was a necessary act by saying, "But cheer up, it's not your Waterloo!"[2]

Also in 1888, Augustus became a consultant to McKim, Mead and White, advising them on their ambitious plans for the Boston Public Library. The trustees had instructed the architectural firm to create "a palace for the people" on a plot across Copley Square from Richardson's triumphant Trinity Church.[3] In compliance, the firm envisaged a collaboration with the most gifted sculptors and painters of Europe and America. Saint Gaudens' own contribution was to be two symbolic groups of figures for the outdoor approaches, a project that never quite got finished. The architects also wished to avail themselves of his taste and judgment in selecting other artists. Unsurprisingly, Saint Gaudens recommended his brother Louis for the great stone lions in the hall of the main staircase and Daniel Chester French for the bronze entrance doors. The recommendations were accepted. Despite his great gifts, Louis St. Gaudens leaned heavily on his brother. When Louis struck a snag, Augustus pitched in, having carved many cameo lions in his day. So, with a pat on the back for the lions here and for Louis there, the animals were finished in time for the opening of the building in 1895. French's fine doors were hung in 1904.

The interior design called for a number of murals. Stanford White wanted all the artists to be Europeans, while Saint Gaudens held out strongly for American talent, including Sargent, Whistler, and Edwin A. Abbey. As usual, Augustus in turn consulted Paul Bion. His French correspondent wrote back with high praise for Sargent and Whistler, but only qualified praise for Abbey.

Abbey, who was making quite a name for himself as an illustrator, had just published his interpretations of scenes from many of Shakespeare's plays. "The originality of Mr. Abbey [Bion wrote] manifests itself mostly in sheer abundance, the inventing of picturesque detail, and he chose to take on Shakespeare who himself is not oriented to the visual sense. Shakespeare is not picturesque, he is passionate. . . . He never stops for a theatrical effect which we might know as a 'tableau.' Mr. Abbey's 'bric-a-

brac' is undeniably splendid, but it takes the Shakespeare out of Shakespeare."[4]

For once, Saint Gaudens did not defer to Bion's taste. Abbey received the commission to do the mural for the Delivery Room of the library, which was also foreseen as a place for people to mix while waiting for their books. The result was a stroke of good fortune. He chose a subject ideally suited to his own rich talent, *The Quest for the Holy Grail*. The wall painting makes the old Arthurian legends glow.

Two of the other muralists who agreed to tackle assignments were the Europeanized American John Singer Sargent and the Frenchman Puvis de Chavannes. So White was appeased, and Saint Gaudens very pleased indeed. Whistler and La Farge were also invited to contribute, but neither ever actually delivered.

The building is a Renaissance palace, noble, a little austere, but most elegant. "Under the library's quiet green tile roof," writes architectural critic G. E. Kidder Smith, "a caravan of thirteen arched windows marches across the façade . . . and picks up the arch motif of Trinity."[5] By being its equal in splendor, the library is perfect counterpoint to Richardson's Romanesque masterpiece across the square. The main credit for its design goes to Charles Follen McKim, but Saint Gaudens' taste and firmness merit an assist. Before the Boston Public Library project, collaboration between architect and artist in the design of public buildings had been sporadic at best. From then on it was standard procedure.

Some time in April 1888 Gussie miscarried again at the age of forty. Along with Homer and her mother she went to Switzerland in September for a two-month stay and another of her quests for a semblance of health.

An odd little incident in June of the same year showed that the name of Augustus Saint Gaudens was not yet as famous as it soon would become. At the time Leland Stanford, the California railroad magnate and Senator, was planning a university in mem-

ory of his son and only child, who had died at sixteen some years before. The campus was to be on a tract of land south of San Francisco, and Stanford had asked Fredrick Law Olmsted to make a topographical survey. He also sought Olmsted's advice on a sculptor to design the frieze for a memorial arch to stand at the entrance to the campus. Olmsted recommended Saint Gaudens, and a meeting with the Senator and Mrs. Stanford was arranged. Olmsted, who was also present, quickly realized that the Stanfords knew nothing of Augustus' work, and even had trouble with his foreign name. Nevertheless, the meeting seemed to go off well, and the sculptor was asked to prepare some sketches during the summer. A few days later Olmsted received a note from the Senator that upset him greatly: on second thought he and his wife had decided that "Mr. De Gordon" had better not try to do a model for the arch. The Stanfords were going abroad and would come back with drawings "of what we think we would like to have."[6]

One day in May 1889 Saint Gaudens paid a call on Daniel Chester French, whose studio was on Tenth Street. French had just finished his statue of Dr. Thomas Gallaudet and his deaf girl pupil, and the plaster cast was about to go to the foundry. The two friends talked shop for a while, with Augustus occasionally glancing at the group. Finally he unfolded his legs and started to saunter out of the studio.

French could stand it no longer.

"See here," he said. "I can't let you go like that, I've got to know what you think of my statue."

"Oh," Augustus answered, "it's a good statue, but the doctor's legs are too short. I thought you knew that."[7]

French, who was about to marry his cousin Mary in Washington, had allowed himself to be distracted by all the planning and excitement. Now, looking at his statue through Saint Gaudens' eyes, he realized that his friend was absolutely right. The legs of the cast would have to be sawed, and inches added. Writing

to Mary to explain that a postponement of the wedding was necessary, he made the best case he could: "When you can pin Saint Gaudens down and get a real criticism from him, it is better than anybody's and so what can I do . . . and meanwhile what kind of a lover will you think me anyhow?" They were married in July instead of June, on what Mary called wryly "a nice hot day in the hottest city in the world."[8]

The year 1889 saw the completion of one of Saint Gaudens' infrequent ventures into high relief (by definition, this is any piece of modeling in relief whose circumference is more than 50-percent detached from the supporting plaque). This particular creation stood almost totally free of the panel behind. It was a likeness of the Reverend James McCosh, who had retired as president of Princeton University shortly before. The sturdy figure of the Scottish-born clergyman was unveiled at the university's Marquand Chapel. Sad to relate, the chapel burned in 1920, and only the bronze head survived.

McCosh was a frequent visitor at the Thirty-sixth Street studio. Once he and Bernard Saint Gaudens found themselves together there, with time on their hands. Bernard launched into a fulsome description of his native Aspet and the Pyrenean slopes. He went on and on about the *genus populus* and how fast the poplars grew. In great detail he described the edelweiss and *narcisses*, the fields of yellow *plantagenesta*. Finally McCosh could take no more. "Ah, but do ye ha' gooseberries?" he asked mildly in his Scottish burr, giving the ebullient Bernard at least temporary pause.[9]

That same year, in addition to the McCosh, Saint Gaudens modeled a moody bas-relief of Kenyon Cox, who had painted his portrait two years before. In addition to his growing eminence as artist and writer, Cox was becoming one of the most sought-after teachers at the Art Students League. Tall, thin as a railbird, with

a shaggy black mustache, Cox brought a passionate intensity to his lectures on the Italian Renaissance. He and his family were early additions to the Cornish colony which formed a coterie around Saint Gaudens. "He was so temperamental he had days when he didn't speak," one of his Cornish neighbors noted, but as a critic and teacher he always seemed able to find the right words.[10]

Cox's teaching methods were not unlike Augustus'. His heart was warm but he could sometimes be a lot ruder than he meant to be. Once he criticized a pretty girl's work by saying, "What in hell did you do that for?" "None of your damned business," the girl answered. According to Mrs. Daniel Chester French, who records the story, "Her answer so appealed to him that he promptly married her."[11]

In June 1889 Augustus and Gussie made a quick trip to Europe along with Stanford White. The time abroad was two weeks, all that either of the men could spare from work. Gussie went straight to Switzerland and a favorite health spa. Augustus and Stanford White spent many hours at the World Exposition celebrating the centennial of the French Revolution.

Augustus explains another reason for the journey: "I was desirous of returning in what measure I could to my student life and environment, and for that reason occupied a little box of a room that MacMonnies offered me, fronting on a charming court where he had his studio."[12]

He picked up his friendship with Bion, already firmly held together by their correspondence, and also with Dr. Shiff and Alfred Garnier.

Working from a photograph, or simply from Augustus' lyrical descriptions, Garnier made Davida the subject of one of his much-admired enamels. Pre-Raphaelite in spirit, exquisite in its blues and purples and brown-golds, the small glaze is still in the possession of Davida's descendants.[13]

After his return to New York, Augustus wrote a friend of his

named Fanny Field Hering to explain why he had not seen her in Paris, although aware that she was also on a visit there: "I was twelve days in Paris and I did not go to see a soul. I passed my entire time at the exhibition and even in that way have created hatreds and jealousies in my immediate family that will never be forgotten. When you know them you will excuse my not having gone to see you during my absurdly short visit."[14] The reference to his immediate family probably alludes to Uncle François, who had not given him very long shrift in 1867, when Augustus was unknown and almost penniless. Convivial evenings with his old comrades at the various restaurants in the exhibition grounds had easy priority over family, and even over the likely charms of Mrs. Hering.

The 1889 Exposition contained much to enthrall and divert. Overshadowing the pavilions and exhibition halls on the Champs de Mars and along the Seine was the brand-new Eiffel Tower, at 984 feet the tallest structure in the world. The huge Galerie des Machines on the Champs de Mars, with its spectacular handling of steel and glass, presaged the architecture of the century to come—and completely blotted out the classical façade of the École Militaire. In celebration of a turbulent century, the young Third Republic gathered sixteen hundred paintings, culled mostly from private collections, and gave them sumptuous display.

Among the most admired works at the Salon, closely allied to the Exposition, were those of the Pre-Raphaelites. Both White and Saint Gaudens liked Edward Burne-Jones' *King Cophetua and the Beggar Maid*, with its dreamlike quality and meticulous detail. The use of anemones—scattered on the steps to symbolize inconstancy and rejected love—particularly appealed to them.

Paul Bion, who had been urging Augustus to come to the Exposition, told him that seeing Paul Dubois' artful, artless *Joan of Arc* would alone be worth the trip. Saint Gaudens' opinion lived up to Bion's prediction: "His *Joan of Arc* is, to my thinking, one of the greatest statues in the world. . . . For elevation, distinction and nervousness of style, it is extraordinary. It . . . makes a man wish to strive higher and higher."[15] The fact that it

had taken Dubois fifteen years to fashion his masterpiece was not lost on Augustus. He often cited it in later years, when his own delays began to drive clients to distraction.

A surprise sensation of the Exposition was a collection of American stained glass. John La Farge was well represented, and received high honors. In the words of a French critic, the panels "charmed the eye" when "the application is discreet and intelligent." But the writer also observed of the deeply striated, iridescent glass that "its thoughtless use makes it insupportable."[16]

Among the diversions, Buffalo Bill and his Wild West Troupe, performing for six sold-out weeks, larruped and lassoed their way into the hearts of thousands.

One more date in 1889 merits entry here: on September 23 in New York Davida gave birth to her son. He was named Louis, for his father's brother, and Paul, a traditional Saint Gaudens family name. His surname was Clark and his nickname, from early on, "Novy."

Although all Augustus' letters to Davida were destroyed, as already noted, another source casts some light on the family life of the Saint Gaudenses in the late 1880s and the 1890s. This is the collection of Gussie's letters to her best friend, Rose Hawthorne Lathrop, the daughter of Nathaniel Hawthorne. Gussie and Rose had known each other as girls in Boston. After Rose's marriage to editor George Parsons Lathrop, the Lathrops lived for a while in New York. In 1889 they moved to New London, Connecticut. Their only son died at about the time that Homer was born. Both Lathrops converted to Catholicism in 1891. After Lathrop's death in 1898, Rose became Mother Alphonsa and head of Rosary Hill, a New York State hospital for poor people suffering from cancer.

It is clear from the correspondence that Rose had compassion for Gussie's many ailments, and that Gussie in turn drew strength from their friendship. Gussie's salutations are always warm: "My

dearest darling friend," "My dearest Rosie Rosie," and the like. Certain themes recur in her letters. One is the urgency and necessity of the European trips. Here is a typical sample, written before she and Homer went abroad in September (1888): "This idea of going to Europe is not all rose colored to me as I must leave my husband but I feel I shall be so much more able to fill my place as his wife if I can get well again that no sacrifice is too much. . . ."[17]

Another recurrent theme is how much she is sustained by Rose's quick sympathy. Gussie reports that she has been in bed for a week and has had trouble sleeping: "I only tell you all this so that you will understand why I have not written before and how I wish I had your loving, sympathetic presence. . . . I wonder why someone must suffer so and try to keep it all bottled up. There are so few that I dare let it out upon and you are one of the few. . . . Now good night dear I am so weary. Lovingly Gussie."[18]

In October 1889, Gussie underwent surgery for a dropped kidney. Her mother and Genie took turns nursing her through the winter.

Two letters to Rose from Washington Place confirm that Augustus was otherwise engaged a good deal of the time. "My husband is so engrossed in his work and spends evenings and sometimes *nights* [Gussie's emphasis] at the studio," she confides to Rose in one.[19] And again, to her friend, "Today, the horse of the Shaw monument is being cast. It has been up more than five years and we have had constant fear of a collapse and latterly Augustus has been so nervous about it that he has slept at the studio."[20]

In May 1890 something happened that Gussie took very hard: "This house has been sold over our heads so in a few weeks adieu to the home of nearly eleven years. I am sad to go. I shall never find a home where I can live so easily. . . ."[21]

Their new residence was at 51 West Forty-fifth Street. Gussie's account of the move, written to Rose on May 13, tells us a lot about her mood, and her evasive action for the summer:

My dearest Rosie Rosie:

 I . . . have been in such a dust and turmoil that I can't write. . . . Plumbers and masons still in the house and nothing to show for it but our mantle pieces from 22 Was. Pl. in place of the hideous marble ones. The whole plumbing has been torn out nearly and new pipes put in. . . . The painters and paperers come next but when it is done we shall be simply clean, not pretty, possibly attractive. Homer, mother and I sail for Europe on the 28th of May and the latter part of June for Norway and the North Cape. My head is really better but I think I am still very nervous and so tired from the moving and turmoil. . . . I hope, to be home the middle of September and have a few weeks in Cornish. What is your wonderful secret work? Can't the fun be shared I should like to laugh too. . . . Lovingly Gussie."[22]

From May to September, and thereafter, Augustus came and went as his work dictated and his heart willed. For most of the next two years, until her move to Connecticut, Davida was a near neighbor, at 143 West Forty-fifth Street.

During that late spring and summer of 1890 he commuted to Cornish as necessary, where both modeling in clay and casting in plaster were in progress. Plaster casting was an important part of the activities there for a very good reason: if clay models were shipped by train there was a great risk of collapse and disintegration. Suitably packaged, plaster casts could be safely sent to New York and the foundries there.

The pattern for the winter of 1890 and the following summer was similar, except that Gussie stayed home. She worked hard and competently, handling a good deal of Augustus' correspondence and even supervising work at the various studios during his frequent trips.

In February 1891 Augustus went to Chicago to help plan the upcoming Columbian Exposition. At the insistence of Chicago architect Daniel H. Burnham, the overall director, he had been selected as principal adviser on sculpture. The Exposition, cel-

ebrating the four hundredth anniversary of Columbus' discovery, actually opened a year late, but no one seemed to mind very much. (Even before its official opening people called it the "Chicago World's Fair.") The nation's self-discovery that it was bursting at the seams with a pioneer energy channeled into science and art was what the fair was really all about, and for that, one year was as good as another. . . .

On October 1891 there took place in New York an unveiling that marked the beginning of the city's long love affair with a Saint Gaudens creation.

24

DIANA OF THE CROSSWINDS

"Let us be Diana's foresters, gentlemen of the shade, minions of the moon; and let men say we be men of good government, being governed, as the sea is, by our noble and chaste mistress the moon. . . ."

—Falstaff in *King Henry IV, Part I*

IMPERIOUS, IMPERVIOUS, beautiful beyond the dreams of men, she rode the New York skies. Her perch was so high that she was the first thing the sun's rays touched at dawn and the last at the fall of night. She was made of strips of sheet copper, invisibly riveted. Her first appearance was not exactly an unveiling, for all she ever wore was the trailing scarf that helped her turn at the wind's will. Her taut bow and swift arrow pointed where the wind lay. On opening night, under the sudden blaze of ten arc lights and sixty-six incandescent lamps, she burst full grown to life. Her name was Diana.

New York gave a collective gasp, and a few whistles. From the do-gooders and the easily shocked came a storm of criticism. Was it proper, they asked, was it *decent*, to put a nude figure of a woman in so public a place as Madison Square—347 feet above it, to be exact—for millions to see? The Philadelphia *Times* was

quick and pious in deploring "the depraved artistic taste of New York," and so were others in the media. [1]

New Yorkers in general took a less jaundiced view. They saw the *Diana* as the crowning glory of Stanford White's new Madison Square Garden, the second Garden and the more glorious. She was simply the finial on the tower of Mr. White's all-purpose pleasure palace—the hippodrome-concert hall-theater-ballroom-roof garden and lord-knows-what-else which was adding new fascination to his name. Some wits said no, that wasn't quite the case: the huge yellow brick-and-terra-cotta extravaganza was simply the architect's rather elaborate pedestal for Augustus Saint Gaudens' loveliest creation.

Whichever her role, the timing of the *Diana*'s appearance was excellent, for America was still in that period of fabulous firsts. The nation's capacity for wonder remained very fresh and new. In 1884 the miracle had been the Brooklyn Bridge, whose span was the longest in the world and whose Gothic towers were New York's highest. Two years later came the Statue of Liberty. When French sculptor Auguste Bartholdi pulled a giant Tricolor from her noble face, and a flotilla of three hundred ships whistled and grunted in the bay, New York became the proud possessor of the earth's biggest statue.

Not wishing to be totally upstaged, the nation's capital in 1888 staked out its own claim. Forty years, two months, and five days after the laying of the cornerstone, the Washington Monument was opened to the public. Weighing in at something over eighty thousand tons, and reaching a height of 555 feet, 5⅛ inches, it was incomparably the biggest obelisk the world had ever seen.

Then, in October 1891, the *Diana* flashed across the night sky. Her credentials were impressive. She was higher than any other statue in New York. Specifically, she was forty-two feet nearer heaven than her closest rival, the Statue of Liberty, whose extended arm and torch were 305 feet above New York Bay at mean tide. She was also a shade nearer than the gilded crown of the Singer Building, which was the tallest "skyscraper" of the day. [2] Other claims to fame on the part of the *Diana* were that

she was the first statue ever to be illuminated by electricity, and Saint Gaudens' only female nude. She was also his first nude of either gender since the misbegotten, half-forgotten *Hiawatha*. She was eighteen feet tall and weighed just under a ton. Mounted on ball bearings, she swung with the wind when the pressure per square foot reached a quarter of a pound.

The tower, which was an attenuated copy of the Giralda of Seville, served several purposes beyond its role as prop for the *Diana*. It also acted as a beacon: when there was a production on, searchlights would sweep it "so that all New York knew there was something playing at the Garden."[3]

Girdling the elevator in the seven-story tower were studios reserved for the architect White and his friends. There the lights often burned late and low. One of the studios was Stanford White's own "Snuggery." Long after his insensate murder in the roof garden, Evelyn Nesbit Thaw remembered watching her mentor working away at one of his designs, "piling mounds of rumpled paper until the morning light broke."[4]

At the top of the tower, reached by a spiral staircase, was a circular balcony with room for just two people. One of White's diversions was to guide favorite guests to this perch high above the sleeping city. From it they would reach up and touch Diana's foot, and feel her turn in the wind. . . .

The original Madison Square Garden, which opened in 1879, was a fairly drafty shell, a circus barn that fast outlived its usefulness. In the early and mid-eighties there had been some fine attractions—Jenny Lind, John L. Sullivan, and P. T. Barnum's circus among them. The circus had two great drawing cards in General Tom Thumb and Jumbo, the elephant who was good with children and played to some four million of them in the course of four seasons.

But cold weather drove the circus south in winter, and the auditorium itself proved almost impossible to heat. Horse shows, flower shows, and conventions were all right for a week's top billing, but the intervening weeks saw a proliferation of empty seats.

What the society leaders of the Horse Show Association and the syndicate of millionaires led by John Pierpont Morgan wanted was something a little more fabulous, a little more in keeping with the times. Even before the old circus barn was torn down, they consulted Stanford White and offered him a $75,000 commission to carry out their ideas. White accepted with his usual alacrity, but suggested that the $450,000 tower be added to give the new complex some real grandeur. The captains of finance capitulated, although the market was plunging at the time. The ultimate cost, tower included, was three million dollars.

Wrecking crews began to demolish the old Garden in July 1889. The new Garden opened on June 17, 1890, with seventeen thousand people paying up to fifty dollars apiece to take part in the celebrations. The tower would not be finished for another sixteen months, but the curtain went up in record time and the show went on.

Stanford White had long been aware that Augustus Saint Gaudens wanted to create an idealized nude figure along more spectacular lines than anything he had yet attempted. Now White offered to underwrite all expenses, provided Saint Gaudens would contribute the statue itself. Finding that his friend the architect was in full agreement that the goddess Diana would lend herself ideally to a role on the pinnacle of the tower, Augustus agreed to undertake the job.

He had already created the idealized head: the bust of Davida modeled in 1886 would do very well. All that was needed to make her into the moon goddess was a crescent moon in her hair, and a magnificent body. In his conscientious way, Saint Gaudens began to read everything he could find in Greek and Roman mythology on Diana's deeds and characteristics, and to refresh his memory of earlier sculptured Dianas.

He learned, of course, that she was Artemis in the lore of the Greeks, that her father in Roman mythology was Jupiter, her twin brother Apollo. At the age of three she made certain rather precocious requests of her father. She asked for a bow and arrows, eternal virginity, and dominion over the mountains and wild places

of the earth. Her indulgent father granted them gladly. Because her mother, Leto, had borne her with no pain, she decided that it was the will of the Fates that she be the protector of all women in childbirth and, by extension, of all children. Other kindred responsibilities described in many of the myths were the moon and the tides, wild animals, woodlands, fields and streams, fertility in all nature. . . .

Augustus found that two scenes recurred often in the Diana-Artemis legends. One depicted the goddess bathing naked in a sacred fountain or secret pool, a rite often billed as the renewal of her virginity between lovers. The second scene stemmed from the first. Actaeon, lone hunter and in some versions king, has come upon Diana in her ablutions. For this invasion of the deity's privacy the hunter, the king, must die. Diana changes him into the stag which is his quarry, and he is killed by his own hounds. In a variation, she herself kills Actaeon with her bow, and then takes another bath to purify herself.

How much Augustus heeded all this lore when creating his own *Diana* is hard to guess. The *Reminiscences* tells us almost nothing except that the statue "was purely a labor of love" in the sense that he took no pay.[5] By the time the memoirs came to be written, the watchful family was well aware of Augustus' relationship with Davida and the close resemblance she bore to the figure on the tower. So the references to it, two in all, are muted and amount to just over a paragraph.

Literature, painting, and sculpture on the subject of the moon goddess helped to inspire him. We know that Saint Gaudens was fond of Shakespeare. In those middle years of intense self-education he may well have come across the magic lines beginning "Let us be Diana's foresters," which form a tribute to Elizabeth the Virgin Queen as well as to Diana the chaste goddess. Peter Lely, court painter to the later Stuarts, portrayed Princess Mary, daughter of James II and later Queen, as a vigorous huntress wearing that crescent moon in her hair.

In sculpture there were many exemplary Dianas. Jean-Antoine Houdon made her into a sumptuous eighteenth-century

beauty (1792) much admired in the Paris of Augustus' time. Of somewhat more immediacy was Jean-Alexandre-Joseph Falguière's interpretation, which was one of the sensations of the 1882 Salon. Paul Bion, Augustus' indefatigable correspondent, was well aware that his American friend liked Falguière, and kept him fully posted on his work. He reported that he displayed "a figure of Diana which I like, very lively and well modeled but a bit coarse and unimaginative. Too much a mere pose of a model."[6]

Falguière was born in Toulouse in 1831. He was a product of Jouffroy's atelier, and became a professor at the Beaux-Arts the same year that he showed his *Diana*. His big lusty nudes under names like *A Hunting Nymph* and *Fighting Bacchantes* were eagerly awaited at the Salon. "Each time it was for the public an amiable little scandal," French critic Léonce Bénédite noted. "Like every good southerner, he was sensitive to glory and did not disdain, occasionally, the accolades of a slightly unhealthy popularity."[7]

Falguière's fame, fairly forgotten now, lasted until his death in 1900 and for some years thereafter. "He often gave proof of his talent, never of his genius," is the way one writer summed him up.[8]

Everyone in Paris knew that Falguière's down-to-earth *Diana* was a copy to the life of a famous French model. In the case of Augustus' lighter, lither version, the origin of the head was Davida as we have seen. The body was copied from Julia Baird, whom people in the New York art world called "Dudie." Dudie lived over the back room on Tenth Street where the Tile Club had its meetings. She was a familiar sight in many of the studios of the Sherwood Building and the restaurant on its ground floor. She posed for the best-known artists of the day, Edwin A. Abbey, Kenyon Cox, T. W. Dewing, Edwin H. Blashfield, Robert Reid, and Edward Simmons among them. She disdained lesser men, feeling that a mediocre artist could diminish her own talents. She preferred not to pose for women or "society" artists, who paid well but whose ideas ranged further afield than those of the pros. Her fee per the normal forty-five-minute hour was the usual fifty cents "for the figure" and a third less when draped. She knew when to be silent and when to talk, and could quickly slip into

any pose from a regal Science on a Throne to a cherub crawling out of a cornucopia.

In an interview in 1897, some of Dudie's effervescence came through: "The thrones I haven't sat on are so few that you could count them on your fingers. For a person who is not royalty I have reigned on more than probably any other woman in this land." She scorned posing for art schools: "I don't care to pose at wholesale." Asked if she objected to modeling for the nude Diana, her answer was: "Not at all. I have often posed for artists in the 'toot and scramble,' if you choose to call it that."[9] (This interview took place at a time when George du Maurier's novel *Trilby* was still sweeping the country. Its heroine was an English model so beautiful she even had beautiful feet. Shoes were called "Trilbies" in her honor. A cigar, a cigarette, a bathing suit, and a restaurant all bore her name. In the novel Trilby spoke of posing "in the altogether." Across the Channel in France this received the literal translation of "*tout ensemble.*" Traveling to America, it became the cheerfully nonsensical "toot and scramble.")

Augustus had known the snub-nosed Dudie of the perfect five-foot-six-inch figure since his own Sherwood Building days. She was a natural for the first weather-vane version of the *Diana*, which he modeled at a time when Davida was preoccupied with her small son. Another consideration was that Davida's figure, although excellent, was better suited to classical drapery and girdles of flowers.

As things turned out, there were two *Diana*s. On that first night in 1891 when the *Diana* burst upon the New York scene, both Stanford White and Saint Gaudens saw that she was out of proportion to the slender summit of the tower. Even before the opening, their friend Thomas Dewing the painter had warned them that the scale of the eighteen-foot figure was wrong. But they had brushed aside the warning on the grounds that he was "only an artist."[10]

Several other matters upset Augustus. The workmen had driven the connecting rod through Diana's heel rather than her toes, giving an effect that was not so airborne as he had hoped.

The trailing drapery was not so graceful as he had intended; some people mocked it for looking like the handle of a teapot.

The result was that the first *Diana* was removed from the tower in September 1892. The alterations cost White more in dollars and Saint Gaudens more in time than either had ever dreamed, but the lesson was learned: *always and always set up a dummy first*.

Dudie posed again. Since time was of the essence, she was on duty for many long hours. This gave rise to a legend that she herself perpetuated in that 1897 interview: that the sculptor caused a plaster cast to be made directly on her body, in order to catch its perfections as quickly and as accurately as possible. "Of course," said Dudie airily, "you mustn't think I was plastered all over at once. . . . I was, so to speak, plastered in sections." Nor could she have stood on one foot all day, she went on to explain. "Mr. Saint Gaudens had two ladders placed in such a position that I could be propped up on them. . . . I didn't dare move for the slightest motion would have spoiled the mold."

It makes a lively story, particularly the part where the mold was cut by a thread and removed in two sections: "ticklish moment," Dudie said, "in more ways than one."

The story has been scouted by many. The most convincing argument against it is the plaster cast, which has survived and can still be measured at the Saint Gaudens Site at Cornish: its measurements do not match Dudie's matchless ones. What Saint Gaudens modeled and sent to be enlarged is six feet high. "Although anything is possible," one skeptical art historian comments, "Miss Baird must have had to do some stretching."[11]

On November 18, 1893, the second *Diana* was hoisted into place. Comment in the New York *Tribune* mirrored the mood of the city: "Our new *Diana* will rise at dawn today, weather permitting, to delight . . . with all her glistening beauty." She was thirteen feet tall instead of the outsized eighteen, and slimmer than ever. That left foot, now linked to the globe below by the toes, seemed barely to graze it. The crescent moon in the hair was gone, and

the scarf like a teapot handle had become a free-flowing swathe of drapery, cinched below the breasts by a casual bit of ribbon.

There was husbandry in the fate of the first *Diana*. She was shipped to Chicago to play a part in the World's Fair. She delighted millions from her new post atop the central dome of the Agriculture Building. The following year a fire destroyed most of the dome, but *Diana's* upper half survived and went on to live for a while in the basement of the Field Museum. She was last seen in the Saint Gaudens retrospective at the Chicago Art Institute in 1909, but disappeared thereafter without a trace.

The second *Diana* continued to delight most New Yorkers and to exasperate the watch-and-warders. Her fans gave her nicknames like "Diana the Huntress" and "Diana of the Crosswinds" (a play on *Diana of the Crossways*, the George Meredith novel). O. Henry and Willa Cather made her a symbol in their books. Actress Ethel Barrymore took a small bronze replica with her on tour, and lightweight champion Benny Leonard never failed to look up at her for luck and reassurance before a fight in the Garden.

There was a marked change in the population of the benches and paths in Madison Square. Nannies whisked their charges to greener fields. Elderly gentlemen with field glasses and memories took over, hands shaking a little as they focused on "the highest kicker of them all."[12] An article in the *Mercury* noted that "Delmonico elegants, Casino Johnnies and every other variety of local dude linger in listless idleness." An Irish policeman on the Madison Square beat explained to the *Mercury* reporter what had happened: "It's all along of her," he said. "I don't think no such statue should be allowed meself, not in a public place."[13]

The do-gooders never relinquished their onslaught. Leader of them all was the insatiable Anthony Comstock, one-man army attacking anything he considered objectionable or obscene. At last, in the summer of 1906, he was put on the defensive. *Collier's* ran a cover showing *Diana* clothed from wrist to ankle in heavy cloth and wearing a placard that read CREATED BY ST GAUDENS / PURIFIED BY ST ANTHONY COMSTOCK. Just below, on

a ladder, was Comstock, wearing a halo and blowing a trumpet labeled CHEAP NOTORIETY.[14]

As it had once before back in the 1880s, the Garden began to lose money. Except for five early years, it never did pay for itself. The impresarios tried everything, but even converting the amphitheater into an ocean and restaging the Battle of Santiago in miniature only helped momentarily. There were six-day bicycle races, prize fights galore, Adelina Patti singing "Home, Sweet Home" with a chrous of a thousand voices, Paavo Nurmi (the "Flying Finn") with his five Olympic medals. But none of it was ever quite the answer to a building in the red. Besides, the heart of the city was shifting farther uptown. One of the last great spectacles was the marathon Democratic Convention of 1924. In a gallant, hopeless gesture, Tex Rickard had made the Garden available without charge.

By January 1925 there were symptoms that the end was near. Wrecking crews appeared uptown on Eighth Avenue to clear away some trolley-car barns on the lot where a new Garden would rise. Four months later, the crews went to work on the old Garden. Wrapped in burlap, the *Diana* was lowered from her doomed tower and trucked to a Brooklyn warehouse. There she languished for seven years, despite rumors that the tower would some day rise again. Finally she found a handsome home atop the grand staircase at the Philadelphia Museum of Art.

The end for the Garden itself came on the night of May 5, 1925. The scheduled event was a prize fight, but most of the capacity crowd had come to say good-bye. A sergeant of New York's Sixty-ninth Regiment blew "Taps." Joe Humphreys, the gravel-voiced announcer, led everyone in a chorus of "Auld Lang Syne." Then he recited a poem of his own, which was not exactly deathless verse but did catch the mood of the evening:

> Farewell to thee, O Temple of Fistiana,
> Farewell to thee, O sweet Miss Diana.[15]

The goddess, as usual, had the last word.

25

COMING TO TERMS

WHEN DID AUGUSTA discover Davida's existence? We know that both women were in Paris with Saint Gaudens at times during the three years ending the 1890s. They *may* have been there on the same trip, and there may have been a confrontation. But a better case can be made for the spring of 1892 in New York.

The piece of evidence that establishes the fact that the discovery did take place at some point is an undated letter written by Saint Gaudens to his wife that leaves no doubt that he had been found out. For some reason the letter survived the family's tidying-up process after the sculptor's death.

It is a classic of its kind:

> Dear Gussie Sweetness and kindness in women is what appeals mostly to men and a blessed charity for human failings makes one well beloved. The quiet dignity of Mrs. Mac-Monnies and Mrs. White toward the gross action of their husbands is far finer and commands a deeper respect than any other attitude they could possibly have taken and way down in their hearts their husbands respect them all the more altho my action is a mere peccadillo in comparison to them it has caused me a misery of mind you do not dream of
>
> You are a noble woman Gussie and I love admire and respect you more than you have any conception of We are

both [illegible] and for our mutual peace of mind on this earth I beg of you not to come down from the high place you hold in my heart G[1]

This letter reminds us how well Saint Gaudens could express himself when so minded. In comparing his own transgression to the more flagrant sins of Willie MacMonnies and Stanford White, he speaks for all errant husbands. Even if the word "peccadillo" seems self-serving, considering that the affair with Davida did produce a child (and was already turning into a lifetime commitment), the letter has quite a righteous, or at least self-righting, ring to it.

Stripped of the rather lofty tone, the meaning is clear enough: Don't make it too hard on me. I won't change my way of life but I'll try not to embarrass you.

The case for attributing the timing of the discovery to the spring of 1892 is that two events come into clearer focus if they stem from a showdown between husband and wife. One is Augusta's sudden departure for a long sojourn abroad in late May. This trip lasted until mid-October. The other event is Davida's late-June exodus from Forty-fifth Street to the house in Connecticut. One can almost hear Augusta's parting injunction to have "that woman" out of the neighborhood by the time she herself comes home.

How Augusta learned about Davida can only be a matter of speculation. Some time in early 1892 Augustus modeled a bas-relief of two-year-old Novy. Gussie knew very well that the sculptor used bas-reliefs primarily as expressions of intimacy and affection. It strains credulity that she did not inquire into the identity of the child when she first saw the plaque at studio or house.

A ten-inch cast of the Novy medallion was actually exhibited that December in a retrospective show of the Society of American Artists. It was simply labeled *Child's Portrait*, in all likelihood out of deference to Gussie's feelings.

Whether the discovery took place in 1892 or later, we surely know one thing: Augustus Saint Gaudens never relinquished his second life until his dying year.

Saint Gaudens' handwriting, when studied by the trained graphologist, confirms certain known traits of the sculptor and suggests others. According to one expert, the hand is a splendid one, "very free and flowing."[2] In general terms this freedom bespeaks the writer's flexibility. The long tails on the word endings, which contribute to the sense of flow, show a generous spirit.

The capital letters are low, "with no swelling or bulge to them." This, in our expert's opinion, is the mark of a modest man—something that Augustus was in the truest sense, in that he was a man who knew his own worth.

The high bar he makes on his "p" is a token of high spiritual aspirations. Augustus was not a churchgoer; he had an almost morbid fear of death and not much belief in the hereafter. Yet there is a spirituality in his angelic figures which can but stem from something spiritual in his heart of hearts.

The way his words follow one another, almost tumbling over one another in their haste, shows his friendliness. The long interweaving "t" bars are indicative of the further gift of empathy. The manner in which the dots over the lower-case "i"s are quickly flicked in proclaims the light touch—the wit and humor that Augustus possessed in such good degree. Concerning his upper-case "I," our expert declared, "I have never seen a capital 'I' like it." Saint Gaudens' are bold upright, with a slightly reverse loop at the top not unlike a tiny cavalry saber. "These upright 'I's,'" the expert concludes, "show his pride. The little loop is artistic and tasteful as well as unique." And as such is confirmation of Augustus' almost infallible eye. There are occasional breaks in the "o" loops, which may be construed as indications of health problems to come. Again, in general terms, the expert opinion is of a grace and rhythm in the script, and something of the exuberant as well.

Saint Gaudens' great bold signature adds to the sum of our knowledge of his character.

There is a sensuality in its boldness and in the firm heavy lines. The flick in the tail of the "G" is evidence of the quick temper and the dot placed so high over the "i" bespeaks his idealism and aspirations. As a whole the signature shows his awareness of keeping a high front to the world and affirms his not-inconsiderable vanity.

Handwriting is revealing because the expert can detect attempts to disguise basic traits and draw further conclusions from them. In the case of Saint Gaudens the handwriting is especially useful to us because he was an intensely private person and not much given to self-revelations. Nor was he articulate on such matters as life, death, and the hereafter. He enjoyed long philosophical discussions with Dr. Shiff, but it was the expatriate doctor who did most of the talking. Every now and then Augustus would interject a pungent phrase: "I once told Shiff that at times I thought that 'beauty must mean at least some goodness.' "[3]

A few shards containing his views on matters transcendental have come down to us. Writing to his favorite niece Rose Nichols, he unburdens himself more than he does to anyone else: "You have often wondered what I think about things. I wonder myself. I think anything and everything. This seeing a subject so that I can see either side with equal sympathy and equal conviction I sometimes think a weakness. Then again I'm thinking it a strength."[4]

He finds that his work best expresses any nebulous philosophy he may evolve in his head: "Yes, 5000 different points of view are possible. After all we are like lots of microscopical microbes in this infinitesimal ball of space. . . . I suppose that every earnest effort toward great sincerity, or honesty, or beauty, in one's production is a drop added to the ocean of evolution, to something higher that I suppose we are rising slowly (damned slowly) to. . . ."[5]

This sense that we are all drifting recurs often: "The prevailing thought of my life is that we are on a planet going no one knows where (Darwin, evolution). But whatever it is, the passage

is terribly sad and tragic, and to bear up against what seems at times the great doom that is over us, love and courage are the great things. . . ."[6]

Despite this tragic sense of life, his outlook is essentially a healthy and sanguine one: "In one of my blue fits the other day . . . reasoning about the hopelessness of trying to fathom what it all means, I reached this: we know nothing (of course) but a deep conviction came over me like a flash that at the bottom of it all, whatever it is, the mystery must be beneficent; it doesn't seem . . . something malevolent. And the thought was great comfort."[7]

Since Augustus Saint Gaudens was artist to the bone, all the things which were dreamt of in his philosophy boil down to his feeling about his craft: "After all, it's the way the thing's done that makes it right or wrong, that's about the only creed I have in art."[8]

Gussie, her mother, and Homer cruised to the Arctic Circle in July 1892 and then spent August and September in Paris. During their time abroad, Genie kept house in Cornish for Augustus, and dutifully reported his comings and goings. On September 13 she wrote her mother to "tell Gussie that he seems very well and busy. He is working hard on a Shaw negro, and yet enjoyed being here for two or three days every once in a while and 'mulling around.' "[9]

Gussie saw Paul Bion several times while she was in Paris and filled the Frenchman in on Bernard Saint Gaudens' failing health and brother Louis' recurring bouts with alcoholism. "I have chatted quite a lot with your wife," he wrote Augustus on September 6. "I got from her the details of the paralysis of your father, which made him more a survivor than a fully alive individual. . . ." On Louis, Gussie's tidings as played back by Bion were not much better: "The lack of capital, the illness . . . the lessening of character and will which resulted once the habit had been acquired, it's like a broken tree trunk."[10]

(Louis St. Gaudens never did completely overcome his prob-

lem. In Cornish, when he felt a binge coming on, he would climb a windmill, pull up the ladder after him, and drain a full bottle of bourbon at his leisure. Only after sleeping it off in the tower room would he finally lower the ladder and rejoin the world.[11] In 1898 Annetta Johnson, a student and assistant of Augustus', married Louis, hoping to reform him, and achieved some success.)

Bion was most sympathetic: "All this shows me that you have many burdens and preoccupations outside your sculpture." He speculated whether these troubles were necessary "to purify your spirit and your ability to feel and transform them so that they can hit the high note" in Augustus' creative endeavor.

A few days later, Bion wrote to apologize for calling Gussie "a hotel sofa" in one of his earlier letters. "I've joked around a bit in regard to her. Actually it is quite sad for you. You have a poor anemic woman. 'Neurasthenic'—the word doesn't help to explain the frailty of her body or her temperament. . . . So I understand your desperate clinging affection towards your brothers, your loved ones, to that which has nourished your heart."[12]

Bion was of course very much Saint Gaudens' man, and had never cared much for Gussie. But a more professional judgment emerged from this same visit. This was the diagnosis of a celebrated French physician named Charest, after several appointments and quite a few tests. Since the doctor spoke no English, Gussie was accompanied to the key meeting by Mary Fairchild MacMonnies, the bilingual bride of the sculptor. After the meeting, the charming Mary, who was herself an artist and as gentle as Willie MacMonnies was flamboyant, set down what she had heard in a letter to Gussie:

Dear Mrs. St Gaudens:

Here is what Dr. Charest said to you as nearly as I can recall it: in general the cause of your trouble in the head is Anemia; also your naturally nervous temperament is still suffering from the shock of the operation you have undergone. He said it was useless to look for the cause of your trouble in the kidney or in uterine maladies from which you have

suffered, they being quite apart. He said you have had a great deal of experience with the surgeons and now it is time to stop. He said the noise resulting from the deafness will not be helped, but the other he believes will disappear . . . with the use of the remedies he prescribed. . . . He told you you needed slight stimulants all the time, either wine with your meals or whisky in the water you drink. . . .

Urging her to follow the six-week treatment prescribed, Mary MacMonnies then ventures her own opinion:

I think he was *extremely encouraging* and that you had better decide to chase away the little blue devils and decide with him that there is practically very little the matter with you. Take things easily and cheerfully, and swallow his prescriptions obediently in the full conviction that you will be cured in a comparatively short time. . . . Dr. Charest is a very great man and if he gives you such encouragement I think that you may permit yourself to be very hopeful. . . .[13]

The suspicion grows that Augusta Saint Gaudens enjoyed a certain amount of her undoubted ill-health, and used it, in Frances Grimes' not unsympathetic view, "to avoid doing certain things she did not want to do."[14]

By October the travelers were home again. With Gussie's return a period of adjustment set in which taxed Augustus' philosophy—basically hopeful yet with crosscurrents of melancholy—to the full.

Meanwhile, the statue of his that more than any other embodies his stoic sense of life, and which is also an apogee in his quest for the good and the beautiful, was already well into her endless vigil.

26

THE ADAMS MONUMENT

"I have put away sorrow like a shoe that is worn."

—J. M. Synge,
Riders to the Sea

SHE SITS DEEP in the hush of a holly grove. The womanly figure, who some say is neither man nor woman, is slightly larger than life. The hood of her heavy cloak causes the face to recede as into a cavern, so that she seems mantled in mystery. The heavy-lidded eyes are lowered; the lips are full and, again, womanly. The nose, like the noses of so many of Saint Gaudens' women, whether angelic or of the earth, is strong and firmly fleshed.

The raised right hand does not touch the face but hovers beside it with an equivocal, questioning life of its own. The toga-like cloak covers all but the face, the raised hand, and the powerful forearm below it. Under the coarse drapery the knees are slightly parted. One rich fold cascades between them all the way to the rough stone base.

She is totally still, with a stillness of the ages and for them.

The grove is lined with holly shrubs, and holly trees arch over it. Hexagonal in form, it is some twenty feet across. Opposite the statue and forming three sides of the hexagon is a stone bench. From it the figure can be contemplated in peace, for there are few visitors. On sunny days, some dappled light filters through.

But the overgrowth is such that the effect is of a sanctuary cut off even from the muted comings and goings of the cemetery. A few birds flit through the holly trees but no bird has ever been seen to light on the bronze statue itself.

The statue and its history both have an aura of mystery and paradox. It is popularly known as the *Adams Memorial*, but this is something of a misnomer. It is indeed a statue in memory of Marian Hooper Adams, who committed suicide in 1885. But nowhere on the red granite block before which the figure sits, or even on the bench across from her, have any name or dates been inscribed. Furthermore, the noble face bears no resemblance to Marian Adams, who was better known as Clover. For Clover was "small and sharp and funny and by no means a goddess."[1] To add to the sense of paradox, Washington's Rock Creek Cemetery, site of the statue, is several miles east of Rock Creek. Many visitors go first to Oak Hill Cemetery in Georgetown, which does overhang the creek, convinced that the famous statue must be there. For many years there was a sign on the high iron gate of Oak Hill with a laconic message on it: "No, it isn't here."

What does the figure mean? Is the message one of hope or despair? Or simply of survival and forbearance? Mark Twain's comment was one of the earliest, and it has persisted: "All human grief is shown in this sad figure."[2] But it is a misconception, for the figure transcends grief and has an element of the supernatural. She seems to sit at some far meridian of the known and unknown, some outer boundary where the finite touches the infinite.

Many call the statue "Nirvana." Henry Adams, possessive about the work he commissioned, said it was "The Peace of God," at the same time recognizing that no two observers reacted in exactly the same way.[3]

As for Saint Gaudens, he hated to be pinned down. Once, when cornered, he confessed that "The Peace That Passeth Understanding" came quite close to what he had in mind.[4]

The relationship of Henry Adams and Saint Gaudens plays such a central part in the genesis of the monument that some facts about Adams' life and his complicated personality are nec-

essary. Much has already been written. Books and articles about his mind and friends and works have become a kind of cottage industry; his sparkling letters have been published in many segments, with a comprehensive edition currently appearing. All that can be done here, in short space, is to touch on the highlights of the life.

Adams was born in 1838 in the shadow of Boston's State House. His blood was of the bluest, if beginning to run a little thinner than in the early days of the Republic. His great-grandfather was the second President of the United States, his grandfather the sixth. His own father, Charles Francis Adams, did the nation great service as Minister to Great Britain for the seven years during and just after the Civil War. Henry served as his secretary, feeling a little guilty at not coming home to fight for the Union but thoroughly enjoying the ways and charm of the British ruling class.

His modest height was five feet three inches. In his thirties he counterbalanced an increasing baldness by growing a stylish Van Dyke beard. Startlingly blue of eye and sharp of nose, he remained slim all his life.

In 1872, while teaching history at Harvard, he married Clover, another proper Bostonian, whose brother Edward Hooper had been a Harvard contemporary of his. Henry's description to an English friend, Charles Milnes Gaskell, during the engagement is a revealing one: "She is 28 years old. She knows her own mind uncommon well. . . . She talks garrulously but on the whole pretty sensibly. She is very open to instruction. We shall improve her. She dresses badly. She decidedly has humor and will appreciate our wit. . . . She rules me as only American women rule men, and I cower before her. Lord! How she would lash me if she read the above description of her!"[5]

In 1877 the couple moved to Washington. Henry pegged away at his history of the Jefferson and Madison administrations, which would eventually run to nine volumes. Clover's wit and brilliance, masking a certain fragility and instability of character, attracted many, and their H Street house across Lafayette Park

from the White House became a haven for the best-born and the beautiful.

There is a glimpse of Henry Adams in one of Henry James' short stories called "Pandora." Alfred Bonnycastle, Adams' thin disguise, "was not in politics though politics were much in him." His social position is so exalted that he can, while planning a party, propose to his wife, "Let us be vulgar and have some fun— let us invite the President."

This role of social arbiter suited Adams very well. He pretended to aspire to the high, windy places of power, to which he felt his heritage entitled him. But he lacked the necessary bonhomie. The clap on the back, the arm flung round the shoulder, induced in him a real revulsion.

It has been said that Adams was one of the few people who could sit on the fence and watch themselves go by. In this guise he wrote *Democracy*, a novel that came out in 1880. He signed himself Frances Snow Compton. Considered "the best political novel yet written in America" by Noel Perrin and other critics, *Democracy* told the story of the beautiful Mrs. Lightfoot Lee and her search for the true meaning of power in the nation's capital. The tone was high comedy throughout. Not until 1921 was the author's identity finally revealed.

Later, in his third-person autobiography, *The Education of Henry Adams*, the comic approach would turn into a brilliant and bitter irony, and the fence-sitting detachment would lead to a most penetrating self-analysis.

Concerning the impression Adams made on his contemporaries, the evidence of the two men who knew him best is enlightening. His brother Brooks, who thought him "the most cultivated and stimulating man, of my own generation," was aware that there was something different about him: "Henry was never quite frank with himself or with others; certainly he was not with me. . . . Henry was always shy and over-sensitive, and disliked disagreeable subjects. Hence he would surround himself with different defences. . . ."[6]

British diplomat Cecil Spring-Rice, when first posted to Washington, wrote home describing his new friend Henry Adams:

"He is queer to the last degree, cynical, vindictive, but with a constant interest in people, faithful to his friends."[7] In another letter "Springy," who was everyone's favorite young attaché, extended his views to the family as a whole: "The Adams family are as odd as can be. . . . They are all clever but they all make a sort of profession of eccentricity."[8]

Brother Brooks made another comment about Henry: "What he really cared for was social consideration, and this he had wherever he chose to live."[9] After the manner of certain Americans who have served an apprenticeship acquiring the airs and graces— and the accent—of the British aristocracy, Adams' surface manner was a tiresome assumption of superiority. He made a cult of unpopularity, of seeking the friendship of the few.

His attitude toward Saint Gaudens was a curious mixture of that sense of his own social superiority and a genuine admiration for his friend's gifts as an artist. Made to feel inadequate by Adams' dazzling conversation and waspish wit, Saint Gaudens tended to be inarticulate in his presence, and this did not go unnoted: "All the others [Adams wrote]—the Hunts, Richardson, John La Farge, Stanford White—were exuberant. Only St. Gaudens could never discuss or dilate on an emotion, or suggest artistic arguments for giving to his work the forms that he felt."[10]

At the same time Adams, the observer and fence sitter, admired the blind energy that drove Saint Gaudens. He saw Augustus as one of the procession of men of action, like Garibaldi and Ulysses S. Grant and Senator Don Cameron, although the battle Saint Gaudens fought was a lonelier one: "He could not imitate, or give any form but his own to the creations of his hand. No one felt more strongly than he the strength of other men, but the idea that they could affect him never stirred an image in his mind."[11]

In his book on Adams, R. P. Blackmur has described this intuitive energy of Saint Gaudens even more succinctly: "He was pure act but his act was an act of taste."[12]

On December 6, 1885, Clover Adams took her own life by drinking potassium cyanide. Her father had died the preceding April,

and she had nursed him in his last illness. Father and daughter had been particularly close, and after his death she had fallen into deep depression. Clover and Henry's many friends, aware of his devoted ministrations before her death and his despair after it, accepted the loss of the father as the motive for her suicide.

Here the mystery deepens. For Henry Adams lowered a cone of silence over his wife's life and memory. Until shortly before his own death thirty-three years later, he never spoke her name. Any relevant letters and diaries he could lay his hands on he destroyed. Stranger still, there is a twenty-year gap in the autobiography on which so much of his fame rests: *The Education of Henry Adams* breaks off abruptly in 1872, the year of the marriage, and picks up again only in 1892. Not until the time when he first sees the finished monument to Clover does a kind of release set in, which allows him to live again, and learn again, after the terrible void.

What kind of love, one may well ask, imposes on the loved one such total oblivion? By not even permitting Clover to live in the courts of memory, he was, as it were, condemning her to a second death. Yet few in his day questioned the overwhelming nature of Henry's grief. Only Brooks Adams, in defining those defenses his brother put up around himself, hinted that the grief might not have been quite so all-encompassing: "One of these [defenses] was that when his wife died, he insisted that he also died to the world."[13]

Only recently has the motivation behind Clover's last act begun to be examined in any depth. But some evidence has always existed that Henry's "vindictiveness," mentioned by Spring-Rice, and his open admiration of beauty in other women, may have contributed to her gathering despair.

One clue here is the near-savage portrait of Clover in Adams' second novel. *Esther* was published in 1884, with Adams again sidelining himself under the drab pseudonym of Frances Snow Compton. Clover is unmistakably Esther Dudley, the main character in the book. Her description echoes Adams' letter about his bride to his English friend Gaskell, but the comment is sharper,

crueler now. Adams' mouthpiece is Wharton, a nervous, fast-talking artist of humble origins, modeled partly on John La Farge and partly on Augustus Saint Gaudens. "She has a bad figure," Wharton complains. "Her features are imperfect. Except her ears, her voice and her eyes, which have a sort of brown depth like a trout brook, she has no very good points. She picks up all she knows without an effort and knows nothing well. . . . Her mind is as irregular as her face. . . . She tries to paint but she is only a second-rate amateur and will never be anything more." About the best that Wharton can concede is that "she has a style of her own." He compares her to a "lightly-sparred yacht in mid-ocean. . . . She sails gaily along although there is no land in sight and plenty of rough weather coming."[14]

Esther sold exactly 504 copies in its first year, and a few score thereafter. No one knows whether Clover actually read the book, but the assumption that there was malice on her husband's part cannot be disregarded.

Adams basked in the company of beautiful women, and made no attempt to conceal his enjoyment. Starting in the early 1880s, he and Clover saw a great deal of Elizabeth Sherman, a niece of the General, who had married Pennsylvania Senator Don Cameron not long before. A widower more than twice her age, Cameron was the prototype of the smoke-filled senator—the kind who is taciturn in public but effective in the back rooms and lobbies.

Adams had a certain grudging admiration for him as "supple in action, large in motive." "When he happened to be right," the historian concedes in his *Education*, ". . . he was the strongest American in America."[15]

Far less grudgingly he praised the beauty and wit of Elizabeth Cameron. She figures as Catherine Brooke in *Esther*, "fresh as a May morning" and "pretty as a fawn."[16] The Camerons were near neighbors of the Adamses on Lafayette Square. In Clover's weekly letters to her father are frequent mentions of breakfasts, luncheons, teas, and dinners, mostly with Elizabeth, sometimes with the gruff old Senator—with Elizabeth always suitably chaperoned. A letter of October 30, 1881, is typical: "Yesterday P.M. Mrs.

Senator Don Cameron and Miss Beale rapped on Henry's window with their umbrellas and of course got in."[17]

Clover was a skillful photographer. Working away in her upstairs studio in the evenings, she would hear the merriment and the trilling laughter. "La Dona," as Mrs. Cameron was called, professed to love both the Adamses, and took Henry's open admiration simply as her due.

Another letter of Clover's to her father in May 1882 lifts a corner on her supposedly idyllic existence. She is commenting on a note from expatriate Henry James, about to sail for England: "He wished, he said, his last farewell to be said to me as I seemed to him 'the incarnation of my native land'—a most equivocal comment coming from him. Am I then vulgar, dreary and impossible to live with?"[18] The tone is light, but there is a darker undertone.

Saint Gaudens had known Adams since those Trinity Church days when he worked for Richardson. Whether, after Clover's death, he observed any symptoms of guilt or remorse in Adams as well as the vast grief is not a matter of record. As was so often true, Augustus was content to make his comment by the product of his hand. . . .

Henry Adams commissioned the monument in the fall of 1886. The summer before, he and John La Farge had taken a trip to Japan which had considerable influence on the instructions the sculptor was given when he accepted the assignment.

The journey to the Orient was an escape for both artist and historian. La Farge was under contract to do a mural for the Church of the Ascension in New York, and also had many other obligations both professional and familial. He jumped at the chance to escape them. Adams did not much care whether he went or stayed, but hoped a change might lift his leaden spirits.

The trip was a success in many ways. The beauties of the Japanese landscape supplied La Farge with an unusual background for his luminous mural of the Risen Christ. Both he and Adams became intrigued by the many images they saw of the

deity Kwannon meditating on Nirvana. Indian in origin and for a time a male god, Kwannon had by evolution become a goddess of contemplation and compassion.

Their Boston Orientalist friend Ernest Fenollosa was also in Japan, gathering material. He taught them many things and showed them "the greatest masterpiece of Suiko art" in the little nunnery of Chuguji. This was a large carving of Kwannon in bronzelike wood dating from the reign of the Empress Suiko (583–628 A.D.). "It is the face of a sweet loving spirit, pathetic and tender, with eyes closed in inner contemplation," Fenollosa was to write. "It dominates the whole room like an actual presence."[19]

Back in New York, Adams and La Farge went around to Saint Gaudens' studio to persuade him to do the monument to Clover. In an interview twenty-four years later, La Farge recalled what happened in some detail.[20]

First of all, Adams described what he wanted in general terms: a figure symbolizing "the acceptance, intellectually, of the inevitable." Then both visitors told the sculptor about the Buddhist goddess Kwannon. Saint Gaudens, increasingly anxious to create abstractions after so many life portraits, was immediately intrigued. He struck a pose with hand to brow.

"No," said Adams, "the way you're doing that is a 'Penseroso.' "

Augustus tried several other poses and finally hit on one that Adams liked. The sculptor, excited, called over an assistant named Angelo Panitti who was mixing clay nearby. He asked Panitti, who did occasional modeling, to duplicate the pose. When the boy assumed it correctly, Saint Gaudens picked up some of the webbing used to keep clay figures moist and draped it over his head. The burlap-like material fell in heavy folds, enhancing the dramatic effect.

"Now that's done," said Adams. "The pose is settled. Go to La Farge about any original ideas of Kwannon. I don't want to see the statue until it's finished." He went on to suggest that Saint Gaudens study photographs of Michelangelo's frescoes in the Sistine Chapel. In particular he cited the mother of Jesse in one of

the spandrels, with her hand raised in a curious, twisting gesture, and the Sistine Madonna drawing her seamless toga about the Christ Child.

After they had gone, Saint Gaudens, fully committed by now, jotted down a few words in his notebook: "Adams—Buhda [his spelling was always rather intuitive]—Mental Repose—Calm reflection in contrast with the violence or force in nature." He added a sketch showing a seated figure in direct frontal pose, legs slightly ajar. [21]

For two years not much happened. Once Augustus wrote from Cornish to ask Adams if there was "any book *not long* that you think might help me in grasping the situation." [22] It seemed that some photographs of buddhas that Adams had given him had been left in New York. In the same letter he reported that he planned "soon to talk with La Farge on the subject, although I dread it a little."

In another letter Saint Gaudens mentioned to Adams that he had enlisted Stanford White's help for the architectural details, especially for the rock and seat, and that White had submitted "a stunning scheme." [23]

Adams' diary for December 10, 1888, notes some progress, and shows that he did not abide completely by his hands-off policy: "I went yesterday to see St Gaudens who has begun the Buddha. We discussed the scale and I came away telling him that I did not think it wise to see it again, in which he acquiesced. . . ." [24]

Saint Gaudens' work-in-progress was curtained off in a corner of the busy studio. In the course of the next two years, Augustus demolished at least three models before he was satisfied at last that he had achieved his interpretation of a Kwannon, and created a Nirvana of his own.

In August 1890 Adams and La Farge were off again, this time on an eighteen-month trip to the South Seas. By now Adams' admiration for Mrs. Cameron had become infatuation. Everyone involved recognized that it was time for a respite. "Departure

when it came was more than welcome" is the wry comment of the editors of the Adams letters.[25]

Adams began to chafe a little in Polynesia. He had already paid out twenty thousand dollars for the monument-in-process and was beginning to worry about his investment. Writing to Elizabeth Cameron in September 1890, he asked that she visit Clover's grave "to see if my work is done or doing."[26]

Mrs. Cameron wrote back that the work was not yet in place. Finally, in March of the following year, she was able to report that the bronze figure was positioned at last. Both she and Theodore Dwight, Adams' H Street tenant and factotum, took photographs, and they mailed Dwight's more professional ones to Tahiti.

When Saint Gaudens heard about the mailing, he went into one of his rages. "I would like to have broken Dwight's head," he told Mrs. Cameron.[27] What he wanted, and had been relying heavily on, was Adams' own first impression when he did come home.

Meanwhile, Elizabeth Cameron showed the photographs to Charles Francis Adams, Henry's businessman brother. His very Adams-like reaction of seeing the worst before the best was hardly reassuring. Nevertheless, Elizabeth reported it to Tahiti: "He said it looked like a mendicant in a horse blanket."[28]

Then John Hay, whose diplomatic career was beginning to take off and who had always been a man of letters and of taste, wrote his impressions to his anxious friend. It remains to this day the matchless tribute: "The work is indescribably noble and imposing. . . . It is full of poetry and suggestion, infinite wisdom, a past without beginning and a future without end, a repose after limitless experience, a peace to which nothing matters—all are embodied in this austere and beautiful face and figure."[29]

Adams wrote Saint Gaudens that he found the photographs "satisfactory" as far as they went, and forwarded Hay's tribute to Saint Gaudens in the same letter: "Certainly I could not

have expressed my own wishes so exactly, and, if your work approaches Hay's description, you cannot fear criticism from me."[30]

Back in Washington by February 1892, he went straight to the Rock Creek Cemetery. He confided his first impression to Hay: "Saint Gaudens is not the least Oriental and is not even familiar with Oriental conceptions."[31]

The realization that something great had been created did not take very long. Although Adams endlessly pretended that he valued the opinion only of the few such as Hay, he would not have been the superb historian he was if he had not possessed a certain seismographic sense of what was afoot. In the same way that he identified the issues—political, scientific, intellectual— that were stirring in the land, he sensed the effect that his monument was creating. No bands had played, no flags were broken out when it was placed in the grove. But people, and not just the few who mattered to him, were visiting it. People were talking. . . .

The fact that the statue was by no stretch of the imagination Oriental ceased to trouble him. "The whole meaning and feeling of the figure is its universality," he wrote to Richard Watson Gilder.[32] And his respect for Saint Gaudens as an artist grew apace.

Excerpts from the *Education*, written from that third-person perch of his, show how his views developed: "Naturally every detail interested him; every line; every touch of the artist; every change of light and shade . . . every possible doubt of St. Gaudens' correctness of taste or feeling."[33] With the coming of spring he went back to the site more and more often. He listened to people talking about his monument: "Most took it for a portrait statue, and the remnant were vacant-minded in the absence of a personal guide." The exception to this lack of feeling were the clergy, who "broke out passionately against the expression they felt in the figure of despair, of atheism, of denial. Like the others the priest saw only what he brought." In summation, discovering that he could in no way fault his sculptor, he equated him with the highest

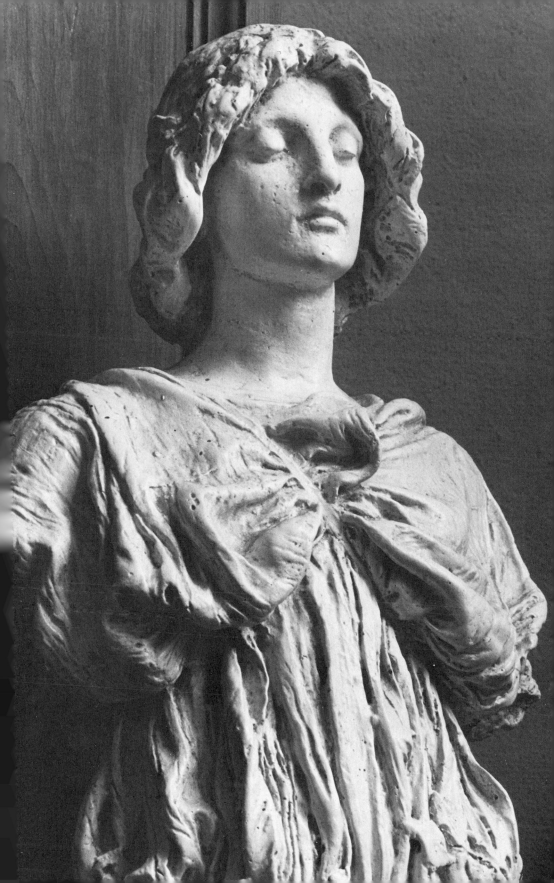

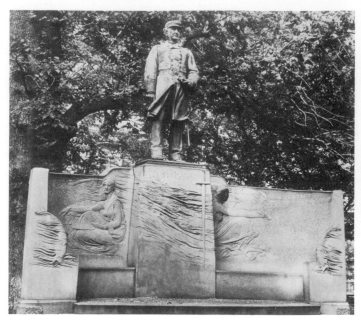

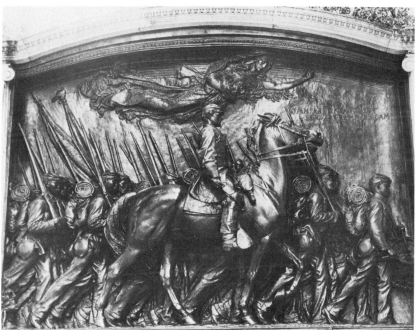

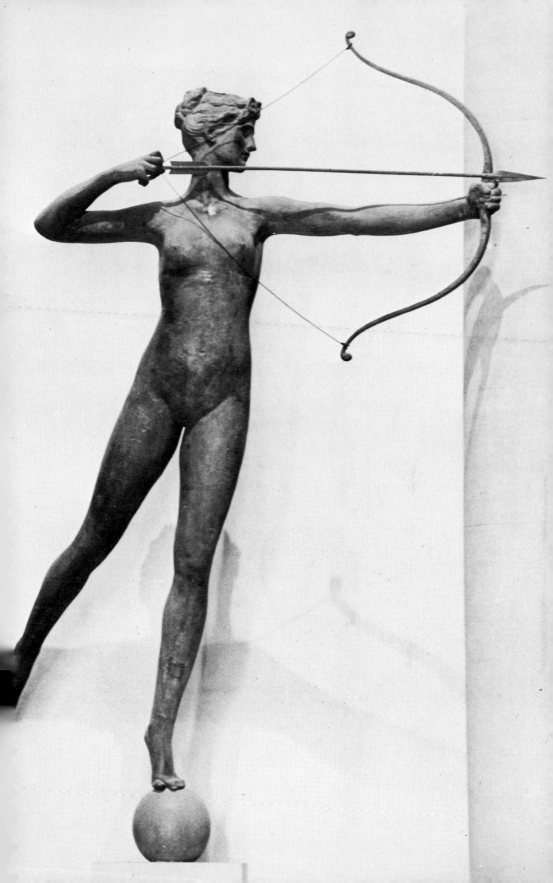

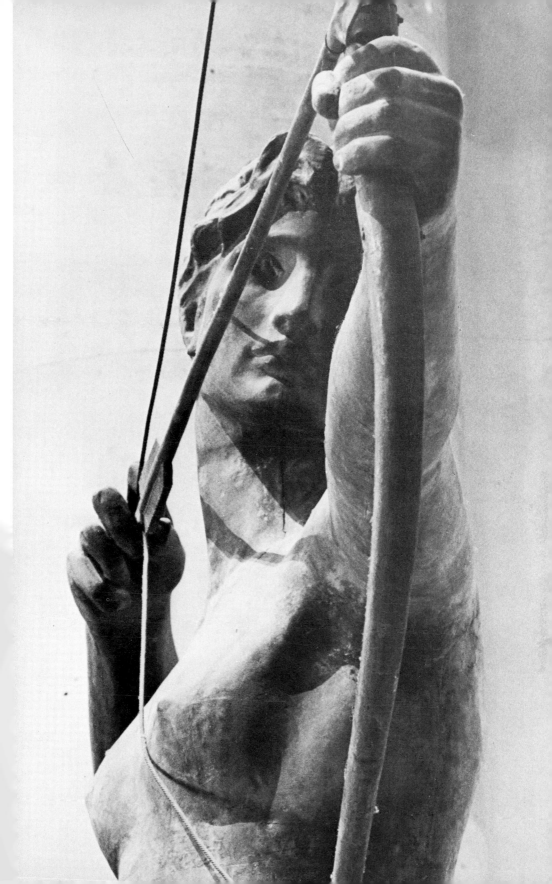

PRECEDING PAGE: *Diana.*
 Photograph: David Finn

OPPOSITE PAGE: *Farragut*
 Monument.
 Photograph: David Finn

RIGHT: *Farragut Monument*, detail.
 Photograph: David Finn

BELOW: *Farragut Monument*, base,
 detail.
 Photograph: David Finn

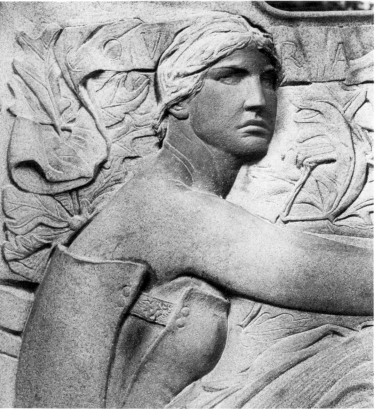

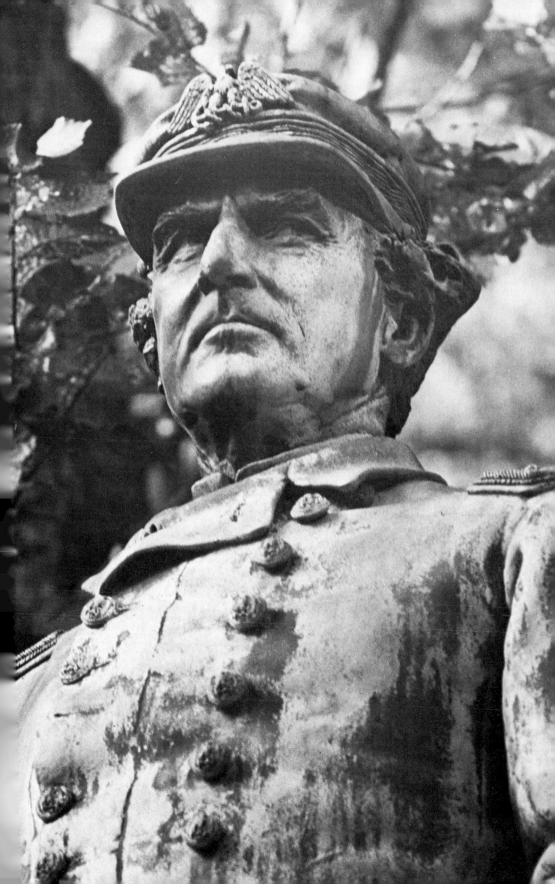

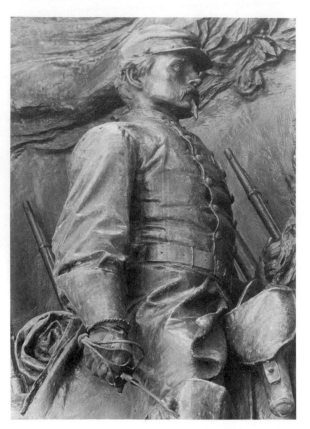

OPPOSITE PAGE: *Robert Gould Shaw Memorial*, bronze relief, 1884–97, detail. Boston Common. *Photograph: David Finn*

LEFT: *Shaw Memorial. Photograph: David Finn*

BELOW: *Shaw Memorial. Photograph: David Finn*

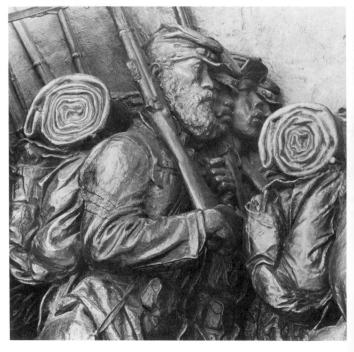

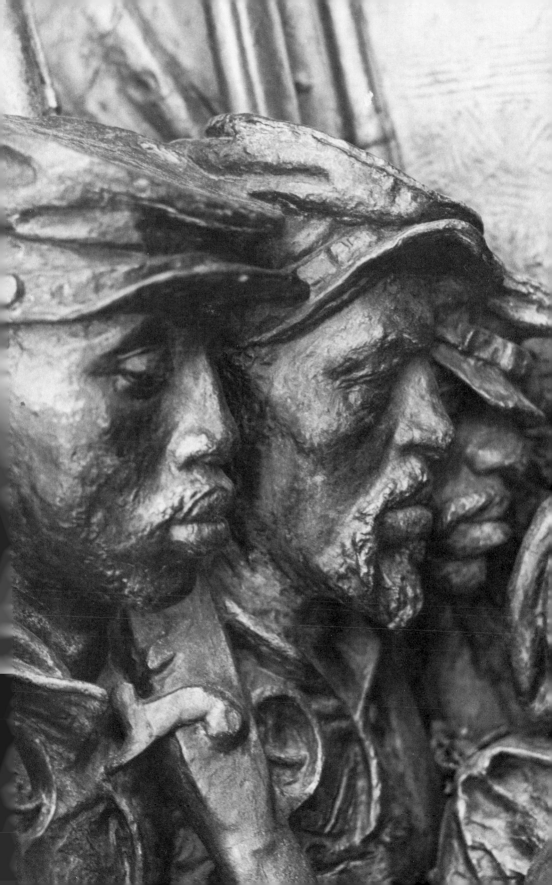

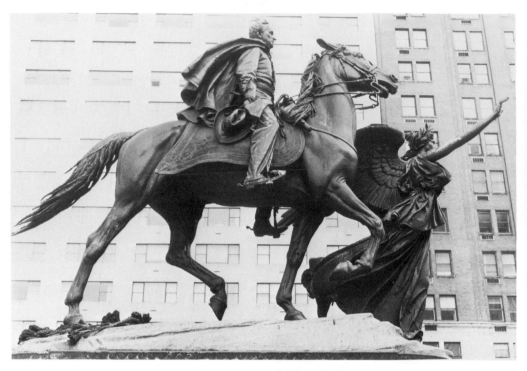

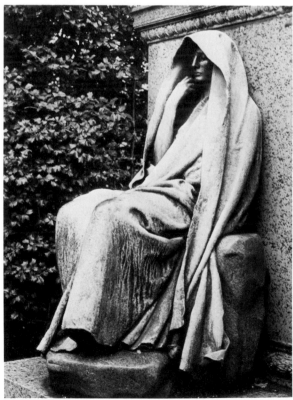

ABOVE: *William Tecumseh
Sherman Monument,* bronze,
1892–1903. Grand Army Plaza,
New York.
Photograph: David Finn

RIGHT: *Adams Monument,* bronze,
1886–91. Rock Creek Cemetery,
Washington, D.C.
Photograph: David Finn

OPPOSITE PAGE: *Adams Monument.*
Photograph: David Finn

FOLLOWING PAGE: *Sherman
Monument.*
Photograph: David Finn

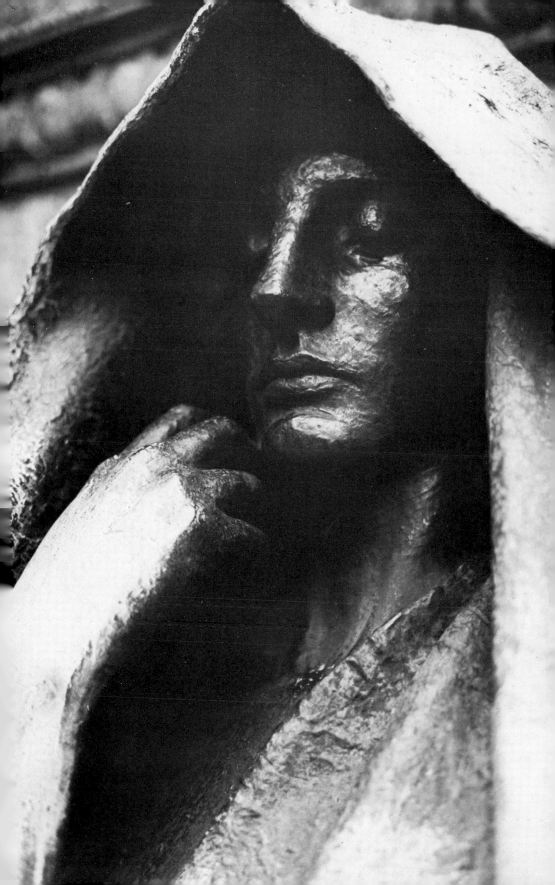

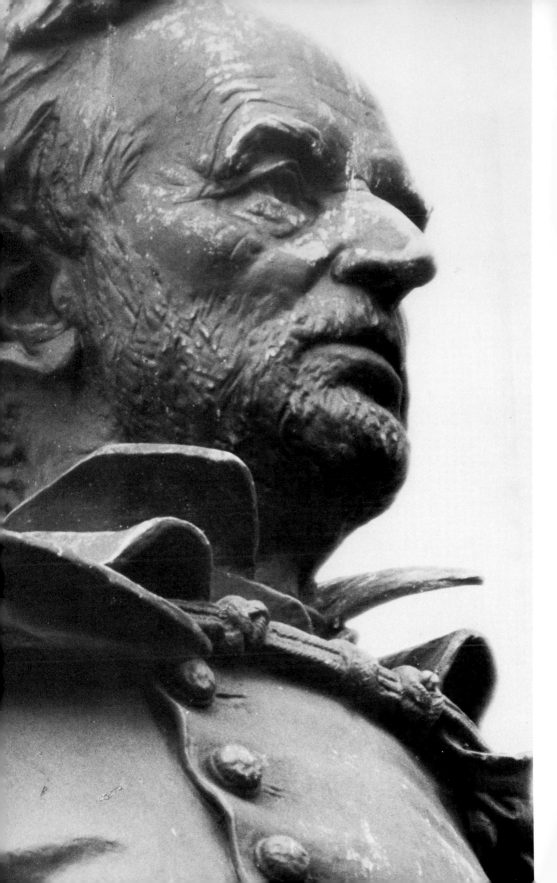

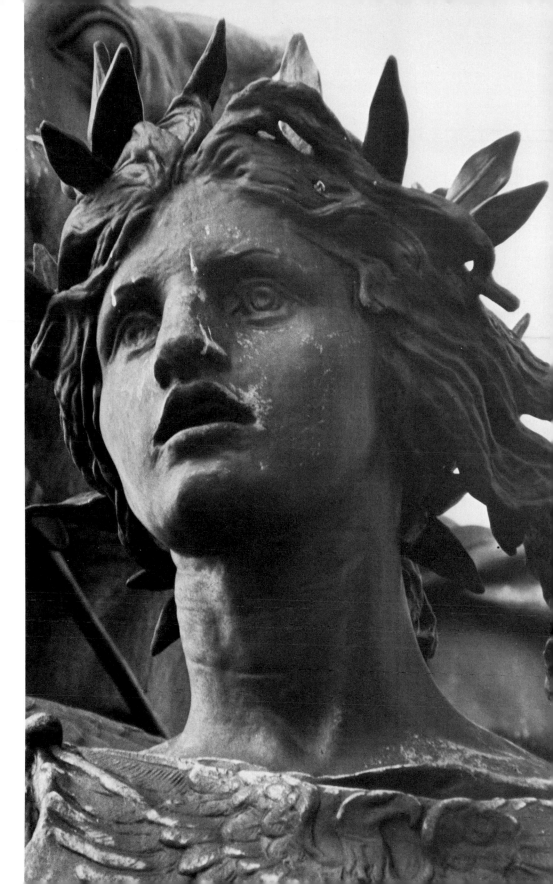

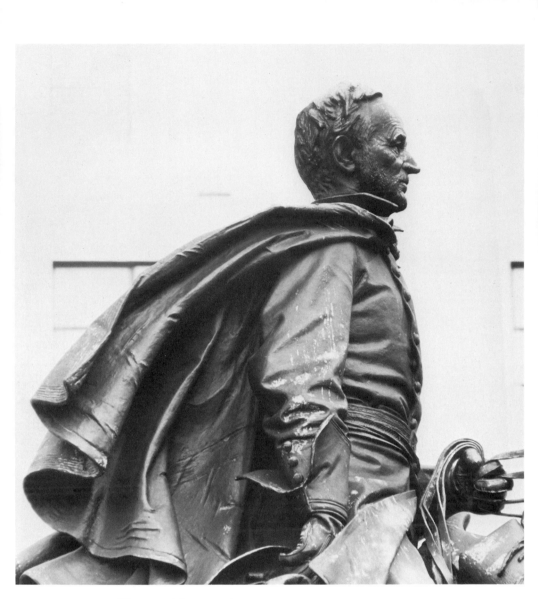

ABOVE: *Sherman Monument.*
Photograph: David Finn

PRECEDING PAGE: "Victory," *Sherman Monument.*
Photograph: David Finn

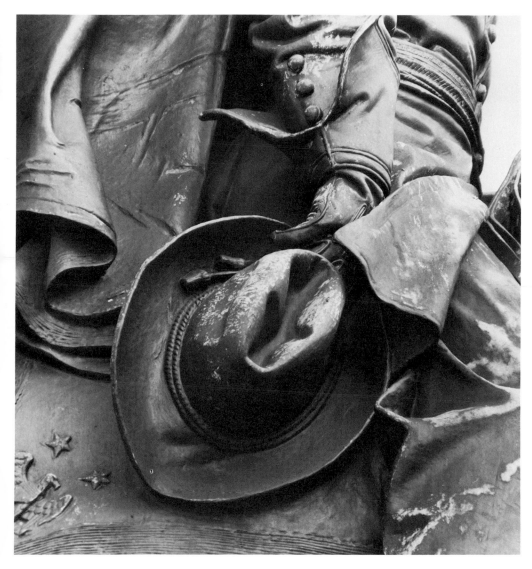

ABOVE: *Sherman Monument*, detail.
Photograph: *David Finn*

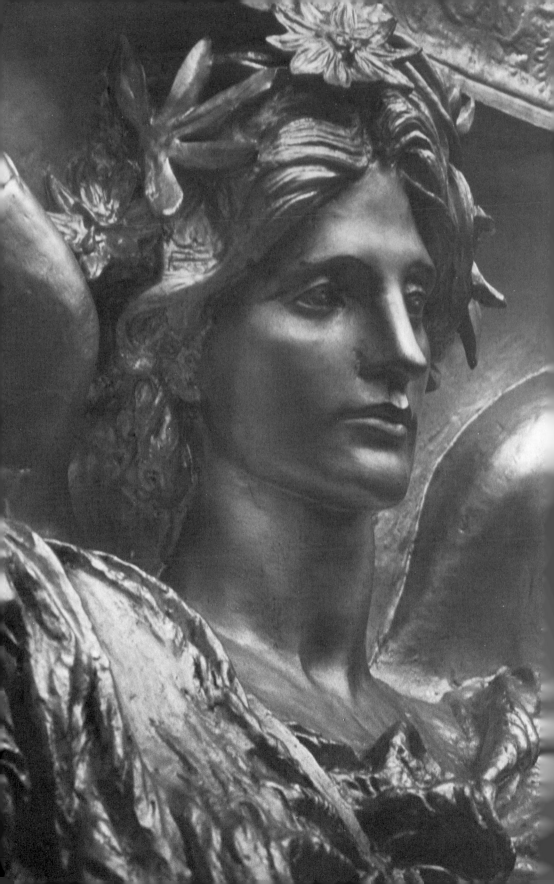

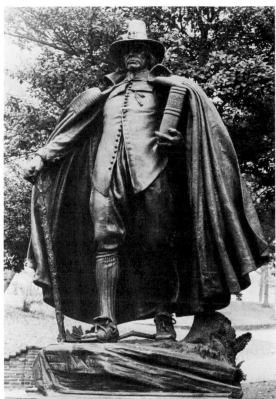

OPPOSITE PAGE: *Amor Caritas*,
 bronze, 1898. Metropolitan
 Museum of Art, New York.
 Photograph: David Finn

BELOW: *Amor Caritas.*
 Photograph: David Finn

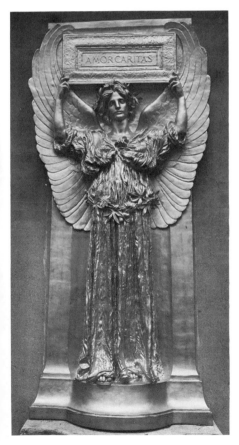

ABOVE: *The Pilgrim*, bronze, 1903–04.
 Fairmount Park, Philadelphia.
 Photograph: David Finn

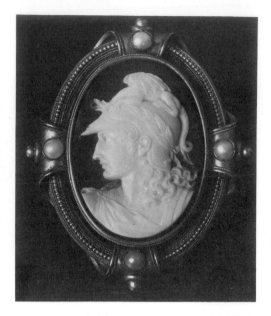

OPPOSITE PAGE: *Bessie Smith White,*
bronze circular relief, 1884.
Metropolitan Museum of Art,
New York.
Photograph: David Finn

BELOW: *Mortimer Leo and Frieda
Fanny Schiff,* bronze relief,
1884–85. Collection of the Saint-
Gaudens NHS. *Photograph:
David Finn*

ABOVE: *Youthful Mars,* cameo
(white image over black
onyx), 1873–74. Collection
of the Saint-Gaudens
National Historic Site.
Photograph: David Finn

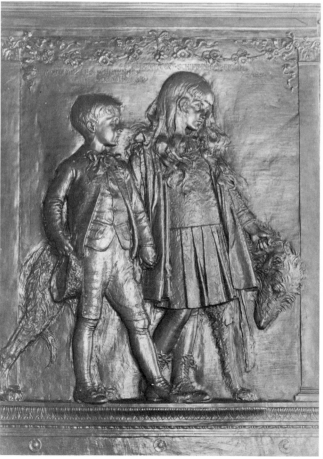

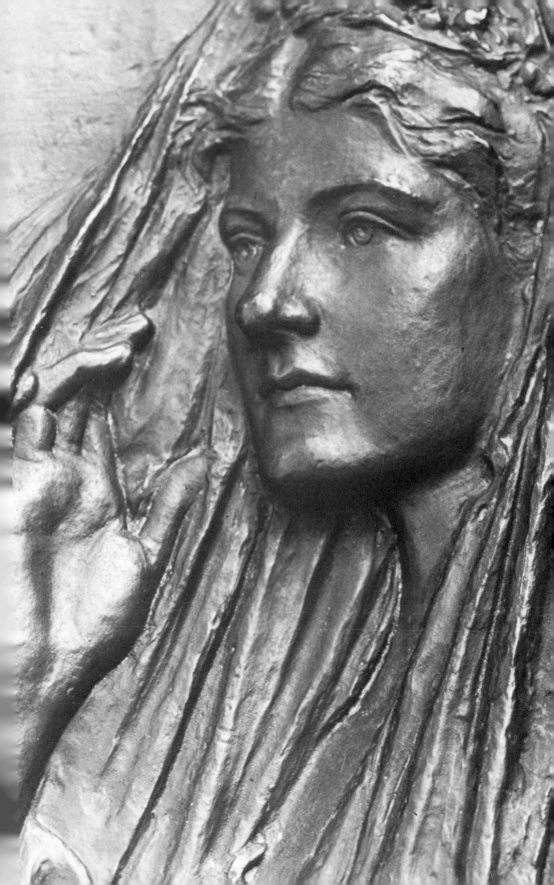

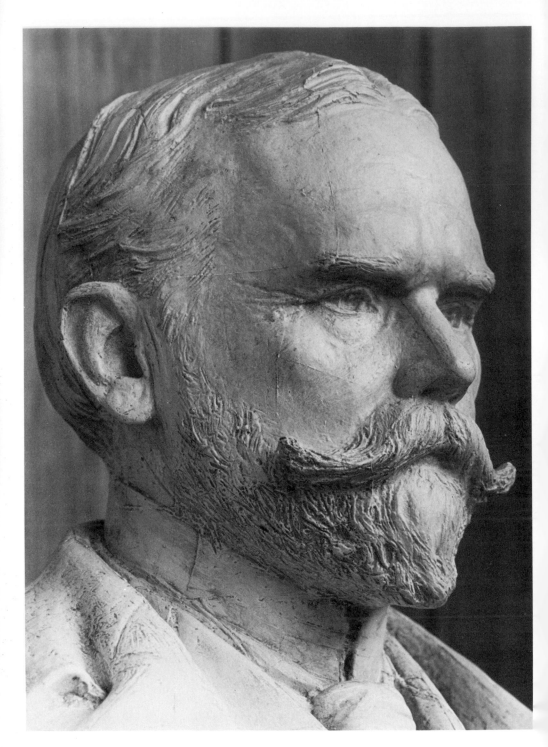

ABOVE: *John Hay,* marble bust, 1904. John Hay Library,
Brown University, Providence. *Photograph: David Finn*

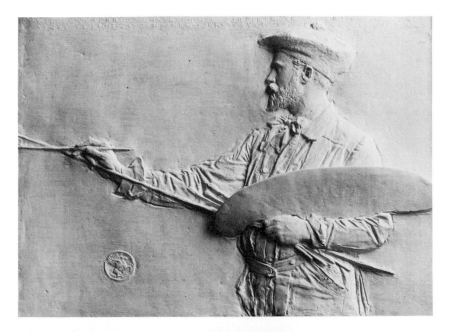

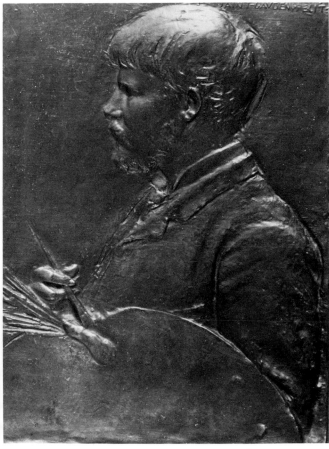

ABOVE: *William Merritt Chase* (plaster model), bronze relief, 1888. American Academy of Arts and Letters, New York (plaster model: Collection of the Saint-Gaudens NHS). *Photograph: David Finn*

LEFT: *Jules Bastien-Lepage,* bronze relief, 1880. Museum of Fine Arts, Boston. *Photograph: David Finn*

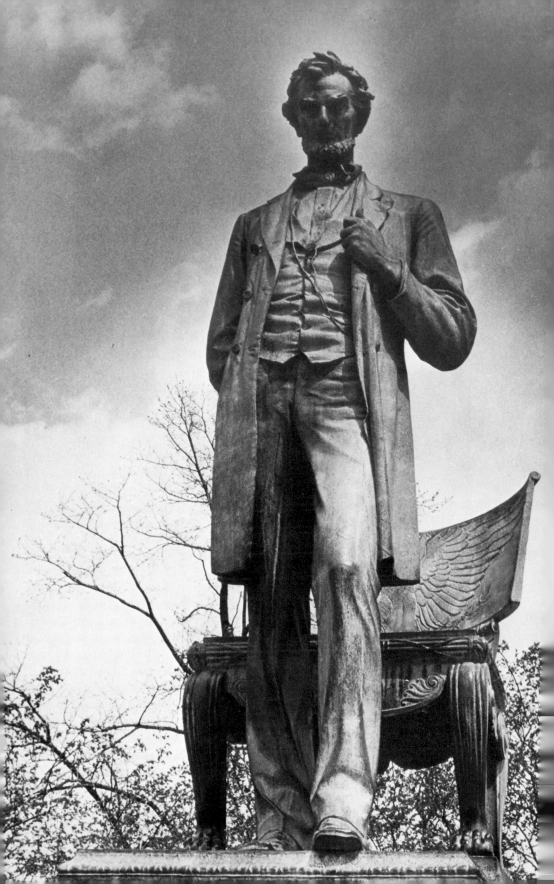

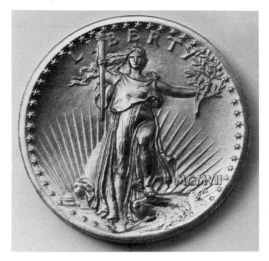

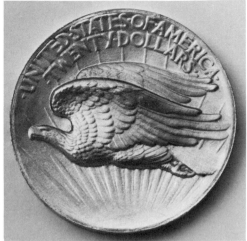

ABOVE: Twenty-dollar gold piece, 1905–07: *left*, obverse of coin; *right*, reverse of coin. Collection of the Saint-Gaudens NHS. *Photograph: U.S. Department of Interior, National Park Service, SGNHS, Cornish, N.H.*

RIGHT: *William M. Evarts*, marble bust, 1872–74. Collection of the Evarts family, Windsor, Vt. *Photograph: Gordon Sweet*

OPPOSITE PAGE: *Abraham Lincoln*, bronze, 1884–87. Lincoln Park, Chicago. *Photograph: David Finn*

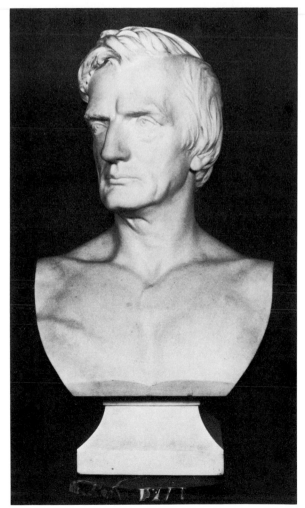

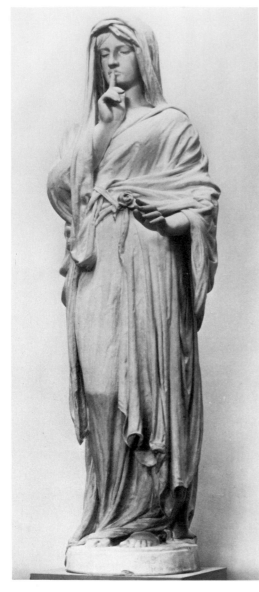

ABOVE: *Silence*, marble, 1874. Masonic
Soldier's and Sailor's Hospital, Utica, N.Y.
*Photograph: DeWitt C. Ward, Juley
Collection, Smithsonian Institution*

ABOVE RIGHT: *Hiawatha*, marble, 1872–74.
Private collection, Palm Beach, Fla.
Photograph: Gordon Sweet

RIGHT: Reredos of St. Thomas Church (New
York), polychromed cement-composition
relief panels, 1877; destroyed by fire
1905. *Engraving by Timothy Cole*

ABOVE: *Peter Cooper Monument*
(plaster model), bronze relief, 1894;
unveiled 1897. Cooper Square,
New York. *Photograph: American
Academy of Arts and Letters*

UPPER LEFT: *Violet Sargent*, marble relief,
1890. Collection of the Saint-Gaudens
NHS. *Photograph: Jeffrey Nintzel*

UPPER RIGHT: *Robert Louis Stevenson*,
bronze medallion, 1887–88. Metropolitan
Museum of Art, New York.
Photograph: Gordon Sweet

LOWER RIGHT: *Frances Folsom Cleveland*,
bronze medallion, 1887–92. Private
collection, Baltimore. *Photograph:
SGNHS*

RIGHT: *General John A. Logan Monument*, bronze, 1894–97. Grant Park, Chicago. *Photograph: Chicago Historical Society*

BELOW: *Charles S. Parnell Monument*, bronze, 1903–07. Dublin. *Photograph: Bord Failte Photo*

LOWER RIGHT: *Phillips Brooks Monument*, bronze, 1896–1907. Trinity Church, Copley Square, Boston.

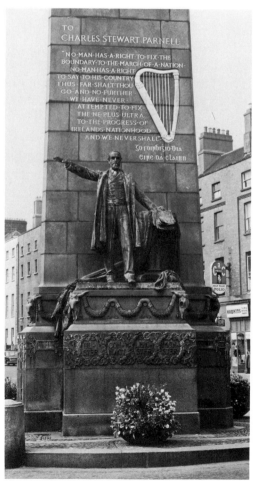

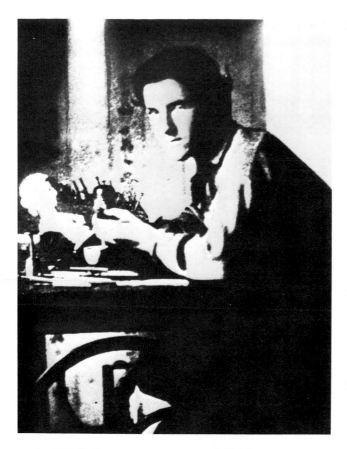

LEFT: Augustus Saint Gaudens at his cameo lathe.
Photograph: SGNHS

LOWER LEFT: *Mary McGuiness Saint Gaudens,* pencil drawing, 1867.
Photograph: Dartmouth College Library, SGNHS

BELOW: *Bernard P. E. Saint Gaudens,* bronze bust, 1867.
Photograph: Gordon Sweet, SGNHS

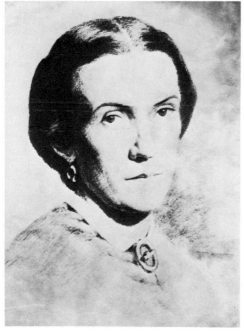

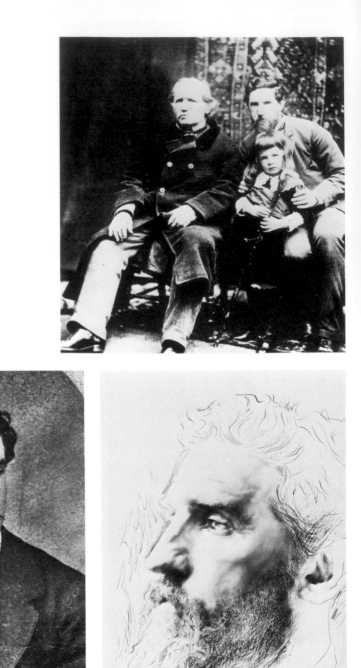

RIGHT: Three generations: Bernard, Augustus, and Homer Saint-Gaudens, c. 1884. *Photograph: George C. Cox, SGNHS*

ABOVE LEFT: Augustus Saint Gaudens at the time of his engagement, Rome, 1874. *Photograph: SGNHS*
ABOVE RIGHT: *Augustus Saint Gaudens*, original drawing by Antonio Ciccone from an 1887 photograph, 1984.

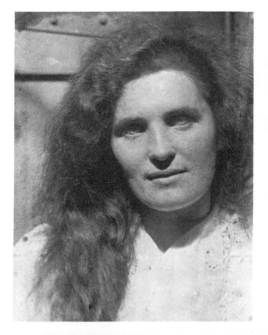

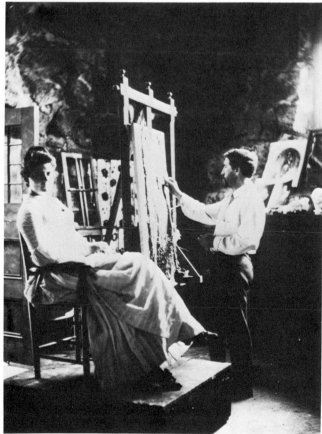

UPPER LEFT: Davida Johnson
Clark, c. 1886.

UPPER RIGHT: Davida Johnson
Clark, first study for head of
Diana, marble bust, 1886.
Collection of the Saint-
Gaudens NHS.
Photograph: SGNHS

LEFT: Augustus Saint Gaudens
modeling portrait of Mrs.
Grover Cleveland, Marion,
Mass., 1887. *Photograph:
Dartmouth College Library,
SGNHS*

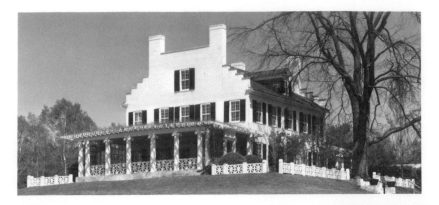

ABOVE: Aspet, home of Augustus Saint
Gaudens, Cornish, N.H.
Photograph:
Jeffrey Nintzel, SGNHS

RIGHT: Little Studio and Pan Fountain
with Mount Ascutney in the
background. *Photograph:*
Aubrey P. Janion, SGNHS

BELOW: Augusta Homer Saint
Gaudens, 1890s. *Photograph:*
George C. Cox, SGNHS

LOWER RIGHT: Louis P. Clark and his
mother, c. 1895.

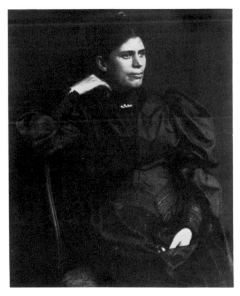

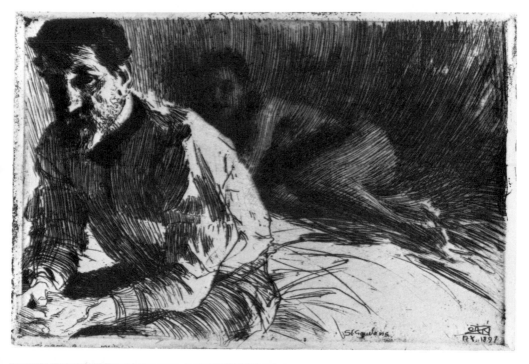

BELOW: Louis P. Clark, 1905.

RIGHT: *Augusta Homer Saint Gaudens,*
bronze bas-relief, 1905–07.
Photograph: David Batchelder, SGNHS

LOWER LEFT: Augustus Saint Gaudens,
c. 1904. *Photograph:*
DeWitt C. Ward, SGNHS

LOWER RIGHT: *Augustus Saint Gaudens,*
bronze bust by Henry Hering, 1908.
Photograph: Jeffrey Nintzel, SGNHS

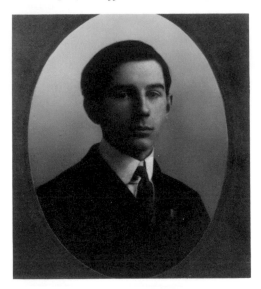

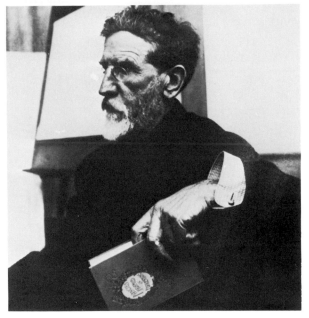

creative tradition: "Like all great artists, St. Gaudens held up the mirror and no more."

Not being exactly of the earth earthy, Adams decided for himself that Saint Gaudens intended the statue to be neither man nor woman. At a White House dinner near the end of Theodore Roosevelt's tenure, the President had referred to the figure as a woman. The next day Adams wrote to straighten him out: "After March 4, should you allude to my bronze figure, will you try to do St. Gaudens the justice to remark that his expression was a little higher than sex can give. As he meant it, he wanted to exclude sex, and sink it in the idea of humanity. The figure is sexless."[34]

Saint Gaudens himself has never been directly quoted on the subject. Homer tells us that his father "occasionally explained" the figure "as both sexless and passionless" and cites the fact that sometimes a man posed for it, sometimes a woman.[35] But this may not be the final word. One has the feeling that the sculptor would infinitely prefer the beholder to make up his or her own mind. To the present writer, the ample hair, clearly visible under the hood, is compelling evidence, and so is much else: by her heavy-lidded eyes and full lips and the tenting line from knee to knee she is indeed a woman.

All his life Adams continued to visit the vale, and to have new insights about the figure. Ten years after he first saw it, he wrote Saint Gaudens about one of them: "Every now and then, in certain light, I see, or think I see, an expression almost amounting to defiance in the mouth and nostrils. You did not put it there, nor did I, nor am I sure of it. . . ."[36]

When they were not together, Adams wrote endlessly to Elizabeth Cameron. He knew that he was running down, and drew strength from her affection even if it could never be the full commitment. She knew very well where, when the time came,

he wished to be buried: "If you want to take charge of the dynamo you can," a typical Adams letter on such subjects ran. "It all makes me look with yearning eyes to my happy home at Rock Creek where I can take off my flesh and sit in the sun on my stone bench to eternity, and see my friends in quiet intervals of thousand-year naps."[37]

Mellowing with the years, but waspish and witty still, protected from the world by a picket fence of adoring nieces, Henry Adams lived to be eighty. He died in 1918. By his wish, he was buried in an unmarked grave next to Clover in the vale. So Saint Gaudens' shrouded figure, brooding away on the threshold of eternity, holds all their secrets now.

The monument has taken its place in the psyche of the fair land. Over the years many have drawn solace from the figure in the vale. To pick three at random: John Galsworthy, Eleanor Roosevelt, and Alexander Woollcott all found their way there and have left impressions. Galsworthy, in the guise of Soames Forsyte on a visit to America, was swept away: "That great greenish bronze figure of [a] seated woman within the hooding folds of her ample cloak seemed to carry him down to the bottom of his own soul." It gave Forsyte more pleasure than anything in America "in spite of all the water he had seen at Niagara and those skyscrapers in New York."[38]

Eleanor Roosevelt went there often to renew and strengthen her spirit. To her the statue represented a person "who had transcended pain and hurt to achieve serenity."[39] She also saw in the figure "a woman who had attained absolute self-mastery," which she felt was a supreme virtue.[40]

Critic and bon vivant Alexander Woollcott, who lived in hyperbole all his days, called the statue "the most beautiful thing ever fashioned by the hand of man on this continent."[41] For once, he did not overstate the case.

27

OF WILLIE MACMONNIES
AND KINDRED MATTERS

SAINT GAUDENS' role in the Columbian Exposition of 1893 called into play certain of his characteristics that would continue to be much in evidence for the rest of his life. These were his patriotism, his leadership, and his warm if not uncritical feeling for gifted colleagues. Three sculptors figure in the unfolding story: Frederick MacMonnies (in particular), Mary Lawrence, and Daniel Chester French.

The mastermind of the fair was Chicago architect Daniel H. Burnham. Just under six feet tall, broad of forehead and rocklike of chin, he was a man of commanding presence. "Make no small plans," he once said, "they have no magic to stir men's blood."[1] In planning the fair he showed that he himself not only was able to dream greatly but also could translate his dreams into reality.

As early as 1890 he recruited the firm of Frederick Law Olmsted and Company to serve as consulting landscape engineers. Six hundred acres of Jackson Park, with waterfront on Lake Michigan, were chosen as the site, and an original outlay of fifteen million dollars was stipulated. The land was forbidding: three ridges of sandbars paralleling the shore, with boggy swales between. The two inland ridges bore a few oak trees gnarled and stunted by the winds off the lake. The outer ridge was swept bare. It was hoped that the wizardry of Olmsted would transform

the area into a wonderland of canals and lagoons, and level land to support the great pavilions. These would cover an area a third larger than that of the Paris Exposition four years before.

Burnham himself had already designed some interesting buildings in the bold new steel-skeleton construction. Later he would create the astonishing Flatiron Building in New York. But the majority of the architects whom he selected to do the buildings in the fair's Court of Honor and along its half-mile lagoon were from East Coast firms. The reason was simple: most of the needed funds had to come from Eastern pockets. Inevitably, the style of the whited pavilions was Beaux-Arts. Louis Sullivan's Transportation Building with its many-splendored semicircle of an entrance was relegated to what he considered a lesser lagoon. Sullivan himself was not reticent about proclaiming his views on the derivative Court of Honor: "Thus architecture died in the land of the free. . . . The damage wrought by the World's Fair will last for half a century from its date if not longer. . . ."[2] More temperately put, the Chicago fair, like so many expositions of its type, was a transparency of the taste of the day rather than a grand projection into the future.

Burnham very much wanted Saint Gaudens to be the prime mover in all sculptural matters. In particular, he had high hopes that Augustus would design the fountain marking one end of the central basin. During that first journey to Chicago in February 1891, Augustus was certainly caught up in the excitement of Burnham's bold plans. The trip out was by private Pullman car, and the company was a goodly one, including Richard Morris Hunt (at sixty-six the jovial dean of American architects), McKim, Sullivan, Olmsted, and many others. At one of the committee meetings, Burnham later remembered, the sculptor showed his enthrallment in his own indelible way: "All day long Saint Gaudens had been sitting in a corner, never opening his mouth and scarcely moving. He came over to me and taking both my hands said, 'Look here, old fellow, do you realize that this is the greatest meeting of artists since the fifteenth century!' "[3]

At another meeting, Saint Gaudens worried over the problem

of giving the Court of Honor coherence and harmony. To hold it together, he proposed a colossal statue of the Republic at the eastern end of the lagoon, with a portico of thirteen columns behind it—symbolizing the original thirteen states. Both concepts were enthusiastically accepted, and the second one quickly expanded into a 104-column peristyle.

Augustus held back when it came to any further involvement than sitting in at the meetings and giving advice. He explained to Burnham that he had undertaken so many commissions that he could neither act as supervisor nor do any sculpting himself. It was decided that Lorado Taft would supervise, and that Saint Gaudens would simply help pick the working sculptors.

Some of the sculpture mania of the French Third Republic had crossed the Atlantic, and the needs for the fair were many and urgent. The problem was made easier since all the statues for the six-month fair were to be cast in a substance called "staff"—a tough blend of plaster, fiber, and straw whose life span was short but whose appearance filled the need very well indeed. Staff was also used in the construction of the buildings that sprang up so quickly and were gone again so soon.

Sculpturally, the two most important undertakings were the fountain for the lagoon and the 65-foot-tall figure of the Republic. As important symbolically if not as vital to the overall design was the proposed figure of Columbus, to be placed in front of the Administration Building at the west end of the Court of Honor.

Saint Gaudens, interestingly enough, said he would break his self-imposed rule about not doing any actual sculpture if Willie MacMonnies would help him model the big fountain. In character, MacMonnies declined to be second man—and then joyfully accepted when Augustus offered him the full responsibility. Augustus nominated his own talented pupil Mary Lawrence to do the Columbus, stipulating that he would keep an eye on the project himself. For the symbolic *Statue of the Republic*, the choice was Daniel Chester French. In the years since his *Minute Man* at the Centennial, he had made a considerable reputation for civic monuments both ideal and abstract.

All three selections received immediate endorsement by Burnham and his committee. As usual in great expositions, time already meant overtime for all concerned.

Saint Gaudens' relationship with Willie MacMonnies, which flickered and flared for sixteen years, held elements of deep affection. He once wrote to Richard Watson Gilder, "My relations with Mac [an alternate nickname] are such that I guess that I see everything in the same way that a mother contemplates her boy."[4] One problem was that the two were too much alike. MacMonnies' vast facility matched Augustus' own, and he was one of the few people who ever aroused the older man's professional jealousy. Physically, they resembled each other quite startlingly, in the reddish hair, the straight nose, and the eyes just a shade too close together. In Willie some of Augustus' less appealing traits were writ large— his bombast, the periodic gloom, and the thirst for fame. Both were womanizers, although Saint Gaudens tended to see his own proclivities as perpetual romance. He rarely discussed and never boasted about his affairs. MacMonnies gloried in his promiscuity.

It all began in 1880, when the sixteen-year-old Willie was hired to do studio chores—mixing clay, keeping the clay models wet and covering them with heavy cloths at night, running errands, and tending winter fires. His wish was to knead clay in more creative ways, and his fingers itched to do so. For months Augustus gave him no heed. Then, during a period when the master was away for some weeks, MacMonnies copied one of the many available facsimiles of Donatello's bas-reliefs.

On his return, Saint Gaudens saw the panel and asked excitedly, "Who did this?"

"MacMonnies," one of the assistants told him.

"Well," said the master in amazement, "we must set him to work at once."[5]

Saint Gaudens gave Willie serious independent work to do, and encouraged him to study at the National Academy of Design as well. In the heady atmosphere of the studio, where many

prominent artists came and went, the boy "missed no word of criticism or comment."[6]

By the time he was twenty-two, MacMonnies was more than ready for the Beaux-Arts experience. Both Saint Gaudens and Stanford White helped make the move possible. He had the good fortune to be assigned to the atelier of Falguière, and soon was taken into his private studio to work by the side of the celebrated sculptor.

Sensing Saint Gaudens' concern, Paul Bion kept his friend informed on each step of Willie's swift rise in France. Bion compared him to a boy "gifted with a superb tenor voice. . . . Now finished with the conservatory, he knows what he's worth."[7] For his first try at a figure of Diana, MacMonnies received an Honorable Mention at the 1887 Salon, already outdistancing Augustus at the same age. By early the next year Bion was reporting that some of Willie's charming simplicity was wearing off: "I had in front of me a boy absolutely intoxicated with his recent successes . . . showing his predilection for the top, already considering himself to have made it."[8] The same letter mentioned artist Mary Fairchild ("real talent . . . pretty, honest, clean as a sword") and reported that she and MacMonnies were engaged. They were married in the fall of '88.

The following year MacMonnies submitted his reworked *Diana*, "running slowly and lightly with an unstrung arrow in her hand," to the Salon at the time of the 1889 Paris Exposition, and just missed the top prize.[9] "Charming fellow, MacMonnies," Bion now conceded to Saint Gaudens, "and very gifted as long as the butterfly doesn't carry him too far. It's flying a little too close to the sun. . . ."[10]

Tipped off by Saint Gaudens that there was a competition for a Nathan Hale for New York, MacMonnies dashed off a rough model and won the contest. Coached long-distance by Augustus, he produced a superb statue of the patriot in his sacrificial last moment on earth. Then, when the time came for Saint Gaudens to select the sculptors for the Chicago fair, MacMonnies traveled to New York to see his mentor—and

arrived back in Paris with the great plum of the celebratory fountain.

Now the picture clouds over. Saint Gaudens began to complain to Bion about MacMonnies' ingratitude. Judging from Bion's response, he also enumerated all the supportive things he had done for Willie. Bion replied: "Your observations are fair to a certain extent, but your conclusion is too severe. MacMonnies is not an ingrate. . . . Though you may have helped in the truly extraordinary ways you mention, he feels, almost morbidly, the inferiority of the position that puts him in with you."[11] It was Bion's theory that MacMonnies would have liked to be a prince and shower Saint Gaudens with his generosity: "I think he would be capable of princely folly should the occasion arise." Again Bion reminded Augustus that Willie's talents and characteristics were those of a tenor: "What good would it be to accuse a tenor of not having a deep bass voice?"[12]

One of Saint Gaudens' complaints is that he believed that MacMonnies had cribbed his *Diana* and gone on to win various honors in Paris with the near copy. It was quite true that the younger man had been working out of the New York studio at the time when Augustus was modeling the earliest version of the *Diana*. But it was just as true that sooner or later many sculptors tried their hand at doing a Diana. MacMonnies' version bears a much closer resemblance to Falguière's lush huntress than to Saint Gaudens' chaste goddess of the chase.

The master was overreacting. Yet an unmailed letter of his to Bion shows how deep was his feeling that the beloved pupil had taken advantage of him. This letter, which was found at Cornish among his effects, was drafted in response to a note from Bion reporting that MacMonnies was upset. Just back in Paris from the quick trip to New York during which he was awarded the fountain, Willie reported that Saint Gaudens was concealing his work-in-progress, such as the Sherman. Augustus wanted Bion to understand his mind:

> I said to myself, Old Man, hide your play or else others more
> light-fingered than you will carry off the fruits of victory.

. . . I do not say that my treasures have been stolen from me but unconsciously unconscionably? they have deprived me of their luster, but rest assured I am not harboring any resentment. There is one of the reasons I had for not showing the Sherman . . . to Mac; the other reason was that I have a very clear idea of what I want to do and a criticism from him would distract me seriously. . . . You know the high opinion I have of his genius but he is young and radical, violent and battling; he would let escape him some thoughtless word to which I would give an unmerited importance. . . . I know myself and am afraid of myself.[13]

Knowing how fond of MacMonnies and his somewhat disturbing charm Bion had grown, Saint Gaudens put the letter aside. Some time after this period of estrangement, Augustus' affection came flowing back. As a peace offering, he sent MacMonnies a cartoon strip of his own making, conveying the message that their various *Dianas* could be a matter of coincidence and independent inspiration.

Meanwhile, back in Paris, Willie created his fantastic fountain with characteristic speed. In all there were thirty-seven figures. Just behind the eagle-beaked prow of the eight-oared boat, he modeled a winged female figure with a trumpet. The long sweeps were manned by eight rather overdressed standing maidens straight out of Charles Dana Gibson. Columbia herself—bare of breast and draped of thigh—sits on a high central pedestal, staring straight ahead. On the high-pooped stern is a virile Father Time, wielding his scythe as a tiller. Add sea horses, garlands, cornucopia, putti, and bacchanti to suit, stir until ready for pouring into a blue lagoon, and you have the end product, saved from being just plain ridiculous only by its exuberance.

Bion, with his immaculate taste taxed to the full, kept Saint Gaudens posted on the progress of the work, and was careful to use fairly qualified praise:

I don't believe there is a single centimeter of area where his own finger has not touched. . . . To me his fountain is a

delight which I hesitate to scrutinize. Criticisms—I could mention some but to what good? It would be silly to criticize the perfume of a rose. . . . His fountain is a kind of boat— an ideal *Mayflower* where all sorts of proud and beautiful young people are assembled to row triumphantly. . . . It is a poem sung by an imperturbable poet like an oriole on his branch.[14]

The various elements of the fountain were shipped to Chicago in good time, assembled and positioned by opening day, and widely hailed as embodying the very spirit of the fair.

Long afterward, Augustus summed up the extravaganza with that gift of his for the offbeat: "Ye-es," he said in answer to a questioner, "it's very fine. It's the most beautiful conception of a fountain of modern times west of the Caspian mountains."[15]

The case of Mary Lawrence is much sunnier. Her father, Henry Effingham Lawrence, came from an old New York family. Among Mary's ancestors were a mayor of the city and the Captain Lawrence who died saying, "Don't give up the Ship." The family brownstone was on East Twenty-fifth Street, but it was the summer place up the Hudson at Snedens Landing that Mary loved.

The Landing had been a thriving river port in the early nineteenth century, but with the coming of the railroads it declined. The great pier, wide enough to accommodate three teams of horses abreast, began to rot away. Then, in the 1860s and 1870s, many old New York families started to summer there, and built fine stone houses along the river.

At fourteen Mary was fully grown and tomboyish, and weighed 150 pounds. "Her interests were dogs, horses, stable boys, fishermen, the kitchen staff, good food and art—mainly sculpture."[16] When she was a Junoesque twenty, she became an Art Students League pupil of Saint Gaudens, who soon spotted her remarkable talent. Her good looks and high spirits made her popular with both the young and the not-so-young. Charles Follen McKim,

whose second wife had died tragically after one short idyllic year, fell in love with her and remained a little so all the rest of his crowded life. He and Saint Gaudens often took the train from New York to Dobbs Ferry, and then the ferry across to Snedens Landing on the western shore, for the ritual-like picnics that were a Lawrence family specialty.

So sure was Augustus of her talent that he gave her the Columbus assignment with no qualms at all, even though she had never done a major work. He did agree to supervise the project, but in the *Reminiscences* he makes it clear that Mary "modelled and executed it and to her goes all the credit of the virility and breadth of treatment which it revealed."[17]

Great captain that he was, Christopher Columbus has always remained a shadowy figure, with attainments that do not particularly lend themselves to portrayal. His skill as a navigator is hard to make dramatic. He can be shown pointing toward an unknown shore and crying, "Sail On!"—or landing on such a shore, sword in hand, to claim it for his Queen. (No painter or sculptor has ever tried to give full treatment to the bitter moment when, after his third voyage to the New World, Columbus was shipped home in chains.)

Mary chose the moment of discovery on the beach of San Salvador Island. To the sword in the right hand she added the flag of Aragon and Castile in his left. She created a haggard Columbus with his head thrown back in a moment of controlled joy.

The concept met quick approval, but not everyone was as carried away by Mary Lawrence as Saint Gaudens and McKim were. The usually genial Frank Millet, who was serving as director of decorations for the fair, resented the fact that a woman had been selected, and seemed to bear her some personal animus as well.

When the larger-than-life figure was finally delivered to its site in front of the high-domed Administration Building, Mary was on hand to help place it on its pedestal. She stepped back to see how it looked, and was startled to hear Millet's sarcastic voice just behind her. "Lost in admiration, eh?" said Millet. He curtly

ordered her to move the statue to the plaza of the railroad station. Even though McKim, second only to Burnham himself, had designated the Court of Honor location, she had no choice but to obey. An appeal to the devoted McKim corrected the relegation, and Columbus was moved back where he belonged. But Mary never forgave Millet. "I could stamp on his face and grind it into the gravel till it bled," was her comment when she recalled the incident.[18]

Two detriti are among the few surviving clues to the relationship of Mary Lawrence to McKim and to Saint Gaudens. One is a note to her from McKim, written August 18, 1893: "This is to let you know that last Monday morning while you were fast asleep the patron [Saint Gaudens] and I passed down the river—on the wrong side of course—homeward bound from Chicago."[19] The letter goes on to describe certain World's Fair revels in lighthearted tone and ends: "hoping that the thought of another picnic will not fill you with actual panic and that you will continue to be very forgiving toward your erring friends."

The other bit of flotsam is a telegram found in a dusty file, very much the way the one from Saint Gaudens to Davida came to light:

To M. T. Lawrence	World's Fair Grounds
14 East 23rd Street	[no date given]
N.Y. City	

Will arrive about two P.M. Monday Will go straight to Fourteenth Street A Saint Gaudens

Below there is a notation which suggests that similar messages had been sent before: "Operator slip message in letter box if Miss Lawrence is absent."[20]

Mary Lawrence married the French-Italian sculptor François Tonetti in 1900. Augustus made all the correct congratulatory sounds but in private bewailed the loss of a fine talent, predicting correctly that Mary Lawrence Tonetti would never do serious

work again. But he carried off his sense of loss lightly enough: "He is a regular picnic feller and she is a regular picnic girl," he remarked. "I suppose there'll be lots of festive children."[21]

At the time of the *Minute Man* commission, Daniel Chester French had few assets but his youthful enthusiasm and his modeler's haptic skill. Also, in his improvised Boston office-building studio, he was able to make use of a borrowed plaster cast of the *Apollo Belvedere*. The embattled farmer certainly stemmed in good degree from the Roman masterpiece. In another sense he bore an occupational resemblance to the Wright brothers' plane at Kitty Hawk, built in a barn. The *Minute Man* took off at the Centennial and, like the Kitty Hawk plane, it flew (how it flew!)—and it has gone on flying ever since.

In the 1880s Dan French, trim of mustache and by Saint Gaudens' gusty standards a bit prim in manner, made a growing name as a civic sculptor who delivered on time. Nomination for the huge assignment at the fair was no more than his due. He did some preliminary work at Cornish in the summer of 1892 and then moved the project to Chicago, where he was given a hangarlike section of the Forestry Building for a work space. "The building was a great barn of a place and very cold," his daughter-biographer would write. "The statue froze up once. . . . Mornings it was sometimes too cold to work at all."[22]

The sixty-five-foot-high *Statue of the Republic* would be the biggest thus far created in the United States. The size presented enormous problems both to the sculptor and to his work crew. One was the simplification of the figure's classic mantle so that the vertical folds, falling some fifty feet, would lead the eye upward to the serene face of the New World goddess. Another problem was the accurate pointing of the twelve-foot-tall plaster model on a final mass of staff five times the size.

French cut his twelve-footer into five pieces. The dimensions were then pointed on the bigger sections, each of which was the size of a small house. The five big sections were taken to the

lagoon, where derricks were standing by, and hoisted in turn into place like a set of building blocks; then the whole was clamped together. The upright figure was strengthened by an interior framework of iron. Finally, the figure was covered by gold leaf, except for the head and arms, which were left white.

Without much time to spare, the goddess was swathed in a canvas covering to protect her from the chill winds off the lake and the eyes of the curious until the opening day.

28

WHITE CITY MIRAGE

O beautiful for patriot dream
That sees beyond the years
Thine alabaster cities gleam
Undimmed by human tears!

—Katherine Lee Bates (1893)

THE CHICAGO WORLD'S FAIR was our first alabaster city, or at least the illusion of same. Poet Katherine Lee Bates was moved by it to such a degree that she sat down and wrote "America the Beautiful." And thanks in good part to the fair's influence, many other white cities came into being between our shining seas. . . .

The fair was a city in that it did have a civic center—the Court of Honor, with its elaborate Administration Building. There was also a Main Street in the form of a teeming Midway, and a suburbia in the wooded, parklike island area which Frederick Law Olmsted conjured up.

Olmsted had indeed worked miracles. In two short years he and Daniel Burnham converted the sparse lakeshore wilderness into a dream world of canals and basins, docks and bridges and islands. The land itself he made level enough and firm enough to support a dozen palaces and some two hundred other buildings.

Then, by the thousands, workmen from all over the country

pitched in. Carpenters, glaziers, iron forgers, molders, joiners, masons, and painters carried out the best-laid plans of the many architectural firms. Finally the workmen yielded to scores of muralists and sculptors. The muralists, in swathed glorifications of the human form, gave life to the bare walls, while the sculptors supplied the frosting on the façades of the great wedding-cake buildings.

The stuccolike material called "staff" was the matrix and life of the fair. It could be prepared at speed by mixing plaster and fiber with water and adding straw. It was as tough as wood, and like wood it could be bored, sawed, and nailed and molded as well. In place on the façades, it imparted a facsimile of permanence and an agreeable brightness.

As Saint Gaudens had been among the first to urge, the theme of the Court of Honor was harmony. Matching cornices sixty-five feet above the pavement stitched the palaces together. The pedigrees of the buildings were certainly Beaux-Arts, in that the architects were almost all Paris-trained. The actual elements were eclectic, with Greek, Roman, and Renaissance all figuring. The Administration Building itself was a fair example. Richard Morris Hunt, harking back to his student days, designed a ground floor featuring a giant order of Doric columns. Above it came an attic story with an Ionic colonnade reminiscent of the tomb of King Mausolus at Halicarnassus—the original mausoleum. Topping the confection was a dome whose design sprang from the one Brunelleschi raised so gloriously over the cathedral in Florence. In this instance the icing was French: Karl Bitter's swirling sculptural groups, inspired by Rude's shrill *Marseillaise* on the Arc de Triomphe.

The eight-hundred-foot Architectural Hall along the main lagoon was middling McKim, Mead and White. Its shallow central dome did double duty as the pedestal for the 18-foot *Diana*. Although the redoubtable Mrs. Potter Palmer, president of the Board of Lady Managers, had wanted Saint Gaudens' nude goddess for the Woman's Pavilion, she had reluctantly yielded to others who felt that the statue belonged elsewhere.

Aware of the Eiffel Tower's vast success at the Paris Exposition, Burnham asked his staff to come up with "something novel, original, daring and unique" for a central attraction, and he got what he asked for.[1] It seemed that for some years a Pennsylvania engineer, George Washington Gale Ferris by name, had been working on a new version of the primordial wheel. The one he now designed for the fair was a revolving bicycle wheel, with seats able to carry so many people that one had to gasp. It was 250 feet high, and its thirty-six cars bore forty people each for a total of 1,440 for any given spin of the wheel.

It was a sensation from opening day. The best of the six stops was at the top, with a splendid view of the city and lake as well as fairgrounds. Quite rapidly Mr. Ferris' wheel and its many successors spun their way into the language. . . .

Two days before the May 1 opening Frank Millet had one of his better ideas. He caused all the flags of participating nations, states, cities, and the like to be furled and tied at the top like pennants on a warship. There were some seven hundred in all, the largest being the Stars and Stripes behind the place reserved for President Cleveland on the reviewing stand.

The great day dawned gray and drizzly, hardly suitable for the breaking-out of bunting. Two thousand official guests filled the stand, which was before the Administration Building. Nearly a quarter of a million thronged the Court of Honor. At 10:30, forty Indian chiefs shouldered their way through the crowd, led by Chief Rain-in-the-Face. By noon the sun was out, and at 12:08 the President pushed a telegraph key of solid gold. Lots of simultaneous action ensued. From the lake the warship *Andrew Johnson* fired a salute of all her guns. A sailor tugged frantically at Old Glory and it cascaded in majestic folds. All the other flags followed suit. The fountains surrounding Willie MacMonnies' love barge shot their first lofty streams, and the spray drifted over the crowd. The gilded figure of the Republic emerged from her cocoon, serene and beautiful in the sunlight. Steamboats in the

lagoons and canals tooted raucously, and electric boats honked. The band struck up the "Hallelujah Chorus." (Still missing was Mary Lawrence's heroic *Columbus*, which was not positioned on its high pedestal until mid-June.)

After the speeches, women in large numbers stampeded for their own Mecca, the Woman's Pavilion. Designed by twenty-two-year-old Sophia Hayden, who had been trained at the Massachusetts Institute of Technology, it was nearer the Midway than the Court of Honor. Many of the crowd surged over to the Fine Arts Palace with its five acres of masterpieces. Others stood in line for the Ferris wheel. Like steel filings to a magnet, sleek imported gondolas converged on the *Republic*, and the gondoliers serenaded the people still milling around the Court of Honor.

Almost immediately the fair ran into financial trouble, for the economic news across the nation was worsening rapidly. On the second day the attendance was a mere ten thousand. Then two Chicago banks failed, and the Panic of '93 was under way. To divert people from their troubles, something drastic had to be done. More entertainment and less instruction turned out to be the solution.

Frank Millet was given additional duties as "director of functions." He organized special days honoring everything from the city of Brooklyn to the Ottoman Empire, from the shoe trade to Izaak Walton. Strolling singers, fireworks, parades for visiting potentates (some mythical), and the ubiquitous Buffalo Bill and His Troupe were other attractions. A nineteen-year-old performer from Coney Island named Weiss began to pack them in under his new name of Houdini.

Cheek by jowl to the Woman's Building was the Little Egypt theater, where belly dancing throve. Bertha Palmer demanded that it be closed down, but it was far too popular for that. To placate her, an amateur historian wrote that the belly dance "was a religious memorial which inculcates purity and self control."[2] She remained unplacated, but the show went on.

The May average was better, but still nowhere near enough—some thirty-three thousand a day. By mid-June admissions had doubled. On Chicago Day, October 9, three hundred thousand people turned the stiles. The record-breaking total for the six months of the fair's life turned out to be over twenty-seven million.

From May on, the famous and the near-famous were coming in ever-greater numbers. Henry Adams, now well into the second year of his new life, felt there the surge and drive of the mechanism that was America:

> Chicago asked in 1893 for the first time the question whether the American people knew where they were driving. Adams answered, for one, that he did not know, but would try to find out. On reflecting sufficiently deeply, under the shadow of Richard Hunt's architecture, he decided that the American people probably knew no more than he did; but that they might still be driving or drifting unconsciously to some point in space; and that possibly if relations enough could be observed, this point might be fixed. Chicago was the first expression of American thought as a unity. . . .[3]

Theodore Roosevelt and his wife spent eleven days at the fair, T.R. on leave from his duties as a member of the Civil Service Commission. "Illuminated by searchlights at night, the façades shone like white marble, while occasional bursts of fireworks bathed them in myriad colors. Edith, floating past them for hours in a hired gondola . . . felt herself 'in fairyland.' "[4] She especially liked their friend Saint Gaudens' *Diana* and the *Columbus*, which she, like so many, attributed to the master and not the pupil. For his part T.R., "ever the archpatriot," admired the statuary of the various presidents.

Southern belle Nannie Langhorne, later Astor, was a lively visitor. One day, when a band struck up "Marching Through Georgia," she yelled, "Three Cheers for Robert E. Lee," and the crowd took up her hurrah.[5]

Scott Joplin came often to the Midway's popular Dahomey

Village. By the hour he listened to the jubilant syncopation of the African drums. Then he would go back to the various night spots of Chicago's Tenderloin and play his inspired piano in such a way that it was hard to tell where Dahomey ended and ragtime was born.

J. P. Morgan stalked through the Palace of Fine Arts and "brutally remarked of the French exhibit that they seemed to have been picked by a committee of chambermaids."[6]

The art actually mirrored the times. Because the Impressionists had already peaked in France, there were no Monets or Seurats or Renoirs. Even Corot was missing, but Gérôme and Bouguereau pleased the multitude as they always had. A wrong was righted when Eakins, shunned and shunted in '76, was well displayed—an *Andrew Clinic* for a *Gross*. Frederick Church and Albert Bierstadt were notably absent, but Winslow Homer, Eastman Johnson, La Farge, Chase, Gari Melchers, Whistler, and Sargent were in the galaxy. One of the Sargents was the mood piece of Homer and his mother. To many, Abbott Thayer's *Virgin Enthroned* seemed like a dream of all American women in one fair form.

The Woman's Pavilion was the source of some controversy. Was women's work in the applied and creative arts honored or simply segregated by such a singling out? It was generally agreed that Mary Fairchild's *Primitive Women,* at one end of the Gallery of Honor, was better than Mary Cassatt's three panels of *Modern Women* at the other. (Miss Cassatt had painted her mural in a specially dug slit trench, because she had not wished to perch on a ladder.) Cecilia Beaux's *Twilight Confidences,* with echoes of Whistler and Sargent, was better received than either. Bertha Palmer had been tigerish in her pursuit of the best paintings and sculpture by women. Ironically, when it came to choosing someone to paint her own official portrait, she opted for Anders Zorn, the popular Swedish artist. His stylish portrait showed her holding a gavel that "glowed like a fairy wand" and wearing a dress that was like a confection of spun sugar.[7]

More of a brouhaha concerned the official medallion to be

awarded to the various prize winners. Secretary of the Treasury J. G. Carlisle commissioned Saint Gaudens to design it. Augustus came up with an obverse closely resembling Mary Lawrence's heroic Columbus, with one amusing addition: just behind the explorer is the tiny head of a henchman that is unmistakably the sculptor himself—in a tradition later espoused by Alfred Hitchcock.

The trouble came with the reverse side. Saint Gaudens and his assistants designed an idealization of a nude boy holding a shield, leaving space on the shield for the name of the award winner. Before the medal was actually struck, someone pilfered a copy and printed an indecent caricature. The outcry was such that some of the obloquy rubbed off on the slightly androgynous figure created by Saint Gaudens and Company. The director of the U.S. Mint encouraged Augustus to make some changes but at the same time instructed Charles E. Barber of his staff to tackle a new reverse. Leaving the sculptor completely in the dark, the director ran off a medal that was half Saint Gaudens and half Barber; the Barber contribution, consisting of some conventional lettering and some rather cluttered symbols, clashed sharply with the delicacy of the figures on the obverse.

Not much could be done about the accomplished fact. But the episode started an accumulation of bad blood between Augustus and Barber, blood that would spurt some years later. Augustus expressed his own sense of outrage in an open letter to the New York *Tribune* that ended: "Mr. Carlisle's may be the legal right to combine my work with that of another on the same medal, but the rare shamelessness of such offense will be appreciated by all my confreres at home and abroad, and it is as much in their interest as in my own unbridled astonishment that I make this protest public."[8]

Controversies and brouhahas to the contrary—and there were quite a few of both—the Chicago Fair was a landmark in American life. Years later, Thomas Beer managed to scoop up some of the magic, and the absurdity, about as well as anyone has ever done:

The nation . . . hastened to applaud this prodigiousness of white stucco pinned to iron between Chicago's smoky breast and the blue water. . . . Mankind now gaped at studded domes and classicized fronts in the best mood of that school infesting Paris after the reign of the vulgar, useful Baron Haussmann. Could the Americans think of nothing fresher? Why not vast wigwams? . . . By night Edison's perfected bulbs dripped glitter on the shivering lagoons. Rockets swam across faint stars. The Midway shows and bands roared wonderfully.[9]

The end was muted. Three days before the closing day of October 31, the popular five-term Mayor of Chicago, Carter Harrison, was murdered in his own home by a disappointed office seeker. Instead of the scheduled band concert, an orchestra played Beethoven's Funeral March.

By closing day, the buildings were cracking and blurring in the cold wind. Leaves clogged the lagoons and danced mournful little sarabands in neglected corners. Mr. Millet's banners, weatherstained by now, were pulled down in silence until only the American flag was left flying. Soon the dismantling process set in. When it was over, all that remained was the Palace of Fine Arts, which was made of sterner stuff than staff. It became, more permanently, the Field Museum. Some years later, a bronze seventeen-foot replica of Daniel Chester French's *Republic* was set up in Jackson Park as a reminder of all that was good and beautiful in the great extravaganza.

Even though he had served as adviser only, Saint Gaudens had been among the leaders. He came as often as he could, and afterward found the words to express his feelings: "The days that I passed there linger in the memory like a glorious dream, and it seems impossible that such a vision can ever be recalled for its poetic grandeur and elevation. Certainly it has stood far beyond any of the expositions, great as they have been, that have succeeded it."[10]

29

A NEW WORLD PRIMACY

"A mediocre sculptor is lost.
The sculptor must be either a genius or a nobody."

—Kenyon Cox,
Old Masters and New

BACK IN THE EARLY 1880s, when the Farragut first brought him fame, Saint Gaudens was one of a number of American sculptors who were making their way. Now, in the years 1894–97—the years between his World's Fair eminence and his departure for Paris—he was to experience, if not particularly enjoy, a time of primacy.

As his fame mounted and the commissions continued to pour in, he sculpted less and delegated more. In the Thirty-sixth Street studio the *Shaw* was moving into a most complicated period; it occupied the central scaffolding and much more space as well. The *Adams Monument* was replaced as a work-in-progress by a statue to honor Peter Cooper for the Cooper Union. To complete two new jobs, the *Garfield* for Philadelphia and the *General John A. Logan Monument* for Chicago, Augustus rented space on Twentieth Street. For the early stages of the *Sherman* he took a small studio on Twenty-seventh Street. Shortly he added a loft on Fifty-ninth Street to do the actual modeling of the General's horse.

Saint Gaudens was never particularly generous about sharing

261

credit. He was like the guildmaster whose success enriched the guild as a whole—or the ship's captain who took the credit if he brought his ship safely to port and the blame if he did not. Augustus himself still bettered what was done, and his helpers knew it. They stayed because they were learning, because they grew fond of him despite his rages and moods, and because life in his vicinity was never dull. . . .

Even as gifted an animal sculptor as Phimister Proctor seems to have been content enough to contribute day labor without more recognition than the prestige of working for the master.

Bernard Saint Gaudens had died in the year of the fair. How deep Augustus' affection for his father had been is recalled in this passage by Homer in the *Reminiscences*:

> I was too young to notice the extent of this love during Bernard Saint-Gaudens' lifetime, but I have a most vivid recollection of the blow that fell upon Augustus Saint-Gaudens when his father died. For he took me that night to the barnlike Thirty-sixth Street studio and there, lighting one feeble gas-jet, walked sobbing back and forth, in and out of the black shadows, telling to my young, uncomprehending ears all that his father had meant to him.[1]

Surviving family ties fell into a pattern that did not vary much during this mid-nineties period. Gussie took an active share in their busy New York life and managed the five months of the year in Cornish with the skill and authority of an army supply officer.

As Saint Gaudens had indicated or at least implied in his letter to her about Davida, he did his best not to cause her any more embarrassment from his double life than was absolutely necessary. When he came down from Cornish he ostensibly stayed at the Players Club, which he had joined in 1891 and which suited him perfectly for purposes of respectability.

Sometimes he managed to spend a week at a time with Davida in the Noroton Heights section of Darien. The white frame house

he bought for her is gone now, but the nearby station from which he commuted to New York during these visits is still there, on a spur of the New York, New Haven & Hartford.

Hard facts about this shadowy phase of Augustus' existence are so rare that it would be easy to believe that the relationship was beginning to unravel. But in 1965 Frank Spinney, then the director of the Saint Gaudens site, managed to contact a man named Charles Patschek, whose grandmother Helen Patschek had been a close friend of Davida's from her early New York days. Charles was a small boy at the time but produced a direct rec-ollection of an incident that had been related to him: "One week-end my father Frank and his brother bicycled to Connecticut to visit Mrs. Clark. Saint Gaudens was there with some of his ac-quaintances. He was amazed that anyone could ride that far from New York in one day. Father was studying art at school and did receive some criticism from Saint Gaudens. . . ."[2]

Patschek also remembered hearing that when his father and mother were married Saint Gaudens gave them an oil painting— a large floral still life—by one of his artist friends.

Another piece of evidence occurs in a letter from Paul Bion in December 1894, which, though it mainly concerns some mod-eling in Paris from a Saint Gaudens rough sketch, contains a glancing reference indicating awareness of Davida's continuing needs. "You'll get 1900 dollars quite legitimately," Bion wrote of the transaction. "I don't think that will be too much of a luxury with Noroton on your back."[3]

Saint Gaudens' busy life as dean and doyen of his profession meant fewer hours of actual modeling. He nevertheless kept a sharp eye on any work that bore his signature—and to varying degrees the mark of his hand. He also watched technical developments in sculpture with close attention, and even made some contributions himself. He was thoroughly familiar with the two methods the foundries used to cast in bronze. For his bas-reliefs he himself favored the age-old method of casting in sand.

Sand casting begins with a shellacked plaster model that is

laid horizontally on a bed of coarse sand in a rectangular iron flask. The exposed upper half of the plaster is covered, in sections, with a fine-grained, cohesive "French sand." A special powder helps separate the pieces of the mold. The process is repeated on the other half of the plaster model, which is then set aside. The sand sections (bearing a negative impression of the original plaster surface) are reassembled in the two flasks (the "cope" and the "drag").

Since nearly all sand castings are hollow, a solid core is constructed, reinforced with an armature of pipes and rods. The surfaces of the core are carefully removed to create the desired (and often uneven) thickness of the bronze. The French sand is then coated with a thin layer of graphite which prevents it from crumbling when the mold is baked. The molten bronze is then poured into the narrow space between the core and the mold. Once the bronze has solidified, the sand and core materials are removed and the numerous seam lines on the metal surface are removed or "chased." The final step is the uniform coloring or patination of the bronze.

If a model is large or complex, the plaster is divided and cast individually. The bronze pieces are assembled and welded together. Nearly all nineteenth-century bronzes, large and small, are sand castings.

The other method, the lost-wax casting process, was well known in the ancient world but then was indeed lost for centuries. It had reappeared in Europe by the 1850s and in America by the turn of the century. A shellacked model is first covered with clay and encased in a three-sectional plaster retainer. The shell is carefully split and the clay removed and replaced by gelatin or a glue-like substance that captures every detail of the plaster model. After it has set, the outer shell and the gelatin mold are removed in sections, and the plaster model is set aside.

Molten wax is applied to the flexible gelatin mold. Once the wax has hardened to a uniform thickness, a core of coarse, plaster-like material is poured into the mold. The outer shell and the gelatin mold are separated, leaving the core and the wax posi-

tive—an identical version of the plaster model. To this surface is then attached an elaborate series of channels (runners, gates and risers) also made of modeling wax. The whole is covered with an "investment mold" made of plaster. After it is baked in a kiln, all of the wax runs off—is, in effect, "lost." The spaces once occupied by wax are now filled with liquid bronze. After cooling, the investment and core are removed, the bronze appendages chased, and the surface patinated.

The fluid quality of the gelatin, the wax, and the molten bronze permit the sculptor greater accuracy in capturing the surface details of the plaster model in single and multiple casting operations.

Many sculptors rely completely on the competence of the experts at the foundry once the work is turned over. Augustus fussed. Even during the first step of plaster casting, often done in the studio itself, he was on tenterhooks. To Margaret French Cresson this trait was in marked contrast to her own father's "tranquility": "Up in Cornish they used to tease Saint Gaudens because he was as nervous as a prima donna when his statues were being cast. He'd strike off into the woods by himself for an entire day, or leave town altogether in an agony of apprehension."[4]

French's wife, who was fond of Augustus, observed other tendencies that were beginning to emerge during the summer of 1894, the Frenches' second and last at Cornish: "I always felt about Saint Gaudens that there was something of a tendency toward, if not morbidness, at least toward introspection, from which he wished to escape; that he craved excitement or at least diversion."[5]

Saint Gaudens' agonizing over the various technical steps stemmed partly from his own first-hand involvement. As an example, he shared in the development of an improved form of modeling clay. During his endless work on the Shaw, he found the wetting down and draping of the covering blankets to keep the clay moist increasingly tiresome. He recalled that there existed in France a clay-based amalgam called "plastoline," which did not require moistening, but was too expensive for everyday

use. At Augustus' request, Bion sent a shipment of plastoline to the United States. Saint Gaudens and Philip Martiny experimented with it and evolved a cheaper variation not unlike what is in use today. (Still considered best by many sculptors is the plastoline made, with the trade name of "Plasticine," by the firm of Giudice of Genoa—a secret formula in which sulphur and glycerine figure along with the clay.)

Another technical step Saint Gaudens helped to develop was the cubical pantograph, which improved the process of pointing. The prime mover here was Robert T. Paine, an Art Students League pupil of Augustus' and then an assistant. The device was first used in enlarging the horse in the Sherman. Increased accuracy and speed (over four hundred points a day) were the new pantograph's very useful contributions.

In addition to such gifted technicians as Martiny and Paine, Augustus was fortunate to have, for the last twenty years of his life, the services of the French-born Gaetan Ardisson, whose nominal duties were those of "molder," meaning that he was the man in charge of transferring the final clay model to plaster. Ardisson's sense of perfection and fastidiousness matched the sculptor's own, and he became the invaluable lieutenant in the whole process, from sketch to bronze. That Ardisson was a troublemaker, "sardonic, malicious, delighting in setting up rows and jealousies," was more than compensated for by his brilliance.[6]

The monument to James A. Garfield, completed in the mid-nineties, is one of the least known of Saint Gaudens' ambitious works. Immediately after the twentieth President's death in 1881, the Fairmount Park Art Association in Philadelphia had started a fund for a memorial. It had grown to fifteen thousand dollars by the time a special five-man committee of the Association recommended that Augustus be the sculptor. Preliminary discussions and sketches took up the next four years. Then, in June 1893, Saint Gaudens told the committee he now wished to do something quite different from the freestanding figure first envisioned. Along with the request he enclosed a water color made by McKim,

Mead and White showing what sculptor and architect Stanford White had in mind: a life-sized bust on a high Ionic pedestal, with an allegorical figure of the Republic to the fore. He also asked for a two-year extension to complete the new treatment.

By no means unanimously, the special committee recommended that the changes be accepted and also granted an additional five thousand dollars to the fee. It was this second contract that Davida and Charles Keck witnessed in December 1893.

By the following March, the relationship with the Fairmount people was beginning to sour, as Augustus' note to White shows: "I am dealing with a committee with whom I am not on very pleasant terms. Some of them understand art but they are Philadelphians and it would take me a week of Sundays to explain to them that the monument would be finer than the watercolor."[7]

The bronze bust of the heavily bearded Garfield which Saint Gaudens produced is perfectly adequate work, but it is clear that Augustus had no special feeling for the martyred President. The allegorical figure of the Republic guarding the marble pedestal on which the bust rests is quite a different matter. Since Davida was doing the posing, the sculptor put all his sensitivity and skill into the modeling.

There was more trouble over the breast-high shield, which was to carry the inscription. Saint Gaudens proposed various bardic quotations from Shakespeare and Wordsworth, and the committee turned them all down. The final lettering simply identifies the man above, with his high office and dates. As a result the lower half of the shield is curiously empty. It could be taken as a *tabula rasa* of an unfinished life, but in fact it testifies to the inability of committee and sculptor to reach any agreement.

Finished in 1895, the Garfield was unveiled in May 1896 with elaborate festivities, including a water pageant on the nearby Schuylkill. Not much has happened since. Ten years later Saint Gaudens asked permission to reduce the shield and to gild the blackening bronze of bust and figure. The Association politely but firmly turned the request down. Today the monument broods away, competent-to-beautiful and almost wholly forgotten.

Truman Bartlett, watching sourly from the sidelines as Saint

Gaudens' star continued up the sky, was delighted to learn that there had been disagreements. "When I went to Philadelphia to lecture, the man who had engaged me to go drove me out to the Park and as we were going along he said, 'There's a monument to President Garfield made by St. Guadens and I as one of the committee assert that it has caused more trouble than anything we have ever erected in the park.'"[8]

Both Charles Keck and Louis St. Gaudens helped on the Garfield. Even more of a collaboration was the flamboyant *General John A. Logan* for Chicago's Grant Park. Phimister Proctor contributed a spirited horse featuring a good deal of arching neck and prancing hoof. Mary Lawrence and Annetta Johnson, soon to be Mrs. Louis St. Gaudens, did considerable modeling of the figure of the political general.

Logan was the kind of ambitious civilian who was always on time for wars. In his early twenties he served in the Mexican War. When the Civil War came, he helped to organize the Thirty-first Illinois Regiment and became its colonel. Later, as a major general under Sherman, he distinguished himself at Atlanta, where his dark locks and gallantry earned him the nickname of "Black Jack." When it came to the next upward step—command of the Army of the Tennessee—Sherman developed misgivings. Fully aware that the fiery Logan knew that wartime exploits had a certain value in the currency of peace and had his eye on what came next, Sherman chose a West Point professional for the push to the sea.

After the war, Logan organized the Northern veterans into the Grand Army of the Republic and became its president. He invented Memorial Day, ran for vice president with Blaine in 1884, and was in his third term as U.S. Senator from Illinois when he died at sixty.

Saint Gaudens' statue shows him very straight and tall in the saddle. At the end of his extended right arm he flaunts a loosely folded banner. His high boots, tethered sword, and holstered

pistols all have a vitality of their own. Man and horse quiver with passion and pride. The cocked pose of the rider bears a marked resemblance to Emmanuel Frémiet's *Joan of Arc* in Paris' Place des Pyramides. Next to the Dubois Joan, Augustus liked Frémiet's treatment best, and kept a photograph ready to hand. So the resemblance is hardly coincidental.

French critic Emmanuel Bénézit's comment on Frémiet's Joan and his other equestrian works applies in some degree to the kindred Logan as well: "If the horses have élan, the people are spoiled by academic considerations and by concern for such matters as getting a likeness and conforming to a convention."[9]

Augustus was never wholly satisfied with the statue. In this instance the committee pushed him so hard that he released the final model for casting even though his judgment told him there was much still to be done on both horse and rider.

The statue was unveiled in 1897. It stands on a shallow pedestal atop a hill. Ninety-six feet of steps and terraces lead up to the location. The overall effect is most spectacular but the suspicion lingers: it is magnificent but it is not *la guerre*, only a very dashing civilian playing at war.

Once again, Truman Bartlett pricked up his ears, and exaggerated the rumors with his hobgoblin glee: "The over ardent friends of St. Guadens have taken good care not to mention the equestrian statue of General Logan and ever since it was set up there has been a quarrel over it between the Army of the Republic and Mrs. Logan. She was so disgusted that she went off and hired an American sculptor in Rome to make another equestrian statue of her husband to be set up in Washington and unfortunately enough it turned out to be as bad. . . ."[10] (Bartlett's taste on matters not involving Saint Gaudens is quite acceptable, for the Washington *Logan* is heavy-handed indeed and mediocre at best.)

Another considerable work from these ascendant years was the *Peter Cooper Monument*. Saint Gaudens portrays the philanthropist, who had lived to be ninety-two, as a rugged old man sitting four-square on a massive chair and grasping a cane in his left hand. Noble head, flowing beard, and vigorous frock-coated

body all contribute to the stalwart effect. Originally planned to fit into the façade of the Cooper Union itself, the statue ended up leading a life of its own some yards in front of it, under a typical Stanford White canopy. Years later Augustus made one of his rare criticisms of a Stanford White contribution. On passing the monument he remarked to Homer "that he was sorry the canopy had not been further studied, since with his more tranquil eye he could see that the delicately-traced architecture and fine lettering were not in keeping with the subject of a heavy and bearded man."[11]

In actual fact, his celebrated instant eye was certainly as good as the tranquil one: the shallow marble canopy, the forthright Ionic columns, and the elegant lettering on the pedestal serve to bring out and enhance the vigor of what is one of Saint Gaudens' most straightforward productions. He made twenty-seven sketches in pencil and clay, and gave the time gladly, for he felt that the work was a labor of gratitude and love. There is no record of how much help he had with the actual modeling, but one suspects quite a lot. All that is missing here is *la patte*, the indelible Saint Gaudens stamp.

Thanks in good measure to Saint Gaudens, Cornish was becoming more and more of a summer haven for artists. The cult of Mount Ascutney was also growing. Children of the summer folk built their sandcastles in the shape of " 'Cutney." One of the local schoolteachers put together his woodpile of birch and oak and maple in the unmistakable contours of the sacred mountain. And the cult of Augustus Saint Gaudens was growing apace. Because he was so completely occupied with his work that he was not able to mix much with the colony, he began to be a somewhat legendary figure.

There was one important addition to the Saint Gaudens intimate circle: Dr. Arthur Nichols and his family. Nichols, a Boston pediatrician of independent means, was married to Gussie's sister Elizabeth. They first came to Cornish in the summer of 1889 to

live at Aspet while Augustus and Gussie were abroad. The following year, on the urging of their eldest daughter, Rose, they bought a house there. Rose, who was eighteen at the time, was already very possessive about her uncle Gus. He in turn admired her boldness and high spirits. Tall, with a Diana-like figure, Rose had certain marked predilections: she liked the limelight, celebrities, travel, and having her own way. Not everyone appreciated her as much as Augustus did. When her sister Margaret was asked why she was so little like Rose, she answered that "she had spent her life trying not to be."[12] When Rose was in full cry, Dr. Nichols found it easier simply to leave the room until calm was restored.

On a trip abroad in 1896, Rose dined in Paris with Willie and Mary MacMonnies. Her report home to her sister Marian shows how concerned she was about the name and fame of Uncle Gus:

I think I told you about going to dinner at the MacMonnies. At the time I enjoyed it very much but ever since I have been morally and physically suffering the consequences. Mr. M. was so clever and plausible that it was only afterward that I realized how unkindly he had spoken of Uncle Gus. He evidently is even more jealous than I could possibly have imagined. . . . He said that he [Augustus] was sentimental in the first place, then that people had treated him as such a divinity, as someone so above and apart from everyone else that even to himself he had to pretend not to be human. . . . I thought he was only joking, but now I think he really meant it. Just because Uncle A is a relation and I am very fond of him, I can't stand up for him in the same way I could for more of a stranger. But I did say I could not believe that flattery made any impression on him. . . . It seems so ungrateful and horrid in Mr. MacMonnies. I can't give you much idea of what he said, it was more the queer air in his tone than anything. He seemed to speak as though Uncle Augustus were nothing but a humbug.[13]

In the same letter, Rose conceded that Augustus was not totally averse to being treated like a god, but her conviction of his essential modesty and good sense also came through.

We can surmise that Augustus unloaded some of his restlessness, and his boredom with the adulation of the many, on Paul Bion. Writing on May 21, 1895, in the course of urging his American friend once again to come to Paris, Bion touched on this matter: "Once rid of that circle of flatterers and admirers, you would see yourself in a light more brutal but also more true."[14] The point Bion was making here was that it would be healthy for Saint Gaudens to discover that his European fame was not all that much. Bion went on to worry about the effect of this truth on any entourage the sculptor brought with him: "You come with a wife and child, with a contingent of friends, officious people and busybodies to whom you represent respect, glory, elevated connections in society. You are a St. Gaudens to be used by them. . . ."[15]

As so often in the past, Augustus did not quite shake loose. The following summer, still urging his friend to come to France to renew himself, Bion reported an odd little echo that he had picked up:

> From time to time I meet an American by chance, at MacMonnies, man or woman . . . and I compare the almost idolizing way they used to speak of you to a certain irritation in reference to you now. It isn't yet a hostility, but it isn't the adoration of yesterday. . . . I think you have come to a decisive moment in which you must renew your lease with public opinion which has up until now spoiled you in making you a favorite, but which will harshly evict you if your credit becomes bad. If not, I believe that a very hard period will have begun for you. . . .[16]

In the context of the letter as a whole, it is clear that Bion believed that the main reason Saint Gaudens' stock was falling was his occupational delays in finishing a commission. The good loyal Bion

very gently offered a solution: "The letter which will bring me the most pleasure will be the one announcing the finish of your Logan and your Shaw."

Bion's letter was dated August 29, 1896. We have seen how the Logan was rushed to the foundry under great pressure from the sponsors. The story of the Shaw, the work to which Augustus' very soul as an artist was committed, is more complicated and infinitely longer drawn out.

He wanted very much to go to Paris—to see the faithful Bion; to see first-hand why MacMonnies was making such a success in France, and what mischief he was up to there; to regain his own perspective. Deep down in his modest but not unduly modest being, Saint Gaudens also wanted his New World fame to spread and grow. He was looking for Old Worlds to conquer.

But first he had to finish the Shaw.

30

SYMPHONY IN BRONZE

"A man who could labor upon a work like the Shaw for fourteen years, fairly loving it into noble perfection, has a right to leave the result to time and to the work itself."

—Lorado Taft,
Modern Tendencies in Sculpture[1]

IF THE *Diana* is a love song and the monument to Clover Adams a requiem, if the Farragut and Sherman are battle hymns and the Lincoln a majestic tone poem, the *Shaw Memorial* could well be called a symphony. There is so much variety to it, from the delicate bas-relief of the hovering angel to the high relief of many of the marching men, to the full, statue-in-the-round quality of the Colonel and his charger, that no other musical analogy would be accurate. To carry the comparison one step further, it would be fair to say that, musically speaking, the instruction under which the sculptor composed his symphony was *nobilmente*, the term Sir Edward Elgar invented for a major composition of his own.

Robert Gould Shaw was hardly the stuff of heroes. He came from an old Massachusetts family whose fortune had been made in the China trade. Fair-haired, even of disposition, he was a natural athlete, with an athlete's grace of motion. During three not very distinguished years at Harvard, his main interests were

music and drawing rather than any serious application to his books. Pressured by his family, he went to work in an uncle's New York office but was bored and restless there. With war clouds gathering, he enlisted in New York's Seventh National Guard Regiment. Later he accepted a commission as a second lieutenant in the Second Massachusetts. By the age of twenty-six he was a captain, combat-hardened at Antietam and Cedar Mountain and sure of steady advancement.

In one of his letters from the front, Shaw wrote his father: "Isn't it extraordinary that the Government won't make use of the instrument that would finish the war sooner than anything else—that is, the slaves? They would probably make a fine army after a little drill, and certainly could be kept under better discipline than our independent Yankees."[2]

When, after the Emancipation Proclamation of 1863, serious recruiting of blacks did begin, it was natural that Massachusetts, home of abolition and much other antislavery action, should lead the way. The state's splendid Governor, John Albion Andrew, had already been pressing the War Department on this matter. Now at last Secretary Stanton agreed, provided that all the officers were white.

Informed of Shaw's views, Governor Andrew offered him the colonelcy of the Fifty-fourth Massachusetts Regiment, soon to be the pioneer black unit in the Union Army. From all over the North and West recruits were pouring in, the first of the 180,000 black Americans who would serve before the end of the war.

Shaw declined the honor. He felt that he had not yet had sufficient military experience, and also that he lacked the true crusading zeal. Then his formidable mother, Sarah Sturgis Shaw, went into action. "This decision has caused me the bitterest disappointment I have ever experienced," she wrote Governor Andrew.[3]

Under pressure from her, and after deep reflection, Robert Shaw reversed himself and accepted the commission. "Now I feel ready to die," his mother wrote him jubilantly, "for I see you

willing to give your support to the cause of truth that is lying crushed and bleeding."[4]

The regiment, nine hundred strong, trained near Boston. All the officers had some abolitionist background. Two were brothers of Henry James. Among the enlisted men were two sons of Frederick Douglass, the former slave whose eloquent voice had trumpeted the call for recruits across many states.

In May 1863, they received orders for South Carolina duty, as part of the forces investing Charleston, and on May 28 there was a parade before they boarded ship. From downtown Boston, the regiment reached Beacon Street by Somerset Street, just east of the gold-domed State House. Then, as the men marched down Beacon Hill toward the Common, there were bursts of cheering, and intervals of silence when all that could be heard was the heavy tramp of feet.

Shaw, riding with drawn sword alongside the front ranks, induced both. To poet John Greenleaf Whittier, he seemed "the very flower of grace and chivalry . . . beautiful and awful, as an angel of God come down to lead the host of freedom to victory."[5]

From one Beacon Street balcony a pretty girl called softly, "Goodbye, Bob."

Shaw looked up, smiling, and raised his sword in salute. From the fine Sturgis house at 44 Beacon, his bride of less than a week watched in pride and fear. His younger sister had her own misgivings: "His face was the face of an angel and I felt perfectly sure he would never come back."[6]

Not all the silences were awe-inspired, for there were Southern sympathizers in the crowd and on the balconies. These "Copperheads" included proper Bostonians who had made proper fortunes in the cotton trade. Legend has it that there were boos and hisses from the Somerset Club balcony as the regiment passed, or at least firmly drawn curtains there.

On shipboard, on the way to the war zone, Shaw was increasingly caught up in the cause he had undertaken with such reservations: "Truly I ought to be thankful," he wrote home. "If the raising of colored troops proves a benefit to the country and

the blacks . . . I shall thank God a thousand times that I was led to take my share in it."[7]

In his last letter before going into combat, Shaw protested an outrageous discrimination. His blacks were being paid ten dollars a month, as opposed to the thirteen-dollar base pay of the white troops. If this continued, he wrote that they "should be mustered out of the service as they were enlisted on the understanding they were to be on the same footing as other Massachusetts volunteers."[8]

Fort Wagner kept a rather low profile of squat earthworks but it was one of Charleston's strongest defenses on the harbor's southern side. The bomb shelters, protected by a deep fosse or ditch and walls of palmetto log as well as earth, could hold sixteen hundred men. In this matter, the Union intelligence reports were very wide of the mark: the besiegers were led to believe that Shaw's regiment outnumbered the Confederates in the fort by a two-to-one margin, whereas the advantage actually lay with the defenders in exactly the same proportion.

On July 10, a squadron of Union gunboats—*Catskill, Montauk, Nahant,* and *Weehawken,* with Admiral Dahlgren flying his two-star pennant in *Catskill*—made a spirited attack at flank speed, scoring sixty hits. In succeeding days, Union batteries on the land side inched to within thirteen hundred yards of the fort, with their Parrott guns well protected by revetments of sandbags over the earth. On July 18, the day of the assault, Batteries Mead, Rosecrans, and Hays bombarded the enemy fort from dawn to dusk, and there was a naval barrage as well.

Wagner was so near by now that when the Union gunners spotted answering fire all they could shout was "Cover, W-a-a-a-gner" before the Confederate shells landed. Nevertheless, gunnery expert Brigadier General Quincy A. Gillmore, in overall command, observing that the enemy fire had slackened off by sundown, assumed that the shells his forces had pumped in had done the necessary softening up. He ordered the assault.

As the day drained away, Shaw spoke quietly to his troops. "I want you to prove yourselves," he said. "The eyes of thousands will look on what you do tonight."[9] With Shaw leading, on foot like his men, they marched silently along the narrow beach toward the fort. On one side was a high dune, on the other the waters of the bay. At two hundred yards the Confederates spotted them and opened a withering fire. Many fell, but the rest pressed forward. Shaw sprang up on the parapet shouting "Forward Fifty-fourth!" For an indelible moment his men saw him by the light of many explosions, sword raised high. Then he was down, shot through the heart.

His men surged over him. Seconds later the color bearer was killed. Sergeant William Carney seized the Stars and Stripes and the men rallied behind him. But the defenders had barely been hurt by the supposed saturation bombing. In the fierce hand-to-hand fighting, numbers quickly told. The order to retreat was sounded. Although thrice wounded by now, Carney struggled back toward the Union lines and miraculously regained them, flag still aloft. For his valor that night he received the first Congressional Medal of Honor ever awarded to a man of his race.

Where the Fifty-fourth had so gallantly failed, others now tried. At the end of the two-hour onslaught, Union casualties totalled 1,515 killed and wounded to losses of 181 for the defenders. The Confederates stripped Colonel Shaw's corpse of his uniform, tossed it in a ditch, and covered it with the bodies of his men. The Confederate commander was mistakenly reported in the press as saying, "He is buried with his niggers," but the effect was the same as if he had: outrage in the North, and a flocking to the colors by many blacks.

When Fort Wagner finally fell on September 6, the Shaw family requested that no efforts be made to recover the body of their son. "We hold that a soldier's most appropriate burial place is on the field where he has fallen," Shaw's father wrote the departmental commander.[10]

The impact of the attack on Fort Wagner helped to trip the delicate balance of the struggle. The face of the war was changing now; the end was nearer.

Poet James Russell Lowell found the words to celebrate Shaw's part, and Saint Gaudens found the place for the words below the horse and rider in his design:

RIGHT·IN·THE·VAN·
 OF·THE·RED·RAMPART'S·SLIPPERY·SWELL·
 WITH·HEART·THAT·BEAT·A·CHARGE·HE·FELL·
 FORWARD·AS·FITS·A·MAN:
 BUT·THE·HIGH·SOUL·BURNS·ON·TO·LIGHT·MEN'S·FEET·
 WHERE·DEATH·FOR·NOBLE·ENDS·MAKES·DYING·SWEET

As early as June 1882 Saint Gaudens was informally designated to create the *Shaw Memorial*. The secretary of the committee, Edward Atkinson, wrote, "I consider you the chosen sculptor . . . yet I assume that the committee must hold itself at liberty to make a change if you shall not furnish them a satisfactory model. . . . Such a contingency is so remote, that I think you may consider yourself absolutely chosen."[11]

Edward Atkinson, who later described himself as the "hyphen" between committee and sculptor, came of colonial stock so sturdy that his grandfather Amos Atkinson served as a minuteman both at Lexington and Concord. An economist whose writings earned him a national reputation, Edward Atkinson developed a relationship with Saint Gaudens that mingled admiration, affection, and exasperation in equal measure. Their correspondence constitutes a classic battle between artist and enlightened, highly motivated philistine.

A second key member of the Shaw committee was John Murray Forbes, a tough-minded patriarch who had played a key role in putting Massachusetts on a war footing in the early 1860s. Once, after visiting Forbes at his Naushon Island home, Ralph Waldo Emerson paid this tribute: "It is [a matter] of course that he should ride well, shoot well, sail well . . . administer affairs well, but he was also the best talker in the company."[12] Two other prominent Bostonians, M. P. Kennard and Colonel Henry Lee, also served as committeemen. They figured less in the unfolding drama but expressed strong views from time to time.

Once the fact was established that the family did not wish

another equestrian figure like those of great commanders of armies, preliminary sketches were quickly submitted showing the young colonel riding alongside his men. Kennard and Lee, in the absence of Forbes, accepted the model "as an indication of the work contemplated." Atkinson's letter to Saint Gaudens on the subject (April 12, 1883) also informed him that a contract was in the making. In February 1884 the contract was duly signed, executed, and mailed to the Thirty-sixth Street studio along with a first check of fifteen hundred dollars.

By 1886 the project is beginning to lose momentum. Richardson has died. Atkinson's letter of November 5 sounds a warning: "I am now bound to tell you that the committee are becoming much dissatisfied by the slow progress. . . . The delay in this matter is now being considered unreasonable by men who are judicious, careful of others. . . . I state this to you with the utmost frankness as your friend."

What is happening is that Saint Gaudens' original concept is becoming much more complicated. The rider and horse emerge as a statue in the round, the marching blacks assume greater and greater importance. Over the head of Colonel Shaw there now appears a premonitory angel expressing the sculptor's growing wish to create idealized figures. Augustus has trouble getting her to soar far enough above reality.

The first horse the sculptor buys to serve as model is a splendid gray, which he stables nearby and rides in the park after work. The horse catches pneumonia and dies. Then he hires a beautiful sorrel from the New York Riding Club. As for models of the marching men, forty blacks are recruited in sundry ways. Several flee in terror when they come to the studio and see plaster heads—painted brown—lying about the studio. "You don't kotch me in that place!" one of them yells from the threshold as he turns and bolts. [13]

On January 22, 1891, Saint Gaudens seeks to allay the committee's fresh worry: "I am at work again on the Shaw," he writes

Atkinson, who has been concerned over his health. "Very much at work you would say if you saw the collection of darkies that have been invading my studio for the past month."[14] He reckons that nine months will now see the completion of the modeling.

Late that year a new worry begins to plague the committee. Mr. Kenard visits the studio and discerns amid the organized confusion *another horse*, quite a different horse, in an early stage of clay. The fear is that Saint Gaudens is allowing other work (in this case the Sherman) to interfere "beyond what would be reasonable and right." In this December 24 letter Atkinson goes right to the point: "I think you are under a moral obligation . . . to devote yourself exclusively to the completion of this work."

Atkinson, who by now is treasurer of the Shaw project as well as secretary, continues to act as buffer between committee and sculptor. His letter of June 1, 1892, mirrors unrest: "At least one member is becoming doubtful of your being able to finish the monument and get it cast. . . . Other members have exhausted their patience but are now satisfied with my assurance that it will be finished within the year."

By November 9 Atkinson is reduced to sending a kind of laundry list for Saint Gaudens to check without evasion: "How many soldiers are there yet to model? Can horse and man be cast separately? Can you give the date of completion, health permitting?"

On receipt of Atkinson's terse questions, Augustus reports back that he has two more soldiers to mold, plus the elusive angel. He hopes to have a plaster cast ready for the foundry by January.

Meanwhile, Mr. Forbes has been growing more and more irritated by the lack of any real progress. From Naushon he writes Atkinson in his pungent way: "St. Gaudens and his angel may give us perfection in the artistic part, he being a genius, but we mortals must expect to be only ¾ perfect." And again, "I have got rather tired of eating, sleeping and living with such a load of monumental stone over me before the hour comes for being put underground. . . ."[15]

Atkinson begins to feel that he is caught in a web. On April

13, 1893, he tells Saint Gaudens that Messrs. Forbes and Lee are getting "a hopeless feeling about the statue." Colonel Lee is seventy-five, Forbes well over eighty. "Of some 30 men who met to originate the statue there are but six living."

In his anxiety Atkinson comes up with a practical solution: defer the flying figure and send the rest to the foundry. In a P.S. to this letter of July 27 he adds: "I know something of metal work as well as you . . . and I know enough of it to know that you can assent to what I propose and that you ought to do so."

Other worries loom. The city government goes out of office the following January and the new administration may not feel bound by what has been undertaken. The installation, Atkinson tells Saint Gaudens, must be made in 1893. "This obligation is now becoming imperative." Augustus, who has certainly been evasive in his predictions of the timing, loses patience. He writes that he is "proceeding with this as fast as human hands can proceed" and that "this incessant prodding does nothing but unfit" him for work.[16]

On September 21, Augustus writes Atkinson from Windsor, "It will not be possible for the big relief to be finished in bronze ready to set up this autumn."

Atkinson's immediate answer is tart: "I regard it as a matter dependent wholly upon your own will. You can finish your work at a given time." He orders him to fix a date. "I will say frankly that I think your reputation as a man of honor and an artist of distinction rests upon your decision." Atkinson has almost had it: "I have stood between you and the Committee as long as I can. . . ."

Forbes' disaffection grows apace. He writes to Atkinson suggesting the names of two sculptors who might replace Saint Gaudens: septuagenarian Anne Whitney and Daniel Chester French, "if he could give us an impromptu statue to be ready at least during the probable lifetime of some members of the committee. . . ."[17]

Two days later Atkinson relays this to Augustus: "It may be our duty to secure some other artist" is his comment.

Evidently Saint Gaudens was spurred to positive response, because on December 4, 1893, Atkinson has taken heart: "Your cheering words about the statue have been duly received and distributed." He assumes that by a little after mid-January "your own work will be wholly finished." But in late January he is again asking terse questions: "1. Is your part of the work absolutely finished? 2. If not, why not and when?" Saint Gaudens' answer of January 31 is evidently inadequate, for on February 1 Atkinson is blunter than he has ever been: "If you do not put aside all causes by which your time is crowded . . . you will make the error of your life. . . ."

By February 6 Atkinson is mollified. "I cannot ask any more of you than what you are doing." But in the spring two nagging problems come to the fore. One is the exact wording of the inscriptions being drafted by President Eliot of Harvard. Told by the committee via Atkinson that the wording was "wholly within their control" and that the "artistic arrangement" was all that was his concern, Augustus for once was out of the line of fire.[18] The other source of acrimony was the committee's wish to pass on all phases of the architectural details of the handsome stone frame, pedestal, and benches that Charles Follen McKim was designing with his usual consummate elegance.

All that summer of 1894 the committee bickered among themselves over the wording, and the location of the various inscriptions. Colonel Lee was the sole member who wanted the Lowell verses on the street side below horse and rider, and was pleased when the others yielded at last to his wish.

The winter was spent soliciting new funds from the original subscribers "or their descendants." In this instance Atkinson loyally defended Saint Gaudens, "whose work has extended in time, in intensity and on every line, far beyond anything contemplated." Whatever monies came in would go half to the sculptor and half for the maintenance of a "very elaborate work which may be subject to deterioration."[19]

In April 1895 an unveiling date was set for October, but there is another spate of argument during the summer over one of

McKim's ornamental vases, triggered by Mr. Kennard's anger that the vases had not been submitted for approval in the first place.

Now the target date for the unveiling becomes May 28, 1896, the thirty-third anniversary of the Fifty-fourth's departure for combat. Atkinson told Saint Gaudens laconically that "Mr. Forbes hopes to stay with us until the work is completed."[20]

Finding a foundry to do the casting at a reasonable price takes up most of the winter. On May 22, 1896, Atkinson tells Mr. Forbes that he has been to New York and satisfied himself that Saint Gaudens' work is done and that he has doled out another thousand dollars to the sculptor. The talk is now of "fixing a date of May or July of next year" and of getting the Gorham Manufacturing Company in Providence to do the casting "for glory not for profit."

Then, on June 5, 1896, comes another bombshell. "We are all appalled and disheartened," Atkinson writes Saint Gaudens, "by learning . . . that you have again decided to reconstruct that angel. . . . Members of the Committee are hopeless of your ever being able to complete this work. . . . Having committed myself [to next May] I think that if I find reason to doubt again, I shall transfer the custody of the fund to the Committee and divest myself of any further responsibility. . . . I have had anxiety, care and trouble enough."

Quite knowledgeable by now in studio ways, Atkinson says to keep the mold as it is, let it be cast as it now was if a new angel doesn't materialize. The whole future hangs on Augustus' response.

The next day Atkinson fires off another round: "You and I are now at the parting of the ways." He tells Saint Gaudens that one person in a hundred thousand would ever know the difference in the angel's size. It was Augustus' assurance that the work was completed that had led Atkinson to give "official information to the public, to the Speaker, to the discontented subscribers, few in numbers. I think you have no right either as artist, contractor or in your personal relations to myself to go back on that assurance."

Among the disenchanted committeemen, Colonel Lee is particularly aware that Saint Gaudens tends to be too much influenced by the opinions of his fellow artists. Had he known Paul Bion's contribution to this state of affairs, especially in the matter of the floating angel, he would have understood even better. The relevant Bion letter goes like this: "I had no need of your 'nom de dieu' allegory in the ceiling. Your negroes marching in step and your Colonel leading them told me enough. Your priestess merely bores me as she tries to impress upon me the beauty of their action."[21]

Lee's response to Augustus' last-ditch wish to change the angel is mild enough: he tells Atkinson he thinks that it is "perhaps induced by too long dwelling on his own work" and by his endless quest for perfection.[22]

Then, on June 9, 1896, Atkinson receives a telegram from Saint Gaudens that brings great relief. The sculptor agrees to go ahead with the completion in bronze as is, with no more tinkering with the bedeviling angel.

Matters are moving at last. On September 4, Atkinson reports on a trip to New York to the so-understanding Colonel Lee: "I wish you could have seen the perfected work. . . . You will rejoice in the completion."

Then comes a break. Gorham agrees to cast and deliver by May 1, 1897, for the modest fee of seven thousand dollars. Rejoicing, Atkinson writes the firm: "It will be a difficult casting and very likely you may not make anything on it. . . . Yet it is a great work and well worth doing. We may now feel well assured that the unveiling can take place May 28, 1897."[23]

During the winter, the date is changed to Commemoration Day, May 31. Planning for the event becomes Atkinson's main concern. On December 10 he informs his committee that the statue is at last in the hands of the founders and four days later tells Saint Gaudens that "Colonel Lee and Mr. Kennard are becoming very proud of the success" on the evidence of some fine photographs.

Mellowing fast, Atkinson writes Forbes on March 8: "If you could see that angel of which you have spoken in such severe

language, I am sure you would approve. The figure adds immeasurably to the sentiment of the work."

The widow of Robert Gould Shaw is incurably ill and living in Cannes, so a set of the photographs is mailed to her. The mettlesome mother is as active as ever. She goes to Providence to see how the bronze cast has come out, then sits down and writes Atkinson that "Saint Gaudens has immortalized my native city, he has immortalized my dear son, and he has immortalized himself"—a sentiment she repeats almost verbatim to the sculptor on the day itself.[24]

Various orators are considered. The final choice is Professor William James, whose two brothers survived Fort Wagner, and, as spokesman for his race, Booker T. Washington.

The great day comes at last. It is gray, with a fine mist. Prowling nervously, Saint Gaudens tells Atkinson he considers such weather "better than clear bright sunshine" for the first viewing.

The reviewing stand is built on the steps of the State House. Across from it, in front of the shrouded, flag-draped statue, are sixty-five veterans of the assault on Fort Wagner, drawn up a few yards from where they so proudly received their colors from Governor Andrew thirty-four years before. Some wear their Civil War uniforms, but the bulk are in timeworn frock coats. One has brought along a carpetbag.

Governor Walcott says a few words. Then, on a signal, a great-nephew of Colonel Shaw trips the cord and the flags fall away. From the Common comes a boom of cannon, answered by an echoing twenty-one-gun salute from warships in Boston Harbor. The parade starts with a march-past of the Governor's stand, the men of Fort Wagner leading the way. In the long files that follow is a splendid contingent from New York's Seventh Regiment, in whose ranks the young Shaw had first served.

The commemorative ceremonies are held at the old Music Hall. All that Augustus remembers later is that Booker Washington makes a great sensation and that William James' main ad-

dress is noble and poetic. Announced by one of the speakers, Augustus rises to take a bow: "It was an awful moment, but it would be stupid to deny that at the same time it was thrilling to hear the great storm of applause and cheering that I faced."[25]

After all the trauma, the story has a happy ending. Colonel Lee, at almost eighty, "full of vigor and energy," tackles the job of editing a special edition of the proceedings. Despite his qualms that he might not survive the ordeal, John Murray Forbes is soon "riding about Naushon Island on horseback," as Atkinson happily reports to Saint Gaudens.[26]

As for the estimable Edward Atkinson, his final word on his long, stormy association with Saint Gaudens takes the form of a character sketch. It comes in a letter to the still somewhat disabused Mr. Forbes, written a few days after the unveiling: "I do not think you do full justice to the artist. He is the 'most natural man' as someone said, that I ever met; conscious of his own power, standing for his own dignity, but extremely modest in everything that relates to personal praise, and desiring to keep in the background rather than to become conspicuous. I should name this quality as assertive modesty: an apparent paradox but well describing him."[27]

Saint Gaudens' own rationale springs from the heart and core of his credo as an artist: "My own delay I excuse on the ground that a sculptor's work endures for so long that it is next to a crime for him to neglect to do everything that lies in his power to execute a result that will not be a disgrace. There is something extraordinarily irritating, when it is not ludicrous, in a bad statue. It is plastered up before the world to stick and stick for centuries, while men and nations pass away. A poor picture goes into the garret, books are forgotten, but the bronze remains. . . ."[28]

Lastly, here is Augustus' feeling concerning the statue he has created. It appears in a letter to Richard Watson Gilder, who has written an ode about it: "That anything I have done should have suggested the inspired and inspiring ode . . . makes all the

great strain and love gone to the making of the 'Shaw' worthwhile, and I have not lived entirely in vain."[29]

The day after the unveiling Saint Gaudens, while bending over a washbasin, had an attack of what he thought was lumbago. "I was suddenly struck, as if with an ax, in the lower part of my back, so that it was with the greatest difficulty that I crawled over to the bed and lay down."[30]

This was actually the first real attack of the cancer that would stalk him from then on. It passed, but ill-health now became another reason for going to Paris and a calmer environment than the din and strain of New York.

The original reason—the quest for Old World fame—was simply whetted by the honorary degree Augustus received at the Harvard graduation a few days after the unveiling. Embedded in the high-flown citation was an unmistakable reference to his habit of chronic delay: "Augustus Saint Gaudens—a sculptor whose art follows but ennobles nature, confers fame and lasting remembrance and does not count the mortal years it takes to mold immortal frames."[31]

He had given his best years to the Shaw. He was tired, and far more ill than he realized. It was high time to be off.

Book III

A SADDENING
OF YEARS

31

PARIS NOCTURNE (I)

"It was a melancholy time for the sculptor. He no
longer felt comfortable with the French people or
the climate."

—Isabelle Savelle[1]

SAINT GAUDENS, Gussie, and seventeen-year-old Homer sailed
for Paris in October 1897. Since the break with their New York
life was intended to be complete, the sculptor took a great deal
of his studio paraphernalia with him. The family stayed at the
Hôtel Normandie until places to work and live could be found.
After an exhausting search, Augustus discovered four small ate-
liers opening on a gardenlike passage at 3 bis Rue de Bagneux,
on the Left Bank. By knocking the four together he was able to
make enough space for his many projects. He and Gussie also
managed to rent a pleasant apartment just off the Champs-Élysées
in the Étoile area.

The main purpose of the move to France was soon accom-
plished, for his wish to measure himself against the best European
talent achieved stunning results. At the Salon of '98 he exhibited
a plaster cast of the *Shaw* and a bronze of the *Puritan*, along with
photographs of some of his other work. The photographs, which
included the *Lincoln*, the *Peter Cooper*, the *Adams*, and the
Vanderbilt caryatids, were much admired. Critic Louis Leprieur

of the prestigious *Arts et Décoration* called the *Puritan* "highly entertaining and picturesque," but he reserved his highest praise for the Shaw: "While presenting prodigies of skill and modeled with a great feeling and understanding which all men of his profession will admire . . . everything is kept subordinate to the ensemble and to the predetermined unity of motion." The article, to Augustus' delight, went on to praise "the superb figure of a woman with flying drapery, symbolical of glory or death," and described Saint Gaudens as "a teacher far superior to his pupil [MacMonnies]."[2]

For the last Salon of the century the following year, Saint Gaudens submitted a plaster cast of the Sherman, just the horse and rider, without the Angel of Victory in the lead. He also sent along a small model of the complete group, with a very American girl-goddess raising a triumphal palm leaf. This elicited particular praise from one French reviewer: "The model proves that there are no subjects used up and done with, and that art, far from having said its last word, ceases not from renewing itself at the call of genius."[3]

The honors and prizes came soon, and copiously. He was made a corresponding member of the Beaux-Arts, and of that citadel of French establishment glory, the Institut de France. For the multiple presentation of his work at the Paris Exposition of 1900, he received a Gold Medal and the Salon's Grand Prix. To cap it all, the beautiful cross of the Legion of Honor, so rarely given to foreigners, was his at last.

In a more substantial way, the director of the Luxembourg expressed the wish to acquire the original *Amor Caritas*, a request that Augustus was pleased to comply with for a modest price.

His reaction to all this was buoyant and boyish. Concerning the Institut membership, he scribbled a line to Louis reporting "this big honor, and wings are beginning to sprout on my shoulders."[4] When, at the Salon of 1899, the plaster cast of the Sherman was given the place of honor, he wrote Homer, who by then was at Harvard: "I have got a swelled head for the first time in my life for the 'Sherman' really looks bully and is smashingly fine.

. . . I have become a harmless, drooling, gibbering idiot, sitting all day long looking at the statue. Occasionally I fall on my knees and adore it."⁵

From a personal point of view, Augustus' days were darker. A letter to Gussie, away on one of her trips, told of his anguished state: "I have been so depressed and blue that I have felt, as I have only felt once before, a complete absence of ambition, a carelessness about all that I have cared about before, and desire to be ended with life. The feeling has been uncontrollably strong and I can sympathize with you when you have that terrible depression that makes you wish to cry. . . . There is too much misery and unhappiness in the world, and all this struggle for beauty seems so vain and hopeless."⁶

It was not always thus, for he was a man of many moods. But he found the chilling Paris winters particularly wearisome. Gussie too, between her comings and goings, was disenchanted with life there. It was a far cry from the perpetual April-in-Paris mood of their honeymoon time twenty years before. She must have unloaded her feelings in a letter to sister Genie, for Genie's answer went like this: "I am glad that you have such pleasant quarters, though sorry that you do not enjoy Paris as you used."⁷

Writing to Mary Lawrence, who had earned her gratitude for closing down the New York studio and doing other chores after the family sailed, Gussie touched on one source of her new misery: "I have so little use for love over here that I find I have an overwhelming amount for my friends at home, and so I send a great big lot to you."⁸

Augustus' own distemper took a curious form, as he described in one of his quick notes to Louis: "I don't like the faces of the men and general tendency to free indulgence in the intoxications of corporeal delights. . . ."⁹

He expressed similar feelings in a talk with painter-critic William Coffin: "Paris nauseated him," Coffin recalled. "He explained that in the streets the men and women he met seemed to him 'to be thinking about sex all the time,' and he found Paris changed. . . . In that talk we were inclined to lay the blame for

certain changes in life and manners on the back of the Republic, though neither of us had monarchical sympathies."[10]

Ernest Renan, the aging religio-romantic writer much admired by Saint Gaudens, said, "France is dying, do not disturb her agony."[11] But he was quite wrong. What France was doing in this *fin de siècle* time was changing, and doing so in a climate of remarkable intellectual vigor. The romanticism of Victor Hugo, who had died in 1885, and of Renan was giving way to new trends and tastes. Catching on were the naturalism of Zola, the psychological insights of Guy de Maupassant, the subtleties of young Marcel Proust. Rimbaud and Verlaine, Colette and André Gide were the voices being heard. There was a whiff of decadence and morbidity in the air, and a continuing revolt against the classicism of David and Ingres. New isms—Expressionism, Pointillism, even a murmuring of Fauvism—were making Impressionism seem conventional and a little dated. Foreigners with names like Modigliani and Chagall came flocking. Boldini painted heiresses "as if they were a species of tropical bird."[12] The young Spaniard Pablo Picasso arrived in Paris in 1900. Toulouse-Lautrec died the following year, a *demi-mondain* to the end.

Small wonder that, in all this ferment, Saint Gaudens felt somewhat out of it. Despite his own gustiness, he was a subscriber to surface conventions, and the new trends made him uncomfortable.

Another reason for his deep depression was that Paul Bion had died earlier in the year the family left for France. The news of his death came shortly after Bion's letter criticizing the troublesome angel in the Shaw. In his grief Augustus wrote Rose Nichols, "Of course the one thing on my mind, the terrible spectre that looms up, is poor Bion's death: night and day, at all moments, it comes over me like a wave that overwhelms. . . ."[13]

While he was working on putting the finishing touches to the controversial angel in the Shaw he had felt "a sad feeling of companionship." But now, back in Bion's Paris, there was just the deep sense of loss.

To fight off his low spirits, Saint Gaudens asked his old friend

Alfred Garnier to join him on a trip to the Pyrenees and Italy. Garnier replied that he had neither the time nor the money. But when Augustus said that he would pay, and that Garnier would more than earn his keep by knowing the best ways to keep the people in the hotels from cheating them, Garnier agreed to go.

The time was December 1897, their first year back in France. Bernard Saint Gaudens' Aspet and the Pyrenean foothills proved to be even more beautiful than his descriptions had painted them. The way the town sat below the snow-capped Mount Cagire was to Augustus "very much as a village might be at the foot of Ascutney."[14] Meeting many Saint Gaudens cousins, including the handsome Aspet postmaster, cheered him greatly.

They went on to Rome via Nice and a walk along the Riviera coast to the frontier town of Ventimiglia.

Arriving late in his favorite city in the world, Saint Gaudens was in a state of high excitement. He insisted on climbing the Spanish Steps and visiting the Caffè Greco. It was sad to see the same waiter there grown old and gray, and to learn that almost all the American colony was gone. But a trip to Naples and Paestum revived their spirits, and a walk from Salerno to Amalfi, partly by moonlight, proved sheer bliss. Augustus had wanted to go on to Venice, but Garnier, who missed his wife, his studio, and his "déjeuner under his own little vine," had had enough.[15] Garnier's own explanation was that his friend "did not seem to be very well."[16]

Back in Paris, Saint Gaudens worked in spurts. Gaetan Ardisson, whom he had brought over to help with the casts for the various salons, took over a good deal of the day-to-day studio activity. Finishing the Sherman group was the top priority. Augustus also started work again on the six idealized figures for the steps of the Boston Public Library, feeling just a little guilty about his procrastinations.

Along with his autumnal moods there were still flashes of high spirits. He saw a lot of Dr. Shiff. Shiff, who had discovered the philosophy of Arthur Schopenhauer, expounded endlessly on Schopenhauer's theory of the redemption of the soul (from sensual

bonds) through art and the ascetic life. This, like so many of Shiff's dilations, struck a respondent chord in the sculptor. When the doctor was not holding forth to Augustus and others in the bars and bistros of Montparnasse, the two friends prowled the city. "He has shown me houses and places galore, for he knows Paris like a book," Augustus wrote home.[17]

Ever since he was small, Homer had been something of a problem. At ten, when he was painted by Sargent, he had an infantile way of running at people and butting them in the stomach. Sargent, portly by then, no longer the slim young man of the early Paris days, found that the only solution was to sit on him until he gave in. (Years later, when Homer was the distinguished director of the Carnegie Institute Art Museum, Rose Nichols' sister Margaret asked him if he still butted people. His answer was very Homer-like: "No, but I wish I *could.*"[18])

The summer that Homer was fourteen, Phimister Proctor was in the Cornish area modeling the horse for the Logan. His memory of Homer as a teen-ager goes like this:

A more mischievous youngster never tormented a neighborhood. One day when he was flying a gigantic kite in the Evarts' pasture, the kite started a long, gliding dive directly toward a fine herd of twenty blooded milch cows. Frightened, the cows started off on a run. When the kite fell on them, the animals panicked and stampeded down the hill and across the meadow, shattering the closed corral gate as they went through it.[19]

Augustus worried a lot about Homer, and missed him during the long periods when the boy and his mother were off and away. During the two years before France, Homer went to Lawrenceville. Then, in Paris, he attended a *lycée*, from which he was admitted to Harvard in early 1898. His academic performance there was so poor that a Harvard official wrote his father that he

would have to take his admissions examinations over again. It was then arranged that Homer would go to Dresden for some tutoring and maturing. This worked well enough to make possible his re-entry to Harvard in the fall of 1899.

One of the early reports from Homer's tutor in Dresden must have been fairly discouraging, for on December 12, 1898, Saint Gaudens wrote his son, "Your report has come . . . and it's not exciting reading. I'm not given to preach now or bore you to death but I think you had better get a brace on."[20]

During the Dresden interval Homer tried his hand at some drawings. Among those he sent to his father was a self-portrait. Augustus' answer was suitably encouraging, then went on like this: "The only thing out in the drawing is the ear. I've forgotten how your ear is constructed, but if it's made like that you have the only ear so placed in the world. You have tipped the top forward. . . . If your ear is so constructed you needn't worry about studying to earn your living. You can earn that in a museum." The letter ends with more whimsy: "Don't drink beer and don't call me papa. Call me daddy, governor, boss or father, or anything. But don't call me papa or I'll cry. Affectionately, Your Daddy."[21]

The marriage of Augustus and Gussie had become a kind of endurance contest, and one that both parties seemed to endure better when they were apart. Given Gussie's disenchantment with Paris, it was inevitable that her itinerancy should soon set in again. She spent the summer of 1898 at spas like Saint-Moritz, Vichy, and Aix-les-Bains. The following summer and fall saw her back at Cornish and Roxbury, a visit prolonged by her mother's death in August.

Meanwhile, one of Saint Gaudens' quick scrawls to Louis, written on October 27, 1899, opens the curtain drawn for so long across any activities of Davida and Novy. It also throws some light on how close to the bone financially Augustus was at the time: "For the present I am dead broke, that's why you haven't received the monthly $50. . . . Homer entered Harvard two weeks ago.

Novy entered French school at the same time. Davida don't like France and wants to get away. Gussie don't like it either and comes over Nov. 1st and so the funny world goes round."[22]

A second letter to Louis, on December 1, encloses the interrupted payment and, far more important, is the only other surviving reference to Davida and Novy in Paris: "Now I'm rolling in gold and should continue to send this amount as before. . . . Novy is growing tall and fat. Davida having spells of contentment and homesickness for her mother. . . . I have started on the library figures which interest me a great deal."[23]

This is perhaps all we will ever know about the second Paris ménage. One question is whether Gussie, in her deafness and her misery, ever became aware that mistress and son were nearby. There does exist one clue to the length of their stay: Davida's California grandson, also Louis Clark, often spoke of his father's fluent French.[24]

32

PARIS NOCTURNE (II)

"For a symbol of power, St. Gaudens instinctively
preferred the horse [to the Virgin]. . . . Doubtless
Sherman also felt it so."

—The Education of Henry Adams

IN THOSE FIRST MONTHS back in Paris, Saint Gaudens made the
discovery that he was no "gelatinous cosmopolitan fish" but American to the core (his letter to Will Low on his Americanism is
quoted in chapter 1). One reason he came to realize his birthright
was the fact that he was homesick, a theme he touched on in
many letters to family and friends.

He particularly missed Mary Lawrence. Over and above her
work as his assistant in New York and as his successor at the Art
Students League, they had done a lot of fencing together at the
New York Fencing Club. Their instructor was Captain Hippolyte
Nicolas, a colorful French veteran of many wars, including the
Crimean.

In January 1898 came a letter from the captain that made
Augustus more homesick than ever:

Dear master and student,
 . . . Miss M. T. Lawrence has taken up her fencing again
for a month now. What a beautiful model she would make

now! She is blooming in her self-development. You could make a great Roman matron out of her. The exercise of fencing is making her heaviness disappear which she contracted during the summer when she was busy with her gardens and, in a month will be superb. She is always the same character: lovable and good. . . . I wish you well and to your good health first . . . fence when you can. I squeeze your hand, your devoted

Capt. Nicolas[1]

Saint Gaudens did not keep up his fencing in Paris, but he knew very well that life could not be all work. Depressed as he often was now, and far from well, he found that the company of women helped revive his spirits. And there was quite a frieze of pretty girls in Paris, to delight and divert.

There was Helen Mears, who at just over twenty-one had modeled *The Genius of Wisconsin* for the Chicago Fair. The following year she became a Saint Gaudens assistant in New York. She and her even prettier sister, Mary, were in Paris when Augustus arrived. He hired Helen to help on the Sherman. Meanwhile, Mary gathered material for her novel *The Breath of the Runners*. Published in 1906 by Frederick A. Stokes, it tells the story of two sculptresses whose rivalry bears a striking resemblance to the love-hate relationship of Saint Gaudens and MacMonnies. Since Mary was also doing some work for the latter, she had a good chance to observe both sculptors in action.

A favorite Sunday pastime of Dr. Shiff and Saint Gaudens was to put on their best Sunday clothes and parade the boulevards, each with a pretty Mears girl on his arm.

Then there was Elizabeth Cameron, more or less settled in Paris by now, yet not totally parted from the Senator. Henry Adams was also in Paris a good deal, in his perennial role of tame cat. When Elizabeth was on her travels about Europe, he would move into her Avenue du Bois de Boulogne apartment and hold forth in her stead in the elegant white-and-gold drawing room.

Elizabeth and Augustus exchanged mildly flirtatious notes,

mostly concerning social engagements and usually by *cartes pneu-matiques*. One of them in Augustus' hand simply reads, "I shall be by the statue at four o'clock this afternoon as you appointed."[2]

Henry Adams asked Saint Gaudens if he could arrange for his divinity to meet Auguste Rodin: it seemed Elizabeth wished to collect him for her salon. Although the relationship of the two Augustuses had never gone much beyond mutual admiration and respect, Saint Gaudens was more than pleased to volunteer to take Elizabeth to Rodin's studio himself. Then he fell ill and had to write her the following: "My dear Mrs. Cameron I am not well and cannot keep my appointment with you tomorrow." He went on to explain that he had asked Rodin if he could bring her along for a 10:30 appointment, then added: "He has telegraphed back that it would give him great pleasure to have us come at that hour." Augustus' solution was that she go alone: "If you will present yourself with my card you will be well received. 'Cela va sans dire.' "[3]

She went, and Rodin quickly capitulated. Soon he was writing her in very Gallic effusions, and shortly became a volcanic worshipper at the shrine of La Dona. (Others who were bewitched by Elizabeth in her Paris days were Anders Zorn, who painted her portrait; Bernard Berenson, who became a confidant second only to Adams; Frank Millet *en passant*; Sargent and La Farge more permanently; French painter Paul Helleu; and poet Trumbull Stickney, who died young. Trumbull was twenty-six to Elizabeth's still-glowing forty-two at their first meeting. In this instance she too was swept away.)[4]

There was one more girl in Augustus' frieze of fair women, and for a time she would bulk quite large. Her name was Helen Benedict, and she was the daughter of Commodore E. C. Benedict of New York and Greenwich. Marian Nichols, Rose's younger sister, who was traveling abroad that summer of 1898, reported home to Rose about her in this way:

> Uncle Augustus went about a great deal . . . with a Miss
> Benedict, a wealthy New York girl who was adaptable, witty,

and tactful. . . . Miss Benedict was apparently a new variety of girl for Uncle Augustus. She was a great horse-woman and when they all drove to Versailles on one of those four horsed coaches she held the reins as they went through Paris. Uncle Augustus said she was so much interested in the lessons she was taking from the coachman that she was quite unconscious of the attention she attracted.[5]

When, two years later, Helen Benedict became engaged to a well-known New York architect, Saint Gaudens scribbled the news to Louis cheerfully enough: "Tommy Hastings is going to marry Helen Benedict daughter of the rich banker Grover Cleveland's friend. She is as redheaded as Marie [daughter of Andrew Saint Gaudens] . . . is the wittiest person I ever knew very deaf and a damn nice girl."[6]

Augustus' cartoon of Helen and himself appears here. It includes a message that, stylistically, is very like the inscriptions on one of his own works: MAY·YOU·LIVE·LONG·BE·HAPPY·AND· CONTINUE·TO·MAKE·OTHERS·HAPPY·COMME D'HABITUDE.

For three weeks in the summer of 1899 Mary Lawrence turned up in Paris on holiday. Back in New York, she announced her engagement to MacMonnies' longtime assistant François Tonetti. Willie MacMonnies himself rushed over to the Rue de Bagneux studio with the news. True to his code, Saint Gaudens made all the right congratulatory noises, but in private he "broke down and wept"—at least in part because he knew that Mary Lawrence would subordinate her fine talent to the modest skills of Tonetti.[7]

Neither MacMonnies nor Saint Gaudens had yet relinquished their flickering friendship. Willie had become quite intimate with James McNeill Whistler, and for a while they taught at the same school. On November 16, 1897, Augustus' first fall in Paris, Saint Gaudens and MacMonnies paid a call on Whistler, and Augustus found the painter much more human than he had imagined him to be. Whistler fell into the habit of dropping by the Rue de Bagneux on his way home: "And in my studio he would sit and chat in his extraordinary, witty fashion. . . . He is a very attractive man with very queer clothes, a kind of 1830 coat with an enormous collar, a monocle, a strong jaw, very frizzly hair with a white mesh in it, and an extraordinary hat."[8]

As for MacMonnies, it took Saint Gaudens several months to realize that the "boy angel" had changed: "Finally with deep sorrow I discovered that the friend I had loved was as dead as Bion to me: the gentle, tender bird I had caressed out of its egg had turned to a proud eagle, with (most naturally) a world of his own, a life of his own and likes and dislikes of his own. And when I realised it the gloom of Paris was unbearable."[9]

Writing to Mary Lawrence, he was more sharply critical: "Of Mac I see nothing. . . . He is no friend of mine, nor is he of anyone I think for that matter, except of himself and of his phenomenal vanity and heartlessness. I'm thoroughly sick of him and his ingratitude. . . ."[10]

In 1899 the MacMonnieses took a studio adjoining Monet's

garden, down the Seine at Giverny. Hearing that Augustus was not well, Mary MacMonnies wrote to congratulate him on the success of the plaster cast of the Sherman at the Salon that year, and added: ". . . would it not please you and Mrs. Saint Gaudens to take a nice little place down here this summer? It is charming country, come and see."[11]

But the gap was widening. MacMonnies' works were becoming more and more flamboyant—the bodies riper, the sworls and festoons richer. In the words of present-day sculptor Walker Hancock, "he was too fond of the spinach,"[12] "spinach" being artists' jargon for festoonery and overelaborate ornamentation. The phrase might well apply to MacMonnies' life as well as his art.

A new disciple soon appeared on the scene to replace the dwindling MacMonnies. His name was James Earle Fraser, and he would become the best-beloved of the many. With his eye for fresh talent, Saint Gaudens had noticed the twenty-two-year-old American's work in several competitions he had judged, and in the 1898 Salon, where Fraser won a prize for the best work by an American.

His father had served as an engineer for the Northern Pacific Railroad when the Dakotas were opening up. Small James made friends with Indians of the Teton tribe and others. The Teton sun dances and the whitening bones of the buffalo on the prairie fascinated him. Back in school in Minneapolis, which was the family's home base, he carved intricate figures on the pieces of chalk that he was supposed to use for his sums—and his schoolmates marveled at his skill.

Fraser studied under Falguière at the Beaux-Arts and then stayed on in Paris. Meeting him, Augustus was intrigued by the aggressive first impression he made and the underlying gentleness which he soon discovered to be Fraser's true nature. Fraser was strong of build, tousled of hair, and very firm of jaw. Malvina Hoffman said he had the "squarest jawbone I ever saw," and the sculptress had seen quite a few.[13] One clue to the real Fraser was

his beautiful, low-pitched voice. Barry Faulkner has supplied other clues: "His character was like a good piece of Scotch tweed, handsome durable and warm."[14]

Liking both the work and the man, Saint Gaudens hired him and assigned him to the Sherman, still endlessly in the throes. Granted, the head of the general, based closely on the life bust, was well in hand, and the body, except for some trouble with the rippling cloak, was near completion. Phimister Proctor had created a spirited horse. The problem was the Angel of Victory. Back in New York, Elizabeth Cameron had posed chastely for the head. The Paris model for the nude body and, in due course, for the classic drapery that covered it was "a young woman from Georgia, dark, long-legged . . . certainly the handsomest model I have ever seen of either sex."[15]

Now Saint Gaudens finally put it all together. The angel grasps the palm leaf in her left hand with a very womanly grip. With authority, almost with arrogance, the right hand is raised in a gesture that is part benediction, part a clearing of the way for horse and rider on the path to eternal fame. Across her breasts, her lightly clinging garment is emblazoned with an American eagle, and the wreath in her hair is of laurel.

"It's the grandest 'Victory' anybody ever made," the sculptor exulted to Rose Nichols. "Hoorah! And I shall have the model done in a month."[16]

Helen Mears, and to a greater degree James Earle Fraser, had helped a lot in the final solution. In his unpublished autobiography, Fraser gave glimpses of his "unforgettable" master: "Our work room was adjacent to Saint-Gaudens' private studio, so near that he could hear our hammering and we could hear his singing. And how he sang! . . . When all was going well, his voice would ring out with bits from the operas, French usually, and he would fit his deep baritone to soprano, bass or tenor arias."[17]

When Gussie's cousin-by-marriage Louise Homer, the great operatic contralto, once heard Augustus singing away, she asked, "When did you ever have time to cultivate your voice?" He answered that he had never had a lesson. Louise insisted that he

was good enough for grand opera.[18] (Either Augustus had improved a lot since the old German Savings Bank days, or Louise was turning on her considerable charm.)

Fraser turned out to be everything that Willie MacMonnies was not, faithful and true-blue. In due course he achieved fame of a high order. His buffalo five-cent piece and his disconsolate Indian at *The End of the Trail* forever evoke his Dakota days. His *Albert Gallatin* and *Alexander Hamilton,* book ends to the north and south of the Treasury Building in Washington, perpetuate the Saint Gaudens tradition at its most elegant.

If the MacMonnies relationship turned sour in Paris, Augustus' friendship with Henry Adams was enriched there. Having settled into his role of confidant and friend of Elizabeth Cameron, Adams was able to accept the fact that she found the sculptor attractive. Abroad, the social gap between Adams, as a scion of America's first family, and Augustus, the bootmaker's son, had less relevance. Adams, with his always superb taste, recognized Saint Gaudens' talent as a gift of the gods. And hadn't Augustus created "his" monument?

A trip which this oddly assorted pair made to Amiens, as told in the *Education*, reveals a good deal about what Adams felt: "Not until they found themselves actually studying the sculpture of the western portal did it dawn on Adams' mind that, for his purposes, St. Gaudens on that spot had more interest for him than the cathedral itself. Great men before great monuments express great truths, provided they are not taken too solemnly."

Adams went on to put this in the context of his theme—later so fully developed in *Mont-Saint-Michel and Chartres*—that the Virgin and Child were the great driving force of the world: "All the steam in the world could not, like the Virgin, build Chartres."

To Adams, both he, the quintessential Bostonian, and Augustus, "a child of Benvenuto Cellini smothered in an American cradle," had half natures only: ". . . and when they came together before the Virgin of Amiens they ought both to have felt in her

the force that made them one; but it was not so. To Adams she became more than ever a channel of force: to St. Gaudens she remained as before a channel of taste."[19]

It is necessary to remember that Henry Adams' worship of the Virgin and Child as the great life force stemmed directly from his love for Elizabeth Cameron and her daughter.

We must also remember how Adams jumped around. "He practised inconsistency as if it was a cult," one critic said. "He was so many-sided that he cannot be painted in a parenthesis."[20]

Adams had a way of assuming that others thought as he did. His belief that Saint Gaudens shared in his own conviction that the hooded figure over Clover's grave was neither man nor woman is a fair example.

Adams loved vast relevancies and startling juxtapositions. Sometimes he found these in his friend Augustus. Then he would contradict himself and write about him in the most simplistic terms: "He is a simple-minded babe," he reported to his niece, Mabel Hooper La Farge, "much younger than you or Molly [another niece]."[21]

Another friend who turned up in Paris was John Singer Sargent. The time was the spring of 1899. "I saw a good deal of him," Saint Gaudens wrote Rose Nichols, "as he came to see me about the enlargement of his crucifixion for the Boston Library. It is in sculpture. . . . He has done a masterpiece. He is a big fellow and what is, I am inclined to think, a great deal more, a *good* fellow."[22]

Their bond as always was their dedication to art. But Sargent's life had narrowed, pleasant as an expatriate existence in high British society can be. Sir William Rothenstein, who observed him over quite a few years, put it this way: "He was like a hungry man with a superb digestion, who need not be too particular what he eats. Sargent's unappeased appetite for work allowed him to paint everything and anything, anywhere at any time."[23] To Rothenstein this "unappeased hunger for mere painting" set him apart. What Rothenstein noticed was what Rose Nichols also had: painting filled his life. Even in his social life there was a limitation.

Chipping away at Sargent's brilliance had of course been a

popular pastime for quite a while. Writing as a fledgling critic, Toulouse-Lautrec took a typical swipe: "Would you like to sell your pictures, Monsieur Sargent? Truly you handle your brush marvelously, but your complicated manner will never regenerate international art."[24]

To Augustus such carping simply begged the question. He had made up his own mind early about Sargent's talent, and came near to matching his voraciousness for work. The two men were indeed shy, but not in each other's company, and this never changed.

The Paris Exposition of 1900 opened on April 14. Over 188,000 people surged through the huge Porte Principale. The portal, which was vaguely Siamese, with obelisks to right and left and an idealized Parisienne on top, set the mood of the fair. Henry Adams dubbed the 270 acres "an inferno of unfinished domes, Greek temples and minarets."[25] The fine wide Pont Alexandre III across the Seine was another access to the fair, built to celebrate the Franco-Russian alliance. Two wedding cakes of disparate size, the Grand Palais and the Petit Palais, attest to this day the fact that the Beaux-Arts style gone wild will never die. On a more restrained note, Eliel Saarinen's Finnish Pavilion, alluring, held out promise of better things to come in the new century.

Technologically, the Exposition was a triumph. The automobile, in the fifth year of its existence, was highly visible. Electricity was what the fair ran on, and was held together by. Specifically, the binding was a rolling sidewalk 3,370 meters long, consisting of three tiers or platforms: one stationary, one moving at four kilometers an hour, and one at eight. This *trottoir roulant* had already been tried at the Chicago and Berlin world fairs. But since a Frenchman named Blot had invented it in the first place, it was very much part of the prevailing delirium of French self-congratulation.

There was much to be proud of, including a whole pavilion for works in Art Nouveau, and the Art Nouveau Grand Staircase.

There was a Palace of Wine, a Palace of Beer, a Château d'Eau, and a Maison de Rire. French bankers grubstaked Rodin to a pavilion of his own. The admission price of a franc apiece brought people flocking there to stare at *The Kiss, The Gates of Hell, The Burghers of Calais,* and all the rest. Rodin's fame was secure at last.

The bulk of the sculpture was gathered under the high glass dome of the Grand Palais. Pleased as he was with the central position given the Sherman, Saint Gaudens—who had served on the jury—was not carried away by the way the selections were displayed: "Such a collection of sculpture, rammed together ignominiously, has never been seen. . . . All the statues were crowded pell-mell, helter-skelter on top of one another, in a bewildering and phenomenal maze of extended and distorted arms, legs, faces, and torsos in every conceivable posture. It took very great patience and calmness of spirit to discern the many remarkable things that were shown."[26]

Another major Saint Gaudens work on view was a plaster cast of the Shaw. To Augustus' pleasure, Rodin, in one of his extravagant gestures, doffed his hat before it and stood bareheaded in tribute.

There are many gaps in the Paris chronology. One gap is the lack of information on when Davida and Novy came and when they left. Considering the amount of time Saint Gaudens spent with others, it is not surprising that Paris was not wholly to his mistress' liking.

As early as the fall of 1898 he was tiring of official commissions. "I want to make a Venus carrying a winged figure of love on her shoulders . . . and the little God of Felicity and Misery shooting his bow," he confided to Rose Nichols, perhaps revealing something of the state of his own heart.[27]

Henry Adams was well aware that his friend had been going through some very low times, but he seems not to have suspected how ill the sculptor was. "He is neurasthenic," Adams wrote to

Elizabeth Cameron on July 13, 1899, "which seems to be just old mild melancholia . . . the oppression of life and the dread of death."[28]

Adams, whose own pessimism was almost a way of life, did his best. Five days after his letter to Mrs. Cameron, he wrote Mabel La Farge: "St. Gaudens is drudging away up on Mont-Parnasse, and every now and then I drag him out of his dreary den where he creates nothing but nightmares. . . ."[29]

In July 1900 Saint Gaudens learned from his French doctors that he was seriously ill with cancer of the lower intestine. The recommendation was that he go home at once to be operated on. He kept the news to himself for some days, then quietly came into Fraser's atelier and told him the situation. In words that the younger man remembered well, Augustus described his reaction:

> Since that diagnosis I've been terribly depressed and unable to sleep, facing all night the realization of a mortal disease. A while ago I dashed out of here resolved to end things by jumping into the Seine. I hurried, probably ran, through the streets and was conscious of seeing only one thing: high on every building was the word DEATH; I saw it as plainly as if it were really printed there in huge black letters. But when I ran up on the bridge something happened; something I don't understand. Maybe the cause was physical—heart action quickened by running. Maybe it was the light on the river. Or the Louvre which had never looked so splendid. Whatever the cause, I saw everything again, and everything about me was unbelievably beautiful. The load of desperation dropped and I was happy. I heard myself whistling.[30]

There is nothing of the neurasthenic in the way Saint Gaudens faced up to his terrible news. The manner in which he fought the sentence he was under, and the creative projects he was able to accomplish in the time remaining him, bespeak a brave and sanguine man.

Gussie had already gone home in June. Augustus sailed on July 18.

33

MAKING DO

ARRIVING IN LONDON on July 17, 1900, on his way to boarding the S.S. *Majestic*, Saint Gaudens wrote Gaetan Ardisson a letter that reveals his state of mind in those last Paris days. It is really an apology for having driven the faithful assistant very hard:

> Dear Ardisson: The horrible mental suffering, the frightful nightmare in which I have been stuck for four days has disappeared like a cloud. Tell Shiff this and Garnier. Shiff was right, it was neurasthenia. Now that my vision is clear I want to correct some of my instructions of this morning. [He goes on to discuss final changes in the Sherman and its molding.] . . . Make a good photograph of the retouched figure and send it to me right away in New York. Then I will give an order for the casting. The doctor will not let me write more. Good bye. I was mad this morning. A ST G.[1]

The "doctor" in the case was a certain Dr. Herring, who took complete charge of the sculptor and served as his escort to America. Dr. Herring sent a telegram to Gussie from London, painting the situation in highly dramatic terms: "SAINT GAUDENS IN STATE OF MENTAL AND PHYSICAL PROSTRATION. TUMOR OF RECTUM DIAGNOSED IMMEDIATE OPERATION ADVISED . . . MEET AND TAKE CHARGE ON ARRIVAL OF MAJESTIC. HERRING M.D."[2]

From Queenstown, where the *Majestic* put in, Augustus got

311

off a message to Gussie at Cornish to calm the situation: "DON'T BE ALARMED. REASONS FOR CONSULTATION ENTIRELY PRACTICAL. NEURASTHENIC DEPRESSION DISAPPEARED."[3] By now Rose Nichols, also at Cornish, had identified Herring as an unscrupulous adventurer whom she had heard talked about in Paris. She and Gussie left for New York the day before the *Majestic* was to dock and, when the liner did arrive, briskly detached Saint Gaudens from Herring. Within forty-eight hours the sculptor was at the Massachusetts General Hospital, where an operation was duly performed. Then, as soon as he was well enough, he was taken to Cornish by train. On September 27 he was able to report to Stanford White that he was making a good recovery: "Dear Stan: I am getting on very well indeed, and considering I am as full of holes as a 'porous plas' [plaster] . . . I wonder I am alive. I think I was on the verge of insanity in Paris. I roam around the hills and loaf for all I'm worth."[4]

Somewhere around November 1, he was back in Boston for a second operation, this time at Saint Margaret's Hospital. Part of either the first or second operation was a colostomy, considered necessary to save his life. Following a period of recuperation in Florida, he was back in Cornish by mid-December. The subzero temperatures and the clear air worked wonders. He began a program of recreation, including lots of outdoor exercise. There was ice hockey on Blow-Me-Down Pond, and tobogganing launched by a steep slide built on the studio roof. Having worked hard all his life, Augustus began to discover the necessity and the joys of leisure: "Play, play!" he would say to his staff. "I wish I'd played more when I was young. I took things too seriously. . . . The thing to do is play more and to flirt more!"[5]

Gussie went away again that winter: "I was so miserable I had to go to the Azores for seven months and so it went on for years of almost constant separation."[6]

Saint Gaudens assembled his staff, each with some special skill to contribute, "were it a poetic grasp, a power of virile creation or an ability to model surfaces."[7] Among those who answered his summons were James Earle Fraser, Henry Hering, Elsie Ward,

and Frances Grimes. In March he wrote Louis, who had been living in Ohio with Annetta's family, to come and assist, or even send "Nettie" alone, "for I believe she could be of serious help."[8] They both came.

In addition to his professional helpers, Saint Gaudens acquired the sporadic services of two gifted and amusing contemporaries of Homer's at Harvard. These were Barry Faulkner and Witter Bynner. Faulkner became a distinguished muralist, Bynner a poet of some renown. Both were musical. They played the piano for Augustus, sang to him and even with him. Their high spirits and affection saw the sculptor through many dark times.

A letter to Dudie Baird sheds some light on Saint Gaudens' comings and goings and moods in the second winter after he came home:

> Dear Dudie
>
> It was "awfully" nice to get a word from you at the Players last week. I tell you—you have got to go abroad to really appreciate what a bully country this is and what bully friends one has at home, not that Paris is not a great place!!!!!!!!!
>
> They gave me a big dinner in New York the other day. I wish you could have been there among the other friends. It was pleasant to see that such a lot of fellers cared to be there. Well here's to you Dudie and to the day when we will meet again in N.Y. The next time I go down I'll try to fix it and get some of the old chums together as of yore. My blessings and my affectionate regards. Merry Xmas [the signature is the familiar profile].[9]

If Dudie was mostly a memory, the real link to the old days was as ever Davida. He never let her go. He saw her when he could, slipping down to New York for professional reasons and later for electric treatments, and still using the Players Club as nominal base. The evidence here is a letter of October 12, 1903, to the steadfast McKim, which also sheds some light on Augustus' fluctuating spirits:

Dear Charlie:—

. . . Please pay as nice a thing as I may be permitted to Margaret for thinking of me and of staying at your house when I go down to the nest within a fortnight.

(Margaret was McKim's only daughter, who lived with him at 9 West Thirty-fifth Street in New York. The "nest" can only mean Davida's home in Darien.)

. . . I am proud to say that I haven't done a stroke of work in three months. It's the first time in years when at some hour or other hour of the day I have not meditated suicide and the first time in my life I have loafed when I could work—the result is I am now even more pretty than you to look upon and if I were a woman I would make the healthiest baby that ever was. As soon as the bad weather drives me indoors I shall resume sculpture with enthusiasm. Affectionately [again, the profile as signature].[10]

From Boston, Augustus' old enemy Truman Bartlett watched with his usual rancor. With his goblin glee he noted that "practically St. Guadens has been a dead man" since he came back from Paris "to have an operation for a disease incurable. . . . Still he has constantly received new orders and neglected those of nine years before."[11]

As usual, there was only a modicum of accuracy in Bartlett's charge. One work, the monument in memory of Phillips Brooks, had been commissioned as far back as 1896. The great preacher had died three years before, and the grieving Trinity Church congregation quickly raised ninety-five thousand dollars for a bronze statue. Augustus accepted the project with special pleasure because of happy associations at Trinity with Richardson, La Farge, and the others. But it was deep concern, not neglect, that delayed completion: the resonant preacher of the Word of God, with a shadowy Christ standing behind him, was one of those combi-

nations of real and ideal—like the Shaw and the Sherman—in the creation of which time could never be the essence.

Many other projects were undertaken, and many completed, in the period between March 1901 and October 1904. A considerable work, done in a respectable two years, was the monument to Roswell P. Flower, a former New York governor, unveiled at his birthplace, Watertown, in 1902. Louis St. Gaudens, James Earle Fraser, and Henry Hering all assisted, and architect Henry Bacon contributed a high stone pedestal and an unusual octagonal plot.

The Sherman, cast in bronze in Paris under the watchful eye of Ardisson, was shipped to New York in sections (December 1902) and unveiled at last the following May. The rectangular Stevenson for Saint Giles Edinburgh, endlessly worked over in Paris and Cornish, with Hering, brother Louis, and Frances Grimes all making their contributions, was finally unveiled in June 1904.

One more work of a very high order belongs to this period of adjustment and making do. This was the bust of Secretary of State John Hay, whose summer place was near Cornish. With help from Elsie Ward and Frances Grimes, Saint Gaudens created, in both marble and bronze versions, a splendidly bearded and mustachioed statesman, more latter-day Socrates than the shrimp to which Sargent had compared him.

Though the *Pilgrim* for Philadelphia's Fairmount Park was more a twin to the Springfield *Puritan* than an original production, it did require a good deal of work during the 1903–4 period. The remodeling was done by Grimes and Hering, and a new base created by architect Charles A. Platt.

One work of major stature that was the subject of many sketches and early versions was the *Abraham Lincoln: The Head of State*, usually known as the *Seated Lincoln*. Companion piece to the *Standing Lincoln*, and also destined for Chicago, it was first commissioned in 1897 by a princely hundred-thousand-dollar clause in the will of industrialist John Crerar. Hering and Ward were the prime movers here, with Augustus supervising, and deeply concerned.

As early as 1898 a movement had begun in Ireland to erect a national monument to Charles Stewart Parnell. Some twenty-five thousand dollars was raised in Ireland and America for the purpose. After considerable negotiation, Saint Gaudens agreed to undertake the project honoring the Anglo-Irish statesman who was the spokesman for Home Rule. Proud of his own Irish inheritance, Augustus went to extraordinary lengths to assure the accuracy of every detail. He built a scale model of Dublin's O'Connell Street and the buildings that would surround the standing figure and obelisk envisioned from the start. A wooden replica of the seventy-foot obelisk and a plaster cast of the figure before it were set up in a field alongside the Cornish studio, and a Dublin tailor was asked to supply copies of the clothes he had made for the great man of ice and fire. The Parnell was unveiled on October 1, 1911, more than four years after Saint Gaudens' death. . . .

Even in the bas-reliefs—the chamber music of the Saint Gaudens oeuvre and the creations on which he stamped his own personality so indelibly—he now began to get a good deal of help. Yet the best of the reliefs from this time manage to preserve the mark of the master more than the statues-in-the-round do. This is particularly true of the big bronze plaque of *Wayne and Virginia MacVeagh* with a most perfect lap dog (1903). The essential modeling of the three profiles is unmistakably Augustan.

What was happening in these first years of the new century was that Saint Gaudens was making the transition from chief executive officer of his busy studio to chairman of the board. There were two reasons for this change. First was his increasing infirmity, for there were long periods when he was too ill to do the actual modeling. Second, by virtue of his triumphs abroad during the Paris years—as well as his long stewardship—he found himself not just the ranking American sculptor, but the ranking American artist as well.

In this role he appeared on the national scene of a burgeoning America in ways that no artist had done before.

34

MOVING UP, MOVING ON

"Thrice over for the good fortune of our country-
men, it was given to you to strike this highest
note."

—Theodore Roosevelt[1]

THE YEAR 1900 was more like the end of an age than the begin-
ning. The good, cautious William McKinley was re-elected
president over the more flamboyant William Jennings Bryan.
Governor Theodore Roosevelt of New York, viewed as a trou-
blemaker, was shunted into the vice presidency. He called it "tak-
ing the veil" and played with the idea of studying a little law.
Pope Leo XIII was ninety on March 2, and Queen Victoria eighty-
one on May 24. The Boer War was winding down. Ladysmith
was relieved in February and Mafeking in May, to the vast relief
of an anxious empire.

The châteaux and palaces of the very rich were proliferating
up Fifth Avenue. Home on a visit after many years abroad, Henry
James found them faintly disturbing: "They had the candid look
of costing as much as they knew how," he wrote, dubbing them
"instalments, symbols, stop-gaps" with "nothing to do with con-
tinuity, responsibility. . . ."[2] In New York alone there were ten
thousand people with incomes of a hundred thousand dollars and
up. The rich were getting richer and the poor were getting rest-
less.

At the Casino Theater the Floradora Sextet won six encores a night as the audience chanted, "Tell me, pretty maiden, are there any more at home like you?" Stanford White owned a permanent seat in the orchestra and dropped by most evenings.

There were some forward-looking symptoms. The digging of the first New York subway was under way. Daniel Burnham's Flatiron Building was finished, cleaving Fifth Avenue and Broadway with its leading edge.

On the national scene, America, fresh from her splendid little war with Spain, began to enjoy her new status as a world power. Hawaii became a U.S. territory.

The real year of change was 1901. With the assassination of McKinley in September, Roosevelt succeeded to the presidency. Ever since the 1896 campaign, T.R. had been worrying about the widening gap between rich and poor, and the growing public sense that there was one law for the lions of industry and another for the average citizen. Now he took vigorous action. Through his attorney general he brought suit against a typical holding company called Northern Securities. The result of the suit was that the company's dissolution was ordered, a decision upheld in due course by the Supreme Court.

There were other breakthroughs. T.R. was the first president to go up in a plane, the first to go down in a submarine, and the first to leave the country while in office (for a trip to Panama).

What was happening was a revitalization of the presidency, along with a renewed realization that all citizens must be equal before the law. The mood of the nation was expansionist, almost imperial, but carrying an awareness that there were responsibilities to go with power. As referee of the peacemaking at the end of the Russo-Japanese War, T.R. won himself a Nobel Prize, and the nation a broadening respect.

One manifestation of the new vigor was the interplay of government and the arts, and here T.R.'s family friend Saint Gaudens was destined to play a part. Senator James McMillan of Michigan was chairman of the U.S. Senate District of Columbia Committee and prime mover in its ad-hoc Park Commission. The principal

concern of the latter was a study of the parks and open spaces of the capital city. The commission would then develop a plan to restore the Mall from the Capitol to the Washington Monument as envisaged by Major L'Enfant a hundred years before—and extend it to the Potomac. It had become sadly clogged by canals and railway tracks, and by the big Gothic Baltimore and Ohio Railroad Station athwart it, blocking the view down the Capitol-Potomac axis.

The professional committee formed to advise McMillan consisted of Chairman Daniel Burnham, "who never hurried and never rested,"[3] the dedicated Charles Follen McKim, and Frederick Law Olmsted, Jr., on whose capable shoulders his father's mantle had fallen. Because of the amount of statuary involved— and his proven usefulness at the Chicago Fair—Saint Gaudens was sought as the fourth member. For some months McKim had been working on a preliminary plan in the spirit of L'Enfant. It featured a Greek temple in memory of Lincoln at the place where the Mall reached the Potomac, a bridge across the river to the cemetery where so many of Lincoln's soldiers lay, and sculptural memorials at the Capitol end of the axis.

McKim showed the plan to Augustus in confidence, at the same time urging him to sign on. In a letter to Daniel Burnham on May 29, 1901, Augustus responded to the call: "I thought it [the study] so splendid and was so impressed, that I want at once to tell you how it struck me. Great Caesar that ought to go through and if my shoulders would be of any good at the wheel let me know and I'll push til I'm blind."[4]

Without more ado, Saint Gaudens was added to the group. Though he was too ill to join in a trip abroad that summer to study European city planning, he did take an active part after the committee returned.

On March 22, 1902, Saint Gaudens and McKim, along with Charles Moore of the McMillan staff, explored the landfill bordering the river at the western end of the Mall. Their purpose was to determine the location of the proposed Lincoln Memorial. They lined up the site with the Washington Monument and the

distant dome of the Capitol. Then they drove the stake where the Memorial would be centered. And there, in the fullness of time (1922), it came to be.

Another national undertaking that Saint Gaudens heartily espoused was the founding of the American Academy in Rome. The idea of such an academy, along the lines of the famous French school in the Villa Medici, germinated during the Chicago World's Fair. Charles Follen McKim was the prime mover, with enthusiastic support from Dan Burnham. "Charles the Charmer" recruited Saint Gaudens. Although the early students were architects, he assured Augustus that the curriculum would ultimately include sculptors and painters as well.

By 1895 enough money had been raised to send the first three architectural fellows. By 1904 the handsome Villa Mirafiore was chosen as a permanent home, and the first steps were taken to raise an endowment of a million dollars.

The quest for funds went well, with J. Pierpont Morgan, W. K. Vanderbilt, and others coming through with a hundred thousand dollars each. As the drive neared its goal, Augustus put his own views into one of his rare speeches: "If but one commanding figure in a century shall result from this foundation; one man inspired by the breath of genius, all the money that will be spent in founding and maintaining it will have been worthwhile."[5]

Part of his own active participation was a letter of appeal to Henry Clay Frick describing the format that was developing: "Each year one man will be accepted as a scholar in architecture, painting, sculpture, and music, and one man in each art will graduate. The course is four years long, so that there will always be sixteen men at the Villa and they are to be selected by competition from the entire country, thus assuring the very brightest men we have."[6] Mr. Frick joined the other munificent founding fathers; Saint Gaudens never ceased his own active support, which he considered one way of showing what he felt about his own years in Paris and Rome. The Academy flourishes to this day.

Augustus was in and out of Washington quite often in the early 1900s, usually with Rose Nichols as factotum, sometimes with Gussie. He kept up with Henry Adams, now settled more or less permanently in his H Street house adjoining that of John Hay. As early as 1901 Adams was deeply concerned about the sculptor's health. On April 16 he wrote Elizabeth Cameron, "Saint Gaudens appears, looks wretchedly. It is my belief it is cancer that ails him. He has the look of it and the tone of it and the melancholia."[7]

Six days later, again to his divinity, Adams enlarged upon the theme: "St. Gaudens and his wife are here. . . . He comes to dine, sometimes with his wife and sometimes without. He is always singularly inarticulate; he can say very little; he belongs to the French type of Rodin, and has even narrower range. . . ."[8]

In the spring of 1903 Adams returned to his slightly patronizing posture in another letter to Elizabeth. Augustus had brought along some of his bas-reliefs, including the recently completed MacVeaghs: "They [the reliefs] are just what Sargent is not—refined and artistic. They are what one wants to be. I wish St. G. were doing a bigger subject but he is half afraid to leave the little track of his cameo—i.e. education."[9]

The bas-reliefs, of course, were less taxing than more monumental work, a fact Adams might have been aware of.

In addition to McMillan-commission business and the modeling of bas-reliefs, Saint Gaudens did jury duty during the years 1902–1903 in the selection of sculptors for two major statues. In May 1902 a panel of three, consisting of Daniel Chester French and Charles Follen McKim along with Augustus, met at the Cosmos Club in Washington to pick an artist to do an equestrian statue of George Brinton McClellan for Connecticut Avenue in the nation's capital. By midnight, after three hours, no agreement was reached; Saint Gaudens vowed he would never vote for the McKim candidate, whom he called "a damned amateur."[10] Ice cream was

called for, a subject on which Augustus and his architect friend had agreed for nearly thirty years. Even this failed to bring a consensus. Four finalists were asked to resubmit models by the end of the year. At a second meeting, in March 1903, the selection panel chose Charles Henry Niehaus. This was overruled by the McClellan Statue Commission, and the commission finally appointed Frederick MacMonnies. With his usual facility, MacMonnies produced a statue that caught the self-importance of the cocky little general to perfection, and managed at the same time to reach new heights of festoonery.

Beginning in March 1902 French and Saint Gaudens were members of a six-man selection board to judge a large competition for the Ulysses S. Grant Memorial destined for the east end of the Mall. There were twenty-seven entries for the $250,000 award. The panel's selection of a relatively unknown New Yorker named Henry Merwin Shrady triggered an uproar, including the offbeat charge by the runner-up that Augustus' vote had been influenced by the social position of young Shrady. The judges stuck to their guns and the Grant Memorial Commission accepted their recommendation. Shrady's lifework—for it took twenty years and he died just before its completion—fully justified their choice: the stolid, muffled Grant is both stoic and heroic. Flanking him on a marble superstructure 252 feet broad are surging groups of cavalry and artillery, which are among the most vivid battle scenes ever captured in bronze.[11]

It was no accident that so many statues of famous men at the turn of the century showed them on horseback. This proliferation stemmed from the mood of an increasingly imperial-minded America. Sensing it, concurring in it, Saint Gaudens worked hard to raise the rather uneven standard of equestrian monuments, not only by his own creations but by taking part in the selection of others who would do good work.

At one of the McMillan Commission meetings the question

was raised whether some of the Washington equestrian statues could not be assembled in a group. Augustus agreed that it was an excellent idea, and "added that a high board fence might then be built around the group."[12]

Several converging factors contributed to the increasing demand for equestrian statues. One was the vogue for the Renaissance, both for study and emulation. As part of its glorification of the individual, the Renaissance produced some of the finest statues of men on horseback ever seen. Another, less tangible, element was an absorption in the half-legendary time of King Arthur. Around 1900 knighthood was again very much in flower. Tennyson's *Idylls of the King* was still reaching a vast audience forty years after the first idyll appeared. Even earlier in the century, Keats had reconjured some medieval magic with his *La Belle Dame sans merci* and knights palely loitering. This had filtered down to the Pre-Raphaelites, who displayed their love of armor and of beleaguered maidens in painting and in poetry.

When it came to sculpture, deeds of derring-do almost *had* to be celebrated on horseback. Colonel Shaw, as we know, actually led the assault on Fort Wagner on foot. General Logan's finest moment came when he dismounted to seize an enemy standard at Atlanta. Saint Gaudens chose to perpetuate memories that were on the edge of myth.

An example of more immediacy in 1900 was that most of the illustrators of the day portrayed Theodore Roosevelt leading the charge up San Juan Hill on a charger rather than on foot, as he had in fact. Later, when James Earle Fraser came to do his heroic Roosevelt for Central Park West, it was almost inevitable that he show the President riding toward some ultimate triumph. (There was always something of Lancelot in T.R.'s ardent spirit, something of Galahad in his soul.)

Nor did Shrady have much choice even with the grizzled, down-to-earth Grant. Most photographs showed "Ulyss" leaning against a tree or sitting on a bench chomping on a cigar. But the

times called for a hero astride a splendid thoroughbred, and the message got through.

The unveiling of Saint Gaudens' Sherman, which took place on Memorial Day, May 30, 1903, was a piece of perfect timing. The chivalric spirit was very much abroad in the land. Augustus Saint Gaudens' own career had taken the high ground, moving on and up like Sherman, his angel, and his horse.

Strictly speaking, the ceremonies were more of a rite of installation than an unveiling. For the statue had already been given multiple exposure in plaster at the Paris Salon and the World Exposition. Well displayed outdoors at the American Exposition in Buffalo (1901), it had received the Gold Medal there. Sensing that the Sherman could constitute a last success with his own mark fully on it, Saint Gaudens had given it top priority for the three years since his return from Paris. In his pursuit of perfection he worked and reworked the details of Sherman's streaming greatcoat, and even of the oft-finished Angel of Victory.

He needed his Cornish studio for rest and privacy now as well as for work, so he requested his architect friend George Fletcher Babb to design a big new studio to house the Sherman and other larger works-in-progress. This was built in early 1901 under the watchful eye of James Earle Fraser.

Augustus also had a bronze cast of the Sherman group set up in the meadow behind the studios. There he experimented with various shades of gilding until he was satisfied at last that he had found the patina of warm gold he wanted.

Meanwhile, in New York, spirited arguments were going on over where the statue should go. Both Saint Gaudens and McKim, who had designed the high red-granite pedestal, favored a location near Grant's Tomb on Riverside Drive. But the blood between the Grant family and the surviving Shermans was running a little chilly, and this was vetoed. Various locations in Central Park were considered and discarded. Finally a compromise was worked out at the southeast entrance to the Park, at Fifty-ninth Street. Though

the corner was almost too busy for real statue-viewing, it did fulfill Saint Gaudens' minimal requirement that his work be given a north-south axis so that the shadows would fall as he had planned.

Since the statue was a gift to the city of New York from its Chamber of Commerce, the ceremonies were long and impressive. Governor Odell and Mayor Low were in the reviewing stand with many members of their staffs. Elihu Root, the popular secretary of War, and Miss Alice Roosevelt represented official Washington. The President's daughter, according to one newspaper account, looked very dashing "in a big, black straw hat trimmed with black ostrich plumes."[13]

Grand Marshal for the day was Major General Adna Chaffee, commander of the Department of the East. A veteran of three years, bronzed, straight as a lance in the saddle, he seemed the very model of the *preux chevalier*. When he came riding up Fifth Avenue on a superb bay at the head of the many regiments and companies, the dense crowd, hungry for heroes, cheered him to the echo.

The lead column of Zouaves in their wartorn Civil War uniforms reached the reviewing stand at 10:20 A.M. and halted at Chaffee's ringing command and raised hand. Then a bugle sounded the salute. Seventeen-year-old Sherman Thackara, the General's grandson, pulled a cord, and the flag swung clear. At the same time the band struck up "Marching Through Georgia."

Even though the swift contours of General, horse, and guardian angel were familiar to many in the throng, the impact of the treatment in bronze was stunning. Applause was rhythmic and sustained. "The gilded statue glitters in the sunlight, sumptuous and splendid," one editorial exulted.[14]

To the tune of "Dixie," the column now started to move again. For the next hour and a half the troops swung past. The Zouaves and other tattered Civil War veterans were given the greatest ovation. New York's Seventh Regiment and its Seventy-first received ovations almost as thundering.

Then came the speeches. Secretary Root delivered the main oration, leaving few stops unpulled: "Neither praise can set up

nor detraction pull down the immortals in that Valhalla of the truly great where he has taken his eternal place. . . . No one will dare to say another could have done what Sherman did. Shiloh and Corinth, Vicksburg and Chattanooga and Missionary Ridge crowned him with laurels." Sherman had become a true New Yorker, Root pointed out, and many New Yorkers learned his true nature: "This stern and relentless master of horrid war had a heart as gentle and as tender as a woman's."[15] Saint Gaudens, who may or may not have been present, was given his share of praise: "It is a fitting and a happy thing that here, too, the genius of the great sculptor who owns this city as his birthplace . . . should make imperishable by his art this silent witness to the honor that we and our children shall ever pay to Sherman, the soldier, the patriot and the friend."

That night Whitelaw Reid, who sixteen years before had persuaded Sherman to sit for Saint Gaudens, gave a dinner for the Sherman family. Augustus was also there, and Mr. Reid noted how poorly he looked.[16]

Praise from fellow artists and art critics as well as the press confirmed the feeling of the crowd that a masterpiece had sprung full-grown into being.

Daniel Chester French, soon to inherit the mantle of ranking sculptor, wrote Saint Gaudens in words that came tumbling: "I do want you to know how really great I feel—I *know* the statue to be—great as few works of sculpture ancient or modern are. . . . It is one of the wonders of the world. . . ."[17]

Lorado Taft caught the essential, as he so often did: "He has successfully united a very precise rendering of an individual with a poetic abstraction. . . . By some magic the artist has made her [the Victory] so integral a part of the composition that her presence pervades and colors the whole."[18]

Royal Cortissoz, whom the irrepressible Maxfield Parrish later dubbed "Chief Rain-in-the-Face" for the way he came to dominate art criticism, made a judgment that would in time be accepted as the conventional wisdom. The gist was that the Sherman would take its place beside Verrocchio's Colleoni and the

Gattamelata of Donatello as one of the three greatest equestrian statues of modern times.

To crown it all, Theodore Roosevelt wrote his friend:

> Your Sherman is the greatest statue of a commander in existence. . . . To take grim, homely, old Sherman, the type and the ideal of a democratic general, and put him with an allegorical figure such as you did, could result in but one of two ways—a ludicrous failure or striking the very highest note of the sculptor's art. Thrice over for the good fortune of our countrymen, it was given you to strike this highest note.[19]

Feeling his own mortality, Saint Gaudens wrote a letter of thanks ending: "And when I realize that you have taken the time to say this to me amid the multitude of other things on your mind, it is a fact that touches me deeply and your letter will be set aside and treasured for those who come after me."[20]

As so often happens in the case of a work of a high order, there were a few catcalls. While recognizing how "splendidly rendered" the statue was, Henry James sensed a certain ambiguity. He saw Sherman himself as "symbolizing the very breath of the Destroyer," but felt that we were also asked to believe that the General was a messenger of peace, "with the olive branch too waved in the blast and with embodied grace, in the form of a beautiful American girl, attending his business. . . ." His conclusion is pure middling James: "And I confess to a lapse of satisfaction of this interweaving—the result doubtless of a sharp suspicion of all attempts, however glittering and golden, to confound destroyers with benefactors."[21]

Georgians resented the fact that Sherman's horse in his forward surge tramples a branch of Georgia pine. Other disgruntled Southerners loved to point out how typical it was of a Northerner to let a woman walk—and ahead of him into battle, at that.

The *New York Herald* commented a week after the ceremony: "All cavalry officers turn their back and drop a tear to see

a famous general, who rode well and always had a good horse, perpetrated on a sorry plug and sitting like a novice. . . ."[22]

But the nitpicks were few and far between. To Augustus, Henry James had simply missed the point about the angel. As for the cavalrymen, their complaints, if true, merely confirmed how successfully he had been able to break away from the stiff seat and parade pose of the military martinet. The eye of most beholders saw beauty in the Sherman, and Saint Gaudens was content to let the case rest on their judgment.

Saint Gaudens' final and most unusual national role still lay ahead. It would stem directly from the President's admiration for the sculptor's gifts: early in his second term Mr. Roosevelt tapped Augustus for designs to improve the American coinage. Although the work was never finished, great beauty did result.

Two intervening events, one tragic, one wholly delightful and rewarding, would tax Saint Gaudens' waning vitality in different ways.

35

THE FIRE AND
THE MASQUE

Gussie resented Augustus' hours of recreation. She felt that he owed it to her to produce as much as he could during the time that remained to him. When she was in residence—and almost to the end she took at least one trip away each year—she ran a taut ship. To Augusta the winter sports in which the staff took such joyous part were almost a sin.

Summer annoyed Gussie even more. Augustus had put in a nine-hole golf course and, when he was well enough, played as often as six days out of seven. "Her face grew dark," Barry Faulkner remembered, "when he took a couple of assistants away from work for an afternoon of golf."[1]

Faulkner's impression of Augusta Saint Gaudens when he first came to Aspet in the summer of 1900 was his lasting one: as he reached the veranda, she approached "with long, graceful strides." He noted that she was "of good height and figure," but that "in repose the expression on her wrinkled face was grim, for she was deaf, pitifully deaf."[2]

She tried to persuade Augustus to send Faulkner on his way.

"Barry, don't mind what Gussie says," Saint Gaudens reassured his young friend. "*I* want you here."[3]

Frances Grimes recalled that Augusta used to heckle Augustus in public: "She said things to him before people that she would have been afraid to say to him alone."[4] Grimes' explanation

was that "Mrs. St. G. was a disagreeable person." Most of the professional staff agreed.

Even today there are stories in the Cornish folklore about Gussie's avarice and her sharp tongue. One story is that Augustus burned a big pile of dollar bills in her presence to show her that money was not all. Another time, when she was baiting him at dinner, with quite a few of the staff and some guests present, Saint Gaudens, seated at the far end, blew his top. He suddenly upended the groaning board, spilling glasses and plates, food and drink into Gussie's lap, then strode off in his fury.

Mrs. Maxfield Parrish was one of Gussie's supporters. Her husband and Saint Gaudens saw a lot of each other, sharing a certain boyishness in their hours of play. For her part Lydia Parrish thought that Augustus had "The strength and virility of the Irish and the finesse of the French."[5] But she also felt that his wife put up with a good deal. She and Gussie shared common ground. Both had been artists, Lydia having given up a promising career. Perforce, both understood the quirks and blind spots of the creative spirit in matters of everyday life. Each had a large staff to direct and commissaries to stock. Neither was running a popularity contest.

As the years passed and the seasons spun, the days settled into a routine. At 6:30 A.M., before his own breakfast, Saint Gaudens came to the studio where the scaffolding and the big projects were kept. From various vantage points he would study the work-in-progress and make quick pen or pencil sketches of what he wanted done, spending perhaps an hour. Then, around ten o'clock, he would come back from his own small studio to see how his instructions were being carried out.

Any modeling that he was still consistently able to do—small studies and sketches in clay—he did in privacy and then brought to his assistants for enlarging, and for more critical study. Several ancillary studios were added to the large one. There was one for marble cutting and one for Frances Grimes. Saint Gaudens never touched the marble himself but pointed with a wand where changes were necessary.

Augustus was in effect an "executive sculptor" now (the phrase is Grimes'). "He was very professional in the way he could direct people, the way he could get people to use every tool."[6] But he always reserved the final changes for himself, and he often made them right up to the moment when the work was to go to bronze foundry or marble cutter.

Barry Faulkner, who had left Harvard after a year, was studying at the Art Students League in the fall of 1904. Anxious for his companionship, Saint Gaudens asked him to come up to Cornish that October to gild and tint some of the small reproductions of the Victory from the *Sherman Monument*. Faulkner came, and was billeted at the Westgate Farm, a mile or so up the mountain road from Aspet. Three other of Saint Gaudens' assistants were also staying at the farm: Frances Grimes, Elsie Ward, and Henry Hering, whom Elsie later married.

On the evening of October 4, Faulkner and the two girls are having supper at the farm. After the meal, Grimes steps out for some fresh air, and sees that there is trouble. Down below, between the farm and the river, a column of smoke is rising in the still, twilight air. It looks very much as if it is coming from Aspet.

She calls the others. Barry Faulkner sprints down the road while Mr. Westgate hitches up the horses and follows with the girls. When Barry reaches Aspet he sees that the storehouses and sheds alongside the big studio are blazing fiercely. The flames are already eating their way into the studio itself.

Faulkner rushes into the studio and grabs the first thing he sees. It turns out to be a small relief by Frances Grimes. He runs out, puts it in a safe place, plunges back in.

Suddenly the grounds are thronged with neighbors and friends. Everyone pitches in to save what can be carried out. Though a bucket brigade is set up, the water supply is pitifully inadequate. The Fire Department at Windsor is alerted, but the distance is considerable.

Two large works—the Parnell and one of Marcus Daly, the copper king—are on rolling platforms, but the casters have been

lightly secured to the floor by plaster. No one thinks to chip the plaster away. Elsie Ward remembers that the plastoline head of Parnell is detachable. Barely five feet tall, she cannot reach the head, so she grabs a ladder. As fragments of the skylight begin to fall around her, she climbs the ladder, lifts the head off the body, and carries it to safety. A six-and-a-half-foot character known as Long Mike Stillman copies her by wrenching the head of the *Phillips Brooks* from its clay body on the dead run and sprinting for the outdoors.

The *Marcus Daly* sinks into the embers with flakes of plastoline bursting from it, "as if from some tortured body."[7] The *Seated Lincoln,* which is nearing completion, is a total ruin.

Bas-reliefs, small figures, molds, and casts are the easiest to handle, and many are saved. With the best intentions in the world, one neighbor manages to drag a worthless iron stove to safety. In the midst of the turmoil, Gussie and Rose Nichols arrive back from a dinner out. Grieved and in shock, Gussie stands on a rise, "black, silent and motionless."[8] Rose Nichols, seeing that the studio's great skylight is about to cave in, screams to the rescuers to evacuate the studio. They do so, seconds before the skylight comes crashing down.

Now a light breeze springs up. Sparks are being carried to the stable near the house. Faulkner clambers up on the low roof of the stable and people below pass wet blankets up to him. The stable is saved, but by that time studio and outbuildings are a total loss.

No one knew how the fire had started. No one was on hand to fight it when it still could have been contained. Saint Gaudens had taken Hering and two others of his staff to New York for some well-earned rest and recreation. Gussie had commandeered the night watchman, who doubled as a coachman, to drive Rose Nichols and herself out to their dinner. The house servants were on an outing.

Inspecting the damage the next morning, Barry Faulkner ran into Gussie Saint Gaudens. Without a word of thanks she dis-

missed him from the place. "She said there was nothing more for me to do," was the way he remembered the scene. "She was right but I resented her ungraciousness."[9]

The loss was staggering, especially of valuables stored in a stablelike shed adjoining the studio: furniture from the New York house . . . photographs, papers, and letters including a treasured packet from Robert Louis Stevenson . . . the drawing Augustus did of his mother and prized so greatly . . . portrait sketches of Saint Gaudens by Bastien-Lepage and Sargent . . . oil portraits of him by Kenyon Cox and William Merritt Chase . . . canvases by Winslow Homer and George de Forest Brush. Even though the insurance coverage turned out to be quite adequate, the sentimental loss and the loss of work-in-progress by a man whose physical powers were waning were beyond any reckoning.

The night of the disaster, Saint Gaudens and Homer were attending a performance of William Faversham in the hit *Letty*, at the Hudson Theater. Not long afterward, Witter Bynner lunched with Saint Gaudens at the Players. "Hal" Bynner, as he was called, later reported to his friend Barry Faulkner how their mutual patron had taken the news of the fire:

> The Saint was saying under his breath "long and livid hell"— while his lips smiled and philosophy pretended and he told me with great vigor the good old story of the Italian fountain in his rooms in Paris and recited in a superb crescendo of Parisian emotion the remarks overheard in a restaurant— "J'ai commandé de soupe à l'oignon chaude, et vous me l'avez apportée *froide*! J'ai commandé une cotelette aux pommes et vous m'avez apporté une *omelette à rhum*. Est-ce-que vous voulez me servir, oui ou non?"
> "Non!!"
> "Je m'en vais!!!"

Gathering momentum, Augustus launched into a "pathetic tale" of Willie MacMonnies' about how he had looked up "an old idle failure of a sculptor" and "of being asked to wait a minute":

Then entering and finding him on a ladder with a tool in his hand applied to an opening of clay on an enclothed figure that had not been wet in years. And the old man looks down with a smile and sings out: "Caught in the act!"

O Barry![10]

So Saint Gaudens wore his misery like a flower, and used laughter to conceal deep hurt. The formula is the same as Richard Brinsley Sheridan's, the night his Drury Lane Theater burned down. Watching the destruction of his lifework from his house across the way, Sheridan poured himself some wine. "Surely," said he, "a man can drink a glass of sherry by his own fireside."

YOU ARE INVITED TO WITNESS THE
PERFORMANCE OF A MASQUE, AT
'ASPET', CORNISH, NEW HAMPSHIRE,
ON THE AFTERNOON OF JUNE 20TH,
1905, AT SIX O'CLOCK, IN CELEBRATION
OF THE TWENTIETH ANNIVERSARY
OF THE FOUNDING OF THE
CORNISH COLONY BY AUGUSTUS AND
AUGUSTA SAINT-GAUDENS.

HERBERT ADAMS,
W. E. BEAMAN,
JOHN BLAIR,
KENYON COX,
HENRY B. FULLER,
PERCY MacKAYE,
MAXFIELD PARRISH,
CHARLES A. PLATT,
BRING YOUR OWN LOUIS EVAN SHIPMAN,
HITCH-ROPE.
 COMMITTEE.

It was not the best of masques, it was not the worst of masques; and as masques go—often by fits and starts—it went very well.

The Cornish colony had one great asset: it was brimming with talent. The poet Percy MacKaye wrote the Prologue. Playwright Louis Evan Shipman, author of *D'Arcy of the Guards*, another William Faversham success, wrote the pageant itself. Maxfield Parrish designed the great silver masks that hung on the sage-green curtain. Musician Arthur Whiting composed or arranged, and conducted, the incidental music.

The setting was a pine grove at the foot of the meadowlike lawn below Aspet. Its semicircular northern end formed the stage itself, with a floor of pine needles. (Behind the stage the land falls steeply to a small stream, which tumbles down to the main brook, Blow-Me-Down.)

MacKaye's Prologue, written in cold roast Shakespearean, was a tribute to the art of Augustus Saint Gaudens. It was charmingly spoken by a "tall, graceful girl clothed in shimmering, many-hued gauzes."[11] The audience, several hundred strong, fanned out from Augustus and Gussie, who were seated front-row center along with Homer and his bride, Carlota, a beautiful Junoesque blonde.

At precisely six o'clock in a soft-gray late afternoon, the curtains part.

Jupiter and Juno are seated in a grove with the herald Hermes in attendance. Behind them is a small temple consisting of an altar and twin Ionic columns. High columns flank the temple, following the curve of the semicircle. It develops that the gods, whose dwelling place is the hills and meadows and river of Cornish, are being invaded by mortals. If a mortal can be found worthy of ruling, Jupiter is willing to step down. But first the other deities must come to discuss the problem. Hermes is sent off to summon them.

In Hermes' absence, a New England farmer wanders onto the scene and entertains Jupiter and Juno with an account of the

Cornish colony seen through native eyes. To some of the listeners from elsewhere the foolery is a little obscure, but to most it is hilarious.

As each of the deities and his or her retinue arrive, there is a thunderclap and much smoke. Then Hermes announces them in a powerful voice. He is played by Percy MacKaye, dressed in an outfit that is almost too gorgeous. A whisper runs through the audience that the self-esteeming MacKaye has done the unpardonable by *renting* his costume.

A somber Pluto is the first to come with his full court, all in black and gold and purple. Neptune arrives with some willowy girls in blue and gray, simulating waves. Diana in white and silver and blue floats in with her nymphs, each armed with a bow and arrow. Mars is played by the ubiquitous Long Mike Stillman, resplendent in a suit of armor of stitched roofing discs. Minerva is the very fair Mrs. Shipman. Sundry Nereids, three Fates, nine Muses, a Pan, and a Cupid with budding wings enhance the scene. The various deities exchange grave greetings with the supergod and goddess.

Just as Jupiter is about to call the meeting to order, there is a particularly loud clap of thunder. Chiron the centaur clatters on stage, followed by a troop of small children. The front half of Chiron is Maxfield Parrish, the hindquarters a wonderful mechanical contraption of Parrish's own devising. The children group themselves on stage. Kicking mightily, the centaur departs, stage right, to laughter and applause.

There follows a debate about the succession, then ritual dances and invocations. As the climax nears, the altar begins to glow, and little pink flames appear on the surrounding pillars. A statuesque beauty in a golden tunic appears amid a cloud of smoke from behind the altar. She bears high a golden bowl. Unsurprisingly, everyone chants "The Golden Bowl! The Golden Bowl!" in cadence. The beauty, who is cast as "The Spirit of Art," hands the bowl to Pluto and Minerva, who continue the argument over who is to succeed. On a sudden inspiration they examine the bowl, while Minerva proclaims that it bears the name of the most worthy.

The name is given, and woods and field ring with the cry: "Saint Gaudens! Saint Gaudens!"

As the entertainment ends, Minerva steps down from the stage and presents the bowl to Saint Gaudens, who is quite overcome. Fauns and satyrs appear on the scene dragging a Roman chariot. Augustus and Gussie climb aboard, not without a word of caution from Gussie: "Mind the paint, Gus, it's fresh."[12]

Everyone who has brought "hitch-ropes" as instructed in the invitation joins in pulling the chariot up the lawn to the pergola in triumph.

After dinner there is dancing in the big studio, which in the eight months since the fire has been completely rebuilt. Exhausted, Saint Gaudens slips away early, telling many that it has been the happiest day of his life.

Gussie weeps from conflicting emotions, mainly joy.

36

THE *SEATED LINCOLN* AND
THE *PHILLIPS BROOKS*

SAINT GAUDENS was pleased with his daughter-in-law. The summer after the Masque he wrote to Alfred Garnier about her in lighthearted vein: "Homer has been married two months to a blonde, blonde, blonde. He is dark, naturally he must have some one who is the color of wheat. They have taken up housekeeping in New York. I suppose I shall become a grandfather. Eh? That's funny, isn't it, when one thinks of the Rue Jacob?"[1]

Carlota was a much-sought-after Pennsylvania girl who summered in New Hampshire. Somewhat later she was described as a "bluestocking that had run a little."[2] But in the early years of her marriage she continued to attract a good deal of admiration for her high spirits and her somewhat rebellious nature. And Homer remained difficult. On the morning of the Masque he found his father putting out chairs for the entertainment. When Augustus asked him to help, Homer stormed off; he is supposed to have boycotted the evening.[3] His friend Witter Bynner has shrewdly described the warring elements: "There is a great deal of Homer's father in him. When the maternal inheritance, like the stormy puppet on those Swiss barometers, swings out from one door, I try to think only of the paternal sunshine inside the other. He and Carlota . . . might have been born one at the north pole, the other at the south, for their similar and yet dissimilar remoteness from people of the temperate zones."[4]

After three years of magazine work in New York, Homer came back to help manage the studio at Cornish (1906) as his father grew weaker. Encouraged by Augustus, Carlota took to painting miniatures, although her inclination was to do frescoes. Her first child, Augustus, was born on July 7, 1909, almost two years after the death of his grandfather.

In the months between the fire and the Masque, the work load at Aspet had picked up with remarkable speed. The *Marcus Daly* was the first of the major losses to be put back together again. The eight-foot figure was cast in bronze as early as 1905 and unveiled the following year in Butte, Montana, the copper city that Daly had done so much to create. On the part of Augustus, there had been no great emotional involvement. Yet the forthright Daly was a more than adequate work, and the last installments of the twenty-five-thousand-dollar fee helped defray the expenses of the rebuilding of the big studio and the setting up of several adjacent ones.

The sculptor and his assistants also turned to the reactivation of two works that were far deeper commitments: the *Seated Lincoln* and the *Phillips Brooks*. In sculptural parlance, both were "heroic-size" statues, meaning that they were larger than life. The Lincoln was completed before Saint Gaudens' death, and the Brooks nearly so. Sadly, he did not live to see either of them unveiled.

As early as December 26, 1904, Saint Gaudens was writing to Gussie (who was on an extended trip to California) that "the Lincoln is pulled together but there is much more work . . . than I had anticipated."[5] On a New York visit, Augustus appealed to Richard Watson Gilder for help, remembering his discovery of the Lincoln life mask: "My cast of the Lincoln head is gone with the rest in the fire—I wish another, will you please let the bearer of this take a cast from your bronze. I remember it was one of the best—I need it for the new Lincoln to replace the other destroyed also in the hell of Windsor."[6]

The bearer of this letter was Ardisson, who quickly accomplished his mission. From there Henry Hering took over, guided each step of the way by his master's knowledge of Lincoln and

determination to make the seated Head of State a worthy companion piece to the Man of nearly two decades before.

Augustus and Hering worked well in harness, one of their bonds being that they had both been poor boys whose early training was at the Cooper Union. Hering leaned heavily on the Saint's guidance. In the December 26 letter to Gussie quoted above, Augustus referred to him as "an admirable workman who can understand and execute what you explain most intelligently." But he added that Hering was "sadly at sea when I am away."[7]

There is evidence that, in the later stages of work on the Lincoln, Augustus was able to do some of the modeling himself. The beautiful Ethel Barrymore was a member of the summer colony at Cornish in 1906. In her autobiography the actress recalls finding Augustus "the most exciting" of all the Cornish artists. Of her visits to his studio she writes: "He was then doing his wonderful *Lincoln*, and he used to let me watch him work. The head was finished, and I never could look at it without wanting to cry."[8]

Although the head derives directly and splendidly from the Volk mask, this second Lincoln is something of a failure. Lincoln seated on an elaborate chair of state lacks the majesty of the standing figure. Its impact on the public was far less. A contributing reason was that the location in Chicago's Grant Park was not finally agreed on until 1926, the year the monument was unveiled at last. By that time Daniel Chester French's version of the seated President in the Lincoln Memorial in Washington had been in place for four years. French's Lincoln was another lineal descendant of the Volk life mask. Even in this short time, the great marble figure and the temple in which it dwells had come to be recognized as a work of the highest order, and a triumphant example of sculptor and architect (in this case Henry Bacon) working together in seamless collaboration.

At the time the big studio was gutted, the *Phillips Brooks* was not as far along as the *Seated Lincoln*. The rescue of the early

version of the head in clay was one piece of luck. Another was that a mask of the celebrated divine that the Brooks Committee had loaned to Saint Gaudens was kept in the small studio and so escaped destruction.

Augustus had been experimenting with many treatments. He had originally planned to have a winged angel behind the commanding figure of Brooks declaiming the Word of God. In the course of dozens of early sketches in pencil and clay, the angel became a Christ, with his right hand resting lightly but firmly on the shoulder of his doughty henchman.

Certain elements in the group remained little changed from the start, including Phillips Brooks himself. A lectern was added, and his right hand raised into a gesture of benediction. The long robe acquired a greater vigor of its own, and the left hand never relinquished its firm grip on the Bible. Stanford White's canopy, consisting of six Corinthian columns supporting a domed roof, did not alter much. The inscription on the panel below proclaiming Brooks as PREACHER · OF · THE · WORD · OF · GOD / LOVER · OF · MANKIND seems also to have found early acceptance. (Brooks' authorship of "O Little Town of Bethlehem" may have been considered a less exalted claim to fame.)

Augustus realized that the Christ figure presented a tremendous challenge. True to his methods of research in his later years, he read everything he could find, including Ernest Renan's *Life of Christ* in French and James Tissot's in English. Although born into a Catholic family, Augustus was no churchgoer: he loved the joy of religion but not the elements of sin and repentance. Now he began to see Christ as a man among men with a message of peace and tranquillity, and it was this interpretation that he sought to capture in clay. Except for the unfinished bas-relief of Gussie, the original version of the head of Christ was the last work he touched with his own hands. Our Lord is bareheaded. Witter Bynner, who watched with deep compassion the ailing sculptor's quest, later described the bust as "a simple, true face, traces of pain fading from the brow and cheek and an illumination of peace behind the closed eyes."[9]

The bust was cast in bronze and also beautifully cut in marble by the Piccirilli Studios in New York. The marble head, which is on view at the Saint Gaudens National Historic Site, exactly matches Bynner's description.

Wishing to add an element of mystery such as he had created in the figure in the *Adams Monument*, Saint Gaudens pressed on with the search. Under his close instruction, Frances Grimes and others modeled a second Christ, the hooded figure that appears in the finished monument. There was something missing this time, and Bynner watched it happening: "I saw him [Saint Gaudens] let the pupil open those eyes of Christ, so that they lost their light, and direct them sidelong toward Brooks."[10] In the search for the mysterious, the mystery and magic were lost. Here there is neither the tranquillity of the East nor the comradeship of the West.

The problem of the two figures in juxtaposition is very great. Lorado Taft states it clearly and well: "Saint Gaudens' idea was very exalted but almost impossible of expression in sculpture. . . . The result, in spite of admirable features, is curious rather than impressive."[11]

Witter Bynner, disappointed by the shadowy Christ with his hand on the shoulder of the stentorian Brooks, said that the group should be called "The boys want to talk to you down at the station."[12] More gently, Walker Hancock has made the same point: "The sculptor has not quite managed to bridge the gap of nearly two thousand years."[13]

Augustus himself was pleased with the way the work was shaping up. Near the end of his life, he is on record as saying, "There, it's all right now; all right now."[14] It is possible that the celebrated eye had failed him, that he was just plain tired.

The Brooks Committee was less satisfied. Before accepting the work in 1910, its members appointed a small advisory committee to tell them if it *was* acceptable. One of the members was Kenyon Cox, who later summed up their recommendation in language such as this: "It isn't very good Saint Gaudens, grade

B, perhaps. But it is unlikely that you will find anything better. So, accept it!"[15] They did.

Today as ever, the *Phillips Brooks* stands in the shadow of the great Boston church. It is extremely interesting, but it is not great. The big cross behind the two ill-assorted figures should be strong and moving, yet it seems just another accessory to the failure. The capitals of the six Corinthian columns are almost a jungle growth of acanthus leaves.

Perhaps if Saint Gaudens had lived he could have pulled it all together at long last.

37

MAN OF ADAMANT,
REALM OF GOLD

But stories that live longest
Are told beneath the glass
And Parnell loved his Ireland
And Parnell loved his lass.

—William Butler Yeats

THE THIRD OF THE heroic figures that were in process at the time of the fire was the *Charles Stewart Parnell*. Thanks to Elsie Ward, the fine, full-bearded head survived the fire. Thanks to Saint Gaudens' strong feelings for his own Irish mother and his motherland, he renewed his resolve to make the statue one of his best. Although the final result did not turn out to be an indelible example of his talent, it deserves study in some depth, in good part because its subject was one of the most fascinating men of his age.

Parnell's being, like himself, only half Irish had always interested Saint Gaudens. The statesman's mother, Delia Stewart Parnell, was American. Her father, Commodore Charles Stewart, who had commanded the USS *Constitution* ("Old Ironsides"), had passed down his hatred of England as the archenemy undiluted to daughter and grandson.

Augustus watched Parnell's meteorlike career with great interest. It came at a time when his own reputation was rising fast. Starting in 1880, the Irish statesman, by perfect control of the eighty-two-man home-rule bloc in the British Parliament, made himself the knife edge on which the government balanced. Both Conservatives and Liberals cultivated him, knowing he could engineer their rise or fall. Ireland's seven-hundred-year dream of independence seemed sure to become real at last.

Then, ten years into his hegemony, scandal swept him away. One of his own henchmen, a certain Captain O'Shea, filed a divorce suit against his wife, Kitty, naming Parnell corespondent. O'Shea had been a complaisant husband for almost a decade: Kitty had born Parnell two daughters, and the Captain had taken it in stride. There had even been a scene in which the great man of fire and ice had simply entered the O'Shea bedroom, thrown Kitty over his shoulder, and carried her off.

After the uncontested divorce was granted in November 1890, the British establishment went into well-feigned Victorian shock over the affair and divorce. Gladstone, who would soon be returned to office, shed a few crocodile tears and tossed Parnell to the wolves as no longer useful. By now married to Kitty O'Shea, Parnell defended his foundering cause with a bleak and biting eloquence, but support drained away. General debility and exhaustion set in, and he died in October 1891 at the early age of forty-five. Ireland's cause lost its momentum for another twenty-five years.

Michael Davitt, one of Parnell's colleagues, said of him, "His mind was barren of all faith except a boundless faith in himself."[1] It was this singleness of purpose that made him the catapult he was. What Saint Gaudens set out to capture was both the physical presence and the motivating spirit. One symbol of Parnell's vaulting ambition was the obelisk that Augustus placed behind the standing figure. When he set up the plaster mock-up of statue and obelisk in the Aspet fields, he saw that the seventy-foot shaft

dwarfed the figure below it and reduced the shaft to fifty-seven feet.

Partway up the granite shaft he placed ringing words from Parnell's most famous pronouncement: NO · MAN · HAS · THE · RIGHT · TO · FIX · THE · BOUNDARY · TO · THE · MARCH · OF · A · NATION / NO · MAN · HAS · A · RIGHT · TO · SAY · TO · HIS · COUNTRY · THUS · FAR · SHALT · THOU · GO · AND · NO · FURTHER / WE · HAVE · NEVER · AT- TEMPTED · TO · FIX · THE · NE · PLUS · ULTRA · TO · THE · PROGRESS · OF · IRELAND'S · NATIONHOOD · AND · WE · NEVER · SHALL.

To drive the message home, Saint Gaudens portrayed the statesman with his right arm extended in a gesture rigid yet elegant, a gesture almost as old as time and certainly as old as the *Apollo Belvedere*. Often, as in the statues of Latin American liberators in our Eastern cities, this can be an air-clawing gesture of considerable vacuity. Here, in close proximity to Parnell's burst of eloquence, it is powerful and right. The wide embrace encompasses all Ireland.

It also serves to reinforce Philippe de Montebello's wonderful all-purpose statement that "The *Apollo Belvedere* is not only beautiful but enormously influential in the history of art. . . . Almost every standing figure, draped or undraped, in any form of movement, from the sixteenth century to the nineteenth, is derived from the *contrapposto* pose of the *Apollo*."[2]

The Parnell was finished in the spring of 1907. It was cast in bronze and shipped to Dublin just before Saint Gaudens' death. The unveiling ceremony took place on October 1, 1911, after a "monster procession made up of contingents from every part of Ireland."[3]

As it stands today, at the lower end of O'Connell Street, it bespeaks a certain ambivalence. The statue itself, noble and commanding, has a very nineteenth-century look. Architect Henry Bacon's obelisk, with its gold lettering and gold Irish harp, seems more modern, even projecting some double entendre in light of the circumstances of Parnell's fall. There is more than a sufficiency of wreaths, plaques, and ox skulls on the pedestal, for which both

Saint Gaudens and Bacon must answer, with a nod in the direction of Willie MacMonnies.

The modeling, done by Henry Hering and Elsie Ward, falls just short of the work of the master. Though the monument is more than adequate and most interesting, there is something lacking. The test is simple enough: we admire what we see but the compulsion to go back, to look and look again, is missing.

During Theodore Roosevelt's first three years in office, he and Saint Gaudens had corresponded on a subject about which both felt strongly: the necessity of improving the gold coinage of the nation. "You know, Saint Gaudens," T.R. once said with his usual vehemence, "this is my pet crime."[4] To bring about any improvements, both knew that they would have to challenge the hierarchy of the U.S. Mint, bureaucrats entrenched in mediocrity and skilled in tactics of delay.

Ironically, the man who stood most in the way of change was the mint's chief engraver, Charles E. Barber. By now in his sixties, he was the man who had enraged Augustus at the time of the Chicago World's Fair. The sculptor had seen Barber's fine hand in the mint's outright rejection of four Saint Gaudens designs for the reverse of the fair's award medals, and his less-than-fine hand in the design that was accepted—a Barber opus of trite symbolism and undistinguished lettering. The result, with Augustus' Columbus at the moment of landing on the obverse and Barber's cluttered reverse, was a monstrosity that Saint Gaudens never forgot or forgave. (In general terms, the obverse is the side of a medal or coin bearing the principal image or inscription, as was the case with the scene of Columbus on the beach. In American coinage, the obverse side is the side bearing the date, no matter where the principal image or device appears.)

Now, thirteen years later, the hostility between Saint Gaudens and Barber flared again. The first clash came over the inaugural medal to celebrate Roosevelt's sweeping 1904 victory, rather than over the long-term problem of the coinage.

At the time when T.R. succeeded McKinley, Barber had designed a perfunctory medal for the mint's presidential series. It showed, in left profile, "a somewhat somber man of forty-three."[5] Three and a half years later, for the special inaugural medal, the authorities simply proposed to change the date to March 4, 1905, and have the medal struck in a smaller, cheaper variant by a commercial mint in Philadelphia. They were content to leave T.R. looking exactly the same, still somber, still forty-three.

The President was not pleased. The original medal was mediocre enough, its duplication almost insulting. He asked his friend Frank Millet, an informal adviser on the arts in much the same way that Saint Gaudens was, what to do about it. Millet's answer went straight to the point: "The President's inaugural medal should come from the hands of a great artist, not a commercial journeyman."[6] Unsurprisingly, Millet suggested his old friend Augustus Saint Gaudens, and the President thought the suggestion a bully one.

As it so happened, the Saint Gaudenses were in and out of Washington during January 1905. On the night of January 11, both the President and the sculptor were among the four hundred guests at the dinner given by the American Institute of Architects to celebrate government support of the American Academy in Rome. In all likelihood Theodore Roosevelt mentioned to his friend the matter of the inaugural medal, and his hope that Saint Gaudens would agree to do it.

The evidence can only be circumstantial, but something that happened the next night lends it credence. Along with Henry Adams, Henry James, John La Farge, and others, Augustus dined at the White House. The President was in rare form, holding stage center with a torrent of anecdotes and bursts of oratory. Adams managed to insert an occasional barb, James waited in vain for a chance to get in a paragraph or two, La Farge chafed. Only Saint Gaudens gave the President his full attention, "an impression of fascinated absorption," never letting his eyes leave T.R.'s face.[7] As La Farge described the scene later to Senator Henry

Cabot Lodge, he realized that Augustus was merely "studying and measuring the proportions of the speaker's face—'His nose is three-quarters of an inch—his forehead so much and so forth.' "[8]

At a meeting during the day of January 18, the President urged Saint Gaudens to undertake the inaugural medal and said that a formal request from General Wilson, the chairman of the Inaugural Committee, would be coming through in a matter of days. Under the presidential barrage, Augustus all but capitulated. On the same day, also at the White House, the sculptor had a meeting with Secretary of the Treasury Leslie M. Shaw, who of course had overall control of the mint. Realizing that this was his chance to shake up the mint with backing from on high, Saint Gaudens agreed seriously to consider the larger, long-term problem of improving the gold coinage of the nation.

On the train to New York the next day, Saint Gaudens sketched out his ideas for both sides of the inaugural medal. In New York he received a telegram from Brigadier General John M. Wilson officially asking him to design it, and this he now agreed to do, knowing he was caught up in the challenge and excitement of the task. But he also knew his own limitations of strength and promptly wrote the President to explain that he could not do the modeling himself: "But I have arranged with the man best fitted to execute it in this country, Mr. Adolph Weinman. He has a most artistic nature, extremely diffident. . . . He is also supple and takes suggestion intelligently."[9] In describing his thirty-four-year-old former helper, Augustus seemed almost to be defining his own formula for the ideal assistant.

Augustus offered Weinman $250, in keeping with his views that "the disposition of the design is nine-tenths of the battle," and Weinman, glad to accept a share in the prestigious task, promptly agreed.[10]

The result of the collaboration is whistle-clean. The obverse is a splendid profile of Roosevelt in the manner of the Renaissance masters, with his name above and title below. Two words to the right cause scarcely a ripple in the smooth surface of the medal:

AEQUUM·CUIQUE. Literally translated, it means "to each what is equitable." More colloquially, it turns out to be Roosevelt's campaign slogan, "A Square Deal for Every Man."

On the reverse there is a heroic eagle on a cliff, almost the twin of the one that Saint Gaudens had proposed for the World's Fair medal and the mint had rejected so summarily. Here was just retribution.

There was one little problem with the commercial mint, which General Wilson sidestepped very neatly. At the time when Augustus agreed to undertake the inaugural medal, the mint's version was already at the foundry. Wilson and his committee decreed that the Saint Gaudens design would be cast in gold for the President and the Vice President, and in silver for the higher officials of the Inaugural Committee; while the Barber medal, in more plebeian bronze, would be run off for lesser officials and volunteers. (The Philadelphia firm's version did have one virtue: it was delivered two days before the inauguration. Inevitably, considering the lateness of the commission, the Saint Gaudens medals were not available until July.)

As it worked out, the Inaugural Committee reversed itself on the silver medal, realizing that bronze lends itself much better to casting. General Wilson explained the decision to Augustus with his usual tact: "The committee decided that it would deem it a sufficient honor for each of its members to have one of your superb medals in bronze, and therefore would require no silver medals."[11]

Before the Saint Gaudens–Weinman medal was actually cast, Weinman took the final models to Washington for the President's approval. He set them up in a room in the White House. "Teddy Roosevelt came in about 80 miles an hour," Weinman recalled years later, "said 'Bully, bully' and dashed out."[12]

Writing to Saint Gaudens after a gold medal and several bronzes had been delivered to his Oyster Bay home, where he was on holiday, Roosevelt exulted: "I like the medals *immensely*; but that goes without saying; for the work is eminently characteristic of you." Then he added an impetuous scrawl to the typed

text: "Thank heaven we have at last some artistic work of permanent worth, done for the government."[13]

After much soul searching, Saint Gaudens finally agreed to take on the assignment of refurbishing the coinage of the realm. He had been under pressure from Rose Nichols and others not to accept commissions that he could only supervise. In this case, the President's vast enthusiasm and his own longtime concern were the deciding factors. The five-thousand-dollar fee figured only marginally. . . .

He turned his attention first to the ten-dollar gold piece, or Eagle. The standing bird on the reverse, as he fashioned it, was close kin to the heroic eagle on the inaugural medal. He tried no fewer than seventy variations. At one time there were twenty-five set up all in a row at Aspet for experts and friends to judge.

For the obverse Saint Gaudens settled on a woman's head in profile, deriving from an early treatment of the Angel of Victory in the *Sherman* group. "Only upon the President's emphatic suggestion" did he agree to add a feathered Indian headdress.[14] With some modifications by Charles Barber, this was the coin run off by the mint in late 1907.

The twenty-dollar gold piece, or Double Eagle, had a more troubled history. The problem came to focus on the obverse. In a letter to President Roosevelt on November 11, 1905, Augustus described the design he had in mind: ". . . some kind of a (possibly winged) figure of Liberty striding energetically forward as if on a mountain top, holding aloft on one arm a shield bearing the stars and stripes with the word 'Liberty' marked across the field, in the other perhaps a flaming torch; the drapery would be flowing in the breeze. My idea is to make it a living thing and typical of progress. . . ."[15]

Three days later T.R. answered with his own specific views on the Liberty figure: "Is it possible to make a Liberty with that Indian feather head-dress? . . . Would the feather head-dress be

351

any more out of keeping with the rest of Liberty than the canonical Phrygian cap which never is worn by any free people in the world?"[16]

Much as he wanted to accommodate his strenuous friend, Saint Gaudens found that the head-dress as well as the wings were too complicated for the small circular space. The Liberty is quite busy enough as it is—almost hyperactive. She bears the torch in her right hand and an olive branch in her left as she strides along, with a good deal of the élan of the Sherman Angel of Victory from whom she directly descends.

The reverse is the main justification for the belief held by many that the Double Eagle is the most beautiful of American coins.[17] It shows in profile a great bird flying across the rays of the sun, shown rising (or setting) below. The eagle is coming in on a wing, but without the prayer that had been appearing on American coins since 1864: the words IN GOD WE TRUST were omitted by the sculptor, who thought them "an artistic intrusion not required by law."[18] Recalling that there had been an outcry when the two-cent piece first bore the four-word phrase, neither the President nor the sculptor foresaw the outraged reaction from both Congress and the public when the words were dropped. What had once been considered sacrilegious had by custom become sacrosanct. (The real storm blew up after Saint Gaudens' death. T.R. continued to defend his view valiantly. But Congress quickly voted to restore IN GOD WE TRUST to the coins of America.)

Omitting the words was one of several means to keep the design of the Eagle and Double Eagle uncluttered. There were several other quite brilliant improvisations. On the milled edge of the ten-dollar piece Saint Gaudens placed the stars of the (then) forty-six states. On the milling of the twenty-dollar coin, he embossed the stars of the thirteen original states plus the words E PLURIBUS UNUM.

Neither of the coins reached the public while their creator was alive. One reason for the delays was the implacable, if somewhat understandable, hostility of Charles Barber. Many years later, his daughter Edith Barber Moseley commented on the

whole bitter episode: "The original attempt [to strike the Saint Gaudens Double Eagles] was an utter failure and the whole thing would have had to be abandoned if my Father had not stepped into the breach, and after long exhausting effort, made it possible to strike the gold coins; but the awkwardness of the whole design was impossible to keep, and the coins have never found favor."[19]

David Proskey, who was a power in the collecting world at the time and a man in close touch with the officials of the mint, held an even harsher opinion. On December 12, 1907, he wrote the mint: "It is most unfortunate that the capable engravers of this Mint should not have furnished designs for the new $10 and $20 pieces instead of allowing a person totally unversed in coin die sinking or design to have foisted such abominable productions upon us—nobody can really say aught in favor of these coins except that they contain the real value of metal, and that was beyond the control of the egotistical St. Gaudens."[20]

The mint came up with many plausible reasons for its tactics of delay: the set of dies for the Double Eagle could not be used in its automatic coining machines; the rims were too high for stacking; many modifications for both designs would be necessary before the two coins could be made ready to be struck. Mr. Barber turned to with a will but no great sense of urgency. . . .

The perseverance of the President and the power of his great office kept the project from foundering completely. On November 22, 1907, for example, he ordered the minting of the Double Eagle "even if it took them all day and night to issue one coin."[21]

Samples of these early runs are extremely rare today. One surviving twenty-dollar piece is currently valued at over a million dollars.

The first strike of the Double Eagle for general distribution was a run of 11,250. The relief is noticeably lower. Instead of the original two folds in Liberty's skirt, there are three. Thirteen rays fan out from the sun instead of the fourteen in the Saint Gaudens design. Ever since the issuance of gold coins was discontinued in 1933, this modified piece has been collected with increasing eagerness.

The whole complicated story has been told elsewhere and

353

often, with conflicting partisanships. Suffice it to say here that Henry Hering, who had done most of the modeling of the Saint Gaudens designs, took up the cudgel after the master was gone. In the state of siege warfare that existed with the beleaguered but resourceful mint, he won some of the skirmishes and lost others.

The campaign itself was won. For Theodore Roosevelt and Augustus Saint Gaudens did break the hardened crust of bureaucratic coin-making. Splendid achievements by established artists followed the two superb Eagles: James Earle Fraser's Buffalo Nickel, Victor D. Brenner's Lincoln Penny, Adolph Weinman's Dime, and the quarters by Hermon Atkins MacNeil and John Flanagan. They all added fresh laurels to the new standard that had been so resolutely brought into being.

38

INDIAN SUMMER
WITH THUNDERHEADS

A MAN LIKE Augustus Saint Gaudens does not go gentle into the night. He feared death, hated any mention of it, and fought it with all the strength he could muster. Along with his late-blooming love of sports, he came to be a strong believer in diet and nutrition and continually followed up new experimentation in the field.

One example of his interest was his spontaneous letter to a Dr. Edward Hooker Dewey: "I am a sculptor 55 years of age and nearly three years ago underwent a formidable surgical operation. I may perhaps be known to you as the author of the statue of Lincoln in Chicago, the monument to Colonel Shaw in Boston, and the Farragut in New York. I am very desirous of seeing you. . . . I am at present going through a period of depression, but nothing can repay you for the three or four weeks of better health since giving your treatment a partial trial."[1] The date was April 5, 1903.

Dewey's part in what became a lively correspondence was lost in the 1904 fire. They did meet, and Dewey recommended the writings of Horace Fletcher, whose theories on eating only when hungry and on chewing thoroughly had people "fletcherizing" all over the country. Saint Gaudens wrote back that he knew Fletcher personally and had read "his recent book, which,

of course, is profoundly interesting, and what you have both done
. . . gives a new look to life."[2]

Dewey was a believer in *no breakfast* and had written a book
by that name. Ten days after his introductory letter, Augustus
reported that he had given the Dewey theory quite a try: "This
is the eleventh day of the no breakfast whatsoever until 12:30 and
I do not seem to get used to it; I am so faint that I almost stagger
around the street."[3] He requested permission to take a glass of
milk on getting up. Six months later, he was asking for more of
Dr. Dewey's writings, reporting that "I still continue in good
spirits and health thanks to your books."[4]

When Dewey himself fell ill in 1904, Saint Gaudens wrote
a letter of sympathy to Mrs. Dewey in admiring terms: "I feel
the blow has fallen on a good man as well as a good friend. . . .
He is so strong and hopeful however that I am certain he will
improve rapidly, and I hope that in the future he will not give
so much of himself, and that he will spare his strength. . . ."[5]

Strength and hope were obviously what the sculptor admired
and himself possessed so largely. To his deep regret, Dewey died
later the same year. Now Saint Gaudens had to turn to others,
and he received a great deal of conflicting advice. One doctor in
Windsor prescribed a pint of ale a day. A Boston doctor said to
eat six meals, and make the noon meal the main one.

In the winter of 1904–05, Augustus underwent a good deal
of electrical and X-ray treatment, both in Windsor and New York.
Some good resulted, for on his birthday, March 1, 1905, he wrote
Homer: "I cannot believe I am 57. I feel as if I am 25 or 30 and
it's incredible that I am so far along in life. I'm feeling better and
celebrated my birthday by working all day for the first time in a
year."[6]

If he could no longer clamber up scaffolds, and had to direct
changes in his major works from sofas and other distant points,
Saint Gaudens was still able to use his haptic skills in many ways.
Small clay sketches, first drafts of bas-reliefs, and the caricatures
in clay that were one of his favorite forms of affectionate teasing
continued to come from his hand.

The best-known of all his caricatures is the parody of Henry Adams that he produced in 1904. Secretary of State John Hay was the prime mover in the lark. At his request and with his guidance, Augustus produced a small circular medallion that perfectly captures the outer gruffness and inner gentleness of their mutual friend. Attached to the bald head of Adams is a body consisting of porcupine quills topped by wings. The lettering on the perimeter identifies the subject as PORCUPINUS· ANGELICUS·HENRICUS·ADAMENSO. Since Adams was in Paris at the time, the Secretary arranged for the bronze medallion to be laden with official seals and delivered by diplomatic courier.

Adams was most amused. His response of September 4 caught the same spirit of high nonsense:

> Your winged and pennated child arrived yesterday by the grace of God and his vicar the Secretary of State. . . . As this is the only way in which the Secretary will ever fulfill his promise of making me Cardinal and Pope I can see why he thinks to satisfy me by giving me medallic rank through you. . . . The medal is probably worth more than the hat. . . . I'm sorry you can't give Hay wings too, he needs them more than I who live in holes.[7]

Early the following year, Saint Gaudens received from Adams a copy of his privately printed *Mont-Saint-Michel and Chartres.* Augustus' acknowledgment shows that his days of feeling inferior to the waspish historian were long past, and that his affection, and appreciation of high literary endeavor, were both considerable:

> *You dear old Porcupinus Poeticus:*
> *You old Poeticus under a Bushelibus:*
> I thought I liked you fairly well, but I like you more for the book you sent me the other day. Whether I like you more because you have revealed to me the wonder of the Twelfth Century in a way that never entered my head, or whether

357

it is because of the general guts and enthusiasm of the work, puzzles what courtesy calls my brain. . . . Last night I got as far in the work as the Virgin, Eve and the Bees, and I cannot wait to acknowledge it till I am through.

Thank you, dear Old Stick in the Mud.

YOUR BROTHER IN IDIOCY.[8]

Another pet project that undoubtedly bears Saint Gaudens' own craftsmanship is a rectangular bronze bas-relief in celebration of the 1905 Masque. In the center Augustus modeled the temple-altar that had served as the focal point of the pageant. The golden bowl is the finial. A plump cupid strums his lyre on the temple steps. Astonishingly, the names of the ninety or so participants are worked into the tight design at top and bottom. The Maxfield Parrish masks appear to left and right, and a stern view of the Roman chariot is embedded in the names below. A small silver-plated reduction of the plaque was given to each of the Masque's participants. Many of their descendants still display the miniatures as a local badge of honor.

By August 1905, Augustus had grown quite philosophical about his infirmity. "Here it has been an adorable summer," he wrote Alfred Garnier, "except this unfortunate condition which keeps me from standing for long and in consequence from working regularly. . . . The older I get the more I see things to take pleasure in, and the more youth seems good to contemplate."[9]

The contemplation of his young assistants golfing and swimming in summer and skating and tobogganing in winter gave him almost as much pleasure as actually participating. But from October 4 through November 25, 1905, he played 285 holes of golf himself, so he was obviously going through a period of remission.

It did not last long. In March 1906 he was back in the hospital in Boston for another operation. Gussie, who was with him a great deal by now, wrote Homer that they did not find a tumor, but swollen, diseased glands that would probably grow into one. She

added that she was not going to tell his father the exact truth, only "that they found no return of the tumor."[10]

A few days after the operation, Saint Gaudens started talking about writing his reminiscences. On March 22, while still in the hospital, he began dictating them to a stenographer. By the end of the month he was able to go home, and there, all spring and well into the summer, he continued to write the memoirs.

By the last days of April he was even able to golf again. James Earle Fraser, who was in New York launching his own fine career, was an occasional visitor now; Rose Nichols, eager and available, was his usual golfing companion. From this vantage point, and her position in the inner family circle, she developed strong and revealing views about her uncle Augustus' basic character:

> The nearer one approached my uncle, the better one knew him, the more one realized that intimacy with him was almost an impossibility. His shyness, self-consciousness, sensitiveness to other people's personalities—call it whatever you like—acted like a wall between him and even those who might be called his best friends. At times his brother Louis to whom he was deeply and tenderly devoted felt this invisible barrier. In spite of hosts of enthusiastic friends and acquaintances, in times of trouble and serious illness there was not one whom he cared to see, or one with whom he could be really at ease, outside of his immediate family. With strangers he always had on his company manners. Not that these manners were not simple and direct. He never put on any side or what we used to call his Louis XV manner except to be in keeping with some elaborate entertainment or in response to some gushing woman of fashion.[11]

It is hard to determine when Saint Gaudens stopped going to Darien to see Davida. All we know is that somewhere in his last year or two, as his health worsened and his various treatments took more and more time, the visits ceased. The hard evidence

here lies in Frank Spinney's interview with Frances Grimes on February 25, 1963.

Grimes recalled that the master came to her studio one day with a letter from Davida in his hand. He wept as he showed her the note. It was, said Grimes, "poorly written and illiterate." The gist of it was "how much she missed Saint Gaudens and hoped she could see him."[12] There is no indication what year or time of year the episode took place.

Correspondence between Spinney and Charles Patschek, whose grandmother Helen was Davida's long-time friend, brought out some additional clues. Helen Patschek lived in the Arlington Heights section of Kearny, New Jersey, but kept in close touch with Darien. Davida developed cancer and Helen devoted herself to caring for her. Charles remembered that Saint Gaudens sent his grandmother a gold necklace in gratitude.[13]

Spinney also discovered a deed of purchase of three small plots of land in Arlington Heights, with Davida Clark's name on it as grantee. The date of the deed is 1907, and the easy assumption is that Augustus paid for the plots.

In 1908 Davida, now the widow Clark, moved to Arlington Heights, settling in a pleasant white clapboard house on a bend of the Passaic River. The house was next to the Patscheks', and Charles told Spinney that he remembered Davida as a gentle and undemanding neighbor.

According to the extant death certificate, she died there on September 15, 1910. Cause of death is given as "post-operative paralysis of the intestine." The certificate is signed by a New Jersey doctor and attested by Louis P. Clark.[14]

So the curtain falls on the few known scenes of a life lived in the shadows.

In May 1906, at the time Saint Gaudens was working on his memoirs and making what seemed to be an excellent recovery, he received a letter from Stanford White. The architect reported

that he and McKim would like to come to Cornish to see their old friend. Augustus replied:

> Dear Stan:
> As to your visit here, I have been trying to get you up here for twenty years and no sign of you and Charles. Yet now when we are having the worst spring that ever occurred (the roads are in awful condition) you want to come up in five minutes. You hold off a little while and I will let you know, perhaps in a couple of weeks from now. But come to think of it, our friend Ethel Barrymore is coming up here. Perhaps that's the reason you old suckers want to come.[15]

The slight testiness here may be accounted for by a feeling on Saint Gaudens' part that the two boon companions suspected how sick he really was and were coming to say goodbye. White's answered showed that his old love and affection had moulted no feather:

> Beloved!!
> Why do you explode so at the idea of Charlie and myself coming up to Windsor? If you think our desire came from any wish to see a fine spring or fine roads, you are not only mistaken, but one of the most modest and unassuming men with so "beetly" a brow, and so large a nose "wot is." We are coming up to bow down before the sage and seer we admire and venerate so. Weather be damned; and roads, too. . . ![16]

As fate would have it Saint Gaudens and Stanford White never did meet again.

On the warm, soft night of June 25, the architect was at his regular table near the roof garden stage of Madison Square Garden. A new musical, *Mamzelle Champagne*, was opening. On stage were six pretty girls not unlike the Floradora Sextette that

White had admired so extravagantly. Comedian Harry Short was singing "I Could Love a Thousand Girls."

No one saw the man approach White's table. Despite the warmth of the night he wore a dark overcoat, incongruous with his straw hat. He pulled a revolver from his coat and fired three shots into White's face and arm at almost point-blank range.

Saint Gaudens, in town for electrical treatment, was staying at the Players Club that night. The next morning staff members hid the flaring headlines from him. Very gently, they broke the news that the insanely jealous Harry Thaw had murdered his friend. It knocked Augustus galley-west. For months he could not even bring himself to look at the preliminary sketches of a Whistler Monument for West Point which he and Stanford White had been designing together.

The pillorying of Stanford White began immediately. In preparation for their defense, Thaw and his lawyers attributed every act of seduction and sadism that Thaw himself had inflicted on Evelyn Nesbit to the playboy architect. Press and pulpit had a field day, and for a sum of $250,000 Evelyn Nesbit Thaw prepared to perpetuate the lies in her husband's defense.

Charles McKim orchestrated the counterattack. Few came forward, for it required some hardiness in view of the public mood. First and foremost was Richard Harding Davis, the war correspondent whose own clean-cut credentials were impeccable. In *Collier's Weekly* that August he described White: "He was a most kind-hearted, most considerate, gentle and manly man who could no more have done the things attributed to him than he could have roasted a baby on the spit. . . . He admired beautiful women as he admired every other beautiful thing that God has given us."[17]

Evelyn Nesbit's mother, Mrs. Charles Holman, announced that she would testify at the trial in Stanford White's behalf. She said that Harry Thaw had no reason ever to be jealous of the architect, who treated Evelyn as he would a daughter: "[Evelyn] was headstrong, self-willed and beautiful and that was where the trouble lay."[18]

Saint Gaudens took up the cudgels in a letter to the editors of *Collier's Weekly*:

Dear Sirs:

I thank you for the remarkable article by Richard Harding Davis about Stanford White in your issue of August 4. It is, to those who knew him, the living portrait of the man, his character and his life. As the weeks pass the horror of the miserable taking-away of this big friend looms up more and more. It is unbelievable that we shall never see him again. . . . In the thirty years that the friendship between him and me endured, his almost feminine tenderness to his friends in suffering and his generosity to those in trouble or want, stand out most prominently. That such a man should be taken away in such a manner in the full flush of his extraordinary power is pitiable beyond measure.

Sincerely yours,

AUGUSTUS SAINT GAUDENS[19]

More privately, Augustus expressed his horror to Alfred Garnier, calling Thaw "an idiot that shoots a man of great genius for a woman with the face of an angel and the heart of a snake."[20]

Up in Boston, Truman Bartlett linked Saint Gaudens to Stanford White in the usual intemperate terms. Addressing himself to the subject of Augustus' friends, he wrote: "His most intimate one was the assassinated designer who left so low a name as a man that the vilest yellow street [journal] refuses to publish the details."[21]

But neither the praise of the faithful and the hardy nor the venom of the envious could bring back Stanford White. After two sensational trials, the verdict on Harry Thaw was temporary insanity, the sentence confinement to an asylum. Across the nation people began to realize that a great and glorious man had been wantonly gunned down. And the sense of loss grew apace.

Saint Gaudens' own grief contributed to another relapse.

39

THE BECKONING HILLS

"It's very beautiful but I want to go farther away."

—Augustus Saint Gaudens, late July 1907[1]

SAINT GAUDENS held up quite well through the early summer of 1906, but in August he broke down completely. "The work of his studio was interrupted," Kenyon Cox reported, "and he ceased even to see his most intimate friends."[2]

After his operation that spring, Augustus had come to depend on a Madison Avenue specialist, Dr. Margaret Abigail Cleaves. Her particular field was the postoperative treatment of scar tissue and inflammations "by means of galvanic and faradic currents"— the latter being the electric currents investigated by Michael Faraday.[3] Dr. Cleaves was also one of the early users of trypsin, an enzyme present in pancreatic juices, for curing malignancy. After an exchange of letters in May, she urged the sculptor to come to New York as often as possible for treatment, and he did so.

Following Saint Gaudens' collapse, she spent long periods each week at Aspet, and seems to have exercised an almost hypnotic influence on her patient. Working closely with Dr. John Brewster of Windsor, she was able to bring about a good recovery. Since there was no electricity at Aspet, Saint Gaudens went often to Dr. Brewster's office for therapy. At Aspet, Dr. Cleaves min-

istered particularly to Augustus' problems of diet and morale.

She attributed the breakdown "largely to the fact that he had used his brain too extensively at a time when he was physically not up to it."[4]

By mid-October, Dr. Cleaves was able to cut down on her trips from New York, and on November 22 she wrote Augustus a letter commending his good progress:

> Dr. Brewster's daily reports fill my heart with gladness despite the fact that you do not tip the scales at 160 pounds. Time and continued good eating is to mend that. . . . So long as I can tell you that the last laboratory report says that there is "absolutely nothing to be found suggesting abnormality of structure" you do not need to worry or be depressed.
>
> This could not be said four months ago. Keep up your courage. Do not over do. But *do*.[5]

It was Indian summer; the leaves had flamed and fallen but the sky was cloudless for days at a time and there was a faint haze low on the horizon. Augustus liked to sit on the terrace at Aspet, with its view of Ascutney and the valley, and feel his strength returning.

His remission was short: by January he was desperately ill again. As Homer reported in the memoirs, "During the winter of 1906–07 we feared he could not live."[6]

Family and doctors went to great lengths to keep his true condition from him. Dr. Cleaves' diagnosis of tuberculosis of the lower intestine was simply to delude him. The fact was that he had cancer of the rectum, inoperable and spreading. Homer wrote Dr. Cleaves to make sure no clinical reports about the famous sculptor appeared in the medical journals. To the public, as well as to the sick man himself, the family maintained the illusion that Saint Gaudens would recover.

Typical of this stance was a letter of Homer's to Edwina Booth Grossman, the daughter of Edwin Booth. Some time before, Augustus had undertaken to do a statue of the actor for Gramercy

Park. On January 12, 1907, Homer wrote Mrs. Grossman in fairly sanguine terms: "Your offer of photographs of Mr. Booth for use by my father is most kind and when the time comes to begin on the monument will be very welcome. . . . My father has been slowly recovering his strength so that I hope, as you say, that before long he will be able to work upon Mr. Booth's statue which I know he has dearly at heart."[7]

That January, Witter Bynner started coming to Aspet often. Barry Faulkner had been awarded a fellowship at the American Academy and was about to embark. So for the next six months it was Bynner who supplied the companionship and took some of the strain off Gussie, Homer, and Carlota Saint Gaudens and Rose Nichols. Because of his gifts as a poet and his compassion, Bynner's reports to various friends are a most tender documentation of the last days.

He wrote Hersilia Mitchell-Keays, his own madonna and close confidante, on his first visit to Aspet after quite an interval:

> I'm afraid he saw my stricken heart, in my face, when I shook that long thin hand—The little bones were as limp as spaghetti! The body was tensely resting wherever it touched the sofa, lest it rub through. . . . They have stopped giving him the morphine he has long been relying on. They are fooling him with empty capsules. . . .
>
> His wife, in her way is kind—but her attention consists of snappings and snarlings . . . not so much against him as against man, woman, child, and God. . . . I believe all his ambitions and intentions are strong enough to raise the dead. All I could think of was Lazarus. But in the eyes comes now and again, above the starved-looking nose, an inward vision of *life*,—of self-creation.[8]

Later in the same month he wrote Mrs. Mitchell-Keays again:

> The Saint . . . was carried out to criticize and direct the work of his assistants on the Phillips Brooks. . . . The other work

going on under these pathetic little visits, during which eight or ten sentences exhaust him—are a new Lincoln (seated) for Chicago . . . a Mark Hanna (nice and ugly) and a group of glorious Caryatides (for the Albright Gallery). The quality which singles itself out for me more and more as the gift above and beyond what other men can do, is not the composition, the modeling, or the technique in any palpable respect,—but an indefinable expressiveness on his more imaginative faces—a forward look of peaceful waiting. The figure for the Adams tomb in Washington, the Shaw face, peaceful in its very advance to war, the Caryatides, and now this strangely fine Christ, in the Phillips Brooks monument, all have it. And as I looked diagonally across the room from my own work and saw his own face rising out of its weakness and wretched apprehensiveness to the contemplation of his work, I saw that same look, that strong, vivid, peaceful, forward look. . . .

He has been having setbacks. He thinks they are drugging him. When I tell him that they've told me how few drugs are now being used as compared to a while ago, he suspects it was told me to reach him. He thinks, too, that he is mortally sick and not being told. He is so actively anxious to live and work that you feel as though he were newly stricken with his whole sickness many times a day. His family proceeds on the assumption that he will recover. I have a throb now and then that he won't. His pain is so evident and so constant![9]

"In the spring he was much better," Homer recorded in the memoirs. "He would sit sketching directions for his assistants on a pad. . . ."[10] A small sedan chair was improvised, in which he was pushed to his studio. But even sitting in the chair was painful. So Bill, the lanky Slovak studio-cleaner, would often carry him there in his arms. Bill told Malvina Hoffman, who employed him later, that the master "never gave up and never whimpered." Bill also remembered that Saint Gaudens was not one to overpraise

his staff: "He wasn't given to passin' out compliments, but if you did a job extra well, he'd smile and say, 'that's better than good.' "[11]

The works-in-progress given priority now were the endless revisions to the *Phillips Brooks* and the eight *Caryatides* for Buffalo. On good days he was able to work a little on his bas-relief of Gussie. But "by July he was back in his room once more, never to leave it," Homer recorded sadly in the *Reminiscences*.[12]

Witter Bynner came often to Aspet until late July. He left then only because he believed that the family, despite their protests, wanted to have the Saint to themselves as the end neared. Bynner's long-unpublished report of July 27 to Barry Faulkner was based on his comings and goings during the late winter, spring, and early summer of 1907. These were the highlights:

I grew used to his gaunt face . . . his look of being hunted by death and knowing it but turning at bay with sheer will. . . . When they would carry him out to the studios and place him in front of his work, the dejection, the grim unhappy will . . . would vanish in an illumination of beauty and the creation of beauty; his eyes would burn again in the moment's victory.

The evening before I left in February, he came down to supper and with an effort which touched me deeply talked of things from which he was growing so much farther away all the time and controlled his illness even to the point of making some of his old-style witticisms and sarcasms, with that kind smile. I felt then, and have felt since when Homer has written me that the Saint kept asking for my return, a curious sad happiness in the fact that I was one of only two or three outsiders whom he could bear to see. . . . Thanks to the sensitive, responsive genius of Miss Grimes, of whom he often spoke to me as the most imaginative and beauty-gifted of his assistants, the Caryatides are done as he con-

ceived them—great noble creatures, bearing a sense of the calm of the Arts in their superiority to life.[13]

The narrative picked up again, after an absence, probably in July:

I found him with a look on his face that told me at once of his being near death. For the first week that I was here, I had supper with him every night. Strange meals they were,— Mrs. St-G. (whose devotion has been very true and beautiful, and made up at the last, I think, for the irritation she must have brought him before she was chastened and sweetened by the final test . . .) and Homer, and the nurse and I. He wanted us to talk and let him listen; now and then he would ask that we talk louder so that Mrs. might hear, though it was harder than usual with her, for, poor lady, she said almost nothing,—sitting there with the love of her youth.

The last talk I had with him was while we watched a great stormy surge of clouds over Ascutney give way at their base to a low level opening of orange light,—chaos pacified. He was saying that if he were able, he would move again, away from the city-people invading Cornish and find another remote country place. After my exclamations on the sunset, that was his quiet comment.

One thinks back to Saint Gaudens' love of the hill beyond the hill. Alfred Garnier recalled this in a letter to Louis: "Our trip to Switzerland years before was like a merry dance. . . . We saw valleys and mountains one after another, and constantly said to ourselves, 'What is still behind them? I wonder what is above and what is below?' . . . We were intoxicated with the air and with the sky. It was a marvelous life which we imagined would last forever. . . ."[14]

Now there was only one hill left to climb.

Toward the end of July, Augustus Saint Gaudens slipped into a coma. He died at 6:50 P.M. on August 3. Frances Grimes wrote

Barry Faulkner what had to be written as simply as possible: "It is over. . . . I am so glad the dear Saint is dead. It is too horrible to live and suffer so."[15]

Charles McKim, his closest surviving friend, was in Edinburgh when the news came. Stricken, he went to the Church of Saint Giles and stood for a long time before the Stevenson bas-relief:

> The pilgrimage there was the nearest I could come to him, but it was a comfort to me to be able to visit the church and to see his great work constantly surrounded by the public, who did not even know the name of the sculptor.
>
> The gulf between him and the next best man in his art will long remain unfilled.[16]

On his father's desk in the little studio, Homer found, among the very few things there, some verses that Witter Bynner had written for his sick friend, and a copy of Bynner's poem to "Diana, Captive," which Saint Gaudens admired. The first four lines set the tone:

> Captive, she hunts on her tower,
> Caught in her turning flight
> From the covert of her bower
> To the covert of the night. . . .

For some hours Homer was in a state of near collapse. He pulled himself together, as the head of the family now, to do the necessary. Accompanied by Marie Saint Gaudens, the sculptor's niece and the daughter of Andrew, he took his father's body to Boston for cremation. The next day the ashes were brought back to Cornish. The service took place that afternoon in the big studio.

The Reverend Oliver B. Emerson, husband of Gussie's sister Genie, opened it with the Stevenson prayer from the Saint Giles monument, "Give us grace and strength to forbear and to persevere. . . ." He also directed the others taking part. Arthur

Whiting played the organ. Kenyon Cox, according to Mrs. Parrish's diary, "never showed himself a bigger man than in the beautiful simple talk he gave."[17] The gist was that Saint Gaudens "professed no creed, but he believed in the universal God and was a God-inspired man."[18]

Percy MacKaye added a poetic note with two verses from Keats' *Adonaïs* and then closed the service with readings that Mrs. Parrish, for one, thought "egotistical and too long."

For a while the ashes rested in a brick vault in Windsor's Ascutney Cemetery. At Gussie's wish, the altar and the two Ionic columns that had figured in the Masque were redone in Vermont marble as the family sepulcher. The ashes were placed beneath it, and there the urn holding all that is mortal of Augustus Saint Gaudens rests to this day.

His spirit is also there, under the wind in the tall pines and across from the fair mountain.

AFTERWORD

GAETAN ARDISSON did a haunting death mask of Saint Gaudens. It is owned by the Historic Site but is not on display. The face is so emaciated that it is shrunk into the mold of bone. Although there is nothing morbid about it, but indeed something saintly and not of this earth, the shock is very great.

It is better to evoke the sculptor by the fine John Flanagan bust, or by the retrospective description that Kenyon Cox gave in a speech in 1908:

> In his spare but strong-knit figure, his firm but supple hands, his manner of carrying himself, his every gesture, one felt the abounding vitality, the almost furious energy of the man. That extraordinary head with its heavy brow beetling above the small but piercing eyes, its red beard and crisply waving hair, its projecting jaw and the great, strongly molded nose, was alive with power—with power of intellect no less than will.[1]

There is another kind of evocation in Richard Watson Gilder's "Requiem," which is very much of its day in its slightly turgid rhetoric, but ends on a high, clear note:

> O star of war! beyond thy troublous beams
> His freed soul wings to a great calm at last;

The deep night, with its tremulous, starry streams
Of light celestial, pours repose so vast
Nought can escape that flood; and now the faces,
Angelical, he moulded with pure art,
In majesty look forth from heavenly spaces:
Enter thy peace, O high, tempestuous heart![2]

Gussie was stricken by her husband's death. In her replies to the letters of condolence which came pouring in she speaks of her terrible sense of being alone and the difficulty of carrying on. But hers was a sturdy New England spirit.

Frances Grimes, who saw her shrewdly and not without a guarded admiration, wrote Barry Faulkner of the changes widowhood had wrought: "You would be interested in what a personage Mrs. SG has become—a huge sombre figure—she looms up in front of the artistic world . . . black and potent . . . she is like some fate Mr. SG himself might have set in motion striding along carrying his laurels—it is terrific."[3]

According to Grimes, Louis St. Gaudens felt that all work in progress should have been cut off with the sculptor's going. Grimes herself was of two minds. She finished the Albright *Caryatides* to everyone's satisfaction, but finally pulled out herself when the conflict over the *Phillips Brooks* seemed never to end.[4] She did, however, keep her own studio at Cornish in the summers.

The cultivation of her husband's fame and the distribution of his works became Gussie's main preoccupation. With Homer's help the distribution was done with shrewd business sense as well as discrimination. The market was never flooded, but major U.S. museums and galleries came to possess editions of some of the best statues in the Saint Gaudens oeuvre.

In late 1908 Gussie wrote a letter to Henry Adams which showed how she was operating. In it she asked for the copyright to the *Adams Monument*. Adams was somewhat surprised, but, gentleman that he was, responded promptly, assigning to her "all my rights, title and interest in, and to, the copyright to the bronze seated figure . . . now on my plot in Rock Creek Cemetery."[5]

Fortunately Gussie's good taste came to the rescue. The master-piece never was copied for commercial purposes.

She was indeed becoming a formidable personage. The late Mrs. Lawrence Grant White, daughter-in-law of Stanford White, recalled Gussie's awesome black-swathed descents on St. James, Long Island, complete with car and chauffeur. Mrs. White compared her to the widows of Marshals of France known as "Les Glorieuses."[6]

World War I brought a grim end to the romantic interlude in the United States. Saint Gaudens was at the heart of the creation of an American mythology to match the chivalric mood. More than any other artist, more than Eakins or Winslow Homer, more than Whistler or Sargent, he had touched the nerve of the nation with his celebration of the heroes of the Civil War. As Theodore Roosevelt recognized, Augustus Saint Gaudens, despite the elaborate name, was of the people and his art was for the people. There is no elitism in his approach; the gap to democracy is easily bridged. In his speech at the Saint Gaudens Retrospective at the Corcoran Gallery in Washington (December 15, 1908), the President linked the Saint Gaudens achievement and democratic pride in this fashion:

> Augustus Saint-Gaudens was a very great sculptor. This makes all the world his debtor, but in a peculiar sense it makes his countrymen his debtors. In any nation those citizens who possess the pride in their nationality, without which they cannot claim to be good citizens, must feel a particular satisfaction in the deeds of every man who adds to the sum of worthy national achievement. The great nations of antiquity, of the middle ages, and of modern times, were and are great in each several case, not only because of the collective achievements of each people as a whole, but because of the sum of the achievements of the men of special eminence; and this whether they excelled in war craft or statecraft, as

roadmakers or cathedral builders, as men of letters, men of art, or men of science.[7]

It was not Augusta Saint Gaudens' fault that the sculptor's fame began to ebb. The age of a romantic, euphoric America in which he figured was fast drawing to a close. The departure of President Roosevelt from stage-center in 1909 contributed; World War I brought the curtain crashing down.

The group of talented men who played key roles in American artistic achievement was fast disappearing. Neither Richard Watson Gilder nor Charles Follen McKim survived Saint Gaudens for long, both dying in 1909. John La Farge followed the next year. Henry James died in 1916, and Henry Adams in 1918.

With special reference to sculpture, the aftermath of the first war saw no full return of the romantic and robust. There was indeed a romantic strain in the elegant suavities of Paul Manship, in Noguchi's quest for basic sculptural reality. The vast stylishness of Elie Nadelman and the down-to-earth vigor of William Zorach also held elements of romanticism.

But Americans studying abroad in the 1920s and 1930s brought back trends that were further out. Framing disparate objects and the use of welded bronze were in, and surrealism and art deco the rage.

During World War II and the years of Korea and Vietnam, romanticism of the turn-of-the-century kind still lay dormant. In the 1960s and early 1970s patriotism and other simple democratic values were denigrated; romanticism receded even further.

Now, somewhat astonishingly considering the hemorrhage of Vietnam, America has taken another turn. The American Dream is back in place. Pride in the past and in the present and hope for the future are acceptable again, along with the belief that nothing is out of reach for those who greatly try. Whatever one's politics or predilections, there is something of the folk hero in a Reagan or Iacocca, and of the heroine in a Ferraro.

In the art world the configurations of the human body are respectable again. Luminism recently shed a new clear light on

the American past. The years from 1876 to 1917, known as the American Renaissance, shine anew. So the return to favor of Saint Gaudens is not totally surprising, particularly to those who have known that the works, even if out to pasture, were never out of beauty.

As the revival grows apace, the question of who influenced Saint Gaudens, and what he himself passed on to others, is more and more the subject of scholarly study and debate.

In the matter of influences, the main lines of investigation are already well defined. Saint Gaudens himself repeatedly acknowledged his debt to Pisanello, Donatello, and other Renaissance masters. He kept a plaster cast of Donatello's *Saint George* in his studio, and a copy of Pisanello's *John Paleologus* medallion was always near to hand. We know, from the introduction he wrote to his friend Fanny Field Hering's *Life and Works of Jean Léon Gérôme*, what pleasure it gave Augustus to salute that celebrated storyteller-in-oil:

> Since an early winter of our Civil War, when, as a boy I stopped evening after evening at Goupil's window on Broadway and admired Gérôme's *Death of Caesar* my admiration for him has never wavered. . . . There is in his art apart from its elevation and virility of style, that which ranks him in my mind with the Greek artists.[8]

When Saint Gaudens filled out the *Who's Who*–like form for the Merriam Dictionary in 1887 he answered a question concerning major influences by listing French sculptors in rough order of preference: Frémiet, Falguière, Rodin, Rude, Carpeaux, Dubois, Mercié. Then he took his pen, circled Paul Dubois and moved him up from six to one.[9]

He kept a photograph of Dubois' *Joan of Arc* in the house in Aspet. He also very much admired what Henry James called the "high seriousness" and the "beautiful cadence" of the Frenchman's *Tomb of Lamoricière* at Nantes.[10] "Meditation," one of the

377

corner bronzes of the sepulcher, is very much in the pose of the hooded figure in the *Adams Monument*.

Move the question of influences and derivations to a social gathering of the art world. In the room the critics, curators, collectors come and go, airing views, comparing likes, talking trends:

Critic: "It seems to me that the tumult of rifles in the Saint Gaudens *Shaw* derives very clearly from the lances in the Velázquez *Surrender of Breda*. They have more power, more thrust, but the provenance is there."

Collector: "There is a rather nasty little angel in Rubens' *Coronation of Marie de' Medici* that bears more directly on the *Shaw*. You may remember that the *Coronation* was one of the murals in the Luxembourg before the series was moved to the Louvre. At the time Saint Gaudens lived just up the way in the Rue Herschel, and the Luxembourg is where he got the idea for his own beautiful hovering angel. . . ."

Curator: "She sprinkles poppies, the Rubens scatters gold coins, but the pose is very like. It's an interesting point."

Critic: "I wonder if the Claus Sluter "Pleurant" in the Dijon *Puits de Moïse* is all of four hundred years apart from the lady in Rock Creek Cemetery?"

Curator: "For just plain mood Bartholomé's *Aux Morts* in Père Lachaise seems to me more the direct ancestor."

Collector: "Does either of you see something of Delacroix's Lady of the Barricades in our man's *Angel of Victory*, leading Sherman on and up?"

Critic: "Ah, yes, but my sense would be that the Marseillaise on the Arc de Triomphe is mirrored there more."

Lewis Sharp has summed up this question of who-did-what-to-whom with special reference to the sculptural ferment in Paris of the late 1870s and 1880s: "It was all around. Everyone copied everyone else. The past was an open book. . . . It would have taken quite an insensitive man *not* to be influenced."[11]

George Moore wrapped it all up in a single sentence: "Monet

in the beginning imitated Manet and in the end Manet imitated Monet."[12]

Augustus Saint Gaudens' place is in the continuum of beauty. Unlike Rodin, who changed the face and form of sculpture so that it was not the same again, he worked in known ways. His claim to fame, like Scott Fitzgerald's in the contiguous craft of word-making, is more as master stylist than trailbreaker—with a style so individual it is hard to match. You can read him too like braille.

Buried in one of the lesser-known Fitzgerald short stories in a definition of America that encompasses the Saint Gaudens mystique as well:

> France was a land, England was a people, but America, having about it still that quality of an idea, was harder to utter—it was the graves at Shiloh and the tired, drawn, nervous faces of its great men . . . it was a willingness of the heart.[13]

Augustus Saint Gaudens helped give utterance to the American dream. The Civil War memorials are counterpoint to the graves at Shiloh. There is, in his men of war and state, that transcendent weariness. It is present too in the face of the secret woman in Rock Creek Cemetery who has seen all and suffered all.

And, like the great Republic he loved so well and served so well, Saint Gaudens possessed the willingness of the heart.

ACKNOWLEDGMENTS
AND THANKS

David Finn took the photographs and they speak for themselves. But his willingness to go the second mile, and his friendship, have meant a lot. Terri Capone of his staff kept us both tracking. It was Jillian Poole's idea that he might help.

Elizabeth Ajemian has, for four years, served as my principal research assistant. She has traveled widely, conducted many interviews, and supplied valued editorial advice as well.

Michael Richman acted as sculptural adviser, historical and technical. Since his own field is the overlapping world of Daniel Chester French, his knowledge was a great contribution.

John Dryfhout, Curator and Superintendent of the Saint-Gaudens National Historic Site at Cornish, has been a main supporter of the project from the start. His catalogue raisonné, *The Work of Augustus Saint-Gaudens*, has been prime source material.

Frank O. Spinney, Curator of the Saint Gaudens Memorial at Cornish (1962–67) before it became an Historic Site, made his wide-reaching research available to me, courtesy of the Trustees, and shared his experience at Aspet.

Valerie Wingfield of the Manuscript Division of the New York Public Library was my special link to the rich source materials there.

Margaret Bouton's doctoral dissertation, *The Early Works of Augustus Saint Gaudens*, was a springboard. Her unpublished notes on the full career proved most useful.

My Harvard classmate and friend Hugh Mason Wade sug-

gested the biography in the first place and made available Cornish lore and his own scholarship.

Mrs. D'Arcy Edmondson was hospitable from the start and told a lot about her own Cornish background. The late Maxfield Parrish, Jr., supplied excerpts from his mother's diary and observations about Cornish.

Sculptor Walker Hancock taught me about his profession and screened technical matter. Anne Truitt helped in the same way.

John Wilmerding, Deputy Director of the National Gallery, shared his knowledge of nineteenth-century American art in general and his views on Saint Gaudens in particular.

William Butts Macomber, President of the Metropolitan Museum of Art, provided support when most needed, and enthusiasm throughout. Lewis Sharp, Curator of Nineteenth Century Art and Sculpture at the Met, was generous of his time and insights.

In San Diego June Clark Moore and her daughter Valerie Saint Gaudens enlightened me with family memories and memorabilia of Davida Clark.

In Cornish, Margaret Platt and her late husband William Platt dipped into memories of the area. Charles Platt, Chairman of the Trustees of the Historic Site, supported the project from early on.

Neil MacNeil opened the world of medals, medallions, and coins, and vetted relevant copy.

Mrs. Archibald Cox remembered the sculptor first-hand from her girlhood and described him to me. The late Mrs. Lawrence Grant White of St. James, Long Island, and the late Alleyn Cox, muralist of the U.S. Capitol, supplied glimpses of the Saint Gaudens family during the sculptor's lifetime. Mrs. Eric Gugler showed me facets of Snedens Landing then and now.

James Kraft and Patricia MacDonald introduced me to the letters of Witter Bynner, published and unpublished.

Alicia Boyd did Pyrenean spade work. Françoise Sarradet, of Paris and Aspet (France), was my link to matters pertaining to the Saint Gaudens family in France.

At the Baker Library of Dartmouth College where so much Saint Gaudens material has been gathered, Walter Wright, Kenneth Kramer, and Phillip Cronenwitt were most cooperative.

Sculptress Katharine Weems recalled James Earle Fraser and others. Leslie Ahlander interviewed the family of Homer Saint-Gaudens' late son Augustus in Florida.

All the staff at the Massachusetts Historical Society were helpful, especially in matters concerning the chapter on the *Shaw*. Malcolm Freiburg, Editor of Publications, was particularly so.

My sister Patricia Wilkinson Howard brought her professional skills as a handwriting expert to bear, and was of assistance in many other ways.

Penny Bryant and Trudy Mussen typed the manuscript and supplied editorial comment as well. Debbie Groberg transcribed difficult tapes with skill.

Jack Stewart was exemplary literary agent and middleman.

Special thanks go to: Alice Acheson, John W. Auchincloss, Mary Ficklen Barnett, Sister Bernadette of Rosary Hill, Thomas B. Brumbaugh, Carolyn Campbell, Antonio Ciccone, Elvira Clain-Stefanelli, Professor Robert Judson Clark, Armida Colt, Gardner Cox, Lois Dinnerstein, James Farley, Mrs. John Ferguson, Adrienne Fischier, Sally Forbes, Rosamond Gilder, Annette Griswold, Karen Grzegorowicz, George Gurney, Mrs. Alexander Hawes, Stella Henry, Marilyn Hofner, Patti Houghton, Mrs. Lawrence Houston, Richard Howland, Sarah Ingelfinger, Mrs. Wayne Jackson, Campbell James, C. Olive James, Andrew S. Keck, Hon. Randolph Kidder, Mrs. Egbert Leigh, Constance Mellen, Herbert Christian Merillat, Mrs. Gordon Morrill, Charles Mount, Hon. and Mrs. Garrison Norton, Sarah M. Olson, W. H. Pear, Louis Rachow, Perry Rathbone, the late Stellita Renchard, Mrs. Hamilton Robinson, William Francis Russell, Mrs. Ned Russell, Michael St. Germain, Ruth Sawyer, the late John Sherman, Alice Shurcliff, Dr. William Shurcliff, Mrs. John Farr Simmons, Stanley Smith, Penelope Taylor, Arline Tehan, Sturgis Warner, John B. White, Peter White, Robert and Claire White, Charles and M. Twinkelle Wilkinson, Josephine Colgate Wilkinson,

Russell and Eileen Wilkinson, Phillip and Eileen Wilkinson Wirta.

In France: Marie Thérèse Caubère, Roger Delpy, the late José Dhers, Pierre Doueil, Mme. Jacques Georgelin, Dr. Bertrand Pradère, and M. Regagnon.

NOTES

PREFACE

1. *The Reminiscences of Augustus Saint Gaudens*, edited and amplified by Homer Saint-Gaudens (The Century Company, 1913), 2 vols., hereafter cited as *RemASG*, with volume and page numbers.
2. *RemASG* I:6.
3. Augustus Saint Gaudens to Homer Saint-Gaudens, n.d., in the Saint Gaudens Collections, Baker Library, Dartmouth College Library—hereafter cited as SG Coll., Baker-DCL.
4. *Yale Review*, April 1914.
5. *Times Literary Supplement* (London), November 27, 1913.
6. Elizabeth Stevenson, *Henry Adams* (Macmillan Company, 1955), pp. 68–69.
7. *Century Magazine*, February 1908.
8. *New York Times*, December 7, 1969.
9. John Dryfhout, *The Work of Augustus Saint-Gaudens*, foreword by John Wilmerding (University Press of New England, 1982), p. ix.
10. SG Coll., Baker-DCL. The note was found on his desk after his death.

1

PYRENEAN PATRIMONY

1. Quoted in *RemASG* I:9. Augustus's father bore the full name of Bernard Paul Ernest Saint Gaudens but liked to change "Ernest" to "Honeste" because he thought "it sounded nicer."
2. Letter from ASG to his friend and fellow artist Will Low from Paris, September 2, 1898, quoted in Low's *A Chronicle of Friendships* (Charles Scribner's Sons, 1908), pp. 482–83.
3. The birth is recorded in the Departmental Archives in Toulouse, dated June 26, 1816.
4. *RemASG* I:6.
5. The quotation is from an inscription on a plaque in the city of Saint-Gaudens, Haute-Garonne, honoring Napoleonic soldiers of the region.
6. *RemASG* I:16.
7. *Procès verbaux des séances et déliberations des états de Languedoc*, March 19–June 19, 1620.
8. José Dhers, *Petite Histoire de Saint-Gaudens* [the city] (Dhers frères, 1974), p. 10.
9. *RemASG* I:138.

2

THE THRUST OF A CITY

1. *RemASG* I:11. All the quotations until note 2 are from chapter 1, "Recollections of Childhood" (1848–57), in the *Reminiscences*.
2. Henry James, *The American Scene*, quoted in F. O. Mathiessen, *The James Family* (Alfred A. Knopf, 1947), p. 657.
3. *RemASG* I:13.

3

THE GLYPTIC ART

1. The quotation is from a letter on display in Barbara Hepworth's studio in St. Ives, Cornwall, England.
2. *RemASG* I:38. All the quotations in these paragraphs on ASG's apprenticeship with Avet and its abrupt end are from the *Reminiscences*.
3. Some years later, the Cooper Institute changed its name to the Cooper Union.
4. The montage of memories is drawn from *RemASG* I:42–43.
5. Gérôme erred on the location of the Senate session on the day of Caesar's death. According to Plutarch it was convened in Pompey's Theater in the Campus Martius. (Shakespeare and Gibbon make the same error.) In the case of Gérôme his motives were purely pictorial.
6. Letter quoted in *RemASG* I:42–43.
7. Margaret Bouton, "The Early Works of Augustus Saint-Gaudens," unpublished doctoral dissertation, Radcliffe College, 1946, p. 76.
8. Maitland Armstrong, *Day Before Yesterday* (Charles Scribner's Sons, 1920), p. 260.
9. *RemASG* I:55.
10. Brenda Putnam, *The Sculptor's Way* (Watson Guptill Publications, 1948 ed.), p. 49.
11. *RemASG* I:52.

4

CITY OF LEARNING, CITY OF LIGHT

1. His *numéro d'enregistrement* was 3712 in the *Registre Matricule des Élèves de la Section Peinture et Sculpture* of the École des Beaux-Arts. The microfilm was found in the French National Archives in 1983, confirming for the first time that Saint Gaudens was formally enrolled.
2. *RemASG* I:74.
3. Ibid., pp. 76–77.
4. Figures given are approximate. They and other material on the Beaux-Arts

here and following are taken from "The American Student at the Beaux-Arts," an unsigned article in *Century Magazine* XXIII, n.s. 1 (November 1881–April 1882).

5. *RemASG* I:78.

6. An entry in ASG's niece Rose Nichols Diary (Nichols-Shurtleff Papers, Schlesinger Library, Radcliffe College), which she kept some thirty-two years later, notes that her uncle remembered taking a Third Prize at the Jouffroy atelier "for one of his studies," but there is no confirmation elsewhere, and it is obvious that ASG was not impressed by this marginal success.

7. *RemASG* I:77.

8. Alfred Garnier is best known for his enamels on copper. He did his own firing and achieved superb coloring. The letter quoted in the text was written in November 1907, three months after Augustus' death (*RemASG* I:87).

9. *RemASG* I:79.

10. Letter from Alfred Garnier to Louis St. Gaudens, November 1907, quoted in *RemASG* I:89.

11. Truman Bartlett, "Autobiography," Manuscript Division, Library of Congress, chapter on ASG ("Saint-Guadens As I Knew Him"), pp. 1–3.

12. *RemASG* I:64.

5

THE TEARING OF THE FABRIC

1. Charles Downer Hazen, *Europe Since 1815* (Henry Holt and Company, 1931), p. 184.

2. During the Second Empire the Beaux-Arts became the "École Impériale des Beaux-Arts"—temporarily, as it turned out.

3. John Russell, *The Meaning of Modern Art* (Harper & Row, 1981), p. 75.

4. Maurice Rheims, *19th Century Sculpture* (Harry N. Abrams, 1972), p. 43.

5. Luc Benoist, *Les Sculpteurs célèbres*, ed. Louis Mazenoid (Paris: Éditions d'Art, 1954), p. 277. In another vivid passage, Benoist writes of *La Danse:* "*Ce fut le dernier sourire d'une époque heureuse, un chef-d'oeuvre et un testament*" ("It was the last smile of a happy epoch, a masterpiece and a testament").

6

WHEN THE WIND IS SOUTHERLY

1. Letter of September 17, 1870, SG Coll., Baker-DCL. This letter was in the Whittlesey family until 1971, when Mrs. Healy, a descendant, sent it to the ASG National Historic Site at Cornish.

2. Ibid.

3. Ibid.

4. Quoted in *RemASG* I:94, 97.

5. Charles Laver, *James McNeill Whistler* (Cosmopolitan Book Corporation, 1930), p. 128.
6. Rodin actually left at the time of the Commune, mainly because he could find no work as a sculptor during those ferocious days.
7. Letter to Mrs. Whittlesey, September 17, 1870.

--------- 7 ---------

A MANTLING OF MARBLE (I)

1. *RemASG* I:104.
2. Margaret Chanler, *Roman Spring* (Little Brown and Co., 1934), p. 267.
3. *RemASG* I:108.
4. Entry in Rose Nichols Diary, Nichols-Shurtleff Papers, Schlesinger Library, Radcliffe College. Based on conversations with ASG, mostly in 1900.
5. From William Davenport, *The Dolphin Guide to Rome* (Doubleday & Co., 1964), p. 24.
6. Maitland Armstrong, *Day Before Yesterday* (Charles Scribner's Sons, 1920), p. 195.
7. *RemASG* I:109.
8. Will Low, *A Chronicle of Friendships* (Charles Scribner's Sons, 1908), p. 221.
9. *RemASG* I:107.
10. Ibid., p. 111.
11. Nathaniel Hawthorne, *The Marble Faun* (Houghton Mifflin Co., 1890), p. 161. The novel first appeared in 1860.
12. Translated from the Latin inscription on the bas-relief of Shiff that ASG modeled in Paris in 1880, when Shiff was forty-seven.
13. *RemASG* I:108.
14. Truman Bartlett, "Autobiography," Manuscript Division, Library of Congress, chapter on ASG, p. 5.
15. Letter from Belle Gibbs (Mrs. John Merrylees) quoted in *RemASG* I:120–21.
16. Quoted in *RemASG* I:121.

--------- 8 ---------

A MANTLING OF MARBLE (II)

1. The bust was last heard of in a private collection in Maryland in 1947.
2. Paraphrase of a letter from ASG to Mr. Gibbs, May 1872, quoted in *RemASG* I:123.
3. The American critic Kenyon Cox, writing in 1914, observed that "*Hiawatha* seems today much the same sort of piece of neo-classicism as was being produced by other men in Rome at the time" (*Artist and Public* [Charles Scribner's Sons, 1914], p. 189).

4. Letter quoted in *RemASG* I:122.

5. Nathaniel Hawthorne, *The Marble Faun* (Houghton Mifflin Co., 1890), p. 122.

6. Ibid., pp. 163–64.

7. Quoted in *Direct Carving in Modern Sculpture* (Washington, D.C.: Hirshhorn Museum, 1983) (pamphlet).

8. Quoted in ibid.

9. Brenda Putnam, *The Sculptor's Way* (Watson-Guptill Publications, 1948 ed.), p. 305. Baillie contributed the chapter "Stone and Marble Carving."

10. William Henry Rinehart died in Rome in 1874. His *Hero* and *Leander*, two separate marble figures linked in one classic tragedy, were much admired.

11. Maitland Armstrong, *Day Before Yesterday* (Charles Scribner's Sons, 1920), p. 258.

12. Ibid., p. 259.

13. *RemASG* I:117.

14. Ibid., p. 118.

9

A PLUMING OF WINGS

1. The *Reminiscences* are vague about the dates of this trip home. The best source is Maitland Armstrong, *Day Before Yesterday* (Charles Scribner's Sons, 1920), p. 259: "The next day I departed for Venice, and a year passed before I could renew my acquaintance with Saint Gaudens."

2. Paraphrase of letter from ASG, May 12, 1873, quoted in Mantle Fielding, *Dictionary of American Painters, Sculptors and Engravers* (Paul A. Struck, 1945).

3. *RemASG* I:128.

4. Ibid., pp. 129–30.

5. Letter from Louis St. Gaudens to his wife, Annetta, October 23, 1902, SG Coll., Baker-DCL.

6. Kenneth Clark, *The Nude* (Doubleday Anchor Books, n.d.), based on A. W. Mellon Lecture delivered 1953.

7. Lecture by Marzio when director of the Corcoran Gallery of Art, 1980.

8. Armstrong, *Day Before Yesterday*, p. 262.

9. Although accorded full ambassadorial privileges and honors, American envoys to Great Britain held the rank of minister until 1893. In that year Thomas F. Bayard became our first ambassador.

10. This expression was much used in the Renaissance to describe an artist who was ready for fame. It was still current in seventeenth-century England.

―――――――――――――――――――― 10 ――――――――――――――――――――

AUGUSTUS AND AUGUSTA

1. John O'Keeffe (1747–1833) was an Irish actor and writer of comic operas. His rollicking verses were very much the kind Saint Gaudens liked to bellow as he worked.

2. Louise Hall Tharp, *Augustus Saint-Gaudens and the Gilded Age* (Little, Brown & Co., 1969), pp. 70–71. The detailed description of Augusta in Rome includes the observation that "her regular features had a sculpturesque quality."

3. Shelley's comment on this pale portrait is surprisingly unpoetic: "A just representation of one of the loveliest specimens of the workmanship of nature." It did inspire his verse drama *The Cenci*.

4. Augusta Homer's letters to her parents during various times abroad (1873–80) are in SG Coll., Baker-DCL. Attribution and dates (when known) of letters during this first trip are given in the text.

5. Letter of May 23, 1873, in Emerson-Nichols Papers, Schlesinger Library, Radcliffe College.

6. Most descriptions of Saint Gaudens call his hair and beard red or reddish-brown.

7. *RemASG* I:138.

8. Ibid., p. 144. The account is one of Homer Saint-Gaudens' interpolations.

9. Quoted in ibid., p. 141.

10. Ibid., p. 133.

11. Quoted in ibid., p. 142.

12. The Mars cameo is on display at the National Historic Site at Cornish.

13. *RemASG* I:114.

14. Quoted in ibid., p. 147.

15. Ibid., p. 134.

―――――――――――――――――――― 11 ――――――――――――――――――――

THE LUCK OF AUGUSTUS SAINT GAUDENS

1. This quote from the French composer (1803–69) is crisper in French than in translation: "*La chance d'avoir du talent ne suffit pas; il faut encore le talent d'avoir la chance.*"

2. Letter of 1885, quoted in *RemASG* I:129.

3. Letter of May 31, 1876, quoted in *RemASG* I:169.

4. Letter to Mrs. Thomas Homer, June 16, 1876, quoted in *RemASG*, I:170.

5. Remark of a contemporary quoted in the *Dictionary of National Biography*, "J. Q. A. Ward."

6. Letter of June 1876, quoted in *RemASG* I:172.

7. "Our sole Old Master, our sole type of the kind of genius that went out with the Italian Renaissance" (Royal Cortissoz quoted in an article on La Farge by Ruth Berenson, *Art and Antiques*, May-June 1982).

8. Quoted in Berenson, *Art and Antiques.*

9. Ibid.

10. John La Farge, S.J., *The Manner Is Ordinary* (Harcourt, Brace and Company, 1954), p. 29. This is the autobiography of La Farge's ninth child and namesake.

11. *RemASG* I:162.

12. Ibid., p. 161.

13. Bainbridge Bunting, *Houses of the Back Bay* (Harvard University Press, 1967), p. 211.

14. Conversation with American architect David Acheson, 1983.

15. *RemASG* I:327.

16. Letter of November 28, 1878, in White Family Papers, St. James, Long Island, N.Y.

17. Theodore Roosevelt, speech at a memorial meeting of the American Institute of Architects, Corcoran Gallery of Art, December 15, 1908.

18. Letter from Richard Watson Gilder to Homer Saint-Gaudens, June 6, 1907, quoted in *RemASG* I:186.

----------------------------- 12 -----------------------------

A TIME FOR PARIS

1. Henry James, "Essay on John Singer Sargent," 1887, quoted in F. O. Mathiessen, *The James Family* (Alfred A. Knopf, 1947), p. 526.

2. Letter of 1878, quoted in Maitland Armstrong, *Day Before Yesterday* (Charles Scribner's Sons, 1920), p. 264.

3. SG Coll., Baker-DCL.

4. Armstrong, *Day Before Yesterday*, p. 308.

5. Ibid., p. 266.

6. Quoted in *RemASG* I:191.

7. Quoted in ibid., p. 204.

8. Truman Bartlett, "Autobiography," Manuscript Division, Library of Congress, chapter on ASG, p. 9.

9. This account of the meeting between ASG and Low is taken from Will Low, *A Chronicle of Friendships* (Charles Scribner's Sons, 1908), pp. 215–16.

10. Low, *Chronicle*, p. 217.

11. Quoted in Armstrong, *Day Before Yesterday*, p. 264.

12. Quoted in letter from Gussie to her father, November 16, 1877, SG Coll., Baker-DCL.

13. Margaret Bouton, "The Early Works of Augustus Saint-Gaudens," unpublished doctoral dissertation, Radcliffe College, 1946, p. 276.

14. Lorado Taft, *Modern Tendencies in Sculpture* (University of Chicago Press, 1921), p. 102.

15. Engraving of the Timothy Cole drawing, *Scribner's*, February 1878.

16. *RemASG* I:161.

17. Letter of January 30, 1878, quoted in *RemASG* I:206.
18. Letter of March 1878, quoted in *RemASG* I:257.

--------- 13 ---------

HERO IN THE MAKING

1. Letter from ASG to Charles Keck, n.d., quoted in *RemASG* I:166.
2. Maitland Armstrong, *Day Before Yesterday* (Charles Scribner's Sons, 1920), p. 260.
3. Letter of March 1878, SG Coll., Baker-DCL.
4. Quoted in *RemASG* I:220.
5. Ibid., p. 244.
6. Letter from Stanford White to Mrs. Lawrence Grant White, November 21, 1878, White Family Papers, St. James, Long Island, N.Y.
7. The episode is described in Charles Moore, *The Life and Times of Charles Follen McKim* (Houghton Mifflin Co., 1929), p. 44.
8. Ibid., p. 46.
9. Letter from ASG to Stanford White, March 1, 1878, SG Coll., Baker-DCL.
10. Quoted in Armstrong, *Day Before Yesterday*, p. 285.
11. Letter of December 29, 1879, Richard Watson Gilder Collection, New York Public Library.
12. Quoted in *RemASG* I:267.
13. Émile Michel, *Revue des Deux Mondes*, no. XXXIX (1880), p. 927. The clear, vigorous French does not quite come through in translation: "*cette hardiesse de conception qui est propre aux Américains et dont Farragut a été un vivant exemple*" gives the full flavor.
14. SG Coll., Baker-DCL.
15. V. S. Pritchett, *The Tale Bearers* (Random House, 1980), p. 130.
16. There are several versions of this story. The most complete is in a letter from Eugenia Homer (Emerson) to Homer Saint-Gaudens after the death of ASG. It is quoted in *RemASG* I:260.
17. Mrs. Daniel Chester French, *Memories of a Sculptor's Wife* (Houghton Mifflin Co., 1929), p. 166.
18. Letter of November 17, 1879, Richard Watson Gilder Collection, New York Public Library.
19. SG Coll., Baker-DCL.
20. Letter from Augusta Saint Gaudens to Mrs. T. J. Homer, May 10, 1878, SG Coll., Baker-DCL.
21. Ibid.
22. SG Coll., Baker-DCL.

14
THE CRESTING OF THE WAVE

1. Royal Cortissoz, *American Artists* (Charles Scribner's Sons, 1923), p. 319. Condensation and paraphrase.
2. Wayne Andrews, *Architecture, Ambition and Americans* (Free Press ed., 1964), p. 152.
3. Ibid., p. 154.
4. SG Coll., Baker-DCL.
5. This episode is told in Maitland Armstrong, *Day Before Yesterday* (Charles Scribner's Sons, 1920), pp. 270–71.
6. Description of White by artist Edward Simmons, recorded in Charles C. Baldwin, *Stanford White* (Dodd, Mead & Co., 1931), p. 272.
7. "Intimate Letters of Stanford White," second installment, *The Architectural Record* XXX, no. 3 (September 1911).
8. Ibid.
9. *RemASG* I:286.

15
A MAN OF NO OTHER TIME OR PLACE

1. The term went into the language when Samuel Bing opened his Salon de l'Art Nouveau in Paris on December 26, 1895. As Bing used the phrase, it referred more to a movement than a style, and concerned the applied arts in particular.
2. Kenyon Cox, *Old Masters and New* (Fox Duffield & Co., 1905), p. 270.
3. *The American Architect and Building News* (September 10, 1881).
4. Letter of 1880, quoted in *RemASG*, I:266.
5. Lorado Taft, *Modern Tendencies in Sculpture* (University of Chicago Press, 1921), p. 97. The quotation is from a lecture given in 1917, before Saint Gaudens' limbo had really set in.

16
WHAT WENT RIGHT AND WHAT WENT WRONG

1. Charles Seymour, *Masterpieces of Sculpture in the National Gallery, 1200–1900* (Coward McCann Inc., 1949), p. 9.
2. C. M. Bowra, *The Greek Experience* (World Publishing Co., 1957), p. 144.
3. *RemASG* I:332.
4. Ibid., p. 33.
5. Henry Holt, *Garrulities of an Octogenarian Editor* (Houghton Mifflin Co., 1923), pp. 109–113.
6. This and the other Truman Bartlett quotes in the same paragraph are from

the chapter on ASG in the "Autobiography," Manuscript Division, Library of Congress, pp. 13–15.

7. Daniel Gregory Mason, *Music in My Times and Other Reminiscences* (Macmillan, 1938), p. 91.

8. Bartlett, "Autobiography," chapter on ASG, pp. 16–17.

9. Letter of December 3, 1892, quoted in *RemASG* I:291.

10. Letter of May 17, 1882, Paul Bion Correspondence, SG Coll., Baker-DCL.

11. Letter of May 24, 1881, Paul Bion Correspondence.

12. Letter, n.d., Paul Bion Correspondence.

13. Quoted in Louise Hall Tharp, *Augustus Saint-Gaudens and the Gilded Era* (Little, Brown & Co., 1969), p. 146.

14. *RemASG* I:307.

15. William C. Shopsin et al., *The Villard Houses: Life Story of a Landmark* (Viking Press, 1980), p. 42.

16. Letter of June 22, 1883, SG Coll., Baker-DCL.

17. Letter, n.d., in White Family Papers, St. James, Long Island, N.Y.

18. Letter of Tuesday, [August] 31 [1883], White Family Papers.

19. Letter of September 27, 1883, White Family Papers.

20. Gussie's letters are in SG Coll., Baker-DCL.

17

THE BEAUTIFUL OBSESSION

1. ASG called this early draft "The Reminiscences of an Idiot." It is in the SG Coll., Baker-DCL.

2. *RemASG* I:6.

3. "The Reminiscences of an Idiot," p. 1. In the final version "theories and dissertations on art" is changed, for no apparent reason, to "a disquisition on art" (*RemASG* I:6).

4. The original 1962 tape was made available by Mr. Farley to Frank O. Spinney, director of the Saint Gaudens Memorial (Cornish) at the time. In 1982, Mr. Spinney loaned it to me. The typescript of the interview was made by Debbie Groberg.

5. John Keats, *Lamia*, illustrated by Will Low (J. B. Lippincott Company, 1885).

6. John Dryfhout was the first to reach this supposition: "It is possible to speculate that since Davida Clark . . . was the model for these figures [he refers to the Morgan angels as well], Louis' signature on the Smith tomb was no doubt a ploy to disassociate Augustus from Davida" (John Dryfhout, *The Work of Augustus Saint-Gaudens* [University Press of New England, 1982], p. 234).

7. The ivory carving and note are owned by a grandson of Louis Clark's who lives in Florida under an assumed name.

8. Paul Bion Correspondence, SG Coll., Baker-DCL.

9. This note was found in 1963 in a Massachusetts gallery and purchased for the SG Coll., Baker-DCL.

10. Daniel H. Burnham Papers, Manuscript Division, Library of Congress.

11. The drawing is in the possession of June Clark Moore of Oceanside, California, widow of Davida's grandson Louis.

12. A copy of the contract is on file at the Saint Gaudens National Historic Site.

18

THE HARDENING OF THE MOLD

1. Truman Bartlett, "Autobiography," Manuscript Division, Library of Congress, chapter on ASG, p. 41.

2. Truman Bartlett Correspondence, Library of Congress.

3. Mantle Fielding, *Dictionary of American Painters, Sculptors and Engravers* (Paul A. Struck, 1945), p. 314.

4. Maitland Armstrong, *Day Before Yesterday* (Charles Scribner's Sons, 1920), p. 286.

5. Quoted in *RemASG* I:263.

6. This quote and those that follow in this paragraph are from René de Quélin, "Early Days with MacMonnies in St. Gaudens' Studio," *Arts and Decoration* XVI, no. 6 (April 1922).

7. Letter, n.d., quoted in *RemASG* I:285.

8. Quoted in *RemASG* I:273.

9. Paul Bion Correspondence, SG Coll., Baker-DCL.

10. *Selected Letters of Mark Twain*, ed. Charles Neider (Harper & Row, 1982), p. 149.

11. *The Quest for Unity: American Art Between World's Fairs, 1876–1893* (The Detroit Institute of Arts, 1983), pp. 26–27.

12. Ibid, p. 25.

19

THE LAND OF LINCOLN-SHAPED MEN

1. This paragraph describing the land surrounding the Cornish area is a paraphrase of Homer Saint-Gaudens' account quoted in Hugh Mason Wade, *A Brief History of Cornish* (University Press of New England, 1976), pp. 45–46.

2. *RemASG* I:312.

3. Maitland Armstrong, *Those Days* (Harper & Row, 1963), p. 37.

4. *RemASG* I:312.

5. Wade, *Brief History*, p. 50.

6. *RemASG* I:316.

7. James Earle Fraser, "Essay on Saint Gaudens," SG Coll., Baker-DCL.

8. Mark Twain and Charles Dudley Warner, *The Gilded Age* (1873). Twain interpolated a lot of personal observation into this first novel.

9. The interview took place on March 13, 1862, and was for *The Atlantic Monthly*. The passages quoted were deleted.

10. Walt Whitman, *Autobiographia*, quoted in James Mellon, *The Face of Lincoln* (Viking Press, 1979), p. 163.

11. Quoted in James Mellon, *The Face of Lincoln*, p. 6.

12. Ibid., p. 146.

13. Twain and Warner, *The Gilded Age*.

14. There was no death mask of Lincoln. In February 1865 sculptor Clark Mills made a life mask so reposeful it is sometimes thought to be posthumous. Gilder also rediscovered this, and made the arrangements for John Hay to buy it. The originals of the Volk life mask and hands were sent to the Smithsonian Institution in 1888 and can be seen there.

15. *The Letters of Richard Watson Gilder*, ed. Rosamond Gilder (Houghton Mifflin Co., 1921), p. 149.

16. Rose Nichols Diary, Nichols-Shurtleff Papers, Schlesinger Library, Radcliffe College.

17. Lorado Taft, "American Sculpture and Sculptors," *The Chatauquan* XXII, no. 4 (January 1896).

20

HE WHO WOULD VALIANT BE

1. This is from the original version of Valiant's song in the John Bunyan classic. It was slightly reworked for Hymn 250 in Episcopal hymnals.

2. Letter of June 10, 1885, SG Coll., Baker-DCL.

3. Letter, n.d., SG Coll., Baker-DCL.

4. Many Cornish residents interviewed by the writer remembered Homer Saint-Gaudens first-hand. This was the consensus.

5. Article in *Life* magazine on the centennial of ASG's birth, August 1948.

6. Letter to Mary Lawrence, 1897, quoted in Isabelle K. Savelle, *The Tonetti Years at Snedens Landing* (Historical Society of Rockland County, 1977), p. 76.

7. Hugh Mason Wade, *A Brief History of Cornish* (University Press of New England, 1976), p. 45.

8. Letter of January 1891, SG Coll., Baker-DCL.

9. Hebrews 11:13, 16.

10. F. Scott Fitzgerald, "The Rich Boy," in *The Stories of F. Scott Fitzgerald* (Charles Scribner's Sons, 1921), p. 177.

11. Will H. Low, "Frederick MacMonnies," *Scribner's* 18, no. 5 (November 1895). The passage applies to assistants in general, not Martiny in particular.

12. Quoted in Lorado Taft, *Modern Tendencies in Sculpture* (University of Chicago Press, 1921), p. 108.

———————— 21 ————————

TWO ROMANTICS

1. Letter, n.d., quoted in *RemASG* I:373.
2. Will Low, *A Chronicle of Friendships* (Charles Scribner's Sons, 1908), p. 389.
3. Ibid.
4. *The Letters of Robert Louis Stevenson*, ed. Sidney Colvin (Charles Scribner's Sons, 1902), II:37.
5. *RemASG* I:374.
6. Ibid., p. 375.
7. Low, *Chronicle of Friendships*, p. 394.
8. Quoted in J. C. Furnas, *Voyage to Windward* (William Sloane Associates, 1951), p. 299.
9. Quoted in ibid., p. 370.
10. Quoted in Low, *Chronicle of Friendships*, p. 378.
11. Louise Hall Tharp, *Augustus Saint-Gaudens and the Gilded Era* (Little, Brown & Co., 1969), p. 213.
12. C. Lewis Hind, *Augustus Saint Gaudens* (John Lane Company, 1908), p. 28.
13. Vladimir Nabokov, *Lectures on Literature* (Harcourt Brace Jovanovich, 1980), p. 180.
14. Lloyd Lewis, *Sherman: Fighting Prophet* (Harcourt, Brace and Company, 1932), p. 646.
15. Ibid.
16. Anecdote handed down in the Sherman family and quoted to me by the late John Sherman, great-grandnephew of the General.
17. *RemASG* I:381.
18. Letter, September 29, 1887, quoted in Low, *Chronicle of Friendships*, p. 395.
19. In the account of the meeting of Sherman and Stevenson I have blended Low's version (from his *Chronicle*) and several bits of dialogue recalled by ASG in *RemASG* I:381.
20. The full lines of the requiem on Stevenson's grave at Vailima are inscribed on the plinth in Saint Giles:

> Under the wide and starry sky
> Dig the grave and let me lie.
> Glad did I live and gladly die,
> And I laid me down with a will.
> This be the verse you grave for me:
> "Here he lies where he longed to be.
> Home is the sailor home from [the] sea
> And the hunter home from the hill.

21. The anecdote is told in the Santa Barbara *Free Press*, December 21, 1924, as part of an article by West Coast painter R. Cleveland Coxe.
22. Quoted in *RemASG* I:377.
23. Quoted in ibid., p. 388.

22

THE DELIGHTFUL ART

1. Brenda Putnam, *The Sculptor's Way* (Watson-Guptill Publications, 1948 ed.), p. 52.
2. Adolf Hildebrand, *The Problem of Form in Painting and Sculpture* (G. E. Stedhert & Co., 1907), pp. 29–30.
3. Ibid., p. 94.
4. Interview with John Wilmerding, deputy director of the National Gallery, December 30, 1981.
5. Ibid.
6. Interview with Frances Grimes by Margaret Bouton, 1945, from Miss Bouton's unpublished Ph.D. notes loaned to the author.
7. Giorgio Vasari, *Lives of the Artists* (Simon and Schuster, abridged ed., 1946), p. 120. Vasari's dates were 1511–74.
8. *RemASG* I:250.
9. Rose Nichols Diary, Nichols-Shurtleff Papers, Schlesinger Library, Radcliffe College.
10. Ibid.
11. *RemASG* I:215.
12. Royal Cortissoz, *Augustus Saint-Gaudens* (Houghton Mifflin Co., 1907), p. 12.
13. Marie Bashkirtseff, *The Journal of a Young Artist* (Cassell & Co. Ltd., 1889), p. 321.
14. This came out in an interview with Rodman Gilder, son of Richard Watson Gilder, by Margaret Bouton in 1945; in Miss Bouton's unpublished Ph.D. notes.
15. Letter from Frances Folsom Cleveland to Daniel Chester French, December 13, 1907, Metropolitan Museum of Art Archives.
16. Letter from Frances Folsom Preston to Margaret Bouton, May 23, 1945, Archives of American Art.
17. Interview with Rodman Gilder by Margaret Bouton, 1945.
18. The Kenyon Cox portrait was destroyed in the 1904 Cornish fire. In 1908 Cox repainted it from drawings and memory. It is now in the collection of the Metropolitan Museum of Art.
19. Letter from Virginia Gerson to Margaret Bouton, May 21, 1945, Archives of American Art. The bas-relief of Chase was presented to the Academy of Arts and Sciences by his widow. The Chase portrait of ASG was another casualty of the 1904 fire.
20. Quoted in Margaret Bouton's unpublished Ph.D. notes.
21. SG Coll., Baker-DCL.

22. SG Coll., Baker-DCL. The year is not given, but 1888 seems to fit.
23. SG Coll., Baker-DCL.
24. Quoted in *RemASG* I:346.
25. Letter to the author, March 22, 1983.
26. John Dryfhout, ed., *Augustus Saint-Gaudens: The Portrait Reliefs* (Grossman Publishers, 1969), p. 43.
27. Royal Cortissoz, *Augustus Saint-Gaudens*, p. 17.
28. Hon. Evan Charteris, *John Singer Sargent* (Charles Scribner's Sons, 1927), p. 137.

23

INTERLUDE WITH DATES AND STORIES

1. Marchal E. Landgren, *Years of Art: The Story of the Art Students League of New York* (Robert McBride, 1940), p. 47.
2. *RemASG* II:17.
3. Joseph Thorndike, Jr., ed., *Three Centuries of Notable American Architects* (American Heritage Publishing Co., 1981), p. 157.
4. Letter, n.d., Paul Bion Correspondence, SG Coll., Baker-DCL.
5. G. E. Kidder Smith, *The Architecture of the United States* (Anchor Books, 1981), I:244.
6. Quoted in Laura Wood Roper, *FLO: A Biography of Frederick Law Olmsted* (Johns Hopkins, 1973), p. 412.
7. Margaret French Cresson, *Journey into Fame* (Harvard University Press, 1947), pp. 156–57.
8. Mrs. Daniel Chester French, *Memories of a Sculptor's Wife* (Houghton Mifflin Co., 1923), p. 154.
9. The anecdote has come down in various forms. This version was told me by Alleyn Cox, mural painter and son of Kenyon Cox, in 1982, not long before his death.
10. Alice Shurcliff, *Lively Days* (Literature House, 1966), p. 35.
11. Mrs. French, *Memories of a Sculptor's Wife*, p. 159.
12. *RemASG* I:324.
13. The enamel of Davida is dated 1889 and signed "Alfred Garnier." It is owned by June Clark Moore of Oceanside, California.
14. Letter of April 26, 1890, O. Hering Collection, Special Collections, New York Public Library. There are nine letters here from ASG to Fanny Field Hering (Mrs. Randolph Hering) during the years 1890–96.
15. Quoted in *RemASG* II:183.
16. *Le Livre des expositions universelles* (Union Centrale des Arts Decoratifs, 1983), p. 88.
17. Augusta Saint Gaudens Correspondence with Rose Hawthorne Lathrop, courtesy of Rosary Hill Home, Hawthorne, N.Y. No date, but this letter refers to coming back from Europe in October, which she did in 1888.
18. Letter, n.d.

19. Letter, n.d.
20. Letter, n.d.
21. Letter, n.d.
22. Letter, May 13, 1890.

------------------------------ 24 ------------------------------

DIANA OF THE CROSSWINDS

1. Quoted in Joseph Durso, *Madison Square Garden: 100 Years of History* (Simon and Schuster, 1979), p. 77.
2. The term "skyscraper" did not come into use until 1894, when an issue of *Harper's Weekly* referred to "the age of the skyscrapers." Two years later Hearst's *Journal* used the word "skyline" for another first coinage.
3. Leland M. Roth, *McKim, Mead & White, Architects* (Harper & Row, 1983), p. 163.
4. Ibid., p. 163.
5. *RemASG* I:393.
6. Paul Bion Correspondence, SG Coll., Baker-DCL.
7. Quoted in Peter Fusco and H. W. Janson, eds., *Romantics to Rodin* (George Braziller, 1980), p. 258.
8. Ibid., p. 363.
9. New York *Herald*, December 5, 1897.
10. Charles Baldwin, *Stanford White* (Dodd, Mead & Co., 1939), p. 210.
11. Jeanne L. Wasserman, ed., *Metamorphosis in Nineteenth Century Sculpture* (Fogg Art Museum, 1975), p. 209. The article on the two *Dianas* and their various reproductions is by John Dryfhout.
12. Cholly Knickerbocker, New York *Recorder*, September 1892.
13. *Mercury*, November 1891.
14. *Collier's*, August 25, 1906.
15. Durso, *Madison Square Garden*, p. 135.

------------------------------ 25 ------------------------------

COMING TO TERMS

1. The letter, on plain paper with no dateline, is in the SG Coll., Baker-DCL.
2. The graphologist consulted is Mrs. John Hayes Howard of Great Barrington, Massachusetts, whose analyses have stood up under many tests of corroborative evidence, and of time.
3. Letter to Rose Nichols, September 2, 1898, in Rose Standish Nichols, ed., "Familiar Letters of Augustus Saint-Gaudens," *McClure's Magazine* XXI, no. 6 (October 1908).
4. Ibid.
5. Ibid.
6. Ibid.

7. Letter to Rose Nichols, February 17, 1897, in "Familiar Letters."
8. Letter to Rose Nichols, January 26, 1897, in "Familiar Letters."
9. Emerson-Nichols Papers, Schlesinger Library, Radcliffe College.
10. Paul Bion Correspondence, SG Coll., Baker-DCL.
11. This story is part of the folklore of the Cornish colony. It was told me in 1982 by the late Maxfield Parrish, Jr.
12. Paul Bion Correspondence, SG Coll., Baker-DCL.
13. Letter of August 16, 1892, SG Coll., Baker-DCL.
14. Interview with Frances Grimes by Frank O. Spinney, August 8, 1963.

26

THE ADAMS MONUMENT

1. Otto Friedrich, *Clover* (Simon and Schuster, 1979), p. 12.
2. ASG entry, *World Book*, 1949 ed.
3. Ward Thoron, ed., *The Letters of Mrs. Henry Adams* (Houghton Mifflin Company, 1918), p. 458.
4. Letter from Elizabeth Nichols to Caroline Dall, March 6, 1892, Dall Papers, Massachusetts Historical Society.
5. Letter of March 26, 1872, in Henry Adams, *The Letters of Henry Adams*, ed. J. C. Levenson, Ernest Samuels, et al. (Harvard University Press, 1982), II:133–34.
6. Brooks Adams, Introduction to Henry Adams, *The Degradation of the Democratic Dogma* (The Macmillan Company, 1919), pp. 1–2.
7. Cecil Spring-Rice, *The Letters and Friendships of Sir Cecil Spring-Rice* (Houghton Mifflin Co., 1929), I:81.
8. Ibid., p. 68.
9. Brooks Adams, Introduction, p. 6.
10. Henry Adams, *The Education of Henry Adams* (Houghton Mifflin Company, 1918), p. 386.
11. Ibid.
12. R. P. Blackmur, *Henry Adams* (Harcourt Brace Jovanovich ed., 1980), p. 138.
13. Brooks Adams, Introduction, p. 2.
14. The passages from *Esther* are quoted in Friedrich, *Clover*, p. 299.
15. Adams, *The Education of Henry Adams*, pp. 333–34.
16. Quoted in Friedrich, *Clover*, p. 300.
17. Thoron, *Letters of Mrs. Henry Adams*, p. 294.
18. Letter of May 14, 1882, in ibid., p. 384.
19. Ernest F. Fenollosa, *Epochs of Chinese and Japanese Art* (Dover Publications, 1963 ed.), pp. 333–34.
20. Washington *Evening Star*, January 17, 1910.
21. Jottings and sketch survive in an ASG scrapbook now in the SG Coll., Baker-DCL.
22. Letter, n.d., quoted in *RemASG* I:359.

23. Letter, n.d., quoted in ibid.
24. Adams, *The Letters of Henry Adams*, III:160.
25. Ibid., p. 213.
26. Ibid., p. 287.
27. Quoted in Arline Tehan, *Henry Adams in Love* (William Morrow, 1983), p. 114.
28. Quoted in ibid., p. 112.
29. Letter of Henry Adams to ASG, June 23, 1891, quoted in *The Letters of Henry Adams*, III:496.
30. Ibid.
31. Quoted in ms. of Tehan, *Henry Adams in Love* and made available by the courtesy of Arlene Tehan.
32. Letter of October 14, 1896, quoted in *RemASG* I:363.
33. This quote and the three following are from *The Education of Henry Adams*, pp. 329–30.
34. Letter of December 16, 1908, in Newton Arvin, ed., *The Selected Letters of Henry Adams* (Farrar, Straus and Young, 1951), p. 252.
35. *RemASG* I:359.
36. Quoted in Andrew S. Keck, "Uncle Henry's Mind," unpublished essay, Literary Society of Washington, D.C., December 9, 1978, p. 14.
37. Letter, n.d., quoted in *The Letters of Henry Adams*, ed. Worthington C. Ford (Houghton Mifflin Co., 1938), II:311.
38. John Galsworthy, *The Silver Spoon and Passers By* (vol. 5 of *The Forsyte Saga*) (Charles Scribner's Sons, 1926), p. 259.
39. Joseph P. Lash, *Love, Eleanor* (Doubleday and Company, 1982), p. 132.
40. Ibid., p. 329.
41. Friedrich, *Clover*, p. 12.

27

OF WILLIE MACMONNIES AND KINDRED MATTERS

1. Russell Lynes, *The Art-Makers* (Dover Publications ed., 1982), p. 447.
2. Ibid., p. 480.
3. Charles Moore, *Daniel H. Burnham* (Houghton Mifflin Co., 1921), I:47.
4. Letter of 1891, R. W. Gilder Collection, New York Public Library.
5. René de Quélin, "Early Days with MacMonnies in Saint Gaudens' Studio," *Arts and Decoration* XVI, no. 6 (April 1922).
6. Ibid.
7. Letter of February 18, 1888, Paul Bion Correspondence, SG Coll., Baker-DCL.
8. Ibid.
9. Ibid.
10. Letter of March 19, 1890, Paul Bion Correspondence.
11. Letter of November 1891, Paul Bion Correspondence.
12. A separate letter of November 1891, Paul Bion Correspondence.

13. ASG's letter of December 3, 1892, SG Coll., Baker-DCL.

14. A montage taken from letters of May 23, 1892, and February 3, 1893, Paul Bion Correspondence.

15. A slightly more formal version of this oft-quoted response is in *RemASG* II:74.

16. Isabelle K. Savelle, *The Tonetti Years at Snedens Landing* (The Historical Society of Rockland County, 1977), p. 13.

17. *RemASG* II:73.

18. Savelle, *The Tonetti Years*, p. 58.

19. Quoted in ibid., p. 61.

20. Burnham Papers, Manuscript Division, Library of Congress.

21. Savelle, *The Tonetti Years*, p. 85.

22. Margaret French Cresson, *Journey into Fame* (Harvard University Press, 1947), p. 171.

28

WHITE CITY MIRAGE

1. Jeanne Madeline Weimann, *The Fair Women* (Academy Chicago, 1981), p. 256.

2. Quoted in ibid., p. 258.

3. Henry Adams, *The Education of Henry Adams* (Houghton Mifflin Co., 1918), p. 343.

4. Sylvia Jukes Morris, *Edith Kermit Roosevelt* (Coward McCann, 1980), p. 146.

5. Warren Forma, *They Were Ragtime* (Grosset & Dunlap, 1976), p. 54.

6. Thomas Beer, *The Mauve Decade* (Farrar, Straus and Giroux ed., 1980), p. 43.

7. Weimann, *Fair Women*, p. 580.

8. Quoted in *RemASG* II:72.

9. Beer, *Mauve Decade*, p. 37.

10. *RemASG* II: 74.

29

A NEW WORLD PRIMACY

1. *RemASG* I:285.

2. Letter from Charles Patschek to Frank O. Spinney, 1965.

3. Paul Bion Correspondence, SG Coll., Baker-DCL.

4. Margaret French Cresson, *Journey into Fame* (Harvard University Press, 1947), p. 213.

5. Mrs. Daniel Chester French, *Memories of a Sculptor's Wife* (Houghton Mifflin Co., 1928), p. 187.

6. John H. Dryfhout, *The Work of Augustus Saint-Gaudens* (University Press of New England, 1982), p. 316.

7. Letter, n.d., quoted in John Dryfhout, *Sculpture of a City—Philadelphia* (Walker Publishing Co., 1974), unpaged (Garfield chapter).

8. Truman Bartlett, "Autobiography," Manuscript Division, Library of Congress, chapter on ASG, p. 20.

9. Emmanuel Bénézit, ed., *Dictionnaire des peintres, sculpteurs, dessinateurs et graveurs* (Gründ, 1976), entry on Emmanuel Frémiet.

10. Bartlett, "Autobiography," p. 20.

11. *RemASG* II: 109.

12. Conversation with Sarah Ingelfinger, daughter of Margaret Nichols (Shurcliff), September 1984

13. Letter of December 1896, Nichols-Shurtleff Papers, Schlesinger Library, Radcliffe College. (The Shurtleff family anglicized its name to "Shurcliff" some time after the papers were deposited at Radcliffe.)

14. Paul Bion Correspondence, SG Coll., Baker-DCL.

15. Letter of August 29, 1896, Paul Bion Correspondence.

16. Ibid.

30

SYMPHONY IN BRONZE

1. Lorado Taft, *Modern Tendencies in Sculpture* (University of Chicago Press, 1921), p. 1.

2. Quoted in Lincoln Kirstein and Richard Benson, *Lay This Laurel* (Eakins Press, 1973), unnumbered page.

3. Quoted in David Mehegen, "For These Union Dead," *Boston Globe Magazine*, September 5, 1982.

4. Quoted in Kirstein and Benson, *Lay This Laurel*.

5. Quoted in ibid.

6. "For These Union Dead," *Boston Globe*, September 5, 1982.

7. Quoted in ibid.

8. Quoted in Brett Howard, *Boston: A Social History* (Hawthorn Books, 1976), p. 242.

9. Kirstein and Benson, *Lay This Laurel*.

10. Quoted in ibid.

11. This and subsequent quotations from the Atkinson correspondence to ASG and others are from the Atkinson Family Papers, Massachusetts Historical Society. Further references are not given in this chapter unless the date is not supplied in the text.

12. *Dictionary of National Biography*, 1928 ed.

13. *RemASG* I:334

14. Letter in Atkinson Family Papers.

15. Excerpts from letters of September 30 and October 9, 1892, Lee Family Papers, Massachusetts Historical Society.

16. Excerpts from letters of August 2 and August 15, 1893, Atkinson Family Papers.

17. Letter of October 9, 1893, Atkinson Family Papers.

18. Letter of April 26, 1894, Atkinson Family Papers.

19. Letter of January 2, 1895, Atkinson Family Papers.

20. Letter of October 1, 1895, Atkinson Family Papers.

21. Quoted in *RemASG* 1:344.

22. Quoted in Atkinson letter to ASG, June 9, 1896, Atkinson Family Papers.

23. Letter of October 8, 1896; Atkinson Family Papers.

24. Quoted in M. A. DeWolfe Howe, *Boston: The Place and the People*, p. 295.

25. *RemASG* II:84.

26. Letter of October 12, 1897, Atkinson Family Papers.

27. Letter of June 9, 1897, Atkinson Family Papers.

28. *RemASG* II:79.

29. Ibid., I:347.

30. Ibid., II:84.

31. Quoted in *Proceedings of the American Academy of Arts and Sciences* 53, no. 10, unpaged (September 1918).

31

PARIS NOCTURNE (I)

1. Isabelle K. Savelle, *The Tonetti Years at Snedens Landing* (The Historical Society of Rockland County, 1977), pp. 78–79.

2. Quoted in Rose Nichols, "Familiar Letters of Augustus Saint-Gaudens," *McClure's Magazine*, October 1908.

3. "Les Salons de 1899," article found in the Louis St. Gaudens folder, SG Coll., Baker-DCL.

4. Letter of December 1, 1899, SG Coll., Baker-DCL.

5. Letter of May 2, 1899, quoted in *RemASG* II:136.

6. Quoted in *RemASG* II:137.

7. Letter of January 13, 1898, in Nichols-Shurtleff Papers, Schlesinger Library, Radcliffe College.

8. Quoted in Savelle, *Tonetti Years*, p. 76.

9. Letter of March 10, 1900, SG Coll., Baker-DCL.

10. Letter to Homer Saint-Gaudens after ASG's death, SG Coll., Baker-DCL.

11. Ernest Renan, *Atget and Proust: A Vision of Paris* (Macmillan, 1963), Introduction.

12. Rebecca West, *1900* (The Viking Press, 1982), p. 101.

13. Nichols, "Familiar Letters."

14. Letter to Mary Lawrence, December [1897], quoted in Savell, *Tonetti Years*, p. 76.

15. *RemASG* II:145.

16. Letter from Alfred Garnier to Louis St. Gaudens, n.d., quoted in *RemASG* II:152.

17. Letter to Rose Nichols, January 3, 1899, quoted in *RemASG* II:194.

18. Interview with Sarah Ingelfinger, daughter of Margaret Nichols, September 1984.

19. Alexander Phimister Proctor, *Sculptor in Buckskin* (University of Oklahoma Press, 1971), p. 129.

20. SG Coll., Baker-DCL.

21. Quoted in *RemASG* II:32.

22. SG Coll., Baker-DCL.

23. SG Coll., Baker-DCL.

24. Interview with June Clark Moore, January 1984.

32

PARIS NOCTURNE (II)

1. Files, SG National Historic Site, Cornish.

2. Uncatalogued Nelson Miles Collection, National Gallery Library, Washington, D.C.

3. Henry Adams, *The Letters of Henry Adams*, ed. Worthington C. Ford (Houghton Mifflin Co., 1938), II:233n.

4. Arline Boucher Tehan, *Henry Adams in Love* (Universe Books, 1983), pp. 182–98.

5. Letter of August 19, 1898, Nichols-Shurtleff Papers, Schlesinger Library, Radcliffe College.

6. Letter of March 10, 1900, SG Coll., Baker-DCL.

7. Barry Faulkner, *Sketches from an Artist's Life*, p. 145.

8. *RemASG* II:180–81.

9. Ibid., p. 15

10. Letter of December 9, 1898, quoted in Isabelle K. Savelle, *The Tonetti Years at Snedens Landing* (The Historical Society of Rockland County, 1977), p. 80.

11. Letter of May 30, 1899, SG Coll., Baker-DCL.

12. Conversation with the writer, August 1983.

13. Malvina Hoffman, *Yesterday Is Tomorrow* (Crown Publishers, 1965), p. 73.

14. Faulkner, *Sketches*, p. 156.

15. ASG, "Reminiscences of an Idiot," SG Coll., Baker-DCL.

16. Quoted in *RemASG* II:135.

17. James Earle Fraser, "Autobiography," manuscript in SG Coll., Baker-DCL.

18. Ibid.

19. Henry Adams, *The Education of Henry Adams* (Houghton Mifflin Co., 1918), pp. 386–88.

20. Harold Dean Cater, *Henry Adams and His Friends* (Houghton Mifflin Co., 1949), p. xvi.

21. Letter of December 3, 1899, quoted in Cater, *Henry Adams and His Friends*, p. 423.
22. Quoted in *RemASG* II:194.
23. Sir William Rothenstein, *Men and Memories* (Coward McCann, 1935), p. 194.
24. Quoted in Gerstle Mack, *Toulouse-Lautrec* (Alfred A. Knopf, 1942), p. 63.
25. Tehan, *Henry Adams in Love*, p. 164.
26. *RemASG* II:185.
27. Letter of September 12, 1898, quoted in ibid., p. 198.
28. Quoted in ms. of Tehan, *Henry Adams in Love* and made available by the courtesy of Arlene Tehan.
29. Quoted in Cater, *Henry Adams and His Friends*, p. 468.
30. Quoted in Fraser, "Autobiography."

33
MAKING DO

1. SG Coll., Baker-DCL.
2. Telegram of July 18, 1900, Nichols-Shurtleff Papers, Schlesinger Library, Radcliffe College.
3. Telegram quoted in letter from Elizabeth Nichols to Dr. Arthur Nichols, July 18, 1900, Nichols-Shurtleff Papers.
4. Quoted in John W. Bond, *Augustus Saint Gaudens—the Man and His Art* (Department of the Interior, Division of History, 1967), p. 113.
5. *RemASG* II:231.
6. Letter from Gussie to Homer Saint-Gaudens, December 1904, SG Coll., Baker-DCL.
7. Comment by Homer, *RemASG* II:231.
8. Letter of March 16, 1901, SG Coll., Baker-DCL.
9. Letter of December 24, 1901, ASG File, Players Club.
10. Maloney Collection, New York Public Library. (Margaret McKim was later Mrs. William J. Maloney.)
11. Truman Bartlett, "Autobiography," Manuscript Division, Library of Congress, chapter on ASG, p. 43.

34
MOVING UP, MOVING ON

1. Letter to ASG, August 3, 1903, SG Coll., Baker-DCL (concerning the three-part Sherman group)
2. Henry James, *The American Scene*, quoted in V. S. Pritchett, *The Tale Bearers* (Random House, 1980), pp. 134–35.
3. Charles Moore, *The Life and Times of Charles Follen McKim* (Houghton Mifflin Co., 1929), p. 192.

4. Letter reproduced in facsimile in Charles Moore, *Daniel H. Burnham* (Houghton Mifflin Co., 1921), vol. 1, between pp. 46 and 47.

5. *RemASG* II:264.

6. Quoted in ibid., p. 269.

7. Quoted in ms. of Tehan, *Henry Adams in Love* and made available by the courtesy of Arlene Tehan.

8. Letter to Elizabeth Cameron, April 22, 1901, in *The Letters of Henry Adams*, ed. Worthington C. Ford (Houghton Mifflin Co., 1938), II:327.

9. Letter to Elizabeth Cameron, April 19, 1903, ibid., II:406.

10. Moore, *Life and Times of McKim*, p. 272.

11. James M. Goode, *The Outdoor Sculpture of Washington, D.C.* (Smithsonian, 1974), pp. 243–48.

12. Louise Payson Latimer, *Your Washington and Mine* (Charles Scribner's Sons, 1924), p. 239.

13. Newspaper clipping, SG National Historic Site, source and date not given.

14. Ibid.

15. Ibid.

16. Royal Cortissoz, *Whitelaw Reed* (Charles Scribner's Sons, 1921), II:279.

17. Quoted in Rose Nichols Diary, Nichols-Shurtleff Papers, Schlesinger Library, Radcliffe College.

18. Lorado Taft, *Modern Tendencies in Sculpture* (University of Chicago Press, 1921), p. 113.

19. Letter of August 3, 1903, SG Coll., Baker-DCL.

20. SG Coll., Baker-DCL.

21. Henry James, *The American Scene*, quoted in F. O. Matthiessen, *The James Family* (Alfred A. Knopf, 1947), p. 660.

22. The comment from the *Herald* is quoted in the *Philadelphia Item*, June 7, 1908; see Margaret Bouton, Sherman file, unpublished Ph.D. notes.

35

THE FIRE AND THE MASQUE

1. Barry Faulkner, *Sketches from an Artist's Life* (William L. Bauhan, 1973), p. 34.

2. Ibid.

3. Interview with Frances Grimes by James Farley, 1962.

4. Ibid.

5. Lydia Parrish, unpublished diary, entry of March 22, 1904. The late Maxfield Parrish, Jr., made excerpts from his mother's diary available to me.

6. Interview with Frances Grimes.

7. *RemASG* II:248.

8. Faulkner, *Sketches*, p. 59.

9. Ibid.

10. Unpublished letter from Witter Bynner. ASG's French anecdote translates: " 'I asked for hot onion soup and you brought it to me cold. I asked for a chop

with potatoes and you brought me a rum omelet. Do you want to wait on me? Yes or No?' 'No!!' 'Then I'm leaving!' "
11. Kenyon Cox, article in *The Nation*, June 24, 1905.
12. Cornish lore from several sources.

36

THE *SEATED LINCOLN* AND THE *PHILLIPS BROOKS*

1. Letter of August 1, 1905, quoted in *RemASG* II:236. Reference to Rue Jacob refers to Beaux-Arts days and revels.
2. Local Cornish lore from various sources.
3. Ibid.
4. Letter to Maxwell Anderson, 1909.
5. SG Coll., Baker-DCL.
6. Letter of January 8, 1905, Richard Watson Gilder Collection, New York Public Library.
7. SG Coll., Baker-DCL.
8. Ethel Barrymore, *Memoirs* (Harper & Brothers, 1955), p. 153.
9. Letter to Haniel Long, May 5, 1917, in Witter Bynner, *Selected Letters*, ed. James Kraft (Farrar, Straus & Giroux, 1981), p. 57.
10. Ibid.
11. Lorado Taft, *Modern Tendencies in Sculpture* (University of Chicago Press, 1921), p. 114.
12. Anecdote recalled by the late Maxfield Parrish, Jr., in 1983 interview.
13. Conversation with the writer, 1983.
14. *RemASG* II:327.
15. Interview with the late Alleyn Cox, muralist son of Kenyon Cox, June 1982.

37

MAN OF ADAMANT, REALM OF GOLD

1. Burke Wilkinson, *The Zeal of the Convert* (Luce–David McKay, 1976), p. 23.
2. *The New Yorker*, January 31, 1983.
3. *Souvenir Program* (The Parnell Monument Committee, 1911), p. 25.
4. Quoted in *RemASG* II:329.
5. Neil MacNeil, *The President's Medal, 1789–1977* (Clarkson N. Potter, 1977), p. 55.
6. Ibid., p. 56.
7. Sylvia Jukes Morris, *Edith Kermit Roosevelt* (Coward, McCann & Geoghegan, 1980), p. 287.
8. Entry of January 15, 1905, Diary of Henry Cabot Lodge, Massachusetts Historical Society.

9. Letter of January 20, 1905, quoted in *RemASG* II:253.

10. Letter to President Roosevelt, March 4, 1905, quoted in *RemASG* II:254.

11. Letter of February 23, 1905, quoted in MacNeil, *The President's Medal*, p. 58.

12. MacNeil, *The President's Medal*, p. 61.

13. Letter of July 8, 1905, SG Coll., Baker-DCL.

14. *RemASG* II:331.

15. Quoted in *RemASG* II:330.

16. Quoted in John H. Dryfhout, *The 1907 United States Gold Coinage* (Eastern National Park & Monument Association, 1972), p. 1.

17. V. Clain-Stefanelli, "Our Most Beautiful Coin," *Washington Sunday Star*, September 11, 1966. The late Dr. Stefanelli was curator of the Numismatic Division of the Smithsonian at the time.

18. *RemASG* II:332.

19. Catalog of Public Auction Sale, Stacks (auctioneers), December 11–12, 1980, p. 82.

20. Ibid.

21. Dryfhout, *1907 Coinage*, p. 8.

——————————————— 38 ———————————————

INDIAN SUMMER WITH THUNDERHEADS

1. Thomas B. Brumbaugh, "A Saint-Gaudens Correspondence," *Emory University Quarterly* XIII, no. 4 (December 1957).

2. Ibid.

3. Ibid.

4. Ibid.

5. Ibid.

6. SG Coll., Baker-DCL.

7. Quoted in *RemASG* II:338.

8. Letter of April 6, 1905, quoted in *RemASG* II:343–44.

9. Quoted in *RemASG* II:236.

10. Letter [about March, 9, 1906], SG Coll., Baker-DCL.

11. Rose Nichols Diary, Nichols-Shurtleff Papers, Schlesinger Library, Radcliffe College.

12. Transcript of interview was included in Frank Spinney research made available to me by Mr. Spinney.

13. Letter from Charles Patschek of May 12, 1965, made available by Frank Spinney.

14. June Clark Moore obtained the certificate in 1984 and supplied the writer with a copy.

15. Letter of May 7, 1906, Homer Saint-Gaudens, ed., "Intimate Letters of Stanford White," Third Installment, *The Architectural Record* (October 1911), p. 404.

16. Letter of May 11, 1906, ibid., p. 404.

17. Warren Forma, *They Were Ragtime* (Grosset & Dunlap, 1976), p. 139.
18. Ibid., pp. 142–43.
19. Letter of August 6, 1906, "Intimate Letters of Stanford White," p. 406.
20. Letter of July 6, 1906, ibid., p. 406.
21. Truman Bartlett, "Autobiography," Manuscript Division, Library of Congress, chapter on ASG, pp. 44–45.

39
THE BECKONING HILLS

1. *RemASG* II:359.
2. Kenyon Cox, *Artist and Public* (Charles Scribner's Sons, 1914), p. 79.
3. Letter from Dr. Cleaves to ASG, May 17, 1906, SG Coll., Baker-DCL.
4. Letter from Elizabeth Nichols to Dr. Arthur Nichols, October 13, 1906, Nichols-Shurtleff Papers, Schlesinger Library, Radcliffe College.
5. SG Coll., Baker-DCL.
6. *RemASG* II:246.
7. ASG File, The Players.
8. Witter Bynner, *Selected Letters*, ed. James Kraft (Farrar, Straus & Giroux, 1981), pp. 14–15.
9. Ibid., pp. 17–18.
10. *RemASG* II:246.
11. Malvina Hoffman, *Yesterday Is Tomorrow* (Crown Publishers, 1965), p. 170.
12. *RemASG* II:246.
13. Unpublished letter, courtesy of the Witter Bynner Foundation for Poetry.
14. *RemASG* II:146.
15. SG Coll., Baker-DCL.
16. Letter of October 19, 1907, to Wiliam A. Coffin, C. F. McKim Papers, Library of Congress.
17. Mrs. Parrish's unpublished diary, courtesy of the late Maxfield Parrish, Jr.
18. Ibid.

AFTERWORD

1. Speech made at the Brooklyn Institute of Arts and Sciences, February 22, 1908.
2. Read at a memorial meeting, Mendelssohn Hall, New York, February 29, 1908.
3. Letter of December 2, 1907, Grimes-Faulkner Correspondence, SG Coll., Baker-DCL.
4. Interview with Frances Grimes by Frank Spinney, June 12, 1962, made available by Frank Spinney.
5. Letter of December 15, 1908, SG Coll., Baker-DCL.

6. Interview with Mrs. Lawrence Grant White by the author, March 30, 1982.

7. Program, Memorial Meeting of the American Institute of Architects, Corcoran Gallery of Art, December 15, 1908.

8. Fanny Field Hering, *The Life and Works of Jean Léon Gérôme* (Cassell, 1892), Introduction.

9. The filled-out form is in the Manuscript Div., New York Public Library.

10. Henry James, *A Little Tour in France*, p. 102.

11. Interview with Lewis Sharp by the author, November 1984.

12. George Moore, *Hail and Farewell* (Colin Smythe ed., 1976), p. 659.

13. Quoted in *The Notebooks of F. Scott Fitzgerald*, ed. Matthew J. Bruccoli (Harcourt Brace Jovanovich/Bruccoli Clark, 1978), p. 191. The complete story ("The Swimmers") was published in *Bits of Paradise: 21 Uncollected Stories by F. Scott and Zelda Fitzgerald*, ed. Matthew J. Bruccoli and Scottie Fitzgerald Smith (Charles Scribner's Sons, 1973).

INDEX

Note: The abbreviation ASG refers throughout to Augustus Saint Gaudens.